THE RISE AND RISE OF
CHAPPELL ROAN

To Klay, who is not afraid of bugs or snakes
KATHERINE

To my late mother, N. Jahanzeb, for always letting me know that there's a special place where boys and girls can all be Queens, every single day
HAMZA

First published in Great Britain in 2025 by Cassell,
an imprint of Octopus Publishing Group Ltd
Carmelite House
50 Victoria Embankment
London EC4Y 0D Z
www.octopusbooks.co.uk

An Hachette UK Company
www.hachette.co.uk

The authorized representative in the EEA is Hachette Ireland, 8 Castlecourt Centre, Dublin 15, D15 XTP3, Ireland (email: info@hbgi.ie)

Text copyright
© Katherine St. Asaph and Hamza Jahanzeb 2025
Design and layout copyright
© Octopus Publishing Group 2025

All rights reserved. No part of this work may be reproduced or utilized in any form or by any means, electronic or mechanical, including photocopying, recording or by any information storage and retrieval system, without the prior written permission of the publisher.

Katherine St. Asaph and Hamza Jahanzeb assert the moral right to be identified as the authors of this work.

ISBN: 978-1-78840-601-7
eISBN: 978-1-78840-613-0

A CIP catalogue record for this book is available from the British Library.

Printed and bound in China

10 9 8 7 6 5 4 3 2 1

Commissioned by Stephanie Selçuk-Frank
Additional text by Sasha Geffen
Publisher: Trevor Davies
Senior Developmental Editor: Pauline Bache
Design: Studio Nic+Lou
Art Director: Yasia Williams
Picture Researcher: Sarah Smithies
Picture Research Managers:
Giulia Hetherington and Jennifer Veall
Assistant Production Manager: Lisa Pinnell

This book has not been authorised, licensed or endorsed by Chappell Roan.

Katherine St. Asaph and Hamza Jahanzeb

THE RISE AND RISE OF CHAPPELL ROAN

THE STORIES BEHIND THE SONGS, TOURS AND RISE OF AN ICON

Contents

6 INTRODUCTION

PART 1 GLIMMERINGS

10 From the Midwest to the Global Stage
16 Musical Roots & Early Inspirations
22 Breaking Out: Musical Influences & Local Fame
32 That Good Hurt: School Nights
46 The Name Chappell Roan & the Origins of an Icon
58 The Making of an Album
62 Opening for Vance Joy & Declan McKenna
68 Welcome to the Pink Pony Club

PART 2 SUNRISE

- 74 Falling & Rising
- 84 Naked in North America Tour
- 86 The Story Behind the Songs
- 92 Song One: Femininomenon
- 98 Song Two: Red Wine Supernova
- 106 Song Three: After Midnight
- 110 Song Four: Coffee
- 114 Song Five: Casual
- 118 Song Six: Super Graphic Ultra Modern Girl
- 122 Song Seven: HOT TO GO!
- 126 Song Eight: My Kink Is Karma
- 132 Song Nine: Picture You
- 134 Song Ten: Kaleidoscope
- 138 Song Eleven: Pink Pony Club
- 144 Song Twelve: Naked in Manhattan
- 148 Song Thirteen: California
- 152 Song Fourteen: Guilty Pleasure

PART 3 STARBURST

- 156 Fletcher & Rodrigo
- 160 Sour
- 162 Guts
- 164 Good Luck, Babe!
- 168 Coachella
- 172 Governors Ball
- 176 Chappell Lollapalooza
- 184 Redefining Fame
- 196 The Midwest Princess Tour
- 208 Awards Season
- 224 TV Appearances

- 228 A SPARKLING FUTURE
- 232 SOURCES
- 238 PICTURE CREDITS
- 239 ABOUT THE AUTHORS
- 240 ACKNOWLEDGEMENTS

Contents

INTRODUCTION

From growing up in a small town in Missouri to gracing the covers of *Paper* and *Rolling Stone* and being named best new artist at the 2024 Billboard Music Awards, the 2024 MTV VMAs and the 2025 Grammy Awards, Chappell Roan's journey into stardom has defied expectations, shattered norms and captured the hearts of millions worldwide. In 2024 alone, her listens on Spotify multiplied at least seventeen-fold – an achievement that many artists can only dream of.

But what sets Chappell apart from other pop icons is not just her rapid rise – it's her authenticity, her artistry and the sheer determination behind it all.

This book details the behind-the-scenes story of 'your favourite artist's favourite artist', the country-girl dreamer turned dazzling drag phenomenon. Her journey – from uploading music covers on YouTube as Kayleigh Rose to earning Grammy nominations, headlining global tours and becoming an icon for a generation – proves that with hard work, resilience, talent and discipline even the most unassuming of beginnings can lead to extraordinary heights.

She's flung open the doors to a worldwide party, and everyone who doesn't belong anywhere else can come right on in.

The Rise and Rise of Chappell Roan: The Stories Behind the Songs, Tours and Rise of an Icon delves into the making of an artist who refuses to fit the mould, with unparalleled insight into the excitement around her performances and her style, which diverts from the traditional pop star – from cigarette butts in her backcombed hair to the iconic white-painted, jester-like face.

PART 1 details the glimmerings of fame in her childhood and late-teen years – from her formative years with her family in Missouri, releasing her first songs and her early performances, to being signed with Atlantic Records, the release of her first EPs, the impact of COVID-19 and the devastation of ultimately being dropped by her record label before being picked up by record producer and longtime supporter Dan Nigro.

PART 2 tells the story of the songs from *The Rise and Fall of a Midwest Princess* – the inspiration behind the lyrics, the musical

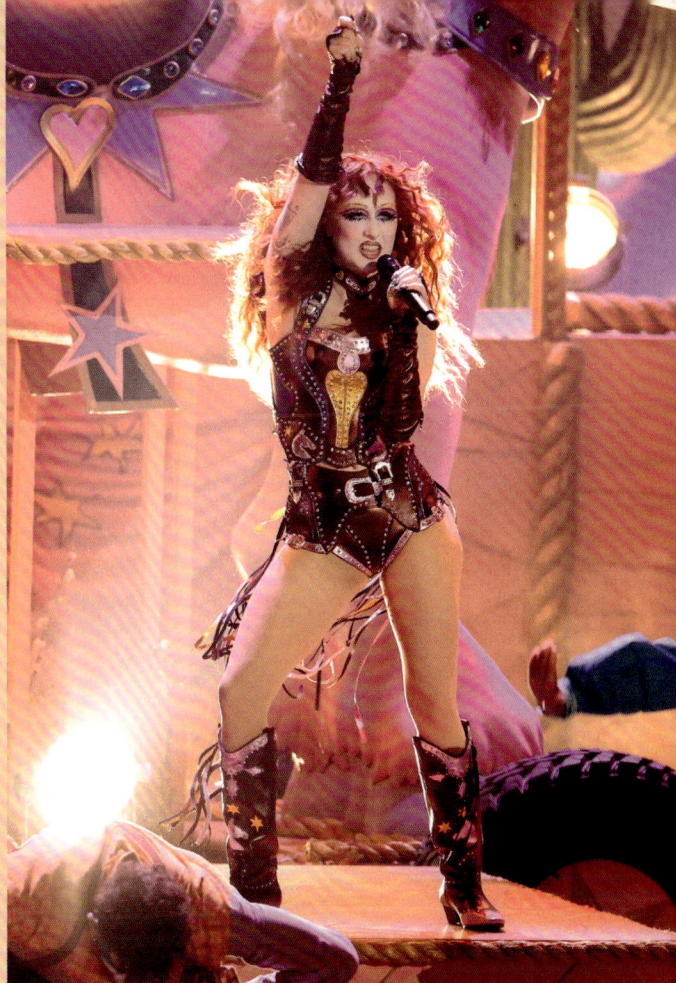

production, the videos and the outfits and the long, hot Chappell summer that accompanied her rise and rise.

PART 3 is a glimpse into the final ascent of her journey to becoming a global pop-fem phenomenon, with insight into her tours, recent music and television appearances along with her determination to redefine fame on her own terms.

The Rise and Rise of Chappell Roan is the story of one girl who 'made it' on a colossal scale, demonstrating that if you stay true to yourself and commit to your artistry, the world is bound to take notice. But one thing is for certain: the best of this feminomenon is yet to come.

INTRODUCTION

GLIMMERINGS

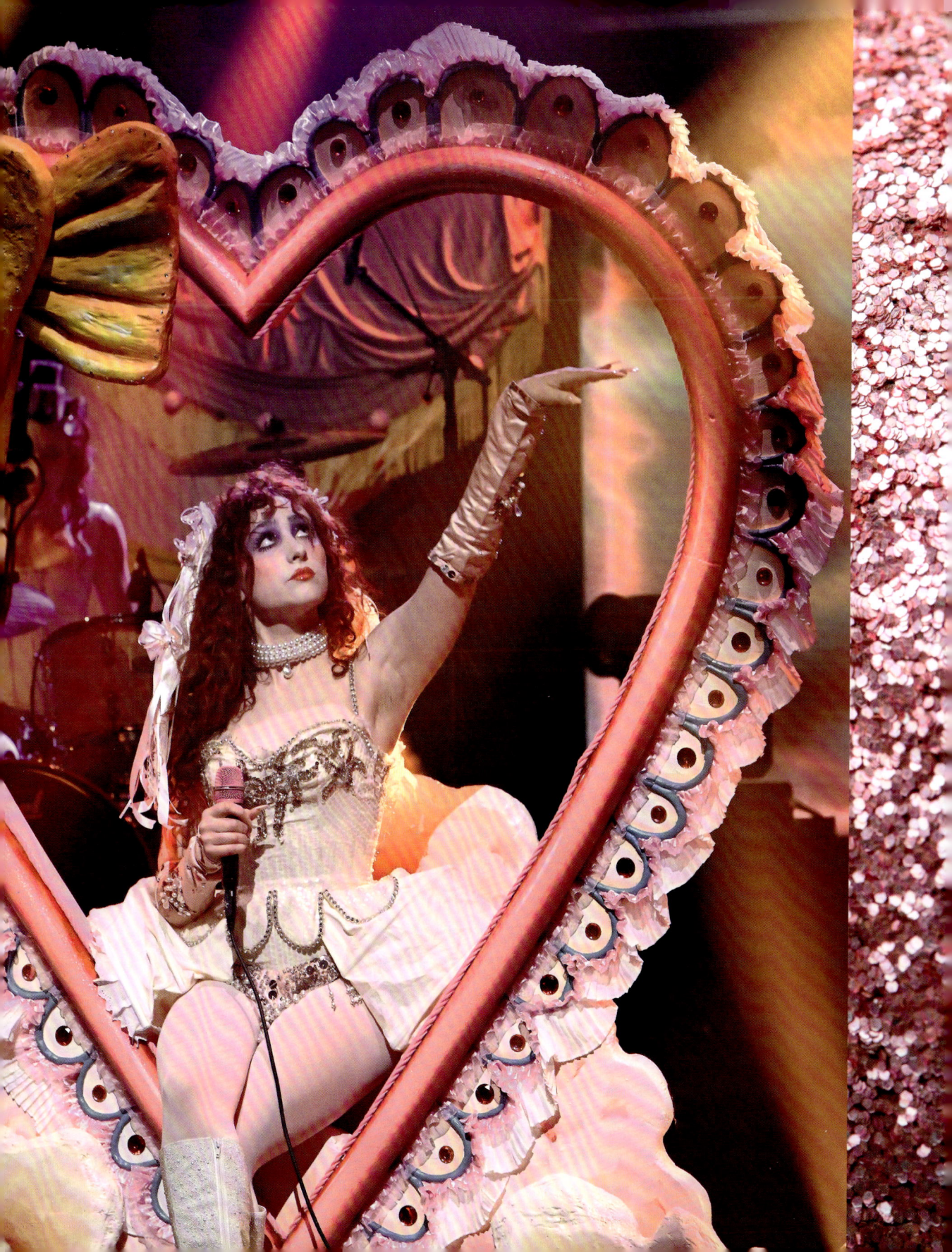

FROM THE MIDWEST TO THE *Global Stage*

Chappell Roan was born Kayleigh Rose Amstutz to Dwight and Kara Amstutz in Willard, Missouri, a town in the American Midwest situated amid the Ozark mountain range. The eldest of four children, she grew up with her younger sister Kamryn and two younger brothers, Dawson and Drew. Her mother is a practising veterinarian and her father a US Navy veteran as well as an intensive care and burns nurse who also runs the family practice.

'Anywhere you go in Missouri, you're gonna see a cow,' Chappell told *Radar Radio with Megan C* about her home state, where even the cities are just a short drive away from rural land. Many residents of Willard embrace the smalltown atmosphere: one local Facebook group calls it simply 'Our Little Town'. But for others, Willard is a 'bedroom community' like many other small suburban towns in America – a place where people have homes to sleep in, but travel to neighbouring towns to work, shop and live their 'real' lives.

Despite the lack of urban amenities, Chappell found ways to pass the time, working briefly as a lifeguard and later at her parents' office. Outside school and working hours, she'd hang out at Sephora in the mall until it closed

INSTEAD OF BEING TREATED LIKE A WHY NOT BE ONE?

and then with friends in the parking lot. She ran cross-country and did arts and crafts, often sewing her own clothes. Growing up around two vets, she was naturally an animal lover. At the age of ten, she got a guinea pig – the first of many.

But for a young teenager with big dreams – one who felt at odds with her surrounding culture – places like Willard could sometimes feel stifling. 'I had this part of me that wanted to escape so bad. I just wanted to scream,' Chappell told *Variety*. 'It was just this dichotomy of trying to be a good girl, but also wanting to freaking light things on fire.'

Particularly stifling was the evangelical Christianity that saturated her upbringing. Missouri is part of the band of American states known as the Bible Belt for their staunch religiosity, and Greene County, where Willard is located, is especially devout. Its congressional district is the second-most conservative in the state, and among the most Republican nationwide – so much so that its longtime representative in the US Congress, Billy Long, was recruited for a role in the second Donald Trump administration. 'There's a lot of churches and there's a lot of straight people with families and it's just really encouraged to take on the role of a wife and mother,' Roan told *Polyester* magazine about her hometown. 'There's this mentality that a woman should be treated like a princess, but also she should be a cook, a cleaner, a driver and so on.'

And Chappell's own extended family, she told *Making the Album* podcast, were 'very conservative [...] highly Republican [Party supporters].' Her uncle Darin Chappell – a former administrator of various cities across Missouri and frequent guest on conservative radio shows – ran for Missouri's House of Representatives in 2022 as the Republican candidate and won. Roan went to church three times a week, somewhat reluctantly, feeling out of place. She got baptized with the church congregation. She even had a purity ring – an item of jewellery that evangelical Christian teens of the time commonly wore as a pledge to remain virgins until marriage.

As she grew older, and grew into her queer identity, she felt only more at odds with her community. 'I didn't know a single out lesbian girl, gay girl, bi girl – nothing,' Roan told the LGBTQ+ newsletter *QBurgh*. 'There were a couple of gay boys in my school who were out and they got terrorized, slurred, threatened.' Roan knew by seventh grade that she was queer, but she didn't yet know where to go from there. 'I saw what would happen if you came out, and I knew that it was a sin at the time,' she said. It would take new surroundings, and new friendships blossoming into more, for her to embrace that identity.

FROM THE MIDWEST TO THE GLOBAL STAGE

However, Willard was the place that shaped Roan, and while her feelings about it are complex, they aren't entirely negative. 'I do love certain parts of [the town] – the peace and growing up in a trailer park; four wheeling, the farm and bonfires,' Roan told *Polyester*. She even reconciled herself with her conservative Christian background, to a degree. She later said that looking back, she was 'grateful' because she 'understood where [those people] were coming from'. As she told *Polyester*, 'It's very easy to label communities that you don't understand, and because I know the inner workings of it, [I don't] see it as anything it's not.'

Roan couldn't abandon her Midwestern roots entirely and nor did she want to. So, as much as she could, she separated the parts of her upbringing that caused her pain from the parts that were dear to her, then transformed and exaggerated their rural aesthetics. 'Oh, my God, this is so camp,' she realized, as she found a way into her artistic identity: the Midwest Princess. Instead of simply being treated like a princess, why not *be* one?

Musical Roots & EARLY INSPIRATIONS

Chappell Roan was not born into a musical dynasty and though her parents were comfortable financially, she did grow up in suburban Missouri, which meant that she was far away from music-business hotspots. Unlike many rising artists, she didn't have industry connections to elevate her into stardom. Instead, her path was paved by a patchwork of influences, trial and error and a relentless drive to find her voice.

Roan's parents, two ordinary people spending their days at their veterinary office, weren't heavily involved in music. As a child, Chappell didn't burn with ambition to become a singer, either; the creative field of her dreams was acting. Music was part of her life – as a girl growing up in the 2000s, amid the pop-princess era of Britney Spears and Christina Aguilera and then the heyday of singer-songwriters such as Pink, it could hardly not be – but it featured more as a backdrop. 'I always

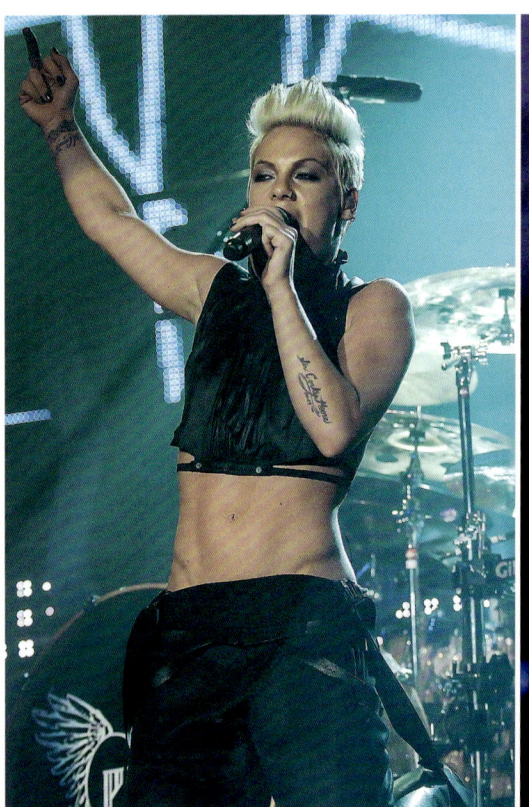
PINK

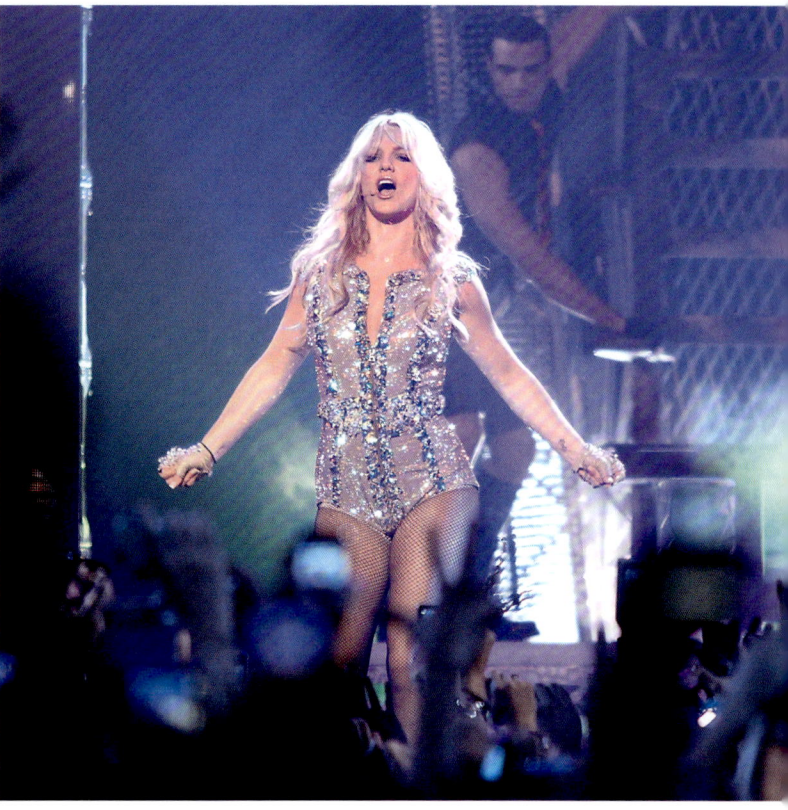
BRITNEY SPEARS

loved Britney Spears, but music wasn't this consuming thing,' she told the *Bringin' it Backwards* podcast.

Instead, her relationship with music was shaped by the same ambient pop culture most suburban kids experience. She grew up singing along with Disney princesses such as Pocahontas and Ariel, and trips to Disney World left a lasting impression on the young Missourian. Watching actors bring the princesses to life with their elaborate costumes and theatricality was her first glimpse of style and performance with purpose – a flair she'd later embrace in drag-inspired stage personas. She was drawn to their hyper-femininity; in one childhood photograph that Roan unearthed and posted on TikTok, she poses with a guitar – but a pink one, with a rainbow strap.

Roan bought her first record in kindergarten: a Pink CD. 'I just thought she was so cool and just so confident and amazing,' she told *Refinery29*. That early admiration for bold, emotional music stayed with her. Years later, she was struck by Rihanna's haunting piano ballad 'Stay' and decided that she too wanted to make music that conveyed that same raw emotion. 'Stay' marked a departure from Rihanna's usual dance–pop sound, reflecting the influence of Adele, whose confessional songwriting and smoky alto had already captured Roan's imagination.

Roan's first concert was a Jonas Brothers and Hannah Montana double bill, an event she still recalls vividly because it featured Miley Cyrus performing both as herself and as her alter ego, Hannah. Roan was just 11 when

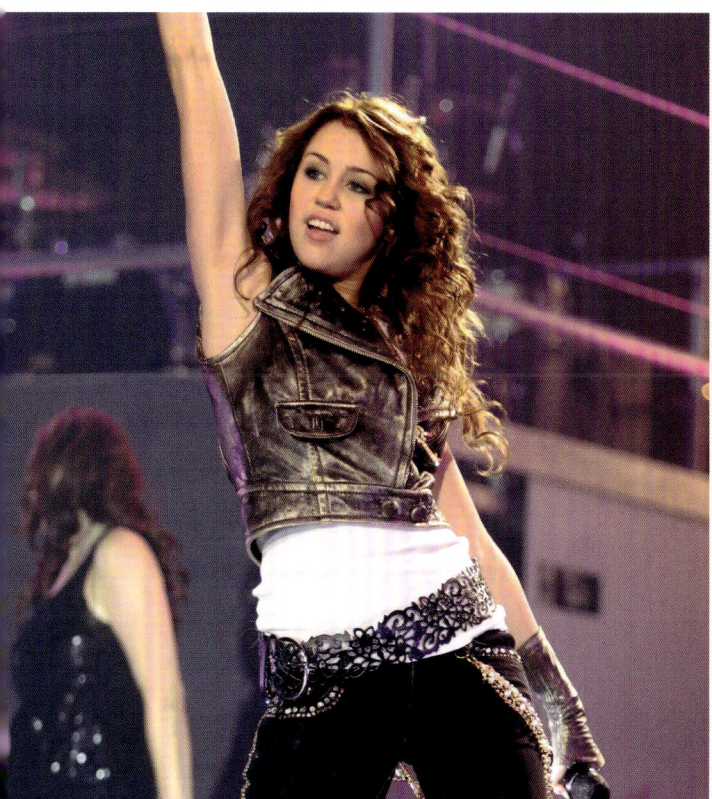

MILEY CYRUS

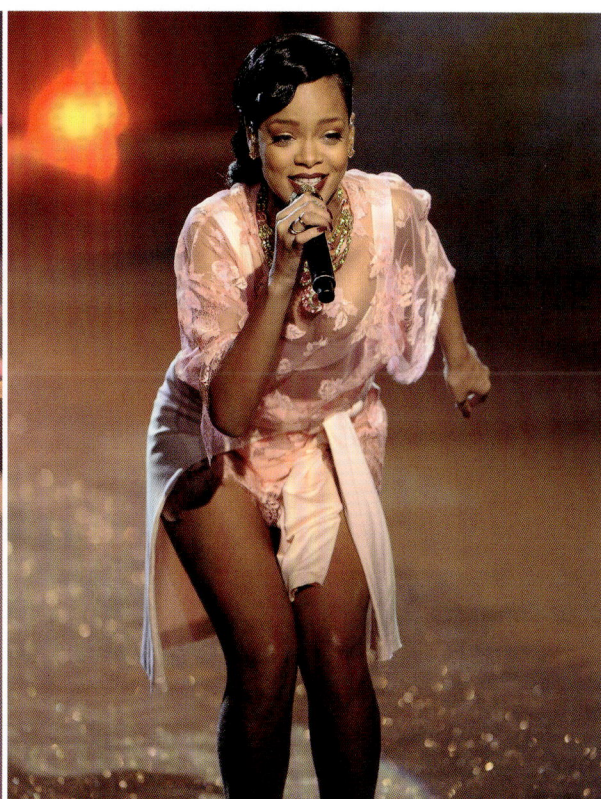

RIHANNA

Miley dropped 'Party in the U.S.A.', singing about landing in Los Angeles with dreams and a cardigan. At the time, Roan hadn't yet imagined that the dream Miley mythologized could one day also be hers.

Roan was fortunate to attend a school that valued music. Year after year, the Willard school district received plaudits for its music programme from the National Association of Music Merchants (NAMM) Foundation, a music-industry nonprofit. In 2016, over 60 per cent of middle-schoolers in the district took part in music programmes. Roan was eager to take her place among them. She started piano lessons aged 12, watching her teacher's hands on the keys until she learned to play by ear.

During her teenage years, Roan started experimenting with her vocal style, drawing inspiration from some of the greats. In a 2023 interview with *The Seattle Times*, she revealed that when teaching herself how to sing she would try to imitate 'the gravel and the vibrato' that Stevie Nicks brought to her voice, as well as the haunting, low voice of Karen Carpenter. 'I tried to mix the two,' she said. However, her early attempts at blending these influences led to what she described as a 'weird accent' that she eventually shed after moving to Los Angeles. There, she leaned into the more natural yodelling sound that is now a signature element of her voice. Despite her unique sound, Roan didn't have formal vocal training until much later. 'I took my first legitimate vocal lesson in December,' she admitted to *The Seattle Times*. In another interview, with *Illustrate Magazine*, she

KAREN CARPENTER

STEVIE NICKS (BELOW AND RIGHT)

elaborated, 'I also took vocal lessons for a couple years, but not classically. [My coach] taught me how to really belt and sing with confidence. It was more of a pop approach to vocal lessons.' These lessons solidified her focus on becoming a pop artist, blending technical skill with emotional authenticity.

Parallel to her formal school studies, Chappell was also getting a secret pop education: the lessons that would perhaps matter most. She was now old enough to discover her own taste, and she soon learned how potent music could be as a form of escapism: of imagining a life outside of her community's constricting norms. Chappel's family was so conservative, she told *Bringin' it Backwards*, that even ultra-mainstream, radio-approved artists such as Drake were people she had to hide on her iPod Touch. In her late teens, she'd go out on the porch in the middle of the night to smoke cigarettes she'd swiped from her grandmother while listening to Lana Del Rey. Lorde had also broken through around this time, with her 2013 single 'Royals', and Chappell became one of the singer-songwriter's many fans. But she hid one specific part of that fandom from Willard's purity-ring distributors: as Roan later sheepishly admitted on TikTok, she lost her virginity to the *Pure Heroine* track 'Glory and Gore'.

This listening, like her music training, set the fuse that would explode into Chappell Roan's brilliant career. It was integral to becoming the artist she is today: someone who has taken heartbreak and transformed it into a celebration that lights up crowded dance floors and house parties and carnivalesque festivals across the globe. As she describes it, 'I snuck my way into this pop, hip-hop world.' And there she stayed.

GLIMMERINGS

Breaking Out

MUSICAL INFLUENCES & LOCAL FAME

In eighth grade, when Roan was around 13, she was ready to step out from behind the piano. She decided to audition for her school's talent show – not merely as a pianist, nor as one choirgirl among many, but as a soloist. She hadn't exactly hidden her singing talent from her family, but this was her first opportunity to truly showcase her vocal prowess to them: not just as parents, but now as part of an audience.

Roan, who had a soft spot for Christmas music and hymns, auditioned with Nat King Cole's 'The Christmas Song'. She was nervous, but she had a lot of support. Her parents were surprised that she wanted to simultaneously sing and play the piano, but they encouraged her wholeheartedly. Her theatre teacher, Amanda Graves, helped her feel comfortable as the bright lights of the stage beamed down on her. And her choir

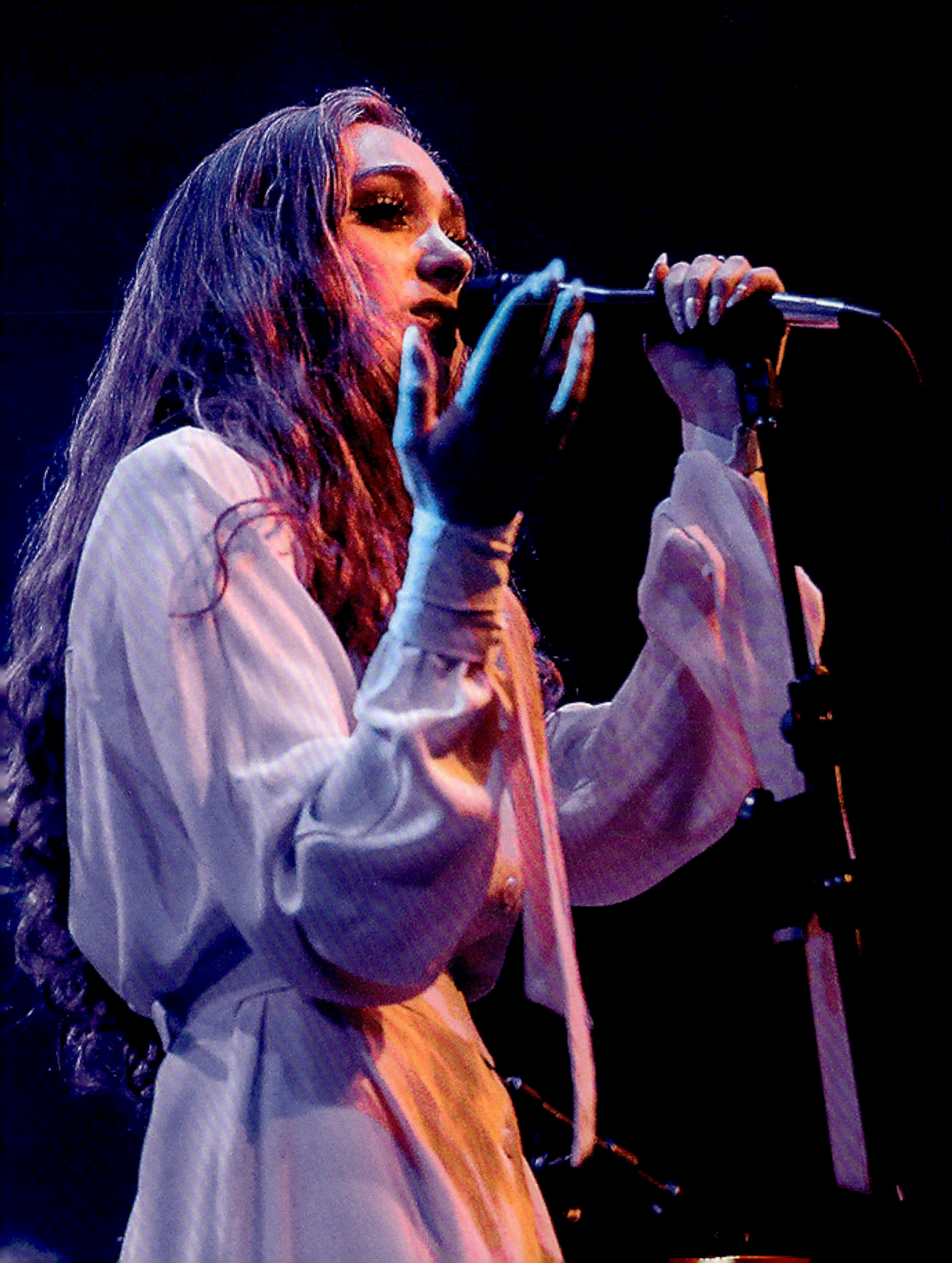

teacher, Emily Witt, reassured her before her audition that she'd be great.

'When she opened her mouth to sing, all the judges' jaws dropped,' Witt told Willard High School's student publication in 2018. 'When she left the room, I started crying [...] she had the most unique voice I have ever heard out of anyone, let alone an eighth-grade student.'

After Roan's talent-show success, Witt invited her to join her advanced music class. But Roan soon became aware that her voice 'stuck out' in the mix of her school choir, as she told the *Springfield News-Leader* in 2017. She was an okay but self-admittedly 'not awesome' music student, applying herself more to the performing arts which better resonated with her. Theatre in particular drew her; she thought that maybe she'd become an actress one day and that music would be a vehicle to help her reach her goal of acting.

Roan began writing songs because of that latent dream of commanding a stage. After all, she was already commandeering the stage – both she and her middle-school friend Kelsey crashed their school production of Disney's *Camp Rock 2* with a new, totally unsolicited composition that they performed live. But Roan had another reason to write, too – that classic teenage motivation: crushing. In school Roan had developed a huge crush on an older Mormon student – the kind of teenage infatuation that can feel so epic it can make you convinced, as Roan told *The Guardian* she'd been, that you have 'to write the greatest love song of all time'. But her crush's family wouldn't let him date outside of their faith – Roan herself was raised nondenominational Christian – so Roan immortalized him not in the greatest love song of all time, but in what she later described to *Rolling Stone* as 'a five-minute boring ballad'.

Roan's parents were supportive of her musical career, despite not being musicians themselves, and she credited her parents – especially her mother Kara – for pushing her to pursue performing. In her early teens, Chappell admitted, she didn't even know how to write business emails, let alone manage a

BREAKING OUT: MUSICAL INFLUENCES & LOCAL FAME

KEITH URBAN AND THE GRAMMY CAMP (2012)

THE GRAMMY CAMP JAZZ SESSION (2012)

music career. So her mother became her manager, setting up gigs and ensuring she had opportunities to play at local country clubs, talent shows and coffeeshops (with tip jars), paying her piano teacher $50 (£40) to accompany her. By age 14, Chappell was performing regularly at local events such as First Night and Artsfest and had two 30-minute sets at Cider Days, a two-day event held on Walnut Street in Springfield, Missouri.

Chappell's first big breakthrough came in 2012 when she won Springfield's Got Talent, a local talent competition, receiving $1,012 (£800) in prize money. Accepting the giant cheque on stage, she announced her musical ambitions with a newfound, brimming confidence that proved prescient, 'I want to win a Grammy. That's my goal. And I'm gonna do whatever it takes to get it.' A video of the event shows a lot of glee in the young Roan's face, as she embraces the crowd wearing a shirt dress with buttons. Her genuine look of surprise is endearing to the onlookers, as they too are proud of her achievements. And not only does she want to win a Grammy, but she also exudes a sense of normality. When asked what she plans to purchase with her prize money, she exclaims, 'A car!' – knowing that, in Missouri, 15 was the age she could get an instruction permit. From this moment – and with her newfound confidence – Roan's star was sure to rise. Her determination to get a Grammy became a reality over a decade later when she was awarded Best New Artist at the 2025 Grammy Awards.

In 2013, Roan (as Kayleigh Rose) embarked upon the rite of passage that most aspiring teenage singers either do or are told, endlessly, that they should do: try out for a talent show such as *American Idol* or *America's Got Talent*. 'The Midwest loves talent shows,' she told the *Bringin' it*

GLIMMERINGS

CAMP ROCK 2: THE FINAL JAM (2009)

Backwards podcast. Roan did try out for *America's Got Talent*; and while she didn't make it there, she still ended up on TV, performing her track 'Crave You' live on *The Mystery Hour,* a Springfield-based talk show syndicated on the Fox network channel. She wore a strapless red dress coupled with a grey cardigan and her nails displayed a French manicure. Playing on a keyboard, she wowed the live crowd with her vocals.

As her teen years in Willard progressed, her determination to pursue music strengthened, in part due to two full-time summer songwriting camps she attended in 2014: the Interlochen Arts Camp in Michigan, and the Grammy Museum's summer camp for high-schoolers. On the *Radar Radio with Megan C* podcast in 2015, a 17-year-old Chappell reflected on the contrasting experiences of the two for young artists, 'They were two completely different camps. Interlochen was all about creativity and working with other people, and knowing yourself as a writer (more).'

Interlochen Arts Camp blends traditional summer-camp activities such as kayaking and hiking with arts classes. Roan attended soley for music, but the camp's alumni span the creative arts and include jazz-pop singer Norah Jones, standup comic Maria Bamford and actors Terry Crews, Vince Gilligan and Felicity Huffman. Roan remembered it fondly, 'You could be whoever you wanted at that camp,' she told *Radar Radio*.

Interlochen was impressed with her, too. According to *Rolling Stone*, the camp's director thought she already had 'Lennon-McCartney-level songwriting skills' when enrolling, and the high school affiliated with the camp offered her a full scholarship to attend as a student. She turned the scholarship down for very teenage reasons: 'I was like, "I love my hick boyfriend, who's a dairy farmer,"' she joked to comedian

BREAKING OUT: MUSICAL INFLUENCES & LOCAL FAME

Bowen Yang for *Interview* magazine. 'So I said no. I look back, and I'm like, "Damn, all that for a Marine?"'

Chappell's time at Interlochen was short but nevertheless deeply formative. Meeting the kinds of creative people she'd had a hard time finding back home was as galvanizing for her music and songwriting as her lessons had been; after years of feeling as though she didn't belong in Willard or Springfield, she'd found a place where she did. '[Interlochen] was kind of an earthy camp,' she stated during her *Radar Radio* appearance. 'I don't want to be like, oh, they're all hippies, but they kind of were.'

This observation wasn't just about the hippie aesthetics – though she did say she put flowers in her hair – but about the values espoused at the camp. One of Interlochen's instructors, Seth Bernard, told Michigan newspaper *The Ticker* that his lessons weren't just about songwriting, but also activism, social change and what he called 'the responsibility of the microphone'. Chappell was one of his students, and Bernard recalls her being genuinely interested in those things as well – foreshadowing the defiant, principled politics she still holds as an adult and which she has never turned her back on.

Roan wrote several songs at Interlochen that would stay with her for years. Among them was the future *School Nights* track 'Die Young'. Bernard recalled feeling 'totally knocked out' when Roan played him an early version of the song. He had no notes. He simply told her, 'Obviously, you have created something special here. You've alchemized these painful experiences you're going through to write a song that's going to mean a lot to a lot of people.'

Grammy Camp, on the other hand, was very different: 'definitely a business camp', Roan told *Radar Radio*. Campers firstly had to audition to get in, and the camp itself had two work tracks: classes with leading industry professionals, including previous Grammy Award winners and nominated artists, as well as sessions to write and collaborate on music with fellow camp attendees. If Interlochen taught Roan that she could belong somewhere, Grammy Camp taught her that she could succeed somewhere, too. 'I learned so much about the industry, and I learned how to network myself and how to work with people under pressure and how to brand,' she said of the experience.

The highlight of Grammy Camp was the live shows, where Chappell and the est of her campmates were finally given an opportunity to perform the songs they'd written together – with industry scouts

swarming among the audience taking notes. The songs that they performed were group numbers, using a meld of the campers' individual styles.

But even amid company and across genres, Roan already stood out among her peers as a vocal talent. On 'Dive', she eagerly plays the hair-flipping hype girl to rapper Kellcee Batchelor's verses, then pours her emotions into the kind of soulful piano ballad she'd refine on her *School Nights* EP. And 'Hit and Run', with rapper TJ Wooten and onetime *American Idol* contestant Stephanie Hanvey, is like Kelly Clarkson doing a countrified 'Rolling in the Deep'. Roan took the bridges, roaring with aplomb.

Roan also began taking informal voice classes around this time. As she told *Illustrate*, with her piano training, her tutor took 'more of a pop approach to vocal lessons' – not theory-heavy classical training so much as learning to belt loud and confidently. (Chappell wouldn't start more formal voice lessons until much later, in December 2022.)

By 2016 – still in her teens – Roan was ready to go nationwide. Her grandparents thought she should pursue country music, while some other locals wanted her to do Christian contemporary. Roan was, by this point, set on pop – at least the ballad-heavy version of it. When talking to the *Bringin' it Backwards* podcast in 2022 about pushing back on these expectations, she sounds simultaneously like the rebellious teen she was and like the unapologetic person she'd remain as an adult, 'I always wanted to be anti-everything. Anything that people wanted me to do, I wanted to literally do the opposite.'

THAT GOOD HURT: *School Nights*

When Chappell Roan first got an inkling she might escape Missouri, she recorded a couple of music videos for her early songs with Jai 'Creative Knightmare' Garrett, a photojournalist who heard Chappell during one of her many local festival slots and started chatting with her grandmother, who was handing out flyers. They erected a stage set in Roan's family's garage and posted the videos on YouTube. She also posted her songs on the then prominent independent record distributor CD Baby. Her personal bio was humble and unassuming. 'Kayleigh Rose is a 16 year old singer-songwriter from a small town in Southwest Missouri [...] Her songs tell a story with a wide variety of emotions being shown. Some songs are heartbreak songs that pierce right to your soul. Others are fun and uplifting that bring out the best in people.' In an interview with *Crucial Rhythm*, Chappell Roan reflected on this early identity: '[Over the years] it's drastically changed. I used to be very dark piano ballad pop. I was a depressed, sad teenager, and it reflected that.'

In 2014, Roan self-released an EP called, simply, *Kayleigh Rose.* Listening to ballads such as 'Tell Me Again', it's easy to hear the potential her local followers heard. Roan was clearly still growing into her voice and her

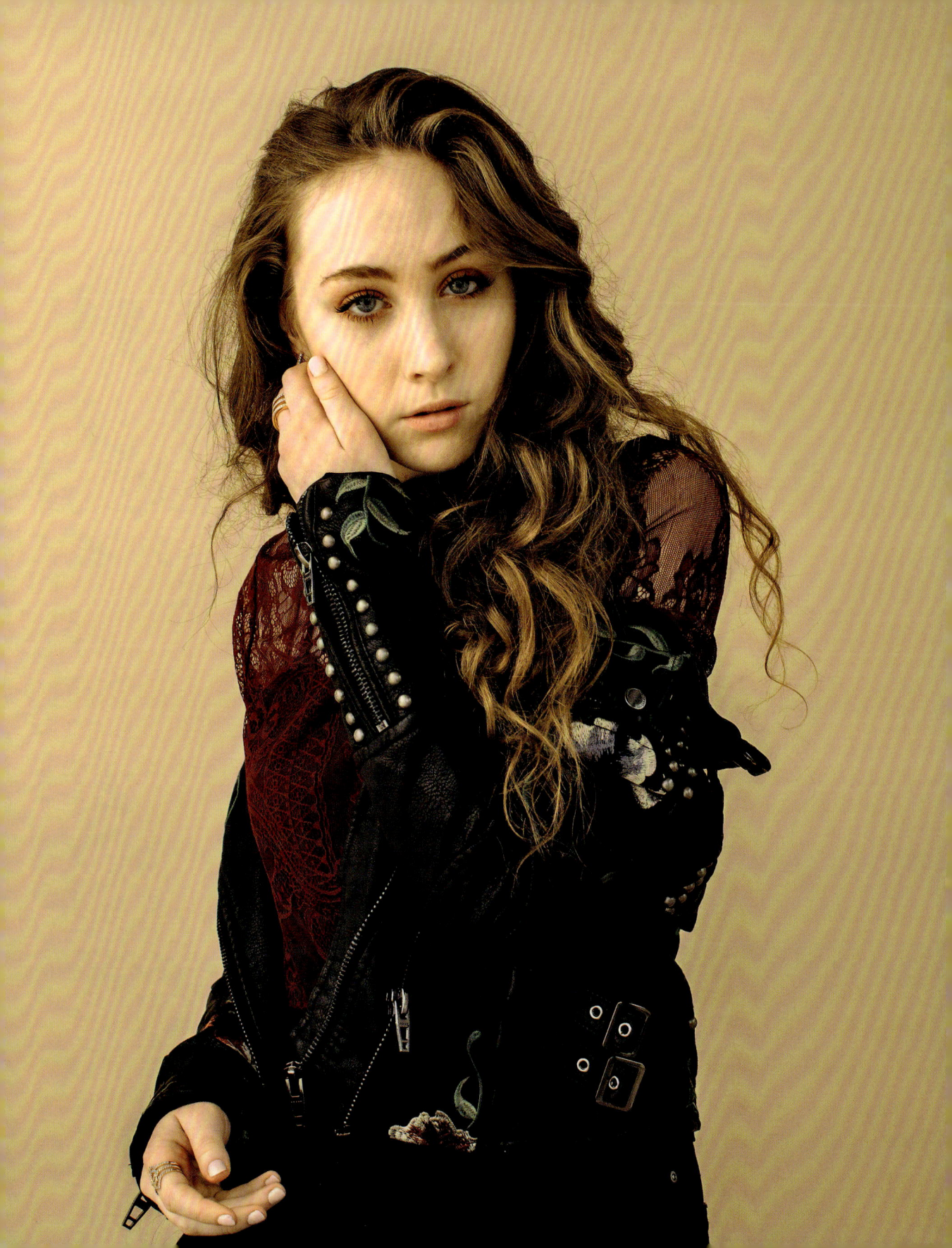

songwriting. She'd developed an impressive, preternaturally smoky timbre, though she hadn't yet gained full control over it. She was also fluent in teenage melodrama – lyrics such as 'I feel your name carved in my bleeding heart' exude the energy of a high-schooler really going through it – but her songwriting overall reflected a 16-year-old's imagination of the adult experience of love and lies. Instead of the lived specifics of *Midwest Princess* tracks such as 'Naked in Manhattan' and 'Coffee', there are songwriting-class techniques; for example, slight tweaks to common phrases like 'lock me up as you *break* the key' and studied abstractions. But she applied them well; the song is a work of careful craft, and not just for someone her age.

And people were starting to pay attention – not just in Missouri, or even New York or Los Angeles, but all the way to Australia. Troye Sivan, a former *Star Search* contestant, had blown up on YouTube during early 2012 with musical covers and skits and signed to EMI in 2013. YouTubers – very aware of how the internet can make you a star – would often throw promo to newcomers, especially fellow musicians. Sivan found the video to Roan's early song 'Die Young' in 2014; later, in November, he tweeted that he'd put the then high-schooler's music on repeat for two months. He wrote: 'LET'S BLOW KAYLEIGH UP BC I HAVENT HEARD A VOICE LIKE THIS SINCE ADELE, NO EXAGGERATION.' Fellow YouTuber Connor Franta, who'd also heard Roan's song when it had 'like no plays', concurred: 'YESSSSS GIVE THAT VOCALLY BLESSED GODDESS HER WELL DESERVED PROMO.' The tweets earned Roan about 15,000 YouTube views – small compared to her fame to come, but a huge deal for a girl who was still in high school and not far removed from scouting out her first record deals.

By now, the industry was paying attention, too. Around the age of 16, Chappell started shopping her demos around to record labels – several of which flew her and her parents out to New York so she could showcase them

in person. It felt like leading a double life: taking midterm exams, while shuttling back and forth between Missouri, NYC and LA to try to be a pop star. Struggling to juggle schoolwork as well as music, Chappell knew one had to give. So she chose to drop out of in-person school and take online classes through Brigham Young University, allowing her to graduate early and focus entirely on her music. In her first interview with *Bringin' it Backwards*, Roan jokingly recalled telling her high school, 'I can't do math at the same time [as venturing into pop stardom].'

One of the labels that met with Chappell was Atlantic Records, who signed her when she was 17. To announce the news, Roan gathered friends and family together in person, ostensibly to celebrate her early graduation. A video of the moment shows her clutching a thick white binder as she tells the small crowd she's being signed with the label for a six-album contract, then declares that she's about to sign the contract then and there. The room erupts. 'OH, MY GOSH!' one of her friends exclaims immediately. Chappell puts the binder down by a Sephora bag, grabs a pen and laughs off her nerves. 'This is scary, man.' Likely never having signed such an important document before, she asks whether she needs to put her full name down on the line – 'That's your name,' one of her friends assures her. And so, the moment that would change Chappell Roan's entire adult life passes – and then she's served a cake decorated with the Atlantic Records logo. Roan's high school also announced the news over the PA because it was such a wild occurrence: the glitter-polished hand of fame reaching down into their small town. 'When I got signed, some kids just flat-out thought I was lying,' Roan told the *Springfield News-Leader*.

ADELE

Roan's first major-label EP was Atlantic's *School Nights*. (Serendipitously, her first billed 'worldwide debut' as Chappell Roan was at a Los Angeles industry showcase for 'baby, baby artists' that was itself called School Night!) While *School Nights* is far from the technicolour club explosion that *The Rise and Fall of a Midwest Princess* would become, the 2017 EP falls well within the bounds of mainstream pop – particularly during a time when mainstream pop still wanted to find 'the next Adele' and make a 21-level bank. Roan's networking was beginning to pay off: several industry professionals worked with her as co-writers and producers on the EP. They included Stelios Phili – a hip-hop beatmaker who had been discovered several years previously by rapper A$AP Ferg; prolific pop producer Andrew Wells; and songwriter Jennifer Decilveo, who'd written for dozens of bubbling-under pop stars (including Roan's future tourmate Fletcher). But despite Roan now working with all-business industry figures, her own songwriting was central. And it came from the same place as it had done when she was an independent teen: the infatuations, challenges and heartbreaks of a young girl in her first relationships, slowly realizing what kind of relationships she *really* wanted.

The EP begins with 'Die Young', co-written with Andrew Wells, which would be her second single off the record. It's a ballad of graceful piano chords, stately march-like percussion and a lyric that guides dark feelings to a life-affirming place. 'I wanna die young,' she sings on the first chorus. By the end, that feeling is flipped: 'I sure as hell don't wanna die young.' The video conveys the

GLIMMERINGS

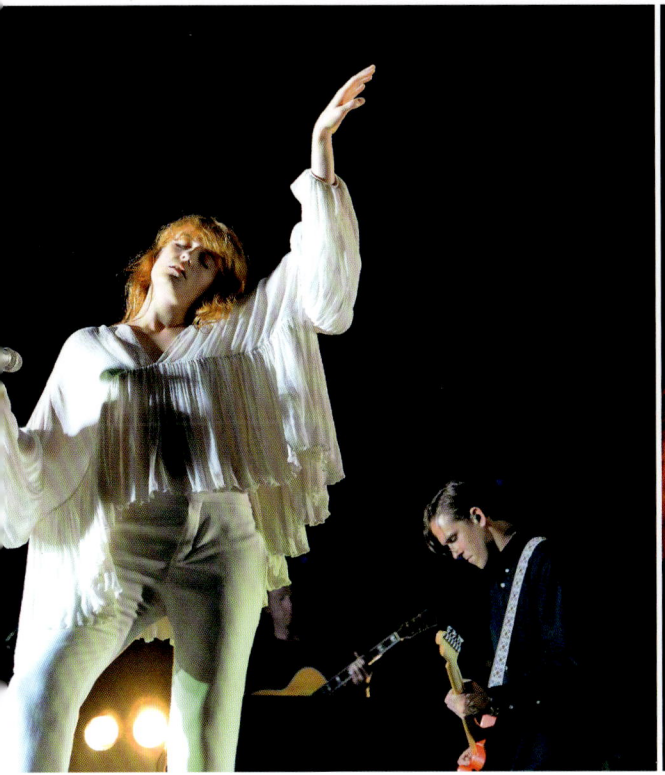

FLORENCE WELCH

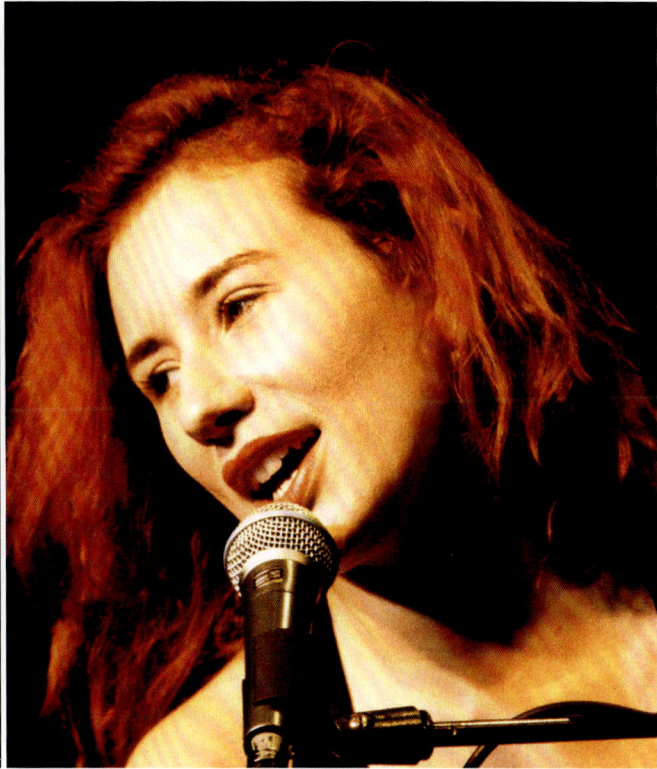

TORI AMOS

same sense of dissipating despair: Chappell casts herself as Ophelia in a gossamer gown, taking to the river to drown. But she's no passive Pre-Raphaelite waif viewed unconscious from afar. By the final shots, Chappell is fully submerged, but she faces the camera with dignity and strength.

'Die Young', one of her Interlochen songs, is an example of Chappell making a mundane class assignment personal. Every day, the songwriting instructors had given campers a prompt such as 'dreams' to inspire a new song. But Chappell wasn't thrilled with that one. 'I didn't want to write about dreams for some reason,' she told the *Radar Radio* podcast. She wanted to write about something real.

In a roundabout way, though, 'Die Young' turned out to be about dreams after all. She told the podcast, 'You have this fantasy of dying young and not caring, and you're kind of in a dream world.' That fantasy was something one of her best friends had confided to her. The friend had been going through hard times: doing drugs, succumbing to apathy and dwelling on the idea of giving up entirely. 'What's the point?' Roan recalls her friend saying. 'I just wanna die young.' Roan latched onto that phrase, and the song she wrote is like a gift to her friend: a map to find her way out of her depression.

'Good Hurt' was the first single from the EP, with good reason. It's the most radio-ready track there, with Roan's co-songwriters Jennifer Decilveo and Andrew Wells pulling out their arsenal of battle-proven songwriting techniques. The pre-chorus sets Roan's reverbed vocals against moody, faraway

THAT GOOD HURT: SCHOOL NIGHTS

chords, an arrangement that had powered singles by hitmakers such as The Weeknd and Florence Welch. The video, full of shrouded ceremonies, ominous creatures and dark grottos, has more than a little Florence, too. Roan languishes in an abandoned bathtub thick with dirt and beetles as an alligator lurks inside, and she lets a praying mantis crawl slowly down her face. (Though the alligator was shot in split screen and wasn't actually in the tub, the praying mantis was real – and Chappell was as freaked out as you'd imagine.)

The hook of 'Good Hurt', though it's far more subdued than the ebullient bursts of *Midwest Princess*, is nevertheless upbeat. Roan makes her way through daintily pirouetting vocal runs and gentle ascents up the scale – all while singing about emotional masochism and longing for her first, worst love. This contrast – a cheerful chorus delivering despair – has been a classic of pop songwriting at least since ABBA and is just as effective in Roan's voice. It's right there in the title: good hurt.

'Good Hurt' has more credited writers and producers (also Wells and Decilveo) than anything else on *School Nights*. It was one of the first of Roan's songs that she'd written with someone else heavily involved, and after premiering the single she said in an interview with Atlantic Records that the experience '[took] half away, since I wrote it with [someone else's] perspective as well.' This comes out in the lyrics, which express a sensibility that's simultaneously mature and naive. Roan likens herself to a vampire and a Medusa, preying on lovers: an adult experience of mutual toxicity, filtered through the images of teenage gothic melodrama. The lyrics admit to drunken phone calls, self-medicating and sleeping with one person while fantasizing about another – but all of this is directed at her first love, a masochistic longing for one's first experience of pain that tends to fade the more years that have passed and the more loves there have been. Though the song is undoubtedly solid – hearing it is like hearing a parallel-universe smash hit – Roan openly admitted the compromises, 'I think there are other songs on the EP that better represent me.'

That becomes immediately clear on the first line of the following song (also co-written with Wells), 'Meantime', a direct reference to Roan's real life, 'I first left to a summer camp.' Promoting the EP in a 2017 livestream, she explained further, 'I wanted to be in love really bad, but in the relationship I was in, the other

person, I felt, loved me more than I could love them at the time [...] I had to figure stuff out with myself first. And in the meantime, I could love them, but not fully.' She called it the most emotionally challenging song on the record to write; listening to its measured piano arrangement, subdued vocal and unsettled lyrics, one imagines the balance between ambivalent resignation and concealed pain must have been hard to get right.

'Sugar High', co-written with Stelios Phili, brings some levity onto the record – relatively speaking, at least. The title sounds crushed-out, but the real-life inspiration wasn't so blissful. As Chappell posted years later on TikTok, 'I wrote this about a boy who was literally so mean to me in high school lol.' And the song by no means sounds upbeat – it's a slow-paced, moody track in the general neighbourhood of trip-hop. But there are moments of showier production, such as the Timbaland-esque strings that swirl in the background, occasionally surfacing at the front of the mix. Most of all, 'Sugar High' sounds sticky, as if there's liquid dripping off the percussion. The lyrics make that even more clear: it's one of those good old candy-as-love/candy-as-sex singles, about a 'chocolate-coated lover' with a 'cotton-candy voice' and 'caramel-apple kiss'. She even compares his love to Laffy Taffy – the chewy confection last immortalized in 2005 via an unserious rap hit by Atlanta group D4L. (If Roan wasn't familiar with the song – having been seven years old at the time – the track's producer, hip-hop guy Phili, was.)

'Bad for You', co-written with Decilveo and Wells is the final track and Roan's favourite off the EP. It takes us out of the sexy candy shop and directly into church. Before the piano ballad begins, there's an a cappella, hymnlike choral intro; later, she likens herself to a goddess. On the chorus, she sings hallelujah and begs for forgiveness for a certain kind of sin – because this is the church of Madonna's 'Like a Prayer' and Tori Amos's 'Icicle', where religion is just another way to seduce someone. The track is like an early version of 'Picture You' from *Midwest Princess*, minus the self-doubt. 'I bet you wonder what I am doing when I'm alone in my room,' she sings, and then later, 'Bet I know exactly what you're doing when you're alone in your room / Darling, tell me if you're having trouble and I'm sure I could help you.' The song is 'adult' in the R-rated sense, but not necessarily in the emotional sense; as a teenager, Roan hadn't yet fully lived out the unrequited complications and specific acts of longing that she'd convey so well in 'Picture You'. For now, she was happy to dress up in the aesthetics, 'the churchy, dark vibe it gives [...] cathedrals and stuff like that,' as she said on her promo livestream.

School Nights was an impressive debut, but undeniably – as Roan has sometimes admitted – a work of imitation. Time, and the guidance of her new producers, had lent her a lot more vocal control and poise than on her previous EP. Yet she often sang with an affected huskiness – the sound of someone who'd been praised so often in her teens for 'singing like an adult' that she'd internalized

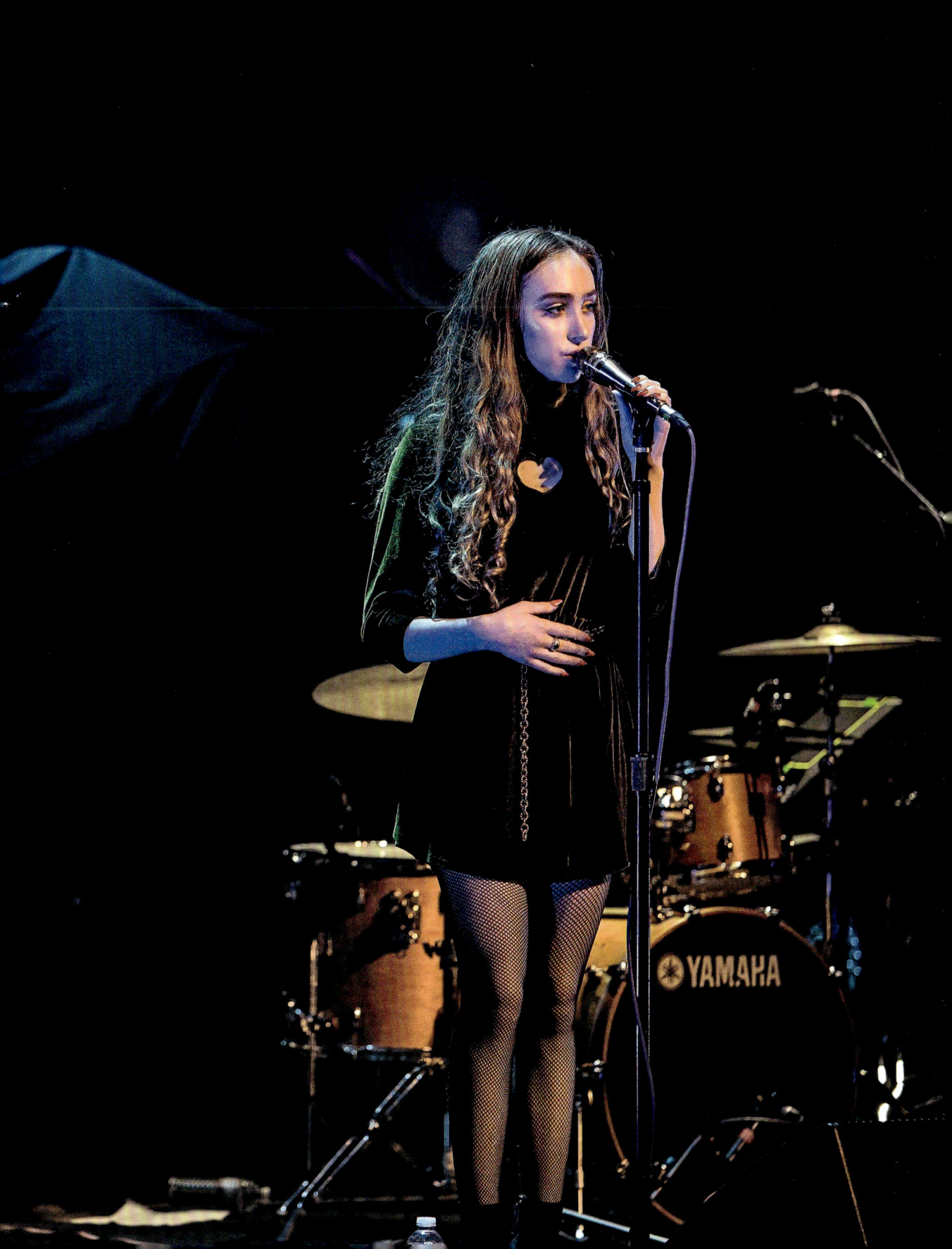

that 'adults' must sing in a particular way, inspired by the voices she loved listening to, such as Stevie Nicks and Karen Carpenter. You can trace almost every song to the specific artists Roan has said she was inspired by. 'Die Young' is reminiscent of the stompy inspirational songs that Pink had pivoted to by the time Roan started writing, as well as of her fellow teenage prodigy Lorde. 'Good Hurt' is the work of someone who has spent time studying Adele's way of crooning out her 'oohs'; there's a hint as well of Rihanna's clipped cadences on the verses.

Roan's persona was also not yet formed. In the acoustic YouTube music-video performance of 'Bad for You', she trials the image that her former label thought would match her music: that of a decidedly normal American singer. Pink light illuminates Roan as she sings an acoustic rendition of the song, her outfit a subdued black turtleneck sweater and her face bare, except for some pink lip gloss, with no trace of the exaggerated makeup she would become synonymous with. The emoting she'd learned as an aspiring actress is evident in her revealing facial expressions throughout the song, but overall her look is unassuming – and, as she'd later admit in interviews, her unassuming look was at odds with her substantial vocal range. Essentially, she looks more Kayleigh than the Chappell Roan persona she'd later adopt.

School Nights was short as EPs go, but by now Chappell had enough singles in her post-Interlochen vault that she planned to release one song per month throughout 2018. And for whatever reason, she'd saved some of her best material for later. By the time she was touring *Midwest Princess* in 2023, she'd disowned her earlier EP, dismissing it as 'dark, angsty pop that was pretty boring'. All the *School Nights* tracks, as well as the rest of her early material, had long since disappeared from her setlists – except for two songs that she still liked enough to regularly sing on stage: 'School Nights' (written by Roan alone) and 'Bitter' (co-written with Andrew Wells).

The 'School Nights' song was another of Chappell's summer-camp pieces. Like the camp productions that did make it to the *School Nights* EP, it's a piano ballad. But this track is far more grandiose than the other material she released in 2017. Its production is rich, with multitracked, ethereal backing vocals and a buzzing, distorted organ in the background. The lyrics are a riff on Lana Del Rey's 'Young and Beautiful', except reimagined through the perspective of someone still in her teens, to whom 'young' means the playground days. 'I wanna stay young with you,' she sings, 'Wanna be a kid with you / Talk slow on a school night...' But although you can hear Lana's vocal skips in Roan's delivery on the verses, the influence is subtler; the song still sounds like Chappell's.

Roan's melody on the chorus lingers on the most mournful notes of the minor scale; her extended vocal run afterwards sounds less studied than her earlier work, but more authentically troubled. And her vocal delivery on the bridge has a percussive swagger beyond anything she'd displayed before.

Essentially, the song has gravity: it's clearly the work of someone who knows it'll utterly transfix an audience towards the end of a show. Indeed, that's where she slotted 'School Nights' on her *Midwest Princess* setlists.

'Bitter' was released in February 2018. A slow, heavy ballad, driven by finger-picked guitar and Roan's echoing vocals, the single was another of Chappell's favourites – in a 2017 livestream, she called it one of the two best songs she'd ever written. It explores the way that harbouring bitterness can be a coping mechanism: self-destructive behaviour that can nevertheless feel good in the moment, unlike the indefinitely delayed gratification that comes, as Roan put it, with 'trying to get better and failing'. 'Bitterness is like drinking poison and expecting it to kill someone else,' she told *Atwood Magazine*, nodding to an old adage that originated with spiritual writer Emmet Fox and trickled into mainstream consciousness through self-help and 12-step recovery programmes.

When writing 'Bitter', Chappell arguably drew upon her own experiences with heartbreak and recovery and her previous struggles with mental health – particularly her hypomania and depression associated with what would in 2022 be diagnosed as bipolar II disorder. In a frank interview with University of Southern California newspaper *Daily Trojan*, she said that 'being bipolar, [she] was so depressed as a little kid and so angry. You just think you're such a bad person, and don't realize that you're really sick and need help, and our parents don't know how to deal with it.' Compounding her mental health was trying to fit into the heteronormative expectations of her hometown in Missouri, which Chappell in her youth never felt able to do.

Like 'School Nights', 'Bitter' is full of the imagery of childhood – TV cartoons, orange creamsicles, toy guns – used to convey darker feelings. 'I used to laugh like the cartoon children / I wasn't always this way,' Chappell sings – an innocence that contrasts sharply with her current state, where she acknowledges 'Having trouble fighting wars in [her] mind'. The chorus is self-aware and deliberately indulgent. Roan brings out all the alliterative wordplay of 'bitter' versus 'better', as if she's toying with the words rather than facing their implications. Then she decides to accept the mess instead of escaping, 'I'm sick in the head and it's not even my fault.' She leaves the resolution ambiguous, but the possibility of growth is still there, 'Just give me some time,' she sings.

That lyric would prove prescient in a different way. Even at the time, Chappell thought of *School Nights* as 'a first glimpse of a story that is yet to come'. In 2023, while promoting *The Rise and Fall of a Midwest Princess*, Roan posted a TikTok reminiscing about how that story unfolded. While the clip was about her most recent album, it's easy to imagine that Roan was reflecting on her past as well. 'I think that whole album encapsulates the whole process of birthing a new me,' Roan recalled, 'and then, ultimately, abandoning it.'

THE NAME
Chappell Roan
& THE ORIGINS OF AN ICON

In 2022, Chappell Roan, in an interview with Oxford University's student newspaper *Cherwell*, explained she 'never felt super connected to [her] real name Kayleigh.' When she decided to go all in with performing, she knew she wanted a stage name. Choosing that name, however, turned out to be one of the hardest parts of her nascent career. '[I] went through – I'm not kidding – thousands of names,' Roan told *Unclear* magazine in 2017. But of those thousands of names, Roan kept returning to one in particular: Chappell.

Roan's grandfather's name was Dennis K Chappell, so she 'took Chappell in his honour', she told *Cherwell*. In the same interview she also stated how she'd planned to pay homage to him following his death. She'd originally wanted to go by just 'Chappell', but after being told she needed a second name had added 'Roan', which 'came from his favorite song': 'The Strawberry Roan'. This old country-western standard, written by cowboy composer Curley Fletcher, is about a defiant, untameable steed. The horse, Strawberry, is a 'roan' whose reddish mane and hair are mixed with white hairs to

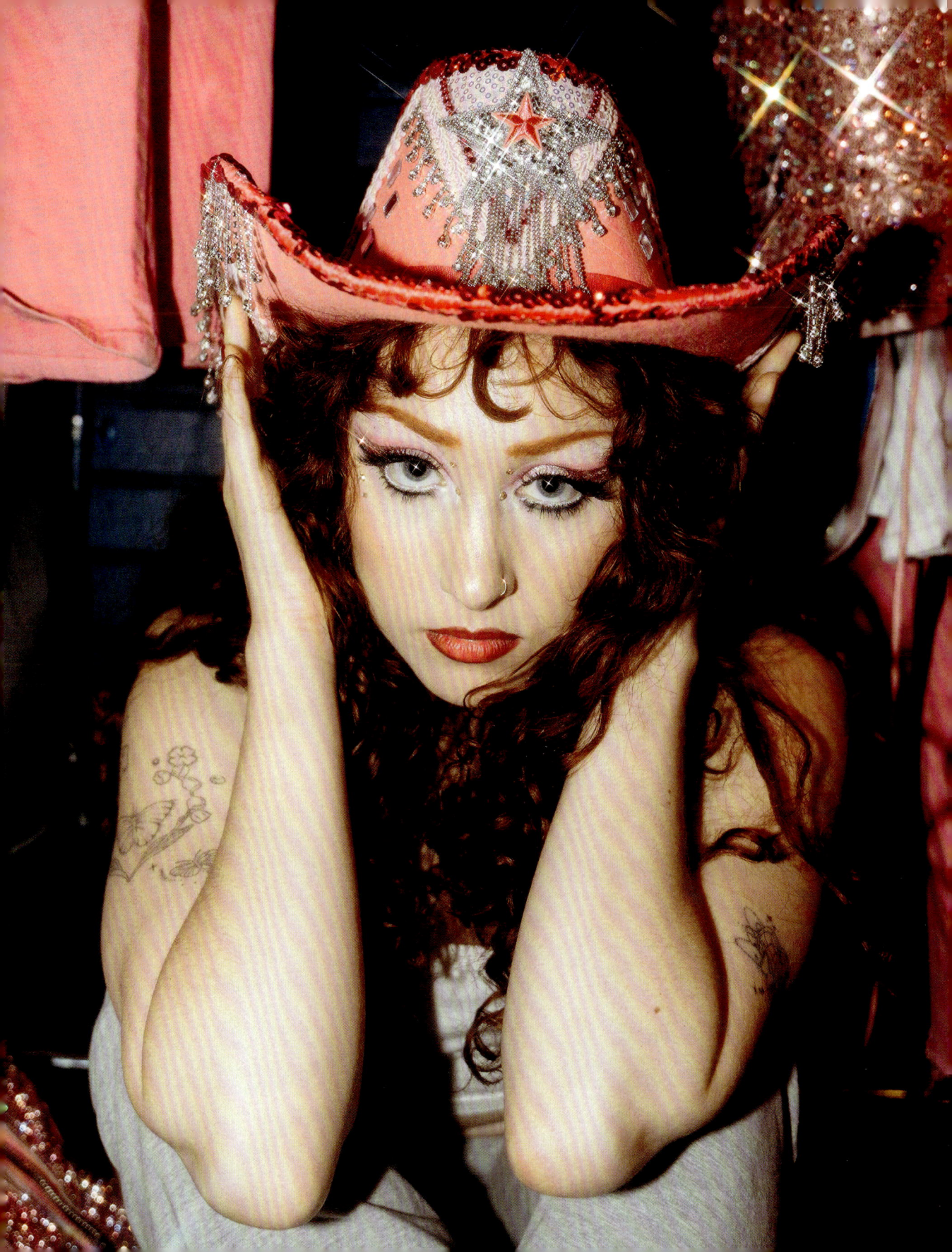

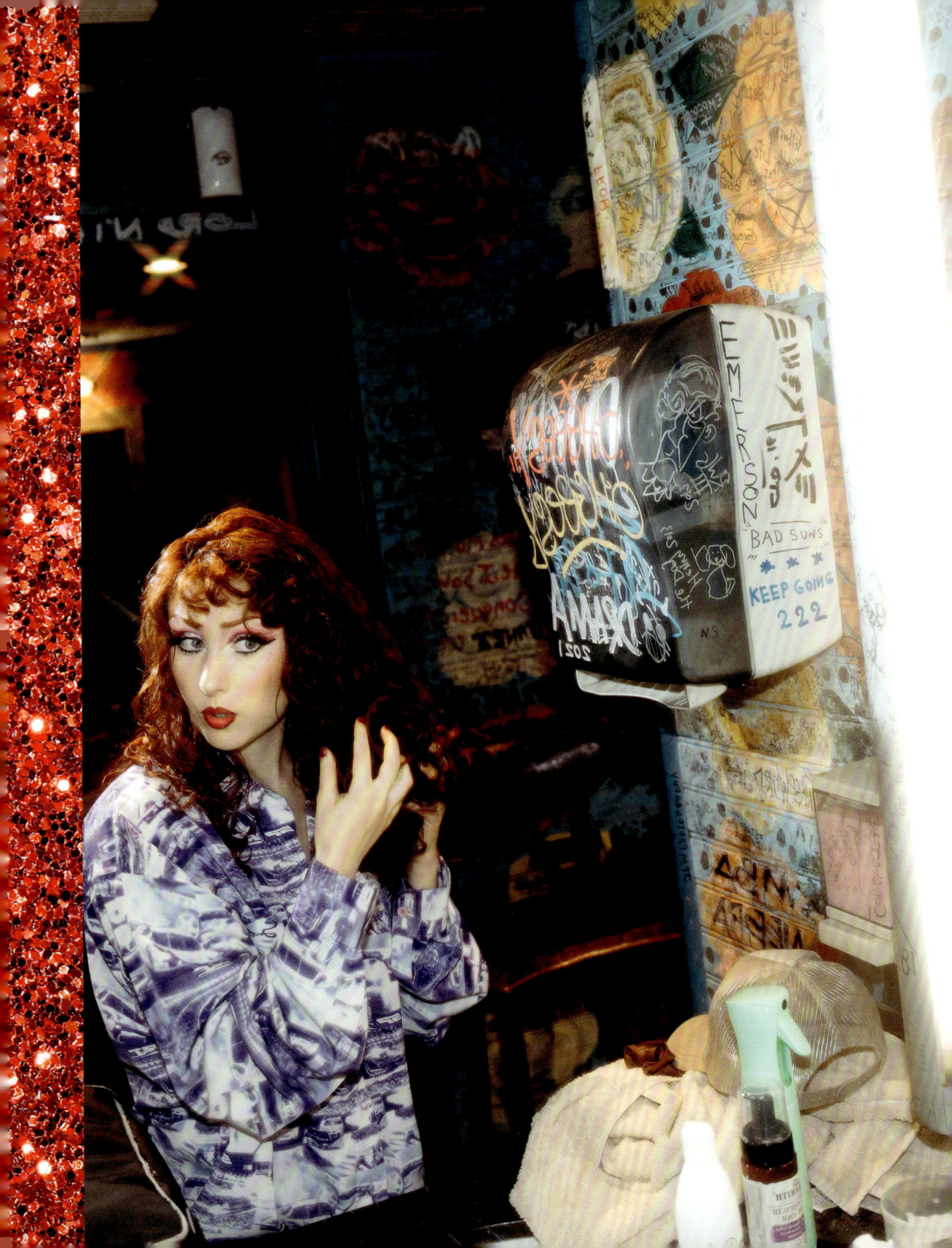

produce a softer red – a pink pony, one might say. As the song goes, 'I'll bet all my money, the man ain't alive / That'll stay with old Strawberry when he makes his high dive.' It's easy to see why Chappell would adopt this uncontrollable, legendary horse as part of her artistic identity.

When Roan's grandfather developed severe brain cancer and was dying, Roan had been worried that he would die before getting to hear her finished songs. So she played him the rough demos she had and promised to adopt his name to honour him. This touching tribute grounded Roan in a sense of familial pride and is the sort of gesture that makes her so relatable to her fans. But it was the development of her drag persona that would mark the true turning point in her career.

Roan's early fashion identity when performing as 'Kayleigh' reflected her everyday-girl upbringing. Footage of Cider Days in 2014 shows Roan sat at a piano as Kayleigh and her performance is tame. Her fashion is nothing out of the ordinary: a natural look, far from the overexaggerated drag-queen makeup that she'd show off on her sophomore album cover. She wears a bright-white sleeveless dress, contrasting against her natural burned-umber-coloured hair. This simple aesthetic carried through her early online performances and YouTube videos. In her cover of her childhood favourite 'Stay', she appeared in a green knee-length dress. Her auburn curls fell below her shoulders and her face was mostly bare.

Much later, in 2024, a barefoot Instagram shoot Chappell did in New York City finds her revisiting that unassuming, vulnerable Kayleigh look, but as Chappell Roan would do it: giving it a subversive, carefree twist befitting of her camp obsession. The Instagram post has several photos taken by Chappell's tour

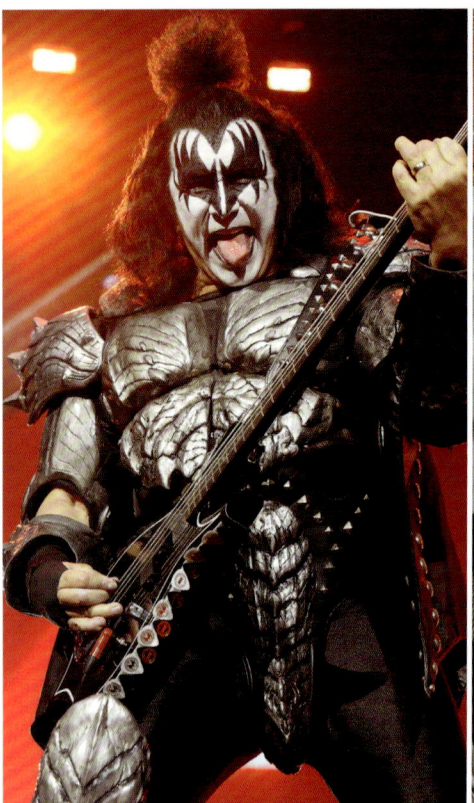
GENE SIMMONS

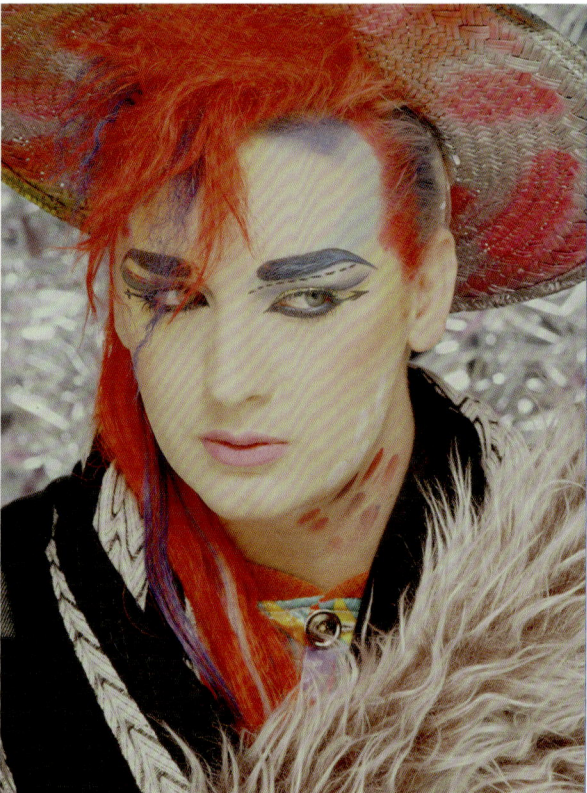
BOY GEORGE

photographer Lucienne Nghiem on the streets of Manhattan, and is captioned with the cheeky, 'No shoes, no shirt, no problem!' Indeed, Roan is barefoot, wearing just a puffy white skirt and a bra. The post got over 1,000,000 likes in less than 12 hours. There's so much going on in this simple photoset. Roan looks like a regular girl who loves gently feminine looks. The image she's portraying is wispy, a princess in the fairy-tale sense; as one commenter put it, she looks like 'some ethereal dream maiden from another realm'. Her *School Nights* self, obsessed with witchy looks, might have loved it. But her image is also subversive in many ways. She's following her caption to the letter, wearing no shirt. While this would be only mildly remarkable in NYC – it's even legal there for women to be completely topless, if they're

adults – it's not an evangelical Willard kind of vibe. And most of all, *she's barefoot in New York City*, something commenters seemed more shocked about (in a good way) than anything else – because as any New Yorker would tell you, there's a lot of dirt, a lot of trash and a lot of fluids on those streets. 'Chappell I love you so much but New York is COVERED in pee,' one Instagram comment reads.

Chappell told *The Hollywood Reporter* that 'Pink Pony Club' marked an evolution in her style from '[wearing] only black on stage' to taking herself 'less seriously'. An article in online magazine *Them* notes that Roan has expressed a fondness for looking simultaneously 'pretty and scary', enjoying the creative freedom that comes with designing her performance attire. Her forebears in this are

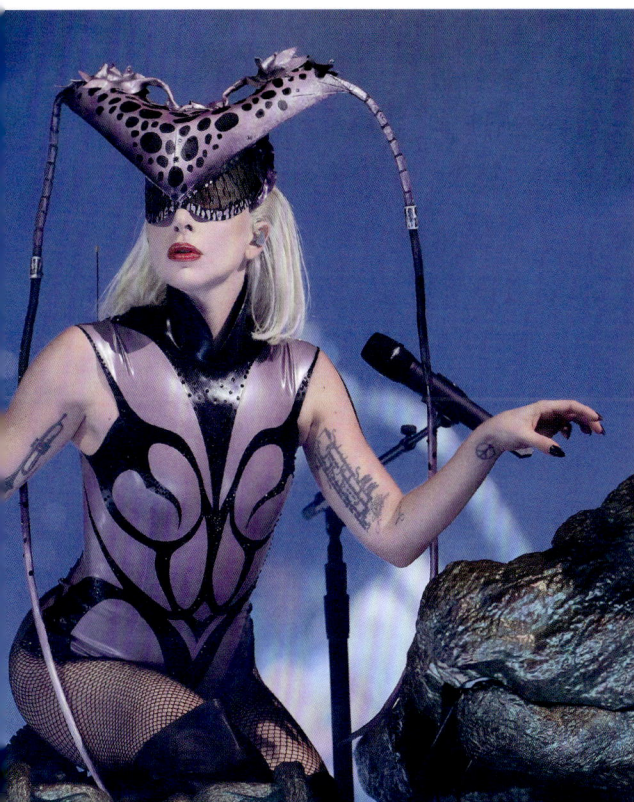

LADY GAGA

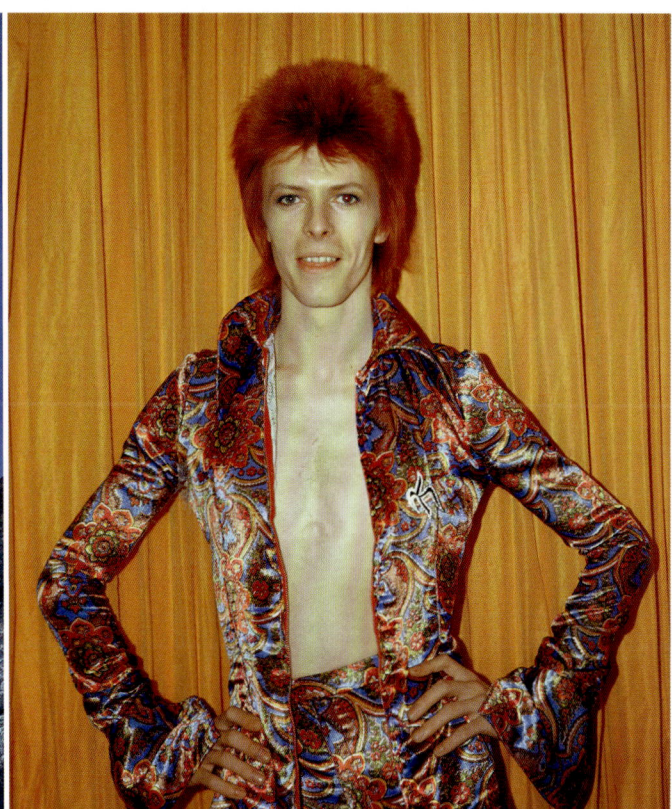

DAVID BOWIE

many: the heavy makeup of David Bowie's Ziggy Stardust and Aladdin Sane characters, the killer-clown stage paint of rock band KISS, the thick borders of Boy George's makeup, or the high-fashion awards-show looks of Lady Gaga that evoke bloody meat, primordial births, or spiky, forbidding architecture. But for Roan this danger is always cut with a lot of fun.

Chappell Roan's fashion identity is rooted in a love for freedom from societal expectations. Her current pop persona, with its over-exaggerated and fantastical aesthetic, stands in stark contrast to the ordinary, modest Kayleigh. And it starts at the top, 'I dyed my hair red in Portland, and then my life changed,' Chappell Roan told Canadian interviewer Nardwuar in 2024. 'I was always so precious about my hair, and I was like, "I can't possibly dye it. That's crazy."' On an impulse one day, though, she did: the start of a process that would lead her to the even more dramatic transformations drag artists make to their images. She began to create a larger-than-life persona: one that would present a curated, aspirational fantasy, while limiting her own exposure to the less supportive elements of the world.

This transformation led to Roan adopting the tagline, 'your favourite artist's favourite artist' – a phrase parodying drag queen Sasha Colby, the 2012 Miss Continental winner, who referred to herself as 'your favourite drag queen's favourite drag queen' during the *RuPaul's Drag Race* finale. Colby, who was crowned the winner of season 15, is a renowned figure in the drag world, heralded for her fierce performances, flawless aesthetics

SASHA COLBY (ABOVE AND RIGHT)

and unwavering advocacy on behalf of the trans and queer communities. She is a trans woman of Hawaiian descent, and her win was seen as a landmark moment for trans representation in the *Drag Race* franchise.

Historically, drag has been associated with cisgender gay men performing in wigs and makeup, but the artform has since evolved, offering opportunities for all members of the LGBTQ+ community, regardless of gender identity or conformity. Chappell told the *Q with Tom Power* podcast that finding her drag persona was 'very freeing' – and that seeing 'Chappell Roan' as a character has helped to separate her work life from her personal life. She credits her embrace of drag to a conversation with London-based drag artist Crayola, aka Gigi Zahir, who encouraged her to tap into her inner drag queen. After attending a show by camp country artist Orville Peck, Roan was inspired to have local drag queens open for her own shows. Today, she receives up to 2,000 applications per gig from drag queens wanting to perform with her.

In 2024, Sasha Colby officially became Chappell Roan's drag mother, a community-driven term that relates to the idea of a 'chosen family' – often expressed as a 'house' in the drag scene – perhaps because a person's biological family has been unaccepting, or hasn't had the resources to help them excel in the world of drag. Fans have embraced Chappell and Colby's mentorship dynamic, as has the very infrastructure of the internet. Around 2024, people noticed that googling the phrase 'your favourite artist's favourite artist' would produce the reply, 'Did you mean: Chappell Roan?' Some people speculated whether this was a purposeful 'Google bomb', with fans flooding the Web with traffic, links and mentions to boost Roan in the page-rank algorithm. Others have different theories: on *Jimmy Kimmel*, Roan jokingly speculated that the event was an Easter egg made by 'this random twink that works at Google [...] some assistant that's like, "I love her."'

Although Chappell is a cis woman, the boundaries around camp and gender identity have become increasingly fluid and label-less, with drag being an expression for anyone in any body to express their fantastic imaginations and chosen image. As such, Colby's relationship with Chappell seems one of acceptance. She has welcomed Roan as a beloved extension to the house of Colby, providing mentorship and guidance as she has navigated her own drag-inspired journey into performing her pop records – and developing her persona.

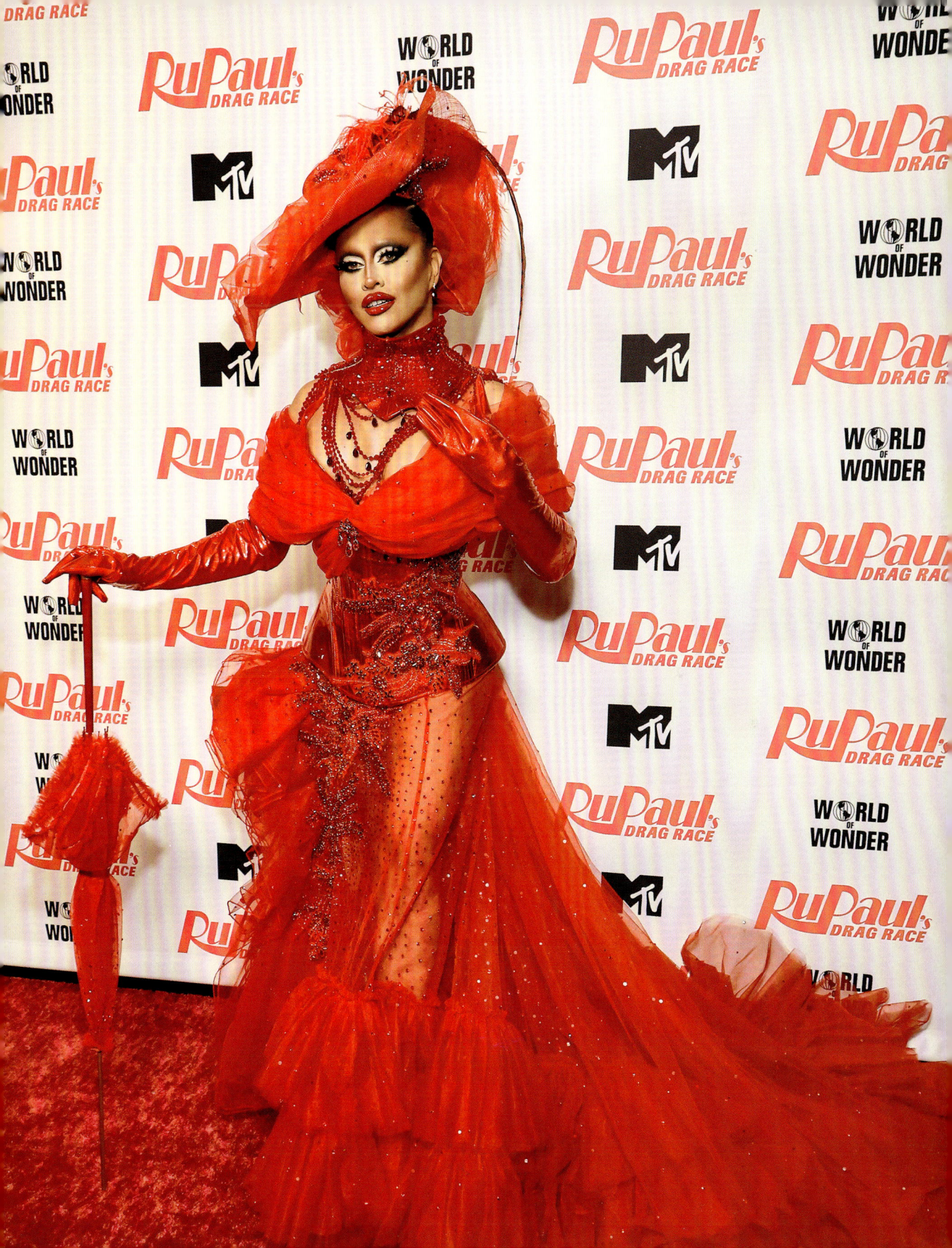

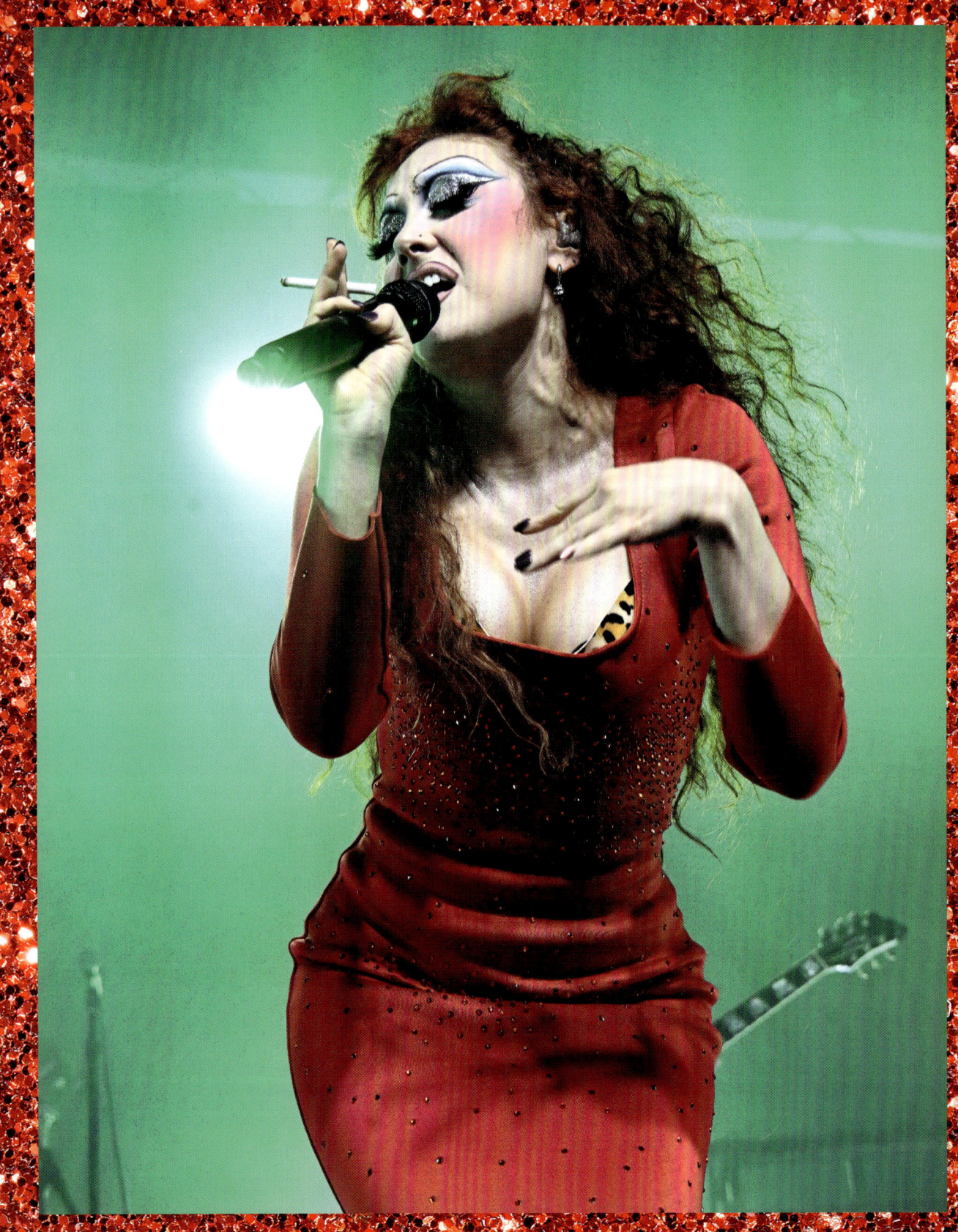

Roan explores hyper-femininity, often subverting beauty ideals by embracing elements of 'ugliness' and 'trash', as she has described in interviews. This materialized in her *Tiny Desk Concert* for NPR Music, where she wore bin bags – the station called the look a 'towering wig (bolstered by a wadded-up trash bag tucked inside), as well as an assortment of stubbed-out cigarette butts'. Completing the look were pink lipstick stains on her teeth and heavy makeup. Here was a riff on drag queen Divine – the self-proclaimed 'Queen of Filth' – and her aesthetic in *Pink Flamingos*, with thin brows and a blue cut crease, despite the frilly fuchsia gown, tiara and pink gloves that lent ideas of a camp, femme princess at first glance.

Roan stops at one moment during the concert, before singing 'Pink Pony Club', to thank the audience for their applause after the first song. 'I didn't really watch the Super Bowl last night,' she says. 'I don't care, first of all. Who fucking cares? *This* is my Super Bowl. Literally, this is the […]. I love it.' She then uses a 35mm single-use camera to take a picture of the guitar player and piano player from her all-female band. This is just one example of her subverting the image-capturing realm of being a pop star. When Roan takes a picture of her band, she is showing people watching online that she too is just an ordinary girl: not merely turning her image over to celebrity photographers and paparazzi, but using ordinary manual cameras to document important aspects of her own life. She didn't feel the need to go on to perform at the Super Bowl, for her, this performance for NPR is just as grand a stage. Later, as she introduces 'Picture You', she once again shows herself as a star who's using technology from the past: this time, she opens a bedazzled flip-phone to send a message. By the end of the final song, 'Red Wine Supernova', she looks like her beehive hair might fall out of position because of her energetic jumping up and down. This unpolished version of Roan, complete with lipstick-stained front teeth, had fans doting on how she kept her ordinariness despite being catapulted with vigour into the role of a celebrated pop girlie.

Roan's immersion in drag culture has significantly influenced her artistry, from her music to her stage presence. As was the case with the Midwest Princess Tour, she often collaborates with drag artists, giving them the slot to open for her. In this way, she weaves drag-inspired fashion into her carefully thought out and energetic pop performances that blend grotesque, horror, burlesque and theatrical elements, with every detail finessed in the weeks leading up to the performance.

A lot of this fantasy – the fashion, the stage presence and the attitude – is the fruitful result of Roan's partnership with Ramisha Sattar, a

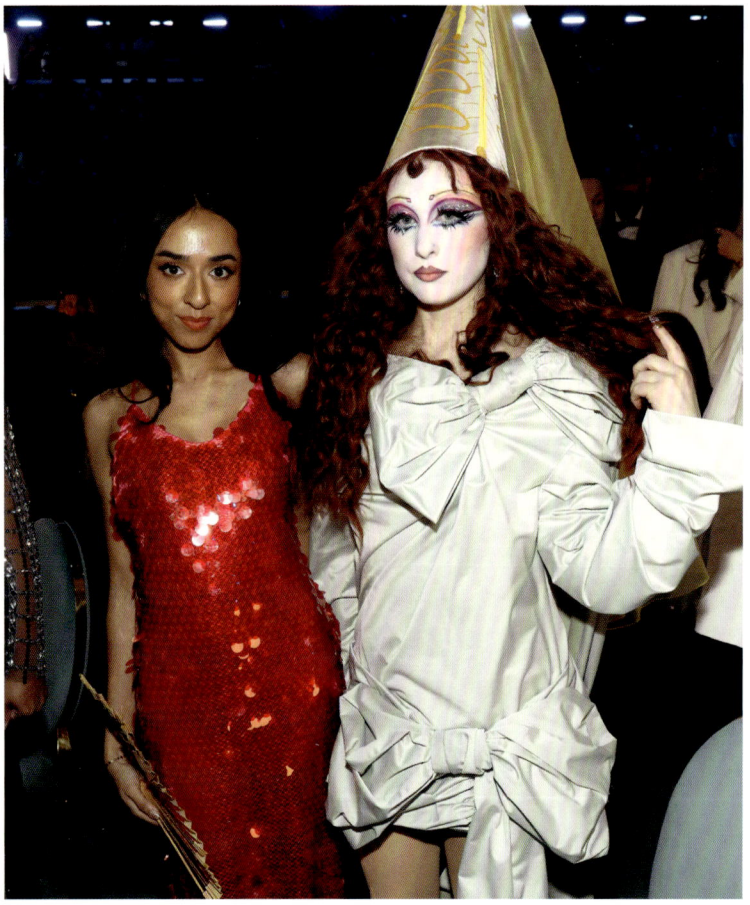

WITH RAMISHA SATTAR

multidisciplinary artist who Roan met on Instagram who quickly became her creative partner and best friend. Together, they sourced materials from California's budget-friendly Santee Alley. Then they crafted custom pieces from what they found, bedazzling them with feathers, beads, fringe and rhinestones. The image they created was not only down-to-earth – as Roan joked to *Rolling Stone*, she was aiming for 'pop star of Goodwill' energy – but also had an anything-goes quirkiness. Any mundane item around them could be transformed; one shirt they made featured Gushers candy. And the labour-intensive process allowed them to refine that aesthetic with intention, even before they secured larger budgets.

Yet, despite the clarity of vision, meticulous attention to detail and kaleidoscopic imagination that she's put into the Chappell Roan project, Roan maintains a firm boundary between Chappell Roan the persona and Kayleigh Amstutz the person. When asked in a Grammys interview, 'Do the songs create Chappell Roan, or is it something you created for the songs, or is it something you actually are all the time?' she responded, 'Chappell is a character [...] I simply can't be her all the time.'

'Chappell IS A CHARACTER. I SIMPLY CAN'T BE HER ALL OF THE TIME'

THE MAKING OF AN *Album*

While working on the follow-up to *School Nights*, Chappell Roan was paired with a succession of songwriters and producers. This process, the songwriting-biz version of a college freshman being randomly assigned roommates, wasn't working for Roan. There wasn't a fit. As she told *Rolling Stone*, she got a new manager, Nick Bobetsky (the two eventually parted ways in 2024), and told him that she was 'sick of singing and performing depressing songs'.

In October 2018, Bobetsky introduced her to one of his managing colleagues' clients, producer Dan Nigro. Nigro, a former indie-rock and emo musician from the band As Tall as Lions, pivoted to songwriting and producing in 2011. He'd since found a fruitful niche producing for bubbling-under pop artists with devoted fanbases, such as Sky Ferreira and Caroline Polachek.

Although Nigro had plenty of songwriting credits to his name, his collaborations with musicians such as Roan produced true musical alchemy. As he told *The New York Times*, he works best with writers who have a strong lyrical voice, 'My strongest suit is chords and melody. It's like finding puzzle pieces that fit together [...] I'll help them if they

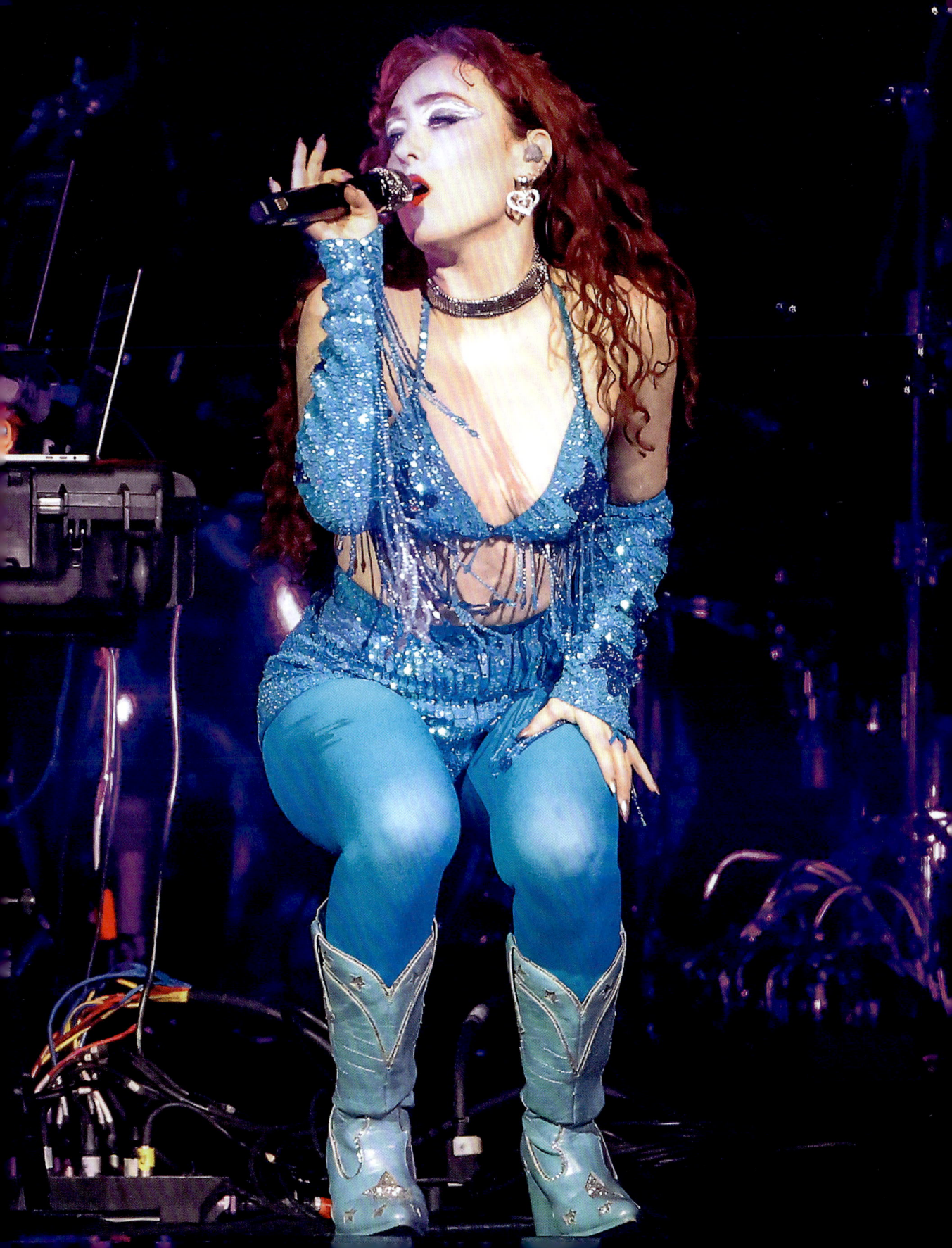

J. COLE

LONDON GRAMMAR

want my opinion on how to word something, but it's their story to tell.' Here, he distances himself from the mansplaining and control so common among pop producers. And both Roan and Nigro have spoken fondly about how their writing sessions were a safe place to push back on one another's ideas – not in an adversarial sense, but as a way to 'share [the] wins' of writing killer songs.

The songwriting world is just as cutthroat as the pop-star business, and just as brutal for not-yet-famous names. You can find your creative lane yet still struggle financially. When Nigro met Roan, he was writing commercial jingles to pay the bills; later, when presenting Nigro the ASCAP Songwriter of the Year Award, Roan joked that she discovered him through McDonald's and Pizza Hut ads.

The light synthpop pulse on the chorus of 'Love Me Anyway' was a subdued version of the sparkler bursts they'd later set off alongside the hooks to songs such as 'Femininomenon' or 'Guilty Pleasure'. Compared to Roan's past songwriter pairings, it was a standout; commercially, though, it was less successful. (It didn't help that Pink had released a single of the same name only a year prior.) The song did make the soundtrack to the Cole Sprouse romcom Moonshot on HBO Max; Roan joked on TikTok that Sprouse put it in the film because he was 'secretly a pink pony'.

When Roan signed with Atlantic, her contract had bound her to them for an initial five-year period. But the music industry is littered with contracts that never make it to the year on the paperwork, and with promises that come with secret expiration dates. Roan received both. 'I was told that [Atlantic Records] were going to put a Grammy campaign behind some of my music when I was 17,' Roan told Bringin' it Backwards. She soon learned, 'They just say shit to make you excited.'

Early signs of tension between Roan and her label are evident in a 2017 Facebook stream with Roan and Atlantic to promote School Nights. As Roan sits in a reception-area chair in the label's office (the Wi-Fi in the original room stopped working), a disengaged-sounding interviewer passes along fans' softball questions about chain restaurants

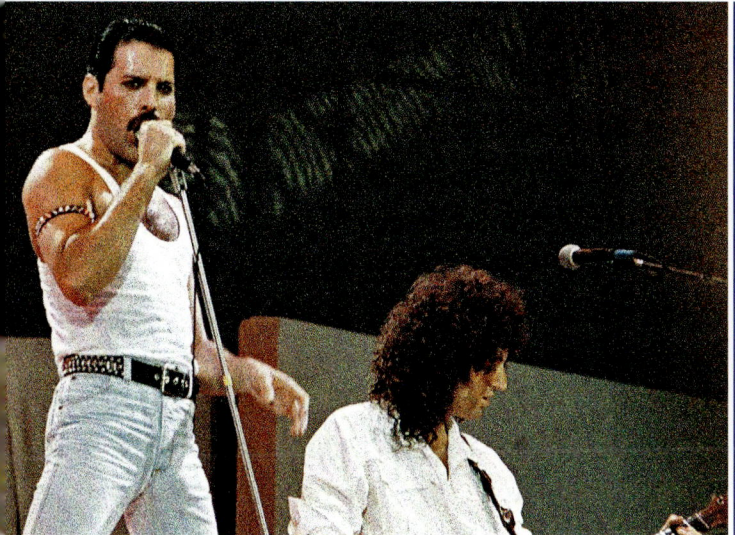

FREDDIE MERCURY

NICKI MINAJ

and potato chips, and Chappell answers with charming but noticeably prepared soundbites. She only really speaks with a spark when talking about writing songs or recording videos. Throughout, it's apparent that the label was still not totally sure how to position Chappell Roan as a musical artist. Roan mentions several acts she loves, including lifelong inspiration Stevie Nicks, as well as other artists she hadn't often mentioned before: rappers such as J. Cole and Nicki Minaj, and moody but palatable alt-pop groups such as London Grammar. Two things are true at once: Roan was genuinely discovering new music, while Atlantic was trying to mould her musical discoveries towards their own marketing needs.

Roan's debut album was set to come out in 2018, but was shelved. She recalled on the *Bringin' it Backwards* podcast in 2022 that Atlantic told her, 'You need to start over.' As it happened, Roan had some ideas for a new start herself. This whole time, she had been trying to reconcile the sombre songs she wrote as a teen with the upbeat songs she *loved* as a teen. There's a common belief that up-tempo pop songs are less valuable and take less craft than slower, 'serious' songwriting, a dismissal that originated with early rock critics and was vigorously seized upon by the mainstream public (most of whom privately and happily consumed the pop music they publicly disdained). But Roan had lived the opposite experience. 'It's easy to write ballads,' Roan told *Bringin' it Backward*s. 'When you start out writing, ballads are the easiest to write.'

This was also the year of *Bohemian Rhapsody*, the 2018 Freddie Mercury biopic starring Rami Malek. Like millions of pop fans, Roan saw the film; and when she got to Malek's recreation of Queen's 1985 Live Aid show, something clicked. When she saw and heard the crowd singing along to 'Radio Ga Ga', she wanted that, too: to elicit that kind of communal joy from a crowd.

Opening For
VANCE JOY & DECLAN MCKENNA

Like many emerging pop stars, Roan built her following through opportunities as a supporting act for established and rising artists. One of her early major career breaks came when she was 19 and still with Atlantic Records, when the Australian singer-songwriter (and Roan's Atlantic labelmate) Vance Joy gave her the opportunity to open his show.

Joy had been chosen by Australian radio station Triple J as the winner of their 2013 Hottest 100 poll after the success of his folky, quadruple-platinum debut 'Riptide', a 'coming of age love story', and its accompanying 2014 album, *Dream Your Life Away*. In 2017, Joy was preparing to release his second album, *Nation of Two*, featuring the lead single 'Lay It on Me'. To promote it, he embarked on a 12-night US tour with fellow Australian breakout Amy Shark and his Midwestern labelmate Chappell Roan. This was Chappell's first experience of a major tour and was a resounding success, with tickets completely selling out within a week of its announcement.

From September to October 2017, the first leg of the tour spanned several major cities in North America, enabling Roan to perform in front of a wide range of audiences, before Vance Joy went on to complete the second (Europe), third (Oceania) and fourth (North America) legs accompanied by other opening acts, such as Plested, Gretta Ray and Karl Kling.

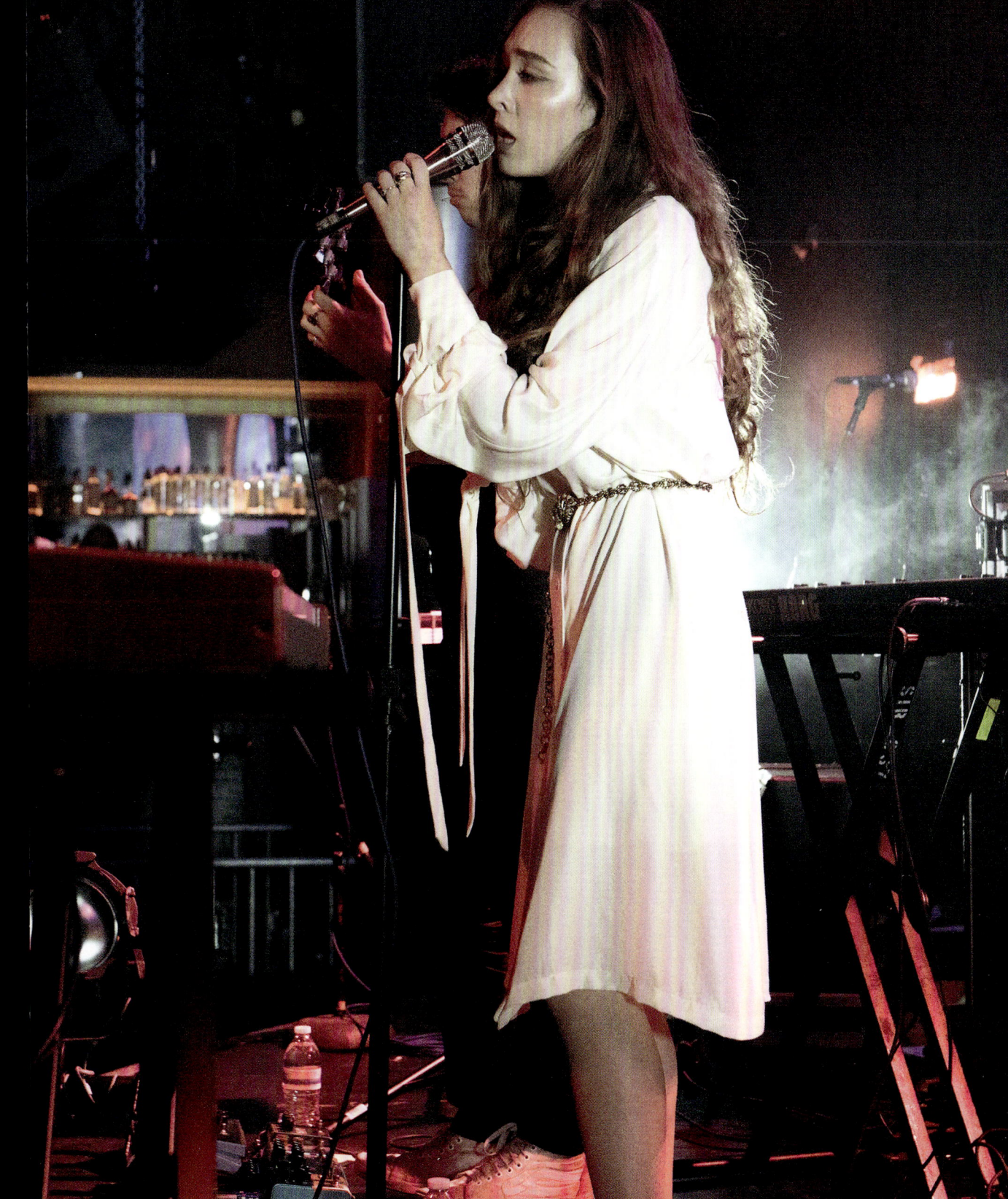

VANCE JOY
LAY IT ON ME TOUR 2017

NORTH AMERICAN CONCERTS, LEG 1

★★★★★★★★★★★★★★★★★★★★★★★

OPENING ACTS: Amy Shark & Chappell Roan

★★★★★★★★★★★★★★★★★★★★★★★

28 SEPTEMBER: Vogue Theatre, Vancouver
30 SEPTEMBER: Showbox, Seattle
1 OCTOBER: Crystal Ballroom, Portland
3 OCTOBER: Herbst Theatre, San Francisco
5 OCTOBER: Fonda Theatre, Los Angeles
7 OCTOBER: Zilker Park, Austin
10 OCTOBER: Gothic Theatre, Denver
12 OCTOBER: First Avenue, Minneapolis
15 OCTOBER: Zilker Park, Austin
17 OCTOBER: Cannery Ballroom, Nashville
19 OCTOBER: Lincoln Theatre, Washington, DC
20 OCTOBER: Union Transfer, Philadelphia
22 OCTOBER: Somerville Theatre, Boston
23 OCTOBER: Brooklyn Steel, NYC
26 OCTOBER: Danforth Music Hall, Toronto
27 OCTOBER: Corona Theatre, Montreal

Roan performed songs from her *School Nights* EP, including 'Die Young', 'Bad for You', 'Good Hurt' and 'Meantime', alongside incidental covers – such as Fleetwood Mac's 'Dreams' – and her unreleased song 'Lavish', an emotive, romantic, piano-accompanied piece reminiscent of the more breathy, heartbroken vocals of her mid-teen musical years (she wrote it when she was around 15), which had been intended for the same 2018 album as the single 'Bitter' but was later abandoned.

The second opening act, Amy Shark, was an Australian singer-songwriter who performed most of the songs from her fifth EP, *Night Thinker*. Sharing the stage with established artists offered Chappell a first-hand look into the music scene's inner workings as she continued to gain experience in the professional sphere.

Roan reflected on this period in an interview with *Unclear* magazine in 2017, describing the nature of touring and the challenges of adapting to life on the road. 'This is my first tour! It's a whirlwind. It's crazy, but Vance Joy's the sweetest person ever, so he makes it seem fun,' she shared, highlighting the support and camaraderie she found in her tourmates.

The constant travel was one of the most difficult aspects for Roan, who likened it to planning a vacation every single day. 'I am constantly tired,' she told *Unclear*. 'It's like gearing up for a family vacation and you're like so excited, so you pack and everything and you're so prepared [...] It's like that every day. It's so tiring, but it's so fun.'

Despite the fatigue, Roan told *Unclear* she was touched by the reception she received from fans of Vance Joy and Amy Shark. 'It's incredible. Vance Joy and Amy Shark's fan

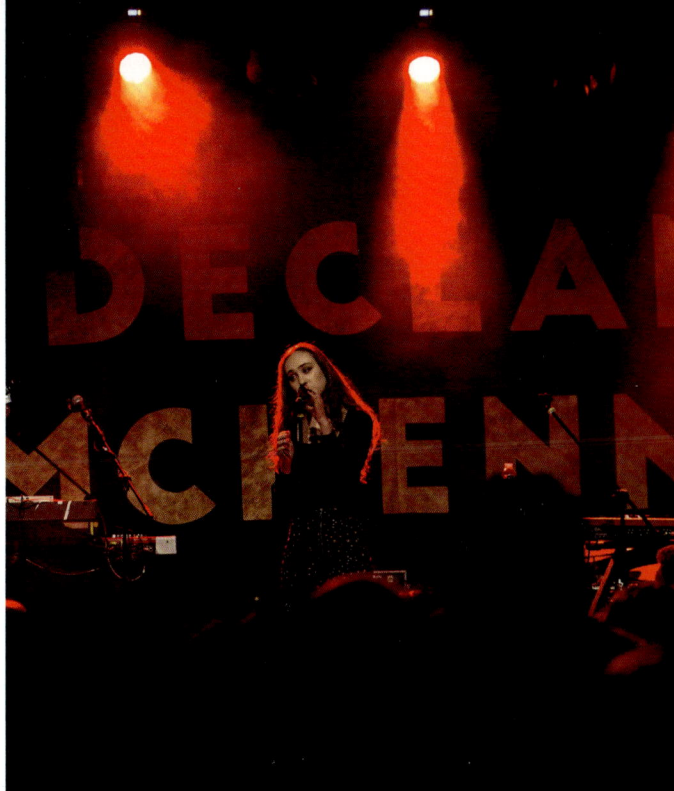

bases [...] they are just so loving and open to my music,' she explained. 'You know, 'cause they didn't come to see me, they came to see Vance, and they're so accepting of me, and it just makes me feel really loved.'

In the same interview, Roan said she especially enjoyed connecting with fans after her performances: 'I go out and sign posters for people, and that's my favourite part. Everybody's just super sweet.'

She went on to say that she was looking ahead to the next phase of her career as the tour wrapped up. She planned to return to Los Angeles to complete work on her album with Atlantic, though the specifics of her next release were still uncertain. 'We haven't really decided if we're releasing a single next or if we're releasing another EP, if we're releasing an entire album, so [...] nothing is, like, decided, but definitely music will come out soon. Early next year!'

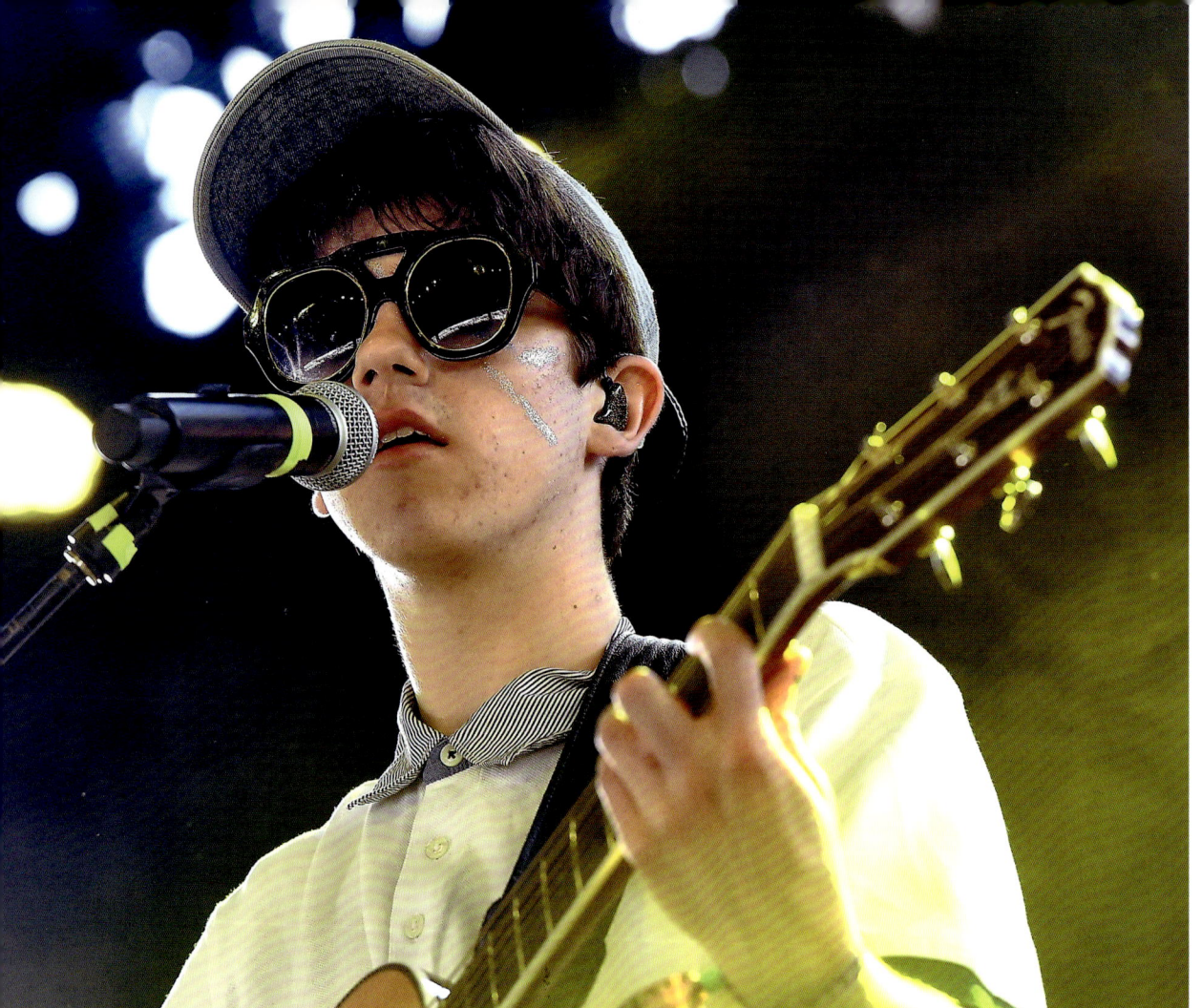

Roan subsequently opened for British artist Declan McKenna in 2018 during his North American tour to promote his debut album, *What Do You Think About the Car*? At the time, Declan was just 19 and had experienced a similar rise to fame as Vance Joy. Like Joy, he was a singer-songwriter and guitarist with tousled brown hair and a slate of self-penned songs. He, too, had been plucked out of relative obscurity by his country's biggest music institutions: for McKenna, success came after he won Glastonbury Festival's Emerging Talent Competition in 2015. Both Joy's 'Riptide' and McKenna's debut single 'Brazil' were jaunty, radio-ready guitar cuts.

But the similarities ended there. Vance Joy was well into his 20s when he released 'Riptide'; McKenna had been just 16 when 'Brazil' was released. 'Riptide' was a love song written with competent, untroubling craft. 'Brazil' was a protest song that wasted no time in tearing into soccer's governing body, FIFA, for flaunting its wealth amid the impoverished parts of Brazil: 'I heard you sold the Amazon,' goes the first line. The video to 'Riptide' had the shallow-focus B-roll of a trad travel ad; the video

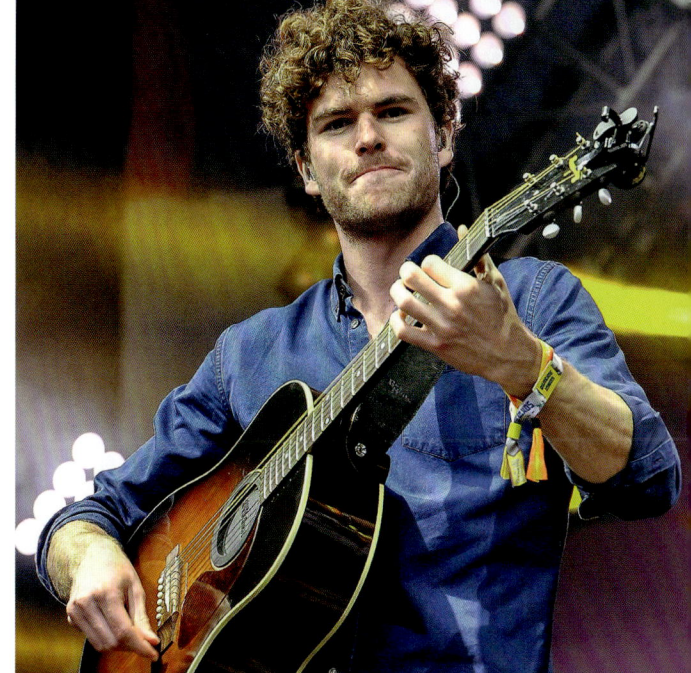

to 'Brazil' had strobe lights and glitter eyeshadow. And while Vance's less successful debut single 'From Afar' included a gay couple (alongside a straight one), McKenna was more publicly fluid in his gender and sexuality; he described it to UK gay magazine *Attitude* in 2017 as being 'here to be experimented with'.

For McKenna, 2018 was a big year: he played Coachella for the first time in April, while visiting the United States again to tour *What Do You Think About the Car?*. Joining him on this tour was Chappell Roan. The tour was more intimate, with smaller venues than on Vance Joy's tour – the highest-capacity venue topped out around 400 people. But while the venues were small, the energy was big. As in the 'Brazil' video, McKenna's stage presentation was splashy and poppy in a way that belied his folk-rock sound. He would close his setlists by bombarding the crowd with colourful balloons – going so far as to promote shows on Facebook by promising prospective audiences 'balloony madness'. Fans loved it.

For Roan, the tour was a mix of inspiration and frustration. While she appreciated the experience and McKenna's artistry, she felt a disconnect between her own music and the buoyant energy of McKenna's performances. *School Nights*, her heartfelt and soulful EP, didn't lend itself to the same exuberant theatrics. After her sets, she watched the audience respond to McKenna and felt the same pull – the same deep feeling of rightness – that she had had when watching Freddie Mercury enthral a crowd. She later told *Variety* that it made her think, 'Why the fuck did I not write music that I can throw balloons out to people [with]?' The question lingered, planting a seed for the colourful and theatrical evolution her music would take in the future.

OPENING FOR VANCE JOY & DECLAN MCKENNA

Welcome to the PINK PONY CLUB

A few months after writing 'Love Me Anyway' and 'California', Roan pitched a new song title to Nigro: 'Pink Pony Club'. Since she hadn't exactly been making music for clubs – let alone pink pony clubs – Nigro was taken aback. 'I remember kind of looking at her like, what?' he told NPR. As they recorded it, though, everything made sense. 'I feel like that was the moment where I think both of us together started to realize, oh, this project is going to be a lot bigger than just moody, dark music,' Nigro said.

'Pink Pony Club' expressed a more expressive and theatrical image, signalling a shift in Roan's style and artistry. The music video, filmed during the height of the COVID-19 pandemic, was set in a Midwest dive bar and featured Roan wearing cowboy boots and tassels, a nod to her smalltown roots in Southwest Missouri. Surrounding herself with drag queens such as Victoria 'Porkchop' Parker (of *RuPaul's Drag Race* fame) and Meatball (known from *The Boulet Brothers' Dragula*), the video juxtaposed rural Americana with a vibrant, queer paradise.

Jonathan Graffam-O'Meara, writing for *The Conversation*, described the video as showcasing 'flashes of a queerly utopic alternative to the oppressively drab dive bar setting: leather daddies fill the dance floor, glitter falls from the ceiling, and drag queens […] take the stage with Roan.' This interplay of rustic charm and queer exuberance remains critical to her aesthetic and thematic storytelling.

'Pink Pony Club' came out in April 2020 during the first crescendo of the COVID-19 pandemic, 'the worst time for a club anthem to come out', Roan told NBC. While her single did get some traction on streaming playlists, the song was locked out of its true spiritual home. And because of lockdowns, Roan also wasn't touring, cutting her off from a main source of income for pop artists. Atlantic noticed these numbers. While the 2020 recession didn't leave labels with no money, they certainly had far less than before – and they were stingier with it. The pandemic exacerbated the industry's worst Darwinist impulses. They showed less patience than ever towards artists who weren't already famous and weren't getting famous fast enough, even if their lack of fame was the direct result of the label's lack of promotion. Speaking to *Bringin' it Backwards* in 2022, Roan reflected on the concentration of proverbial (and literal) wealth, 'The system isn't set up to grow baby artists. It is made to grow artists that are doing well and to make them do better.'

For those baby artists, one of two fates would await. They could languish in limbo, their labels unwilling to release their music or to let them leave. Or they just got unceremoniously dropped. Roan's fate was the latter.

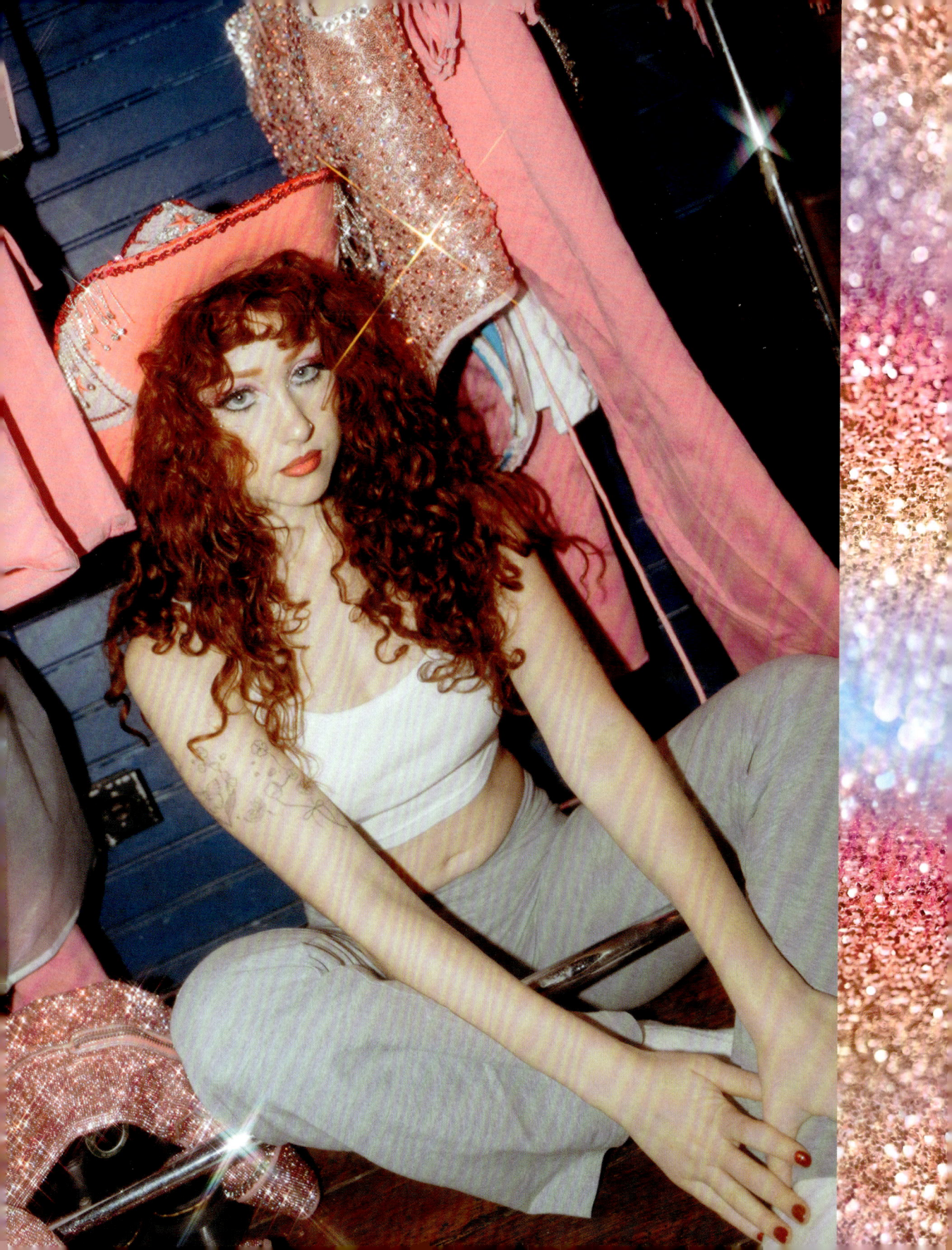

FALLING & *Rising*

Atlantic told Chappell Roan that they were dropping her in August 2020 – just ten days after she released 'California'. This placed Roan's musical career in stasis for over a year. Not only did the actual act of dropping her take a while – Chappell said it was five months before all the legal paperwork was done and her label ties were officially severed – but she said that also part of the agreement was that she couldn't legally release any new music for quite some time afterwards. The label did allow her to retain the masters to some of her songs, including 'Pink Pony Club' and future singles such as 'Naked in Manhattan'. This was not a common gesture, especially for a new artist who had been dropped, and Roan later described it as a small act of generosity from the label. But that didn't change the fact that she was now unsigned and broke, in the middle of a creative realignment she hadn't fully figured out.

Chappell Roan and Dan Nigro were determined not to give up. That October, Roan moved back to Missouri to process her Atlantic breakup with her family: a lot of therapy, a lot of crying in her room. Then, she returned to Los Angeles. To replenish at least a small part of her income, she took a string of part-time jobs in LA and Missouri: at a doughnut shop, at the Midwestern coffeeshop chain Scooter's Coffee, as a nanny, as a production assistant. She's been open about these unglamorous financial realities. In a clip from the 2024 MTV Video Music Awards red carpet that resurfaced on

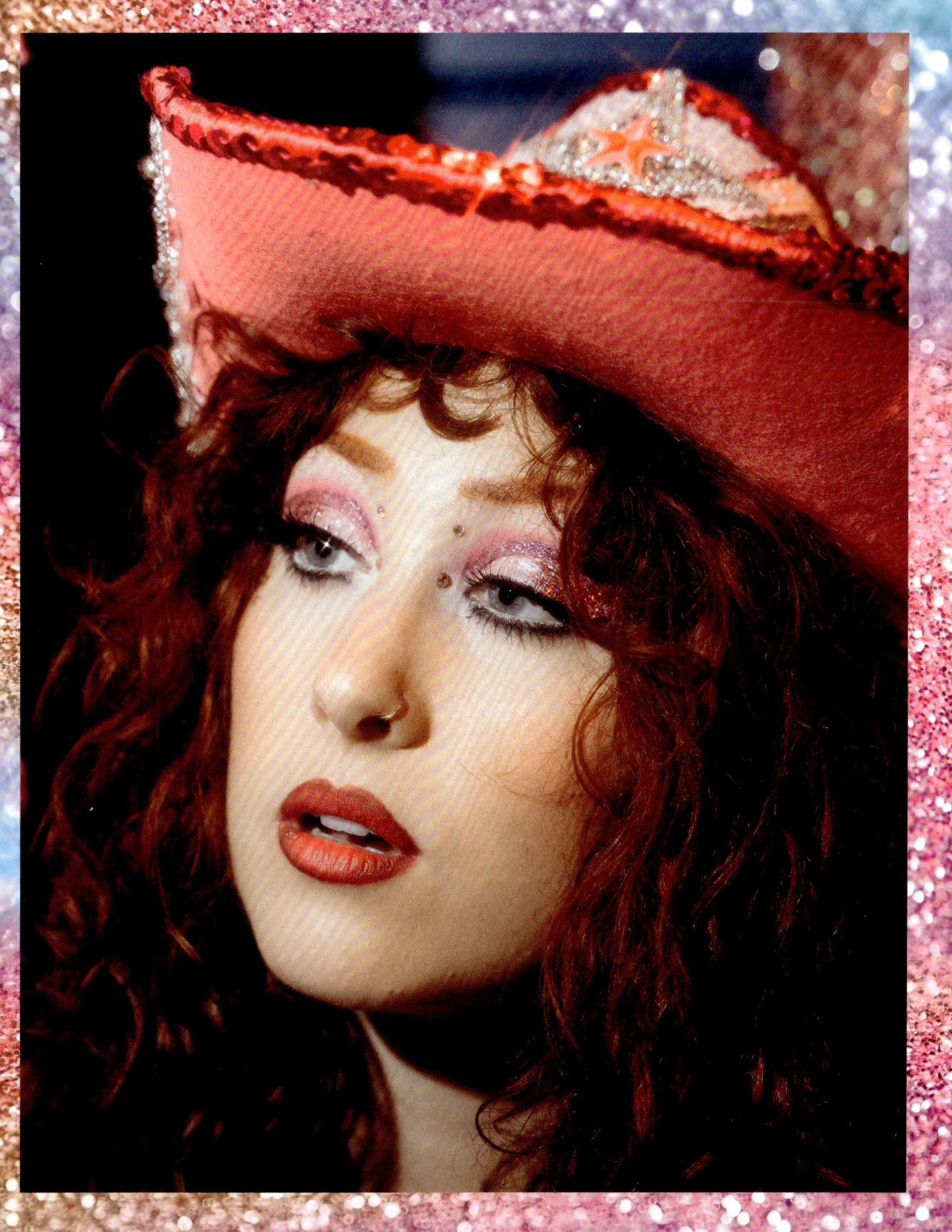

TikTok, she joked that she was 'once a drive-thru girl'. When asked by the interviewer whether she was *actually* a drive-thru girl, she dug in: 'Yes, girl. A coffee kiosk in the Midwest – it's called Scooter's. That's who I am.'

But drive-thru jobs seldom last forever. (Chappell did sign a publishing deal with Sony in 2022, a less gruelling source of income that gave her space to focus on her music while also allowing her to build industry connections.) She promised herself that she'd spend one year trying to rebuild her career before she gave up. And she decided to make the most of the creative control she and Nigro had now that they were no longer being jostled around by a major-label hand. Chappell posted teasers of song after song online from what would become 2023's *The Rise and Fall of a Midwest Princess*: 'Naked in Manhattan', 'My Kink Is Karma', 'Casual', 'Femininomenon'. The process was similar to major labels' post-Spotify protocol of throwing consecutive singles into the streaming oceans until one of them didn't sink. The difference here, though, was that Roan was doing it on her own terms.

There was a less rosy side to this independent approach. Roan's friends were helping out with the songwriting and costume-making, but otherwise Roan and Nigro had taken on the duties of a whole record label mostly by themselves: singing, songwriting, producing, practising their instruments and coordinating session musicians, copywriting, marketing, management, A&R. They were doing the work of dozens of people, and without the salary that would normally come with such a heavy workload.

Essentially, they had become musician entrepreneurs – so, Nigro reasoned, why not make it official? In 2023, he started a label imprint called Amusement – a nothing-to-lose plunge he hoped would help him and Roan get her finished album out into the world in front of a sympathetic audience and maybe even make real money along the way. As he told *Billboard*, 'I just believe in [Chappell] so much that I was like, "Do I want this added stress in my life? Is it worth it? Yes."'

Unlike many record label imprints, Amusement was independently funded and the music released under it was not bound to any one label. This allowed Roan and Nigro to maintain full creative control. Labels are, after all, in the business of bartering numbers – of streaming plays, social-media mentions and audience counts – for money. Roan was hitting those metrics by herself, and the success of her independent singles gave her

the leverage to make practical choices about her career. And she knew it. As she told *The Face*, she could now pitch her music in words the music industry understood, 'Look at the numbers, b*tch!'

Just as *School Nights* was commissioned on the back of Roan's previous YouTube videos, the early *Midwest Princess* singles gained most of their traction online. ('Casual' in particular became a minor viral hit.) Tech marches on, though, and this time YouTube wasn't her platform of choice. As she put it to *Rolling Stone*, 'I started gaining a lot of followers when I was being really insane on TikTok.'

This wasn't unusual for pop artists. In the years since Roan had signed to Atlantic – especially since 2020, when screens had for a time provided the only way for fans to see their favourite artists – the now embattled social-media platform had become a huge part of the major-label promo apparatus. The industry had watched obscure album cuts, decades-old singles, niche cult bands and former one-hit wonders become relevant again, seemingly at random, as everyday teens used them to soundtrack TikTok trends. And labels wanted to re-engineer that success for themselves, not as random viral moments but as something music-industry folks could deliberately trigger.

The relationship between labels and TikTok had soon become symbiotic – or perhaps, depending on who you asked, parasitic. By 2022, dozens of pop stars, including Ed Sheeran, Maggie Rogers and FKA Twigs, had begun to post about being pressured by their labels to produce a constant stream of 'low fi tik toks' (in Florence Welch's words), or even being prevented from releasing songs until one of their non-musical clips went viral (as Halsey claimed). Naturally, these posts were

WITH JUSTIN TRANTER AND DAN NIGRO

themselves TikTok videos: a socia media cycle. And while the artists were usually in on the joke – after posting her own label callout, Charli XCX said she'd just been 'lying for fun' – you could tell that their resentment wasn't entirely tongue-in-cheek.

Roan also had mixed feelings about TikTok and was far from being an uncritical cheerleader despite embracing the platform. She was wary of her career being reduced to just another viral moment – the lower half of the pop charts were full of musicians who got famous on TikTok for one week and one week alone. As she later told *Rolling Stone*, with characteristic bluntness, she eventually came to view TikTok and other socia -media platforms as 'fueled off of mental illness, straight up'. But being unsigned at least meant Roan was free of the corporate pressure her musician peers faced – and free of the

FALLING & RISING

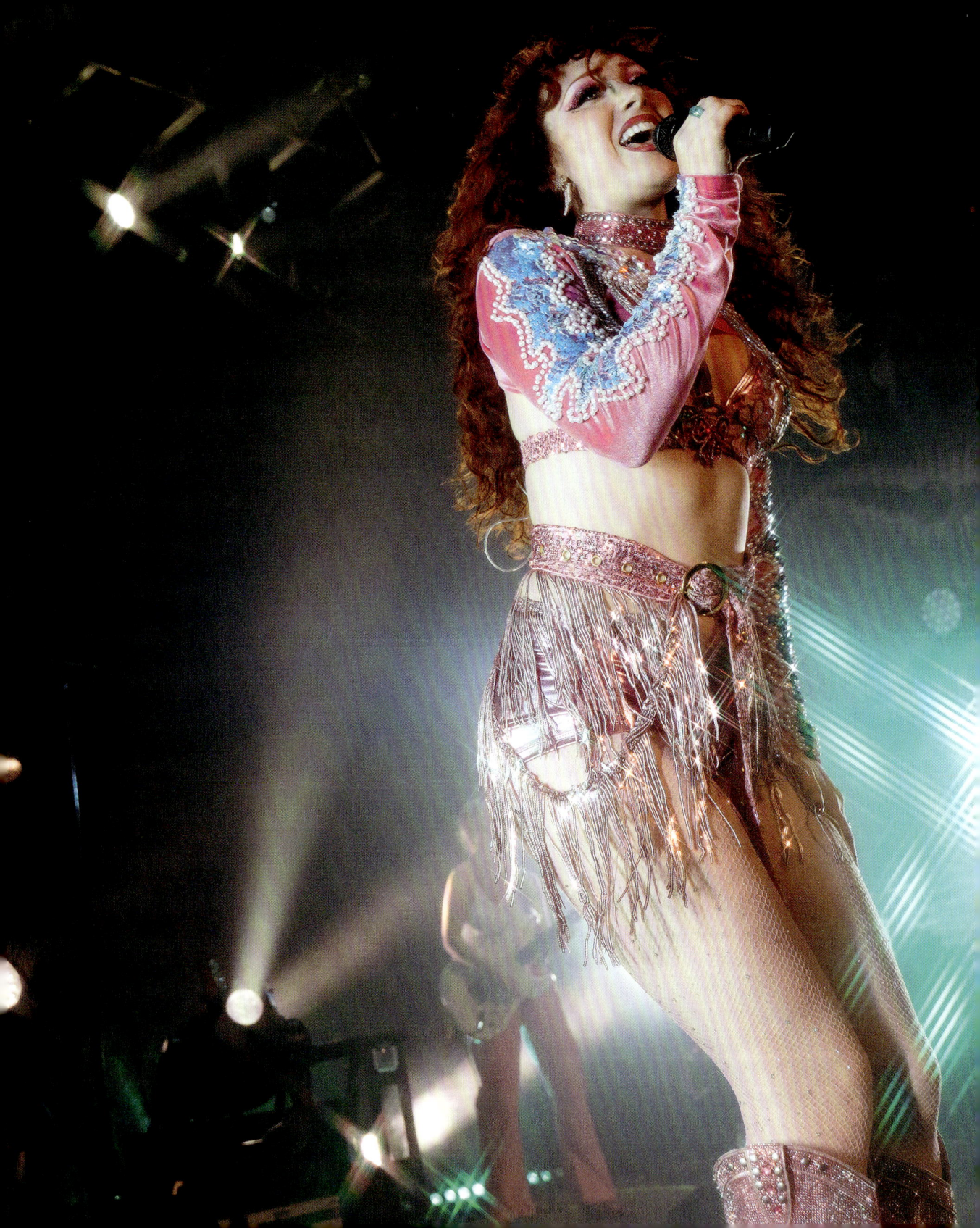

ceaseless music-business schedule that would make TikTok just one more time-consuming obligation. 'I gained a lot of speed at the beginning of the year with TikTok because I wasn't busy,' she told *Billboard* in 2022. 'I had time to post twice a day, go live once a day, repeat.'

Perhaps that's why Chappell Roan's online presence seemed so natural, relatable, unfiltered and not focus-grouped. She'd intersperse livestreams with previews of her new music, or record her candid, stream-of-consciousness thoughts. She shared her hair routine, sang to her guinea pigs, extolled the sexual prowess of 'girls who get 9–12th place in *Mario Kart*' and rated the decor of her tour motel room. (Her verdict: closet space 3/10; broken air conditioner '-1467/10 but the aesthetic was there.') And she read the comments; for instance, in the comment section underneath one of the 'Casual' previews, she responded to a girl who had asked whether she should text her ex back. Her advice: not until listening to that song.

Chappell also shared stories from her life in the way you'd tell them to the group chat or several hours deep into a party. In one video, she freestyles over the instrumental to Rick James's 'Super Freak' with a dramatic retelling of a day she passed out from whipping her hair really hard and woke up in the hospital with a neck sprain. In another, she rips into 'indie boys' and their music, 'What are you singing about? Literally f*cking a cigarette?' Those stories were sometimes deeply personal. In summer 2022, she posted a montage of videos she'd recorded in her day-to-day life,

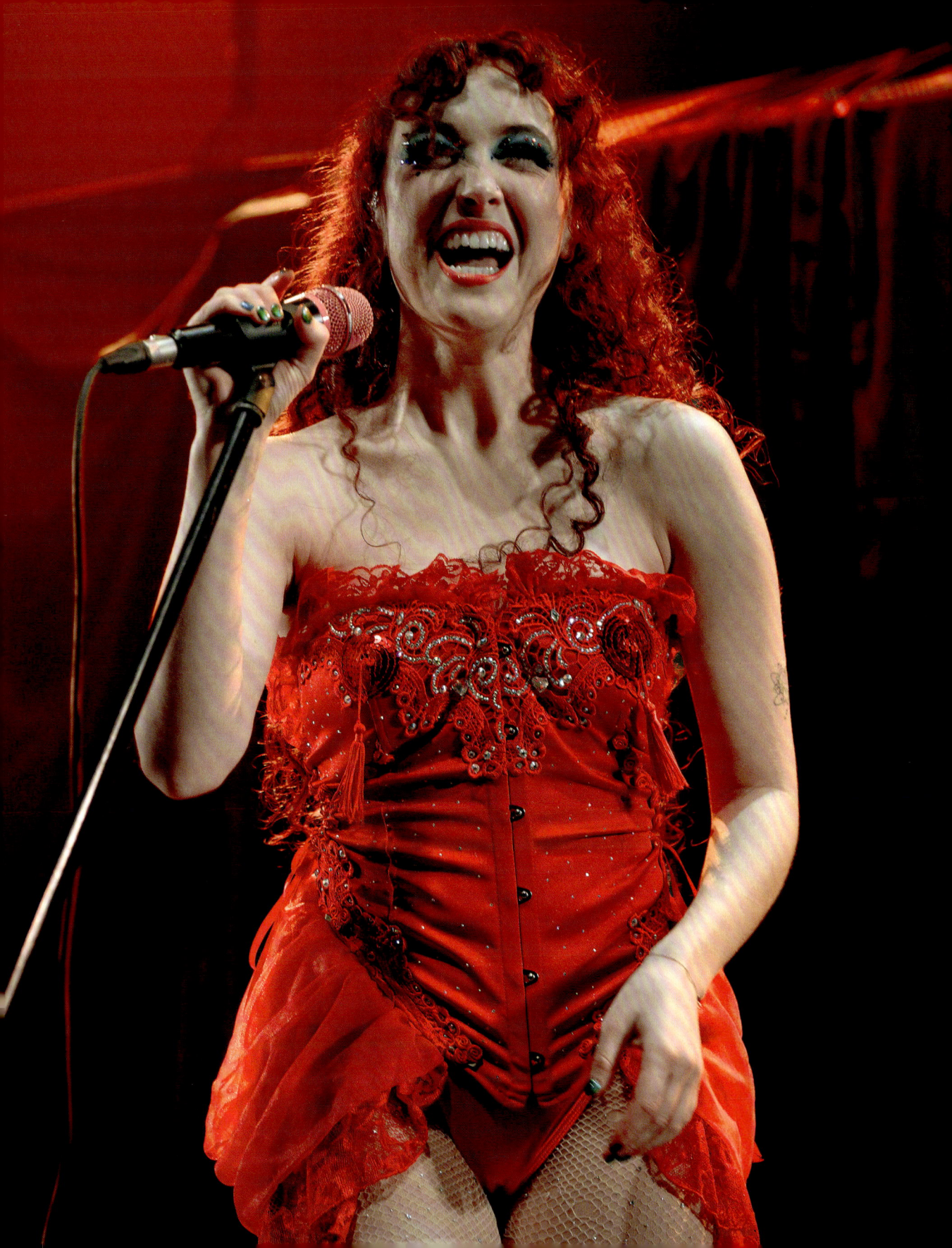

documenting her experiences with bipolar II: losing weight from not sleeping and eating, and struggling to find the right medication when some made her feel numb while others blunted her creativity.

These revelations – both musical and personal – were followed intently by her fans. Roan said she gained 30,000 followers in one month while promoting 'Naked in Manhattan'. And judging by the ultra-invested commenters on her TikToks, the engagement was genuine. Chappell incorporated fan speculation directly into her songs' promotional cycle. For instance, when she released the audio for 'Naked in Manhattan' on TikTok, with the Apple Notes app and lyrics floating on the screen, one person asked Roan in the comments, 'Wait a damn minute.... Is this why you were in NYC???' Chappell replied, 'Putting puzzle pieces together.'

As Roan's following grew, it became clear that her popularity wasn't contained to arbitrary numbers online. Justin Eshak, the CEO of Island Records, attended one of Chappell's shows at the Bowery Ballroom in New York City – a show she had sold out, decisively. Her stagecraft was on point: in one highlight performance, she snarls out Alanis Morissette's 'You Oughta Know' in a tattered red minidress and chunky cerulean eyeshadow, flanked by backing bandmates wearing devil horns. By the final chorus, the crowd was shouting so loud that Chappell barely had to sing. Speaking to *Hits* in 2024, Eshak recalled, 'She was selling out the Bowery without a label [...] It was f*cking bonkers. People were losing their minds.'

Island, a subsidiary of Universal Music Group founded in Jamaica, had seen historic success in the 1960s and 70s thanks to reggae

legends such as Bob Marley and titanic rock acts such as U2. But by 2022 the label had been bought, sold and restructured so many times that despite having massive artists including Drake and The Weeknd on its roster, its reputation and market share were both floundering. Eshak was hired that year to reinvent the label as an incubator of new, vibrant artists – and when watching Chappell on stage, he knew he was looking at one of them.

Roan didn't sign with Island until she was convinced the label wouldn't discard her in two years as Atlantic had. As she told *Rolling Stone*, she pressed them relentlessly, 'Give me a [pitch deck] on how you would market me. Give me a deck on what you would do with my career. What do you see in five years? If you can't even do it in a hypothetical situation, you don't know how to figure it out.' Ultimately, though, they figured it out well enough that Amusement would partner with Island Records. Chappell had a large platform once more.

The launch of Amusement contained one more symbolic hint of Chappell's career transformation to come. Alongside Nigro's 2023 announcement on Instagram, he unveiled the label's logo: a rainbow.

NAKED IN NORTH AMERICA Tour 2023

USA
15 FEBRUARY: Crescent Ballroom, Phoenix
18 FEBRUARY: House of Blues Cambridge Room, Dallas
19 FEBRUARY: House of Blues Bronze Peacock Houston
20 FEBRUARY: The Parish Austin
22 FEBRUARY: Vinyl, Atlanta
23 FEBRUARY: Basement East, Nashville
25 FEBRUARY: The Foundry at the Fillmore, Philadelphia
26 FEBRUARY: Black Cat, Washington DC
28 FEBRUARY: Webster Hall New York City
1 MARCH: The Sinclair Boston

CANADA
3 MARCH: Velvet Underground, Toronto

USA
4 MARCH: A&R Music Bar, Columbus
5 MARCH: Subterranean Chicago
6 MARCH: Gillioz Theatre, Springfield
8 MARCH: Marquis Theater, Denver
9 MARCH: Soundwell salt Lake City
11 MARCH: Madame Lou's, Seattle
12 MARCH: Doug Fir Lounge, Portland
14 MARCH: August Hall, San Francisco
15 MARCH: The Fonda Theatre, Los Angeles

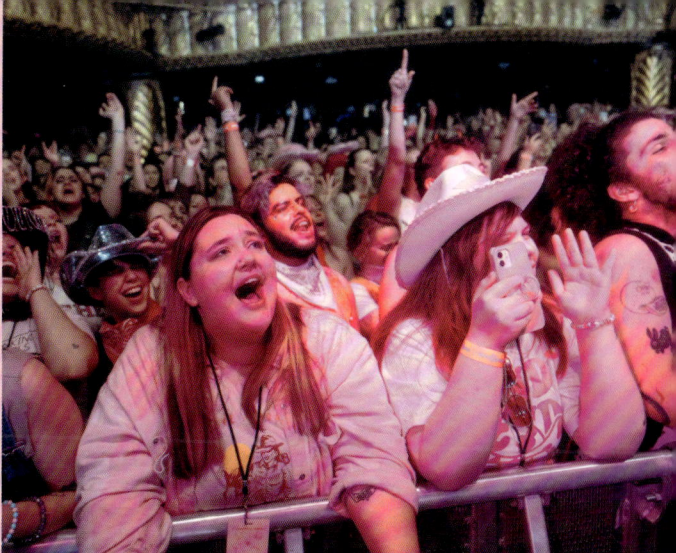

Chappell Roan's 'Naked in North America' Tour – her first solo headlining tour – began on 15 February 2023 at the Crescent Ballroom in Phoenix, Arizona, a little-known and intimate venue. A recap video shows Roan on stage saying she's 'trained for this, I've trained for this!' – a moment of self-actualization, where she's finally ascending on her trajectory to stardom and able to headline her own tour after being an opening act for Olivia Rodrigo and Fletcher in May and November 2022 respectively.

The capacity of the venues for this sold-out 20-date tour ranged from just over a hundred (Denver's Marquis Theatre) to 1,300 (the Gillioz Theatre in Roan's native Springfield, Missouri). Roan made it a real highlight of the shows to include performers of colour, stating that a portion of proceeds from the tour would go to the Black trans charity, For the Gworls. In the recap video's voiceover, Roan says that the tour's ethos was to, 'give back to the queer community, and to create a safe space for everyone to dress up, be silly and dance.'

On some dates, Roan performed covers of songs such as Miley Cyrus's 'The Climb' and Lana Del Rey's 'Brooklyn Baby', while the permanent setlist also included a cover of Alanis Morissette's 'You Oughta Know'. Writing in *Backward Noise* magazine, Maggie Didier described Roan's performance as 'ethereal' and her voice 'so magical, even at times with a sound reminiscent of the Cranberries.' In the *Daily Trojan*, meanwhile, Ms. Dacity suggested that Roan had thrown a 'killer kiki' with the final show of the tour, at LA's Fonda Theatre, and praised the 'dazzling performances from three local drag queens: Missile Aneous, Aiana Shaw and La Kelly Ru.' Once again reiterating her support for local queer artists, Roan had told her fans, 'When you tip your drag queens – if you didn't get a chance, we've got a tip jar at the merch table – you are directly supporting your local drag community.'

What was also evident throughout this tour was Roan's commitment to her craft and appreciation of her fans – for whom she performed unreleased tracks and provided a party where they could dress up and express themselves freely. By the end of the 'Naked in North America' Tour – long before her Grammy win – Chappell's explosion onto the pop scene had firmly cemented her status as 'the next big thing'.

THE STORY BEHIND THE *Songs*

The Rise and Fall of a Midwest Princess is a hell of a title. In eight words, Roan conveys a self-mythologizing identity that's both lofty and rootsy while also turning her whole musical career up to that point into a dramatic narrative arc, with coronations, dethronings and triumphant rebirths. But *Midwest Princess* isn't at all the kind of over-laboured concept album that another artist might make from that title. The rise and fall are more personal. What's risen is Chappell Roan's artistic character, in all its dramatic glamour, and her embracement of her own identity and sexuality. The only things that have fallen are the years of unsatisfying relationships and unaddressed doubts that once kept her from doing this.

One throughline of *The Rise and Fall of a Midwest Princess* is frustration – but a specific kind. It's not sexual frustration, per se – although there's plenty of that coming from the lovers Roan shrugs off – but disappointment with how far your romantic reality is from the ideal, elusive satisfaction. Sometimes it's

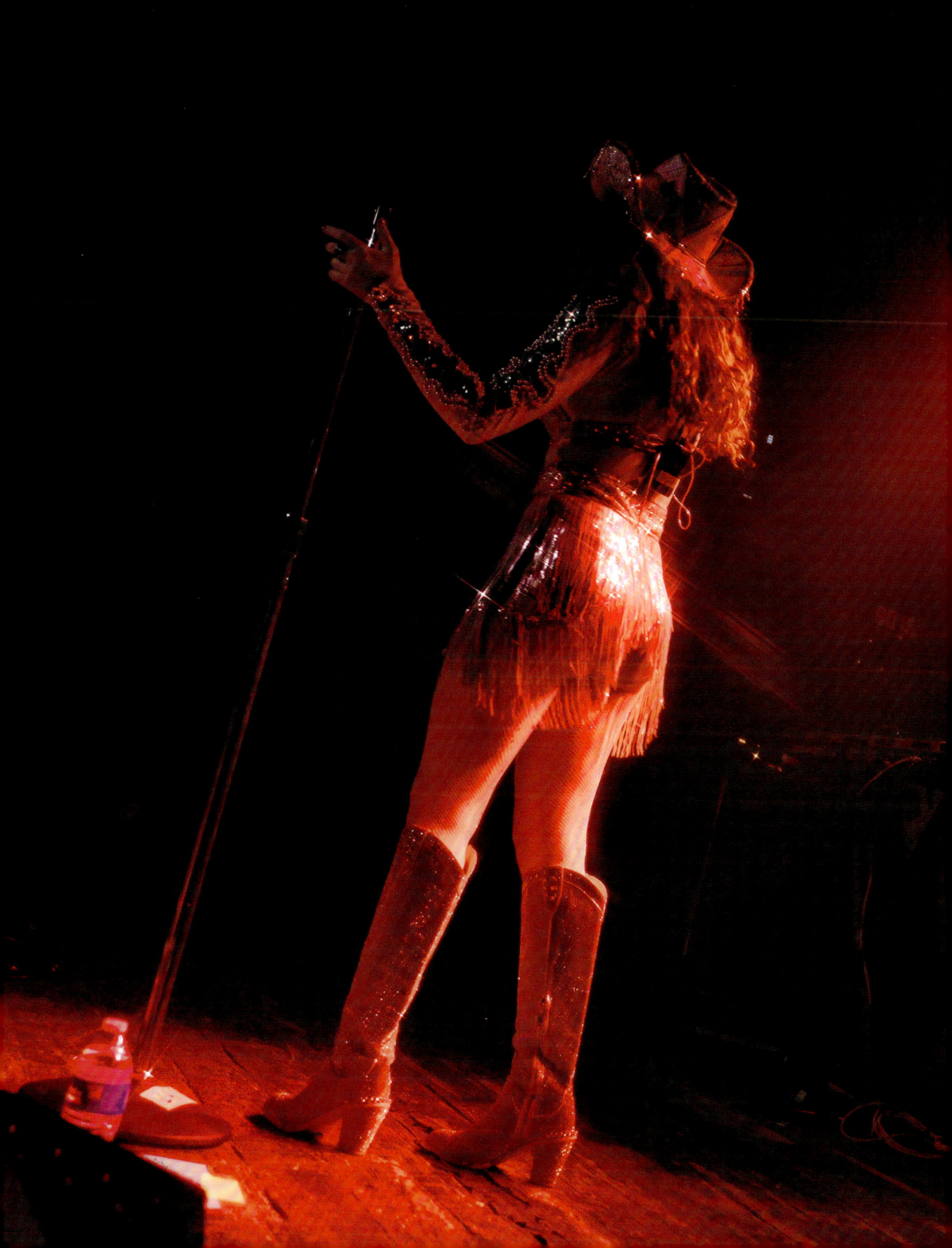

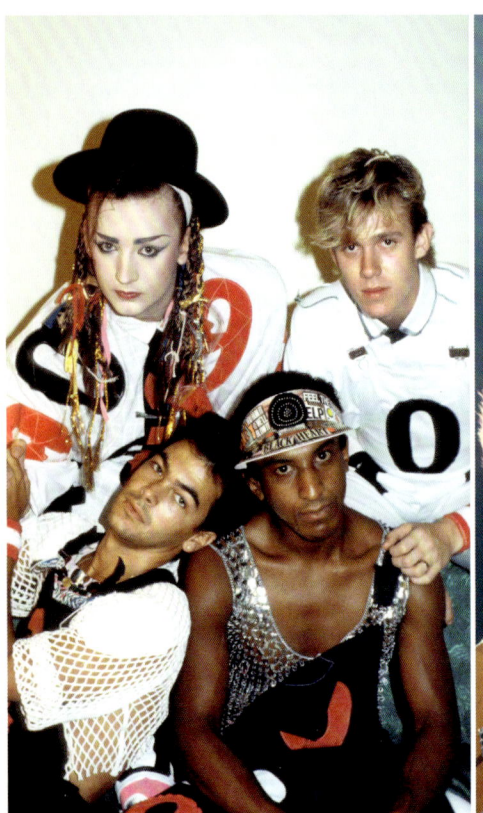
CULTURE CLUB

PRINCE

directed at one other person: the 'casual' situationships, the stubbornly 'straight' girls giving you only so much hope as can fit into the air quotes.

Another constant is Roan's fusion of radio-ready synthpop and coffeeshop folk with bold queer aesthetics. The lyrics are full of the kind of unapologetic sapphic sexuality that was unheard of on radio stations just a few years ago: specifying her taste in women right down to the choice of bra, confessing her childhood crushes on *Mean Girls* characters and detailing every way that girls can do it better.

The videos to *Midwest Princess* are an essential part of the project. Roan has toyed with the hypothetical of making the album into an actual film – or, better yet, a musical. In a way, though, she has. Like her predecessor and new fan Lady Gaga, Chappell Roan loves an event video. And her voluminous vault of clips is prolific and imaginative enough to constitute a miniature cinematic universe. Roan's take on the event video is a little more down-home, though. She records a lot of videos with her close inner circle, including Gia Rigoli, a producer she's worked with since the *School Nights* era. Rigoli has also brought in her own close friend, director Jackie! Zhou – a sound director and another huge Chappell Roan fan. (Zhou's sister introduced them to Roan's music.) But although the videos originate in small, close-knit friendship groups, their ambitions are certainly not small. Whether they're set in rural dives or glitzy stages, they are all resplendent with technicolour, drag-influenced iconography.

JANELLE MONÁE

EURYTHMICS

The album is finally a love letter to pop music – and especially pop in its most subversive, campy, non-heteronormative incarnations. Chappell has no time for people who want to dismiss the genre, because she knows whose approval really matters. 'Everyone is trying to be like, "Oh, that's just like a little left of center,"' she told *The New Nine* in 2022. 'I'm like, "No, bring back plain center pop. Girls just want to have fun. Come on."' So finally free of the morose acoustic songs of her early career that she'd come to resent, Roan has totally flung herself into a maximalist, colour-soaked, viscerally thrilling sound.

The songs are full of deliberate nods to legendary pop-music icons and interpolations of killer hits. They're like the cap on a wave that's been building pressure for years. Both her music and the visuals she's used to illustrate it, call back to the campy, androgynous synthpop acts of the 1980s: Culture Club, Bronski Beat, Prince, Eurythmics. These artists ventured daring experiments in the new arena of MTV, competing to catch the eyes of cable subscribers. In the 21st century, queer artists such as Janelle Monáe, Sophie and Fever Ray have played in similar ways across streaming video platforms, charging their music with surreal, grotesque and futuristic imagery.

And to all this, Chappell Roan adds campy, arena-sized iconography of her own. As the old theatre-kid saying goes, it's better to be big and wrong than small and right. And better still is to be – like *The Rise and Fall of a Midwest Princess* – big and right.

THE STORY BEHIND THE SONGS

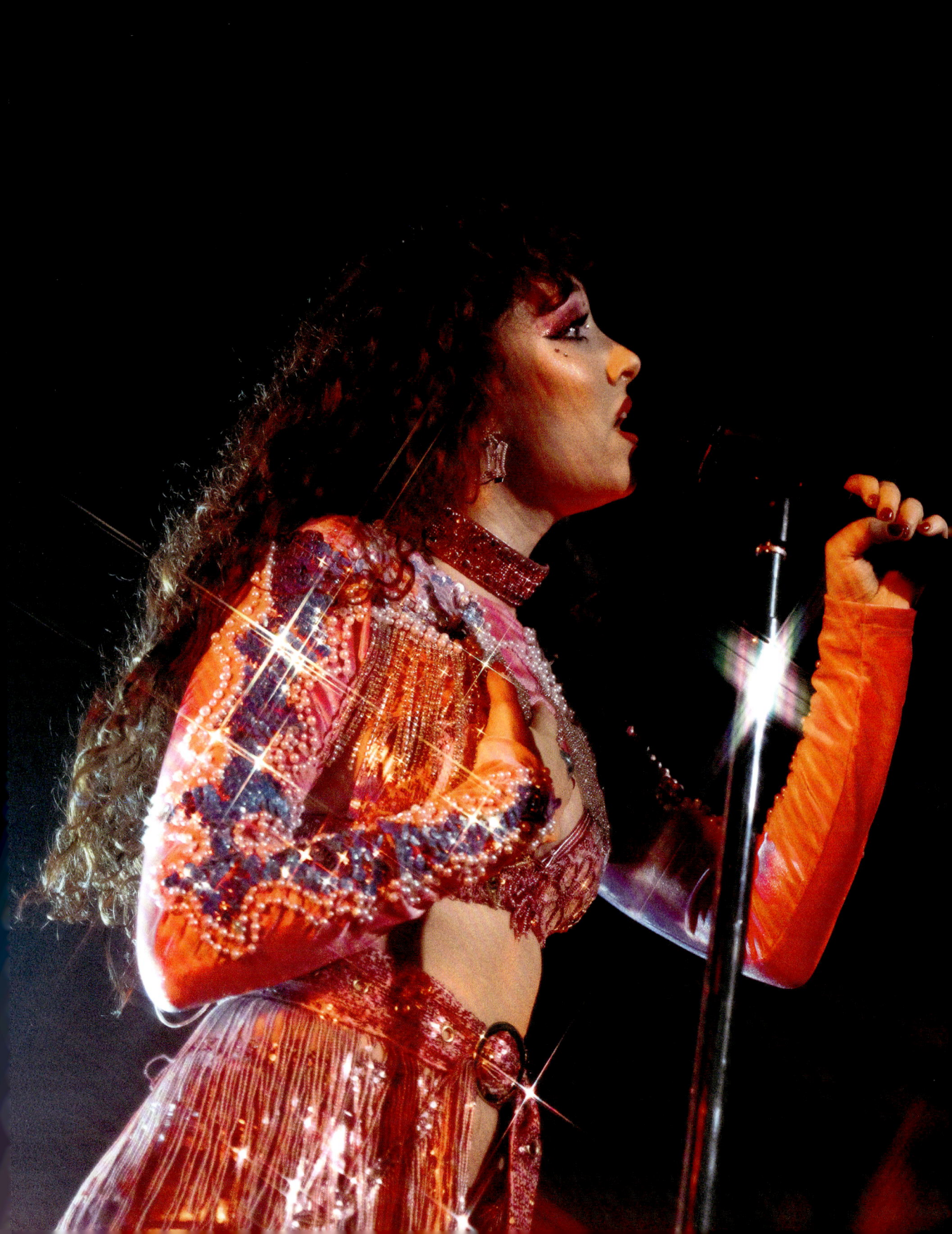

TRACK by TRACK

THE RISE & FALL OF A MIDWEST PRINCESS

TRACK by TRACK

Song One
FEMININOMENON

RELEASE DATE	12 August 2022									
WRITTEN BY	Kayleigh Rose Amstutz, Daniel Nigro									
US BILLBOARD CHART POSITION	66									
UK CHART POSITION	N/A									
PRODUCTION CREDITS	Produced by Daniel Nigro	Co-produced by Mike Wise	Engineered by Daniel Nigro	Strings by Paul Cartwright	BGVs, MS-20 Synth, Drum Programming, Piano and Bass by Daniel Nigro	Drum programming by Ryan Linvill	Lead and BGVS by Kayleigh Amstutz	BGVs by Emily Williams	Mixed by Mitch McCarthy	Mastered by Randy Merrill at Sterling Sound

In this iconically named first track of *The Rise and Fall of a Midwest Princess*, Chappell Roan directs her sexual and romantic frustration at the entire world – or at least the straight men in it. She'd have to stop the world to stop the knowledge that somewhere out there is transcendent omnigasmic fun; but over here there's just another dude she met on the apps, cheating and ghosting and disappointing in the most mundane of ways. And by the time she released 'Femininomenon', Roan had accumulated plenty of that knowledge. She said on TikTok that she'd 'almost been married twice' (she doesn't divulge the reasons those engagements ended) but that it was her shorter-term relationships – if you could even call them that – that drove her to write 'Femininomenon'. She wrote the song after several exhausting, uninspiring dates with random guys from the normcore dating app Hinge. Why, she asked herself, was every single guy she met incapable of bringing her any romantic or sexual pleasure? She did have one big clue: she also met one woman on the apps, and she remembered how that one date alone was 'miles beyond' all of the others. Thus, she formulated a new pleasure principle: the transcendent joy she wanted – *needed* – must be a feminine phenomenon, the sole creation of women. Chappell took the irritation she'd felt with both men and heteronormative expectations and pulverized it until it became an empowering anthem, simultaneously defiant and joyful.

'Femininomenon' is a celebration of girls getting other girls off and also of big beats. It's like a new generation's version of Tori Amos's 'Raspberry Swirl', except this time performed by someone who's not only a gay icon but also gay herself. Like most of *Midwest Princess*, 'Femininomenon' was a Dan Nigro collaboration and was co-produced by Mike Wise, a Canadian pop journeyman who'd started out producing mostly for the

hyperlocal Canadian market. When *The Rise and Fall of a Midwest Princess* was in the works, he'd just begun to place songs with rising artists such as Allie X and Bülow in the global market.

For the single's video, Chappell wears an outfit that pays homage to her Missouri roots while also nodding to her adventurous camp aesthetic. It's a spicy version of dirt-bike gear, with a souped-up helmet, handmade assless chaps and DIY neon accents, plus a badge representing her Missouri hometown on the right shoulder pad. Reflecting on the look in 2023, Roan told *The Walk In with Mo Heart* TV show: 'This is probably my favourite look of all time. This is real dirt-bike gear; like, you can feel it. I ordered it off Amazon and then I had a friend who [handmade] assless chaps.' She added that the helmet was bedecked with jewels by hand, in a slightly haphazard way – though 'you can't really tell'. Unless, that is, you followed her on TikTok: in August 2022, she'd posted a video of her and her friends using a hair dryer and credit card to affix decals to the helmet, then finishing sewing the jacket over the burner of their cramped apartment's stove. (Don't worry – it wasn't on!)

The title is a tongue-twister, befitting for a song that's all about tongue-twisting. Nigro came up with it, and while it took a while for Roan to wrap her head around it (and around the pronunciation), she was soon all in. 'I know you *know* how to say "supercalifragilisticexpialidocious",' she teased a commenter on her TikTok: once you get it, you get it. She joked in an interview with Nigro and Brandi Carlile at the Grammy Museum in 2024 that she'd forevermore lost the ability to say 'femininity'. (She'd even considered calling the whole album

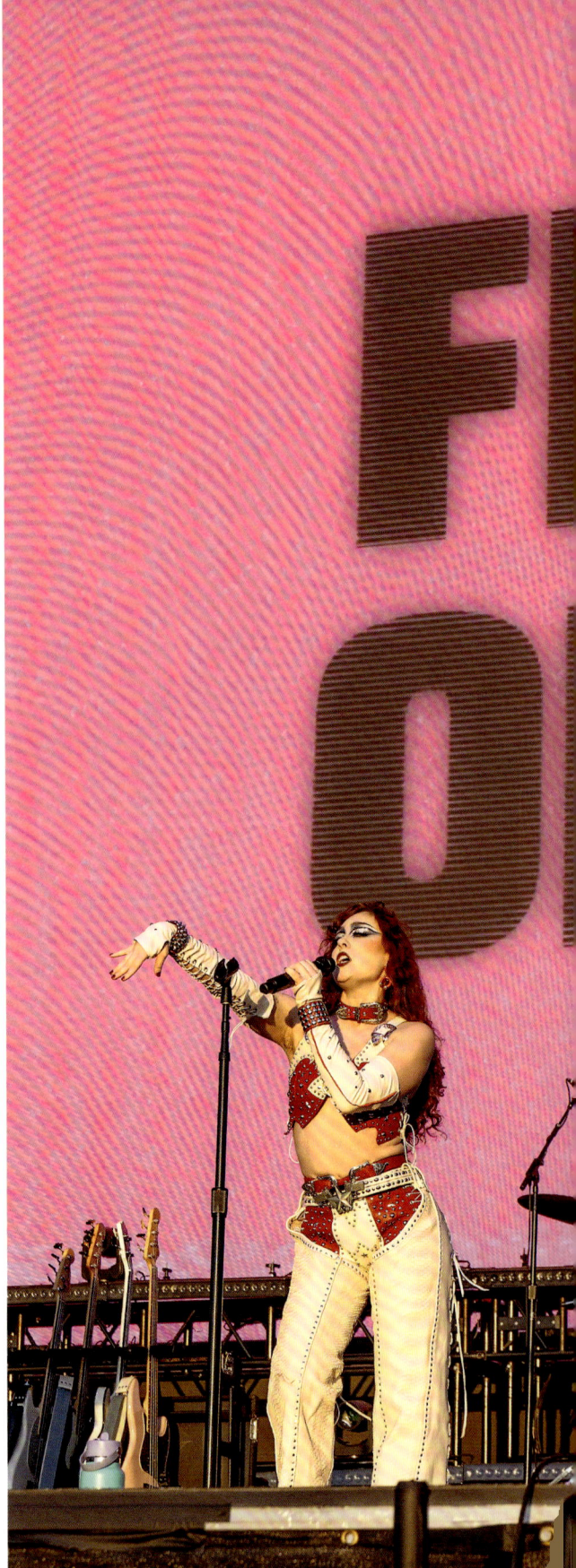

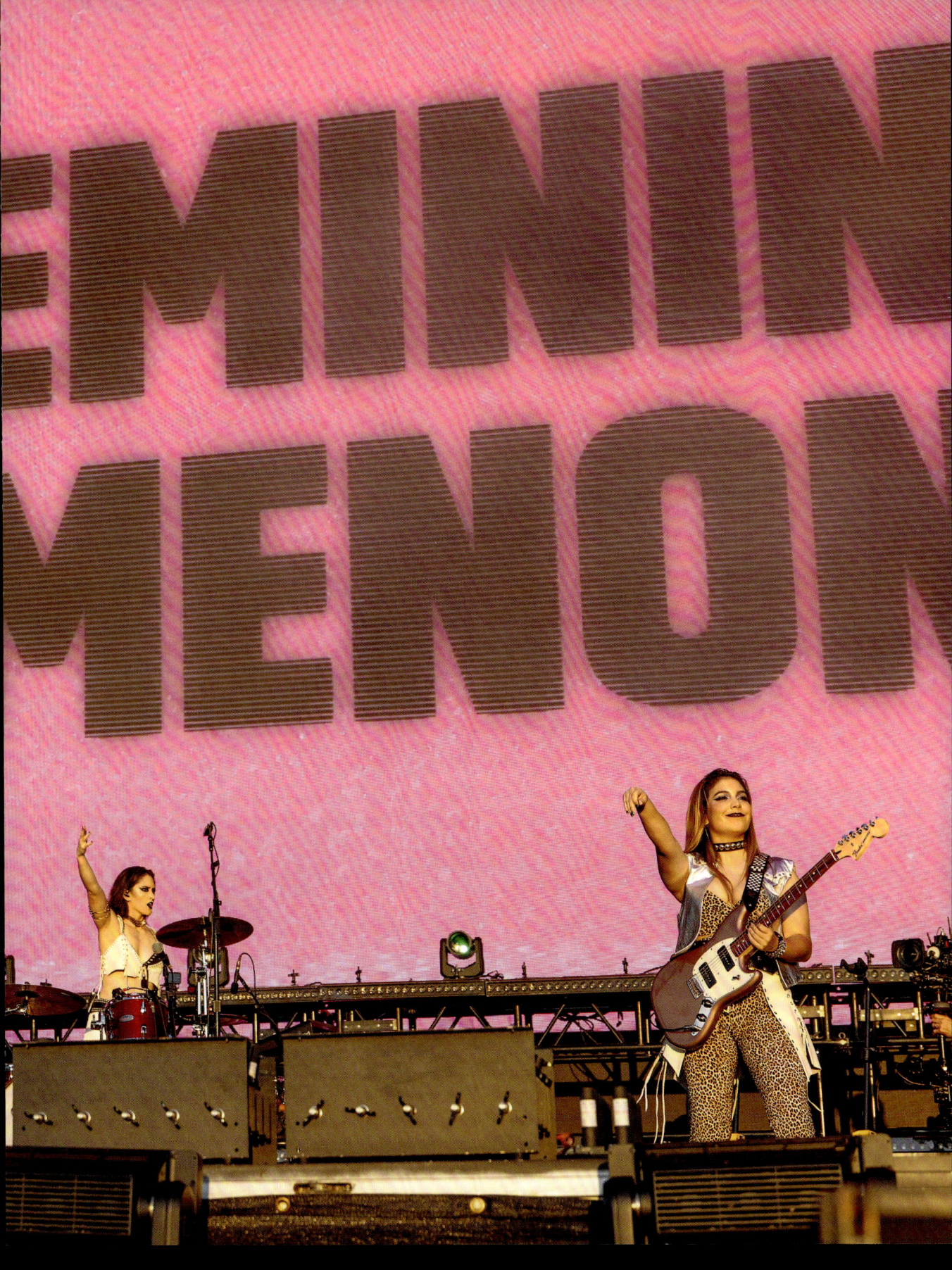

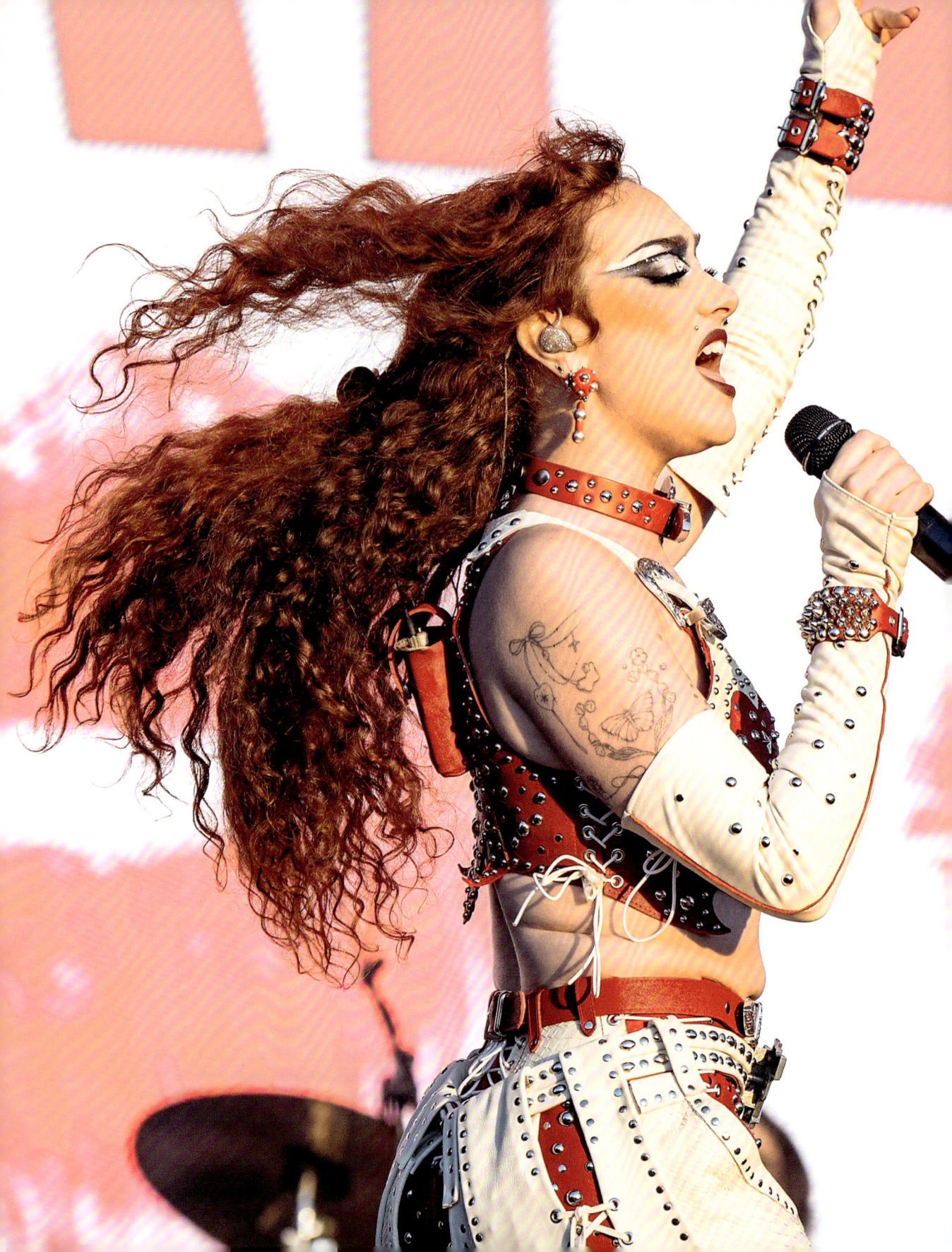

Femininomenon, but decided she didn't want to troll people's voice boxes that much.)

Part of the genius of 'Femininomenon' is in how Roan and Dan Nigro channel her years of men-induced frustration into the song itself and its musical architecture – its genre choices, its volume dynamics, even the stresses of the syllables of the lyrics – until the music speaks the feeling. Roan makes the women-loving-women conceit into a poptimist metaphor: girls are so much better than boys, just like (as she maintained) ballads are so much better than pop. But the shift from ballad to anthem isn't just a genre switch-up – it's a way for Roan to dramatically fling all her disillusionment into orbit.

And if the Grammys gave out acting awards, the introduction to 'Femininomenon' would win one for how well it pretends to be a ballad. Roan plays with the listener's expectations of how a ballad is structured, how it sounds and what it says. A cinematic arc of melodramatic strings unfolds in the track's first seconds; and once you know where the song's going, you can hear how those strings hang in the wings of Roan's sedate verse, subtly signifying the stagecraft to come. The story is a slightly risqué take on a lovelorn weepie, 'Should've listened to your friends / 'Bout his girlfriend back in Boston...' Roan's vocal is restrained, with only a slight crescendo, and her lyrics are the kind of shrugging breakup postmortem – 'You sent him pictures and playlists and phone sex' – that suggests she's told the story too many times before to be shocked. As she sings, 'Same old story.'

Fifty seconds in, Chappell drops her heartbroken affectations, swapping out her keening post-Taylor vocal for nonchalant, staccato spoken word and replacing those strings with a growling bassline. Her lyrics almost sound incomplete, as if she's finishing each line silently inside her head: 'Hit it like – get it hot / Make a b*tch – it's a fem...' Then Chappell drops subtlety entirely, with a revving-engine sound effect and a bratty mic-smash of a pre-chorus: 'Can you play a song with a f*cking beat?' And so, she does. The chorus that follows is a pulsing anthem of femininity that most assuredly has a beat: a glitter nuke that obliterates everything that was there before.

Roan keeps that energy the whole way. In the chorus, she brings those choppy lyrics back but she also completes them – and the full lines are as irreverently, jubilantly wacky as anything in Chappell's persona. A girl who can 'get it hot' is one thing, but a girl who can 'Get it hot like Papa John'? Absolute keeper. (For the record, Roan has said the line isn't sponcon. And fans have embraced it: they've been known to wave empty Papa John's pizza boxes in the air at shows.)

The song's climax is a chanted interlude of a bridge where Chappell shifts focus from her own sexual liberation to that of the whole audience. She stages an exuberant mock-protest – which doubles as a clever way to teach listeners how to pronounce the song's name. She turns her microphone into a megaphone, addressing the girls around her with *Powerpuff Girls* pep: 'You know what you need / And so does he / But does it happen?' she asks. 'NO!' her audience proclaims. (Live audiences proclaim it loudest of all.)

Again: 'But does it happen? / 'NO!!' / Well, what we really need is a –' and the crowd roars – 'FEMININOMENON!'

RED WINE SUPERNOVA

RELEASE DATE	17 May 2023						
WRITTEN BY	Kayleigh Rose Amstutz, Lixa, Amy Cuney, Daniel Nigro, Annie Schindel						
US BILLBOARD CHART POSITION	41						
UK CHART POSITION	31						
PRODUCTION CREDITS	Produced by Daniel Nigro	Additional by Annie Schindel	Guitars, Juno, Synths, Bass, Drum Programming, Percussion and BGVs by Daniel Nigro	BGVs by Cara Salimando and GiGi	Mixed by Serban	Mastered by Randy Merrill	Recorded at Amusement Studios

'Red Wine Supernova' is a vicarious fantasy. The single is a crush song about Chappell's infatuation with a woman with 'Playboy, Brigitte Bardot' looks and the superhuman sexual confidence to go for what and who she wants. The woman lives in the theatrical, hyperreal world of sex symbols, a performance come to life. She's an archetype of sexual power, reincarnated as a modern, confident queer woman. She says exactly what she means; as Roan's lyric goes, 'You just told me / "Want me to f*ck you?"'

Chappell's character, by contrast, lives in the everyday world, full of insecurities, roommates and twin beds. Her crush's confidence seems almost unreal; and Chappell's admiration is very reminiscent of a recurring, shared experience of queer girls, where every new romantic obsession comes with an introspective question: 'Do I want to be her, or do I *want* her?' But 'Red Wine Supernova' is a *double* vicarious fantasy: in the song, Roan wants both of those things. So she answers her crush's proposition with unambiguous and enthusiastic consent, 'Baby, I will, 'cause I really want to!' Even if she has doubts – the prelude to that line is one long pep talk, with Roan psyching herself up to finish the flirtation she started – she's *thrilled* to learn through practice.

Roan recorded the first of several demos of 'Red Wine Supernova' in 2019. But those demos, like much of her songwriting at the time, were subdued and, despite being synth-based, unplugged at heart. They did not live up to Roan's title, a wink at Oasis's 'Champagne Supernova' with the drink

THE RISE & FALL OF A MIDWEST PRINCESS

PRINCE (TOP LEFT);
MADONNA (BOTTOM LEFT)

swapped out for something more deeply coloured and classically sensual. Nor did they represent her aesthetic. On TikTok, playing back one of the early recordings, Roan was downright dismissive, 'I'm gonna skip to the chorus, it's so boring.'

Another drastic change: the first versions of 'Red Wine Supernova' were written about a man, something Roan jokingly called a relic of her 'straight era'.

Roan and Nigro both knew the early versions of 'Red Wine Supernova' weren't working, so Nigro got an idea, 'What if we lean into the yee-haw of it?' So they sped up the tempo of the drums to double-time, peppered the vocal line with tossed-off 'y'all's, and packed the song with playful irreverence. This wasn't just your everyday yee-haw; the final transformation of 'Red Wine Supernova' was country camp of the Orville Peck variety. Roan summons the kitschy energy of late-90s and early-2000s pop-country – think Shania Twain's iconic 'Man! I Feel Like a Woman' intro, 'Let's go, girls!' – then tweaks it with an overtly queer twist, turning what could have been a throwaway genre dalliance into an undisputed anthem.

One of the many 'Red Wine Supernova' demos namedrops Madonna and Prince, 'You like Prince, "When Doves Cry"...' In the final song, though, Roan's soon-to-be-lover isn't just a Prince listener but a Prince *character*, a sexual dynamo right out of 'Darling Nikki': 'She did it right there, out on the deck!' But where the old version of the song used the Prince reference to tap into the sexual liberation and playfulness of the artist's

SUNRISE

THIS *Single* IS A CRUSH SONG

music, and how it blurred the lines between lust versus love and fantasy versus reality, the final version taps into Roan's own playfulness. Her music and her fantasies speak for themselves.

Crucially, Roan cranks up both the goofiness *and* the lust of the lyrics. During their 2024 Grammy Museum interview, Nigro told Brandi Carlile that the song's big line (the one that made him and Roan feel like 'lyrical geniuses, the greatest geniuses in the world') – 'I heard you like magic / I've got a wand and a rabbit' – is a pun on the names of two vibrators that, like all good pickup lines, is both immensely corny and frankly sexy. It's not just a joke – it highlights how, in the world of 'Red Wine Supernova', sex and fantasy are as fun and ridiculous as they are real and electrifying. Fittingly, one of Chappell's previews of the single on TikTok was a Notes app screenshot of the lyrics, in which she embellished the song's working lyrics like 'long hair, no bra, that's my type' with emoji after saucy emoji.

Even amid the fun, there's an undercurrent of danger – of that 'good hurt' Roan wrote about years ago. Roan's prospective lover greets her with 'canine teeth in the side of [her] neck'. This vampiric, bestial image is definitely in the realm of things that two consenting humans might do, but represents the raw side of desire: pointed and dangerous. It's almost a predator-versus-prey scenario in which Roan's lover becomes the predator – confident, sexually assertive, in complete control. But Roan is no prey. She is actively participating in the fantasy, and she wants it all. It's danger in the kink sense – something Roan spells out on the bridge – where carnality is limited only by what both women really, really want.

The video to 'Red Wine Supernova', creative-directed by Chappell Roan's close collaborator Ramisha Sattar and released in June 2023 for Pride, is a celebration of the song's most iconic line. The first shot has Chappell captivated by some lesbian smut: the cover to an old-fashioned pulp novel called *My Romance with a Magician*. A blonde woman nuzzles a dark-haired woman in a backless black dress, a slow dance one second away from becoming more.

Thousands of these books came out as the paperback market exploded in the 1940s. They were virtually always illustrated by straight men with a leering male gaze, and marketed as

'LONG HAIR,
NO BRA,
THAT'S MY
Type'

exaggerated cautionary tales or taboo 'scandals' for male sexual consumption. But the books were also sought after (and sometimes written) by queer women of the time; even among the lurid caricatures, they saw vague, distorted reflections of their own stories. Roan's cover is a recreation of those covers illustrated by Brazilian artist Jenifer Prince, whose artistry is all about reimagining that old pulp. Her splashy pop art fits perfectly into the Chappell Roan project, and the difference in vibe between the old paperback art and Prince's art in 'Red Wine Supernova' is ineffable.

Neither woman on the cover of Roan's novel is obviously a magician, so she imagines one into the scene in order to insert herself into that romance. The magician, played by IRL mentalist Magical Katrina, has a dyed-red bob, a spangly jacket, a tiny top hat and a leotard showing off her thighs. She poofs away a 'GOD HATES MAGIC' sign – a tactful but clear reference to the Westboro Baptist Church, the infamous US hate group – then shoots Roan's character look after teasing look. The camera lingers on her pulling a red scarf from her shoe, up her leg and past her decolletage. But just as much, the camera lingers on Roan, absolutely loving the chance to live out her fantasy. The magician practically drags Roan's character into bed – again, with her very enthusiastic consent – then whisks her into her showgirl's boudoir. She makes Roan over: trading her plaid sweetheart top and country-pinup fit for a glittery black corset and tasselled opera gloves. They do stage magic – routines devised by Katrina for the video to 'push the boundaries of [her] creativity'. And they have a long makeout at the end, as softly draped curtains frame them and a vulvic stained-glass lamp shines.

The video ends with a classic, 'It was a dream…or was it?' moment. There's a dreamy fantasy feel; near the beginning, the screen fills with the kind of doodles you'd find on the notebook of a girl with a crush. Midway through the makeout, we cut back to Roan's lawn. A prying older woman tries to put the 'God Hates Magic' sign back. The magician and Roan shake their wands, turning her into a fluffy rabbit. In the final scene, Roan, now alone on the lawn but still in her showgirl outfit, leans down and kisses the rabbit on the head, as if sharing a secret.

THE RISE & FALL OF A MIDWEST PRINCESS

Song Three
AFTER MIDNIGHT

RELEASE DATE	22 September 2023								
WRITTEN BY	Kayleigh Rose Amstutz, Casey Smith, Daniel Nigro								
US BILLBOARD CHART POSITION	22								
UK CHART POSITION	N/A								
PRODUCTION CREDITS	Produced by Daniel Nigro	Engineered by Daniel Nigro	Assistant Engineer, Austin Healey	Lead and BGVs by Kayleigh Amstutz	Drum Programming, Guitar, Synths, Percussion, BGVs by Dan Nigro	Bass by Jared Solomon	Drums by Sterling Lawes Mixed by Serban	Mastered by Randy Merrill	Recorded at Amusement Studios

The title 'After Midnight' comes from an old aphorism Roan heard from her mum and dad, 'Nothing good happens after midnight.' (Thanks to an episode of *How I Met Your Mother* – and in a sign of evolving cultural norms – the more common understanding among millennials and Gen Zs is, 'Nothing good happens after 2am.')

The phrase is a mental curfew warning against the kind of late-night decisions that begin with alcohol and segue into sex. But it also reflects the conservative-Christian milieu in suburban Missouri – or four hours away in Oklahoma, where co-writer Casey Smith grew up – in how it conflates actual danger with lower-stakes sins such as hangovers and party fouls, or even just hooking up in ways conservatives might not like. 'A lot of what I was taught was, I think, out of fear,' Roan told the *Making the Album* podcast about the song. So after moving to LA, Roan took up her own motto, '*Everything* good happens after midnight!'

Roan's parents weren't the only ones pre-emptively scolding her. 'People would always beg me to not become Miley Cyrus [after moving to LA],' she told *Bringin' it Backwards*. 'And in my head, I was like, "I love Miley Cyrus."' The cautionary tale they meant was Miley's villain-arc Bangerz phase and her infamous 2013 performance at the MTV VMAs, where she twerked on stage with Robin Thicke. There were many legitimate critiques of that era – particularly around Cyrus's co-optation of hip-hop culture and Black music. But such social justice concerns often get hijacked by conservative morality

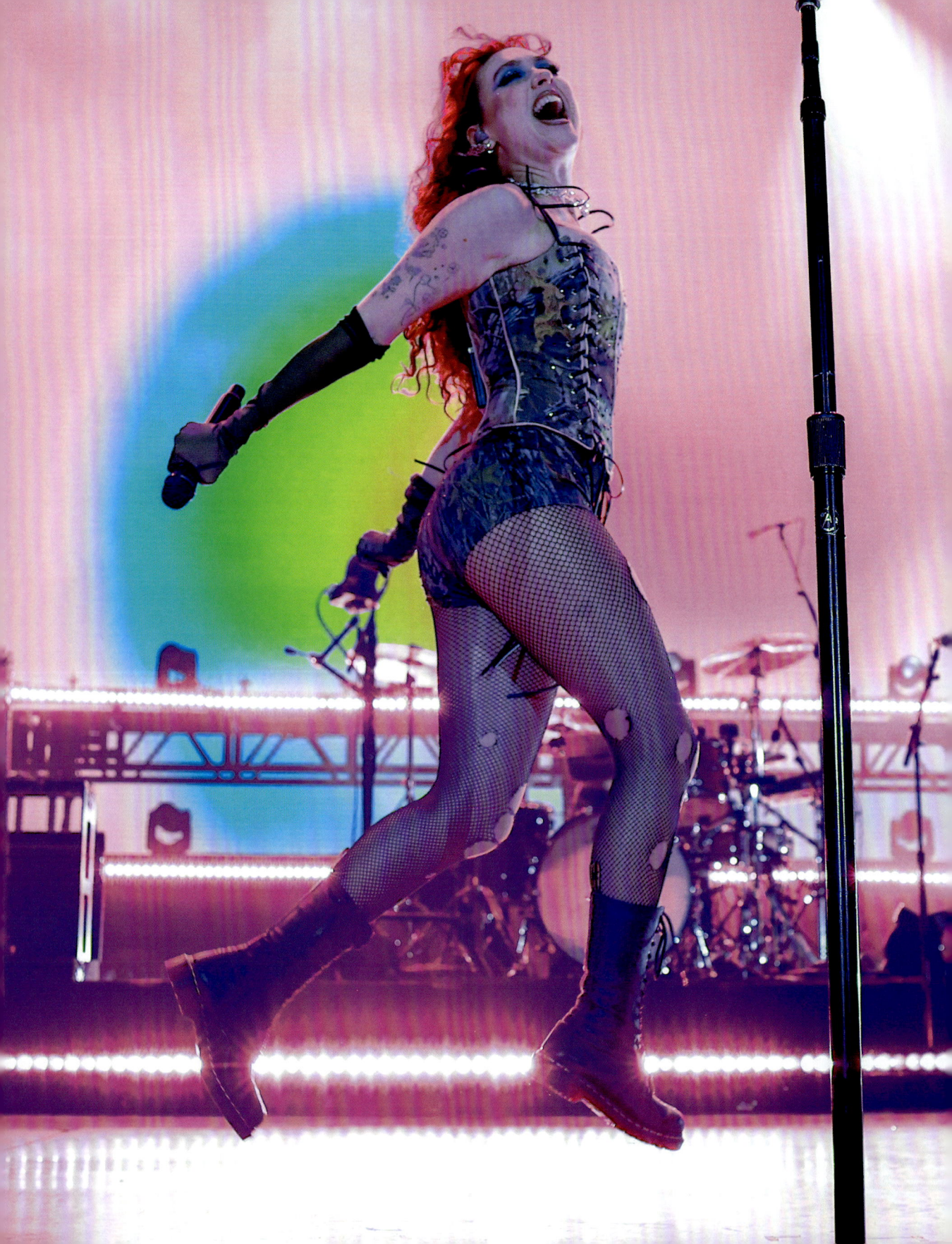

police using the legitimate critiques as a cover to smuggle in their own judgment or bigotry. And some of the Miley backlash, especially the stuff Roan heard in the Midwest, undeniably had that undertone: saying-but-not-saying that she was too slutty, or acting out too much. Like 'Pink Pony Club', 'After Midnight' is, as Roan told *Bringin' it Backwards*, her 'f*ck you' to everyone who would deny her God-given right to act out. (And Roan was eager as always to unapologetically say what everyone else wouldn't, 'The VMAs with the foam finger [...] it *rocked*.')

However, 'After Midnight' is not soley about rebellion. Although there are much gaudier, campier songs on *Midwest Princess*, 'After Midnight' is, as she told *Making the Album*, simply a moment of 'bubbly pop'. Specifically, it's a glossy disco revival, evoking both classic 70s hits and their modern recreations. The smooth discotheque funkiness is unlike anything else on Roan's record – kind of like her take on the recently rediscovered dance-pop icon Sophie Ellis-Bextor, or the slinky, pleasure-loving singles of Jessie Ware.

As on 'Pink Pony Club', Chappell's heroine in 'After Midnight' is a newly anointed libertine. Her heroine is willing to throw down in the bar and is unashamedly sexually fluid – she teases that she wants to kiss your girlfriend, and your boyfriend, too. But she's still making her first tiptoeing steps into her good-girl-gone-bad era. Her mother's words, 'It's not attractive / Wearing that dress and that red lipstick' – follow her through the club doors. While there, Roan tellingly says that she only feels 'kinda' freaky, and she entertains the possibility that maybe it's just the club lights that are making her act up.

Eventually, though, she embraces every possibility that might come out of a late night – the sordid hookups, the wild dancing and the afterglow of the next morning. Roan savours every moment equally. She lingers on her most disco-romantic words, such as 'moonlight' and 'sunrise', and sighs out every line she can. Even when she's all but interpolating Usher's 'Love in This Club' on the bridge, seizing the chance to 'Be a freak in the club', the vibe isn't one of debauchery so much as glamour. She makes starting a bar fight and stealing your girl sound like the most aspirational cocktail-attire soiree in the world.

Track by Track

Song Four
COFFEE

RELEASE DATE	Album only									
WRITTEN BY	Kayleigh Rose Amstutz, Eric Leva, Maya K, Daniel Nigro									
US BILLBOARD CHART POSITION	N/A									
UK CHART POSITION	N/A									
PRODUCTION CREDITS	Produced by Daniel Nigro	Engineered by Daniel Nigro and Chris Kasych	Lead and BGVs by Kayleigh Amstutz	Flute by Ryan Linvill	Electric Guitar by Dan Stewart	Acoustic Guitar by Ariana Powell	Piano, Bass, Acoustic Guitar and BGVs by Daniel Nigro	Mixed by Mitch McCarthy	Mastered by Randy Merrill	Recorded at Amusement Studios

SUNRISE

'Coffee', written with Berklee College alumna Maya Kurchner, is perhaps *Midwest Princess*'s most traditionally composed song. It's a ballad with sturdy bones, the kind that could slip into Joni Mitchell folk or lonesome country twang without rewriting. Everything is organized. The piano keeps steady time; lyrics such as 'Every place leads back to your place' are arranged like self-contained aphorisms; the wistful pangs of blue notes in the chorus fall exactly where they should. Nothing on *Midwest Princess* is accidental, though, and the studiedly mature composure of 'Coffee' plays right into the song's theme: a presentation of the things Roan knows she *should* do.

Roan wrote 'Coffee' about one of her many commutes to New York City in her early career. This particular trip was for her 'Naked in Manhattan' shoot – and, as it turned out, the single's title became a self-fulfilling prophecy. Roan's ex was living in New York, and on that trip Roan indulged in one of the all-time classic dating delusions: thinking of some totally foolproof ways to meet up with her ex without later hooking up with her. Maybe if they just got coffee, she told herself, it would be fine? Maybe if it was during the day, no afterparties, no second locations and *obviously* not alone together. As one of Roan's tourmates would say, 'Bad idea, right?'

In the lyrics, Roan maps out the city in emotional landmarks – kind of like a sister ballad to St Vincent's 'New York'. Nowhere is safe from memories and yearning. 'The Italian place' where she'd normally go for dinner bears the indelible imprint of meeting then

MAYBE IF THEY JUST GOT *Coffee* IT WOULD BE FINE?

fighting her ex's family. In 'the jazz bar on MaryAnn Street', the memories of old drunken trysts fog and perfume the air with their too enticing silage. (The street is not real; Roan holds her personal life at a distance and 'Coffee' is not about distracting her listeners with hints and lore.)

Wherever she goes, the city immerses her in reality: you can't have a low-stakes, subtext-free reunion with someone you're still longing for. There is no place and no way to do it, no set of rules that love and lust can't override.

Speaking to *Rolling Stone*, Chappell framed the song explicitly as a fable with advice, 'I recommend everyone to just get coffee. Listen to the song or don't – but only get coffee, don't do anything else.' And in the version of her trip in the song, she takes her own advice and de-escalates. In an exercise right out of the songwriter's handbook – and one Chappell had known since 'Die Young' – the final verse flips the hook into the wistful but wiser 'let's not do coffee, let's not even try'. In reality, many people relate more to the pre-chorus, 'I'd rather feel something than nothing at all.' You already know where Roan's real-life story went. Roan knew it when she was planning the trip.

TRACK BY TRACK

Song Five

CASUAL

RELEASE DATE	28 October 2022							
WRITTEN BY	Kayleigh Rose Amstutz, Daniel Nigro, Morgan St. Jean							
US BILLBOARD CHART POSITION	59							
UK CHART POSITION	44							
PRODUCTION CREDITS	Produced by Daniel Nigro and Ryan Linvill	Engineered by Daniel Nigro and Ryan Linvill	Mixed by Michael Coleman	Drums by Sterling Laws	Lead and BGVs by Kayleigh Amstutz	Bass, Guitar, Acoustic Guitar, Synths by Ryan Linvill	Guitar, Synths, Piano, BGVs by Daniel Nigro	Mastered by Randy Merrill at Sterling Sound

The ballad 'Casual' presents Chappell at her most chill – or, more precisely, Chappell forcing herself for several minutes to act chill and then giving up in righteous indignation. The title is wistful and ironic, taken from her personal experiences. As she said on TikTok, 'I really envy the girls who can be chill about casual relationships [...] [I don't know] why I let every single situationship consume me, but here we are.'

The arrangement is comfort-food mope-pop: 'broody and pouty and moody', Roan told Emerson College radio station WECB. The subtle percussion mirrors rocking a child to sleep. The melody lilts; the crinkles in her voice evoke her idol Stevie Nicks. When previews of the track took off on TikTok in 2022, fans compared the sound favourably to Taylor Swift; some even speculated that the song was a Taylor leak. But this arrangement is, deliberately, presented as an awkward fit. Unlike the hyper-poised 'Coffee', the ballad structure meanders. Roan's vocals land on syllables they normally wouldn't.

The central image of the chorus is decidedly unsafe, the sort of thing that would scandalize the Adult Hits radio stations whose playlists sound like 'Casual', 'Knee deep in the passenger seat and you're eating me out...' (Roan clarifies that this Twister-esque sexual contortion didn't actually happen: most of the details in the song are embellished, composite vignettes from multiple relationships. But she'll admit, 'It's a nice line!')

This meandering structure mirrors the aimlessness of the relationship Roan describes – one that her partner refuses to define even while they continue to demand emotional labour. 'Casual' doesn't particularly sound like it crescendos to anything – much like the relationship Roan describes doesn't seem as though it's going anywhere. The object of the song boasts how they'll give her 'no attachment', despite being happy to *receive* attachment from her. What does crescendo is Roan's vocal delivery, which grows increasingly raw and forceful as the song progresses; a dynamic shift from restraint to release that mirrors the narrative arc of the song. The outro is an eruption of frustration. Roan's voice kicks down the genre's drab walls and bursts out of the lyrics' rhythmic scansion. The arrangement intensifies slightly, but her raw delivery is what truly powers the emotional catharsis. She is finally saying what she really feels, 'I hate that I let this drag on so long, you can go to hell!'

The music video, directed by Hadley Hillel, one of Roan's old Interlochen friends, turns that journey into a dark-fantasy cautionary tale. As Hillel told the University of Texas newspaper *The Daily Texan*, they wanted to explore the metaphor. 'How can we bring in an unexpected element here to really embody the sort of danger and intrigue of a casual relationship and how it can feel so good but be so empty and dark underneath all that?'

The video is heavy with symbolism. In the intro, Chappell buys a pink ice pop from a stand at the beach – a symbol of innocence just like the orange creamsicle in 'Bitter'. She's soon distracted by a news broadcast from a miniature TV, about how a boy found a severed ear in the ocean that might have belonged to one of four men who had gone missing there. As Chappell eats her treat, another omen emerges from the sea: a frantic, bloodied, shouting man who runs out of the surf, shakes her shoulders and warns her in a shaky voice, 'Stay away from the water!' Then emerges the reason why: a seductive mermaid-siren with demonic red eyes, a barely there outfit and red paint and ruby jewellery that drip down her chest like entrails. Roan stares, transfixed, as the mermaid approaches her and devours the ice pop. The scene – with Roan's auburn curls framing her

transfixed expression – is like a queer incarnation of *The Little Mermaid*'s Ariel, with the storyline of Christine Daaé from *The Phantom of the Opera* just before she walks hypnotized into the Phantom's subterranean lair. The metaphor is clear: no matter how many scare-quotes-included 'casual' relationships one has endured, they still have a way of pulling you in.

As the video progresses, Chappell takes the mermaid back to her smalltown home; and on the TV, the two watch a stage recreation of the underwater love affair that now occupies Roan's dreams. The mermaid then pulls her beneath the surface of a swimming pool to further tease the idea with a passionate kiss. The two share intimate bedside chats, tandem bike rides and other presumably tender moments – but tender for only one half of the couple. When Roan rests her head on the mermaid's shoulder, the mermaid turns away to flirt with a couple of beach bros. When Roan caresses the mermaid's skin, she is smiling with empathy while the mermaid's face is blank and unemotional. When she surprises the mermaid with a handmade 'WELCOME HOME!' seashell banner inside her home, the mermaid just stares in wordless disgust. And when the mermaid abandons Chappell for a man – another future victim – she's crushed. The video's penultimate scene delivers the one possible payoff. Chappell, alone in the mermaid's grotto, rips the whole place apart from coral to floor – and in the process reveals the stage set as a destructible sham. Her catharsis bubbles all the way up to the surface.

Roan's first live performances of 'Casual' were similarly emotional. The heartbreak was still raw and she'd cry while performing the song. Nowadays, when she performs 'Casual' live, Roan's more aligned with the epiphany on the outro and with the vengeful girl from the beach. She'll rip into a rock arrangement of the track, amping the audience up, 'How upset can we get together right now?' That's 'upset' as in 'angry', as in 'never again'. She won't be gaslit into believing that the intimate moments she was there for never happened. And if someone tries anyway, there will be nothing casual about how hard they're dropped.

SUPER GRAPHIC ULTRA MODERN GIRL

RELEASE DATE	22 September 2023							
WRITTEN BY	Kayleigh Rose Amstutz, Jonah Shy, Annika Bennett, Daniel Nigro, Mike Wise							
US BILLBOARD CHART POSITION	16							
UK CHART POSITION	N/A							
PRODUCTION CREDITS	Produced by Daniel Nigro and Mike Wise	Additional by Jonah Shy	Engineered by Daniel Nigro, Mike Wise and Jonah Shy	Lead and BGVs by Kayleigh Amstutz	Drum Programming, Synths, Guitar, BGVs by Daniel Nigro	Mixed by Serban	Mastered by Randy Merrill	Recorded at Amusement Studios

'Super Graphic Ultra Modern Girl' is a pop lover's pop song. It has one of Roan's biggest hooks, blasted into the world like a wide-angle laser beam. The lyrics are bedazzled; the words wear prefixes like glittery makeup. Boys aren't just boring but also *hyper mega* bummers, girls aren't just cute but *hyper*-sexy, *super* graphic, *ultra* modern.

The phrase, 'super graphic ultra modern', was coined in 2021 by the Consumer Aesthetics Research Institute (CARI), an online design community, to describe a bold, hyper-stylized aesthetic beloved of 70s' designers. Roan heard the term on an interior design video on YouTube, 'I was like – *ding*!' she told *Making the Album*. It's a phrase with a specific meaning: a combination of 'supergraphics' – a design term for huge geometric graphics splashed across entire walls – and an 'ultramodern' feel. The CARI website lists out the mood board: 'plastics, curves, plush materials, rainbows, inflatables, shiny metals, fibreglass, prefab everything, supergraphics galore, pleasure furniture, Helvetica, icons.' In other words, the spiritual opposite of some random dude in fugly jeans.

'Super Graphic Ultra Modern Girl' was one of the later tracks Roan wrote, and like 'Femininomenon', it was produced with Mike Wise. Speaking with *Pride Source*, Roan recalled that she and the team had been struggling with an early mega-bummer version of the song that 'lacked a lot of depth', so had started looking for musical touchpoints. She'd loved Charli XCX's *Crash*, in particular the ultra-polished 'Yuck', and asked herself, 'Who does Charli's sh*t?'

One of Roan's goals for *Midwest Princess* was to pay homage to the camp-pop icons before her, to 'honour pop music', as she told the *Making the Album* podcast. And on 'Super Graphic Ultra Modern Girl' she puts herself in direct, deliberate conversation with her musical forebears. The hook evokes the juiciest bits of the melody of 'Footloose'. The spoken-word intro was inspired by Lady Gaga's 'Alejandro', a self-aware bodice-ripper of a song that scandalized Roan as a middle-schooler and also blew her away. Towards the bridge, there's a drum breakdown right out of Madonna's 'Vogue'. In the video, she dresses as an extraterrestrial and invades Los Angeles in a leotard, aquamarine goggles and shiny silver boots – a very Cyndi Lauper move, from one of her multiple films and TV spots in the 80s and 90s, where she communicates with aliens while wearing neon fits.

There's also more than a little Greta Gerwig Barbiecore, in its shamelessly celebratory pop and its loud proclamations about how girls are everything while boys are basically just Ken. That's not an accident; Roan reportedly wanted the single to be on the 2023 movie's soundtrack. (In another world, it might have been: the Barbie soundtrack was compiled by Atlantic.)

But where 'Super Graphic Ultra Modern Girl' really stands out is in its relationship to fame. Most of *Midwest Princess* focuses on the 'Midwest' half, with love, lust and heartbreak songs that could remind listeners of their own girls next door. 'Super Graphic Ultra Modern Girl' represents the 'Princess' half. The song is like a musical makeover, turning its listeners into celebs. On the second verse, she and her girls storm the runway, strutting 'from Tokyo to New York' and flashing the camera. The lyrics speak the language of the tabloids – 'At every party we're the party [...] We're hot! We're drunk!' – and then flips those rags off, well aware that two decades ago they would imply (or just say outright) that their girl-girl makeouts and ass-shaking were signs of an out-of-control crisis, instead of self-actualization.

Ultimately, Roan and her girls don't just transcend the suburbs; they transcend earthly bounds, leaving the bummers to crumble with the world as they taunt, 'We're leaving the planet, and *you can't come*!' But Roan's listeners know better. The song promises her fans that if they can hang with the super-graphic ultra-modern girls – or even if they just think they might want to – then they can already claim their invitation to the mothership.

TRACK by TRACK

Song Seven

HOT TO GO!

RELEASE DATE	11 August 2023								
WRITTEN BY	Kayleigh Rose Amstutz, Daniel Nigro								
US BILLBOARD CHART POSITION	15								
UK CHART POSITION	4								
PRODUCTION CREDITS	Produced by Daniel Nigro	Engineered by Daniel Nigro	Assistant Engineer, Austen Healey	Drums by Sterling Lawes	Guitars by Sam Stewart	Lead and BGVs by Kayleigh Amstutz	Bass, Guitars, Drum Programming, Moog, Percussion, Synths, BGVS by Daniel Nigro	Mixed by Mitch McCarthy	Recorded at Amusement Studios

'HOT TO GO!' is the zillennial lesbian 'YMCA'. It's a cheer anthem, complete with a '5-6-7-8!' lead-in, for the people that traditional homecoming days weren't made for. 'This is to honour that part of my f*cking self that was too scared to be a cheerleader!' Roan crowed while announcing the track on stage at the 2023 Austin City Limits Music Festival in Texas. It's flirting practice: the idea behind the song, she told *Vulture* magazine, was how she wanted love interests to tell her that she was hot, not merely pretty, and how she summoned her Chappell persona to help her feel comfortable with the idea. It's a song that earns every one of its capital letters.

The song, like most of Roan's early *Midwest Princess* releases, became an instant hit following her TikTok teasers. The title 'HOT TO GO!', which Roan turns into 'H-O-T-T-O-G-O', demands choreography, making the letters 'YMCA'-style with your arms and following along with the interlude: 'Snap and clap and touch your toes / Raise your hands, now body roll...'

Chappell's aim when writing 'HOT TO GO!' was simple: a single that would 'mean something, but also feel like bubbles,' she told *Making the Album*. Her vocals could be called bubbly: they throb and fizz with the exaggerated vibrato of Madonna in *Like a Virgin* and *True Blue*. Chappell also reveals another songwriting aim in the song itself, as she nonchalantly reveals a music-making motivation that other artists wouldn't dare admit to, 'And baby, don't you like this beat? / I made it so you'd sleep with me!' (The first

verse substitutes that with 'dance with me', fooling no one.) That line serves, in the album's sequencing, as a sequel to 'Red Wine Supernova' and to the ultra-confident, ultra-horny propositions Chappell gets from her crush. Now, on 'HOT TO GO!', she's found her own kind of sexual confidence, one that is authentically hers.

She's proudly dorky, sometimes practically pouty, 'I try not to care, but it hurts my feelings [...] No one's touched me there in a damn hot minute!' The food-as-sex conceit – being 'hot to go' like a raring horse, but also like a takeaway pizza – is something she's done all the way since 'Sugar High'. This time, though, Roan incorporates it into the whole aesthetic.

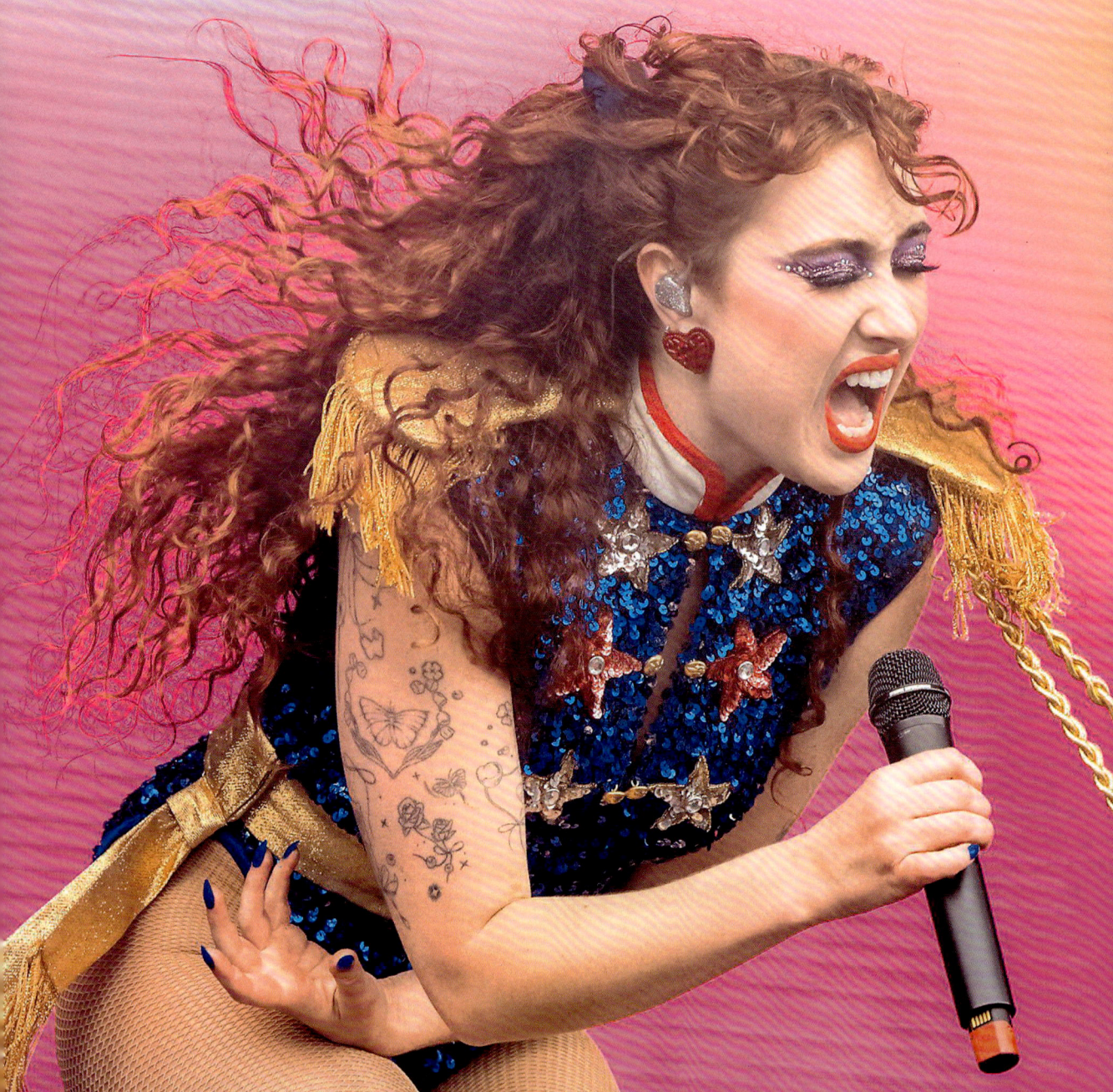

The title card of her behind-the-scenes video for the record is a pizza box, one assuming image that does a lot. It's unpretentious, like her Missouri hometown – which she'll show off in the actual music video; it's a reference to 'Femininomenon' and its Papa John's jonesing; and it's a sly wink at the meal's reputation as the ideal post-coital snack, so well-known even the stodgy magazine *Reader's Digest* wrote about pizza in bed.

Roan's 'HOT TO GO!' isn't about Roan alone. It's about the huge communal chanted chorus, the backing vocals massed as if a whole block party is in on it. The singalong is mandatory, as is the choreo. Roan once scolded the VIP section at the indie-leaning Bay Area festival Outside Lands for acting like disengaged hipsters, 'It's so weird that VIP thinks they're so way too cool to do this! Be fun and try!' That reminder, though, is rarely necessary anywhere else that 'HOT TO GO!' is played. Over a year later, it's still a guaranteed firework that ignites the energy of any room with anyone who's aligned: gay clubs, house parties, certain weddings and even ultra-masculine sports arenas. As Roan joked to *Rolling Stone*, 'I need the World Cup to get on board with "HOT TO GO!" and then I'm f*cking set forever.'

The 'HOT TO GO!' video is a Chappell Roan lookbook all by itself. She's a drum-corps majorette in a US flag palette, red and white stars splayed across her blue bodice. She's a cheerleader. . She's dressed for homecoming or prom, wearing the kind of dresses she might have bought at Forever 21 in high school – Roan has joked in interviews about her nostalgic attachment to the brand and how she wishes she could still shop undercover there. Specifically, in the video, she wears an apple-green minidress with a ballet-style skirt and ruched sides, and an asymmetrical pink dress with a wide, contrasting cummerbund panel and the most time-bound fashion trend of the mid-2010s, the high-low hem.

The video, shot in Springfield, is also a celebration of Chappell's Missouri childhood. She visits the landmarks. There's a metal sculpture outside a food-service marketing agency that's billed as the 'World's Second-Largest Fork'. (It used to be the biggest, until Oregon dethroned it with its own fork sculpture in 2022.) There's 'Wild Horses', a mural by Springfield artist Susan Sommer Luarca, which was commissioned in 2008 to enliven a drab, ugly masonry wall visible from one of the city's main drags. There's a shot of Andy's, a frozen-custard chain and a favourite of Roan's, with a sign proclaiming that 'BLACKBERRIES ARE BACK!'

The B-roll brings out even more country imagery. Horses hang out by a John Deere crane. There's an appearance by Miss Over Bored, the candy-coloured monster truck driven by Indiana mom and big-rigs enthusiast Deidra Ballard. And Roan struts multiple times in front of a Sinclair Oil station, its walls full of fuel ads and makeshift signs reading 'HONK IF YOU LOVE GAS' and – the politics of the region unavoidably making their way into the shot – 'GAS WAR'.

This gas station has been specifically chosen. If the camera shot extended just a little further to the left, you'd see its sign bearing the name it was given after one of the people who built it in the 1930s: Gay Parita.

TRACK BY TRACK

Song Eight

MY KINK IS KARMA

RELEASE DATE	6 May 2022						
WRITTEN BY	Kayleigh Rose Amstutz, Justin Tranter, Daniel Nigro						
US BILLBOARD CHART POSITION	81						
UK CHART POSITION	N/A						
PRODUCTION CREDITS	Produced by Daniel Nigro	Engineered by Daniel Nigro	Mixed by Pedro Calloni	Bass and Drum Programming by Ryan Linvill	Guitar, Acoustic Guitar, Drum Programming, Synths, BGVs, Piano by Daniel Nigro	Lead and BGVs by Kayleigh Amstutz	Mastered by Randy Merrill at Sterling Sound

'My Kink Is Karma' is an instantly classic title and an outrageous escalation. Promoting the single on TikTok, Chappell called it the 'baby sister' of 'Naked in Manhattan' – maybe if its baby sister was *really* going through it. Flashback to 2018 and 'Bitter', the lead single from the proposed *School Nights* follow-up, where Roan gives herself permission to be a kinda angry ex, 'I love being bitter / It makes me feel better.' By 2020, here is her more specific stance, 'People say I'm jealous but my kink is watching / You ruin your life [...] Using your distress as foreplay [...] It's hot when you're going through hell / And you're hating yourself!'

The conceit is wild; at first it was too wild even for Chappell. 'I literally walked out of the [studio] session,' she told *Making the Album*. 'I was like, "This is the dumbest thing ever."' But the song itself, co-written with Justin Tranter of Semi Precious Weapons, is an edgier take on the kind of colossal synthpop track that Taylor Swift codified on 1989. The verses set Roan's pop melody and understatedly sugary harmonizing against prickly percussion loops and an insistent bassline, prominent at the front of the mix. As several of Roan's TikTok commenters noticed, the beat and bassline are very similar to, of all things, Nine Inch Nails' industrial seether 'Closer'. The connection is surprisingly apt: 'Using your distress as foreplay' could well be a Trent Reznor line.

Roan is unsparing in her dismissal of an ex-boyfriend who made their breakup

unexpectedly nuclear: kicking her out in the middle of the working week, wrecking her income and – worst of all! – stealing her 'cute aesthetic'. (Even though the ex in 'My Kink Is Karma' is a man, lots of Chappell's fans who've dated and broken up with women have found this relatable in a hyper-specific way. How can you win the breakup if you've lost the look?) Roan recaps every sordid turn in her ex's spiral – from getting kicked out of his own apartment to pathetically hitting on 18-year-old girls – as a new, hot, prurient thrill. When she says her 'kink is karma', she means every implication. When she gets to the pre-chorus, a series of escalating, 'Oh God's', it's not just a musical climax that the song sounds like.

When Roan performs 'My Kink Is Karma' live, she loves to remind the audience who it's about. That can vary. In her Austin City Limits set, she rewrote the words, aiming the karma not at her ex but at a former theatre teacher who Roan said kicked her out of drama club. (It's unclear when or why.) The tabloids were quick to add this to the judgy narrative they'd already started to counter-programme against Roan's success, misinterpreting some stage banter to claim Roan literally called her teacher a b*tch, rather than crowing the word out as triumphant punctuation. Compared to Roan's searing performance, theirs was the grudge that seemed petty.

But during most shows, the recipient of Roan's is the same man/ex getting humiliated and re-humiliated nightly in pop-banger form. 'This is a message to your fiancée – you should break up!' she crowed at Lollapalooza in Chicago. Whether or not that fiancée was listening, the message was clear: the best revenge is becoming unforgettable.

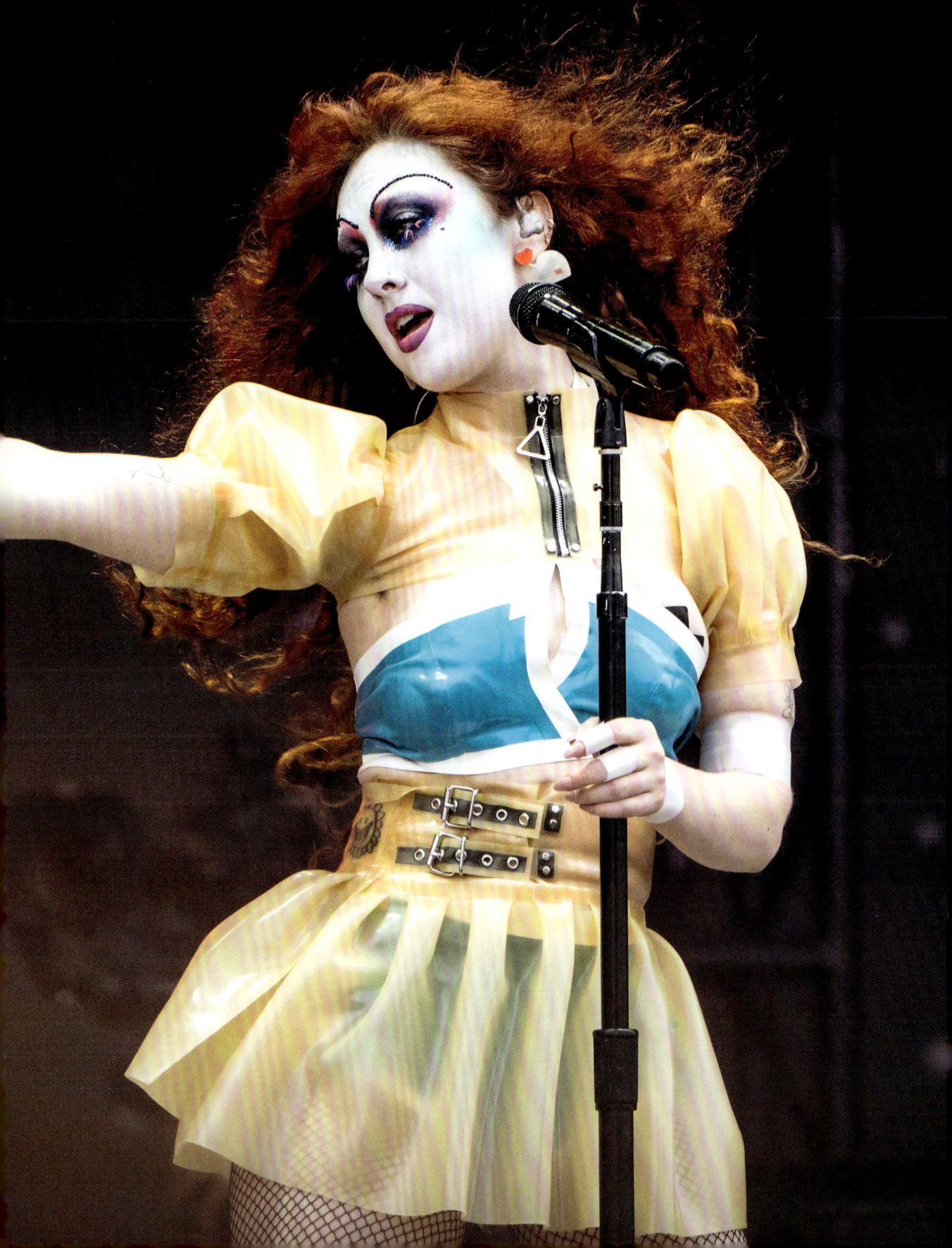

The video to 'My Kink Is Karma' is, like much of Roan's filmography, a work of love by her longtime ride-or-dies. Directed by Hadley Hillel and featuring actor Jimmy Elinski, the clip starts as a down-home, slice-of-life clip about a woman's scummy boyfriend, then goes full-on clowncore, dramatizing both the karma and the kink.

Roan leans hard into her proximity to country Americana, as well her youthful fascination with the interplay of religion and sex. The rural coding in the intro is huge: a picture of Jesus, a white-bread sandwich, a hanging American flag and a mounted deer head, all arranged in a snug bedroom with wood-panelled walls. (In a more suburban part of the country, her bedroom would more likely be the nondescript, landlord-grey room of a prefab house.) We're first introduced to Roan's lover through a torso-less shot of his rugged blue jeans; later, he storms out of the house in a cap and a *Streetcar Named Desire*-esque white tank.

But just before the first few shots, we see a discarded lacy thong; and before that, a figure with Luciferian horns in silhouette against red burlesque lights, smoking a cigarette. Later on we get the full reveal. Roan wears exaggerated clown makeup and light-blue eyeshadow, her face made up to resemble a pale heart. She's worn the look before, with purpose, 'People in my hometown call gay people clowns,' Roan announced from the Manchester stage during her *Midwest Princess* Tour. 'That's why I actually wear my white face. Like, b*tch, I'll show you a clown.'

Roan's character is named 'Karma', inspired by the queer-coded *Powerpuff Girls* character Him: a demon as omnipotent as he is pink. Her lover, in turn, is transformed into a sad-sack *Pagliacci* clown. The power dynamics are not the same, and Roan makes that known right down to the makeup. Roan's painted face is flawless; the man's is crudely done, with uneven, smudgy borders and paint flaking off his skin.

Roan's Karma character drags this dude into a kinky game of BDSM clowning, emphasis on the latter. 'We could have gone the very easy route of being super-sexual,' Roan said to LGBTQ+ publication *Into*, perhaps by borrowing the stock dominatrices of Rihanna's 'S&M' or Christina Aguilera's 'Not Myself Tonight'. Instead, Roan sexualizes Clown Alley stage gags. She smashes her lover's face into a cake and licks off the frosting, then shackles him to a giant neon-red heart. In the climax, she aims a red bow directly at his face. The sight of him – basically a crucified jester in his boxers, makeup messier than ever, bemused at the heart-tipped arrow going straight through his head – is absurd.

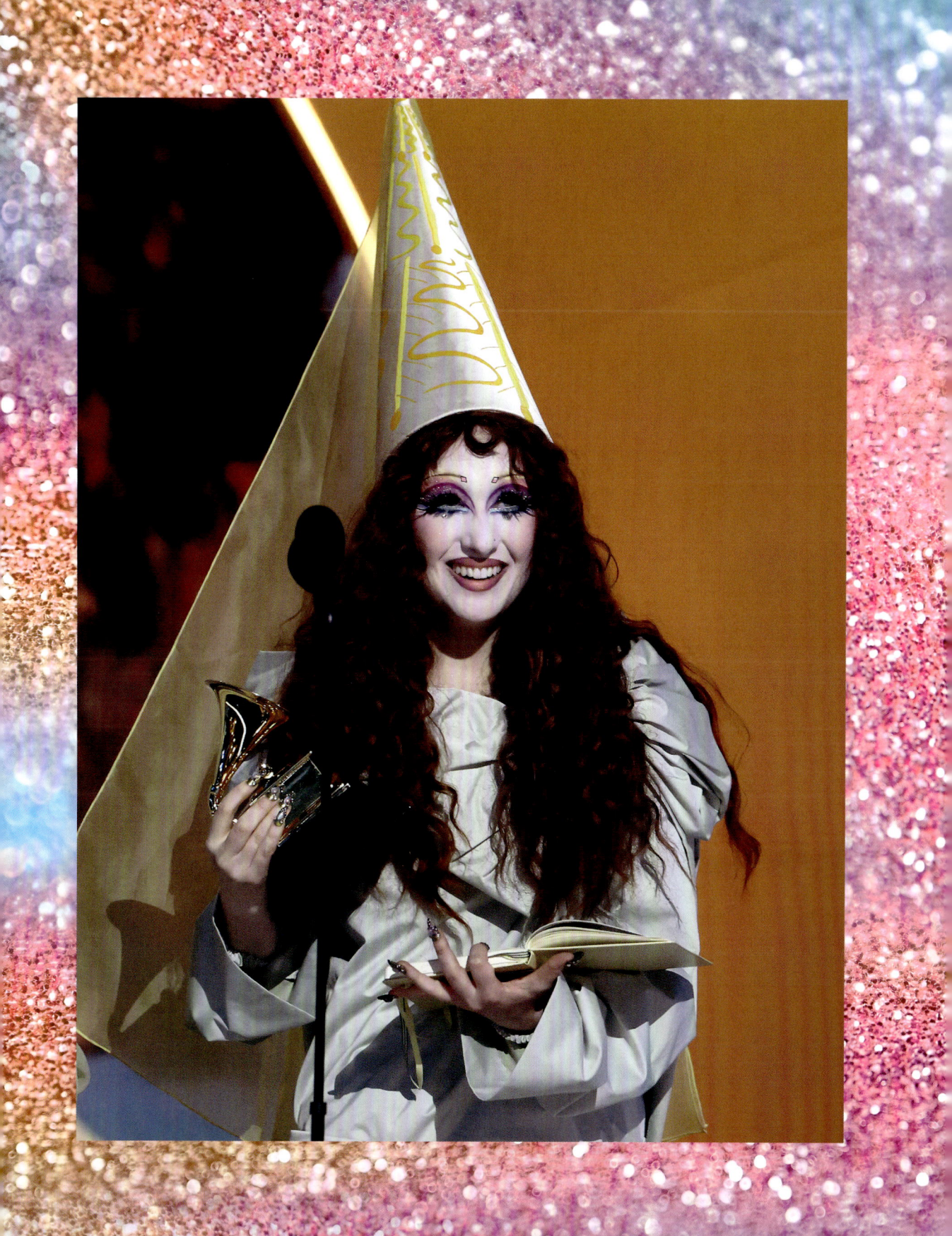

Song Nine
PICTURE YOU

RELEASE DATE	Album only									
WRITTEN BY	Kayleigh Rose Amstutz, Daniel Nigro									
US BILLBOARD CHART POSITION	N/A									
UK CHART POSITION	N/A									
PRODUCTION CREDITS	Produced by Daniel Nigro	Engineered by Daniel Nigro and Ryan Linvill	Assistant Engineer, Austin Healey	Lead and BGVs by Kayleigh Amstutz	Acoustic Guitar, Electric Guitar, Synths, Drum Programming and BGVs by Daniel Nigro	Drum Programming, Bass, Saxophone by Ryan Linvill	Violin and Viola by Paul Cartwright	Mixed by Nathan Phillips	Mastered by Randy	Recorded at Amusement Studios

'Picture You' begins as a stately waltz, a gentle rhythm with an arpeggiated riff. A few seconds in, that waltz unravels: the air going out of the arrangement, the track slowing to a stop. It's the same effect as the outro to 'Good Luck, Babe!' and it represents the same intrusion of reality. Little in love, or on this record, is uncomplicated. Even the most seductive reveries can deflate into nothing.

Roan wrote 'Picture You' about an online relationship where, as she told *Rolling Stone*, 'all we did was sext.' In other interviews, she likened the situation to the situationship from 'Casual', with the lover she finally ditched as she crowed about how they never got her off. But 'Picture You' clarifies that statement: they never got her off *directly*. The song is about when her ex wasn't present as a real-world sh*tbag, but was an absent and thus perfect fantasy: the body imagined inside a lipstick outline in the mirror, the star of the mental scenes she takes off her dress to, the fantasies turned into high-stakes rituals. Is it casual then?

The song sounds smoky, the scraping of the acoustic guitar audible, Roan's vocals trilling and cooing, the string section twisting into suspenseful melodies. There's a sexiness to the arrangement – which Roan intended, as the lyrics include fairly explicit descriptions of masturbation. But the mood is also spooky – Roan was going for what she called Tim Burton vibes with those strings – and vaguely sad. As she told *Rolling Stone*, 'There's a dissonance, like, "Oh, this is sexy, but something's off." [And] that's what an online relationship felt like.'

Roan's scenario is devastating because it captures a very specific aspect of long-distance longing. Even the most routine, unengaged knee-deep-in-the-passenger-seat hookup is still a real-body connection with a real person who's a breath away. But the scene in 'Picture You' is distanced, one-sided and parasocial. No matter how much Roan tries to guess whatever parallel fantasy she may or may not be starring in in her lover's mind, she can never know. The closest Chappell can get is imagining stock scenes about hot librarians – 'Am I doing research in a miniskirt / At the library in your hometown?' – rather than the individual, directed, personal longing taking place inside her head. She knows how the fantasy can be hotter than the reality.

TRACK BY TRACK

Song Ten

KALEIDOSCOPE

RELEASE DATE	Album only
WRITTEN BY	Kayleigh Rose Amstutz
US BILLBOARD CHART POSITION	N/A
UK CHART POSITION	N/A
PRODUCTION CREDITS	Produced by Daniel Nigro \| Mixed by Tom Ehmhirst at Electric Lady Studios

'Kaleidoscope' bridges the old Chappell Roan and the new. The song, a spare piano ballad, sounds like something a precocious Kayleigh Rose might have composed on her early EPs. It's the only song on *Midwest Princess* Roan wrote completely by herself; Dan Nigro is credited only as a producer here, but has co-writing credit everywhere else. And 'Kaleidoscope' is even inspired by the same song that got Chappell writing music: Rihanna's 'Stay'.

However, the central image of a kaleidoscope – a spyglass-like toy that uses mirrors and baubles to produce surreal, vibrant and ever-changing patterns – is far removed from the sombre tones of *School Nights*' music and videography. Chappell Roan is herself like a living kaleidoscope, a human dervish of whirling colour; she's naturally drawn to the metaphor. Moreover, the voice of the song – both Chappell's literal singing voice and her songwriter's perspective – is clearly that of someone older. It's the voice of someone who's not only realized she can't be with the person she wants, but who's also had to learn how to live in the world where this didn't happen.

Chappell Roan made 'Kaleidoscope' because her feelings commanded her to. She'd recently fallen in love with her best friend – a common experience for young queer girls, as they slowly realize what their undying 'platonic' devotion to their besties really is. Sometimes that revelation deepens and heightens the relationship; sometimes, it's just agonizing. As she told *Rolling Stone*, after she and her friend ended up making out once on the dance floor at a club, Chappell's realization happened instantly, 'I'm queer. This is what love feels like.'

But when Chappell confessed those

feelings, her friend told her that she needed a week or so to process the information before the two could talk about it. Chappell wrote the song before having that conversation with her friend, in a three-hour session of reflection. The writing process was a way for her to climb inside the rejection she'd already resigned herself to (and which did arrive), then to try to reshape her heartbreak from the inside into somewhere she could live.

'Kaleidoscope' is one of the few ballad-ballads on *Midwest Princess*; and when Roan played the song for Nigro, they knew they had to treat it with commensurate gravitas. Nigro even rented out the studio with the piano Adele supposedly played on 'Someone Like You'. Roan, perhaps out of nerves, downscaled to a smaller home setup. They were meticulous about everything, including the make of piano (Nigro tested out dozens to find one with the right tone) and the precise distance Roan stood from her mic.

Despite its painful origins, 'Kaleidoscope' is not a sad song – at least not uncomplicatedly so. Chappell wants to find wonder and colour even in the most negative emotions. 'Love is a kaleidoscope,' she sings, a metaphor that captures both loss and beauty. Love is transient, she's saying; no matter how captivating it feels, it could change into something else within seconds. But just as each short-lived image in a kaleidoscope yields to another one that's equally dazzling, painful feelings can yield to happier ones just as fast. 'Even all the change,' Roan sings, 'is somehow all the same.'

Everything about 'Kaleidoscope' – every second Chappell extends a high note, every moment her vocal becomes breathy and trembling – feels deliberate. And Roan's songwriting is just as careful with the details. She sings, ruefully, about how once the two women 'crossed a line', everything even tangentially related to her friend became newly charged – a transformation that recalls something the poet Carol Ann Duffy wrote in 'Name': 'When did your name change from a proper noun to a charm?' Everything has meaning, down to the way she writes 'the cursive letter A' in her friend's name. Unsurprisingly, prying fans have interpreted this line as a clue to a real-life woman (whom Roan, guarding her privacy, has not named). However, it's evocative on its own. Cursive script turns the straight print A into something curved and adorned, a letter you linger upon.

Most of all, 'Kaleidoscope' sounds like closure, and whether Chappell found that closure after she wrote the song, she's reached that place now. 'I'm so grateful that [the experience] happened,' she told Brandi Carlile in their Grammy Museum interview. 'One, for the first time, I got confirmation that I am not a fraud for saying that I'm gay. And two, what an incredible person to fall in love with for the first time.' Or, as she put it to *Making the Album*, 'Even taking space is love.'

CHAPPELL ROAN IS *Herself* LIKE A LIVING KALEIDOSCOPE

TRACK BY TRACK

Song Eleven
PINK PONY CLUB

RELEASE DATE	3 April 2020								
WRITTEN BY	Daniel Nigro, Kayleigh Rose Amstutz								
US BILLBOARD CHART POSITION	5								
UK CHART POSITION	1								
PRODUCTION CREDITS	Produced by Daniel Nigro	Mixed by Mitch McCarthy	Mastered by Randy Merrill at Sterling Sound	Piano by Benjamin Romans	Guitars by Sam Stewart	BGVs by Kate Brady	Programming by Ryan Linvill	Synths, Keyboards, Piano, Bass, Programming, Guitars, BGVs by Daniel Nigro	Lead Vocals by Kayleigh Amstutz

In the liberatory 'Pink Pony Club', a girl flees her smalltown Southern home against her mother's objections to manifest her 'crazy visions' of life at the titular club, a backlit, gender-unshackled, technicolour paradise, 'Where boys and girls can all be queens every single day.' 'I'm gonna keep on dancing at the Pink Pony Club,' Roan sings, her voice emphasizing the last few words: a defiant, full-throated cry of self-actualization.

Roan's Pink Pony Club is a composite, a fantasia of freedom made from her memories. The exterior is a now closed strip club near Springfield. Roan drove by the building from time to time on her way to the Hickory Hills Country Club, enthralled by its Barbie-pink paint job, but never went in. After moving to LA and turning 21, Roan went on a wild night out to what would become the Pink Pony Club's interior: The Abbey, a storied gay bar in West Hollywood. The club was founded by another Midwestern transplant, David Cooley, who moved from Ohio to LA in the 80s. Cooley envisioned his space not just as a leather bar or a hangout for 'pretty gay boys', but one for queer folks of all kinds, 'My philosophy from day one has been that everyone is welcome,' he told *WeHoOnline*. That was certainly Roan's experience. The place was packed, the air was fogged up, the go-go dancers swung from the ceiling and she was entranced. 'It was the most spiritual experience,' she told *Headliner*. 'I just felt like I belonged there.' The night was transcendent enough that Roan briefly considered becoming a go-go dancer herself.

The cover art for the 'Pink Pony Club' single reflects this merging of locations: the LA gay club and the Midwestern strip joint. Chappell wears a wide-brimmed pink hat – much like the one Lady Gaga wears on the

cover to her rootsy 2016 album *Joanne* – and a dress with a modest high neckline. She's also basking in a hot-pink spotlight against a black background, with her name above her in neon, star-studded marquee text; it's as if she's a showgirl taking to a darkened stage. The video is even grittier, set in a dive bar full of grizzled, bearded barflies. But Roan, as she always does, gives that bar a queer makeover. The room is soon commandeered by leather daddies who lift Chappell up to crowd surf before grinding on each other; then, drag icons Porkchop and Meatball enter the bar to hold court.

'Pink Pony Club' is a lot of fun – but it isn't frivolous. The song comes out of a long tradition in popular music and musical theatre: the aspiring star with an unshakable longing for the thrills of the stage, even as she's warned that they're sinful. The archetype is strong; and it resonated with Roan's upbringing in a conservative Christian milieu, dreaming of the life they oppose. On the *Bringin' it Backwards* podcast in 2022, Roan spoke about her drive 'to somehow piss [her] hometown off', continuing, 'I don't know where this comes from inside me [...] this deep drive to make my hometown hate me.'

And Chappell's storytelling, nuanced as ever, has a bittersweet subtext. The lyrics leave it ambiguous as to whether the girl still speaks to her family, and whenever she goes out dancing she imagines her mother's scolding voice, '"God, what have you done? / You're a pink pony girl..."' (Her real-life mother wasn't offended, though. As Roan's mum told *The Independent*, 'I love singing it with her at her shows and I love it when you can just see the people just respond to that song so much [...] even when we're grown up, we really care

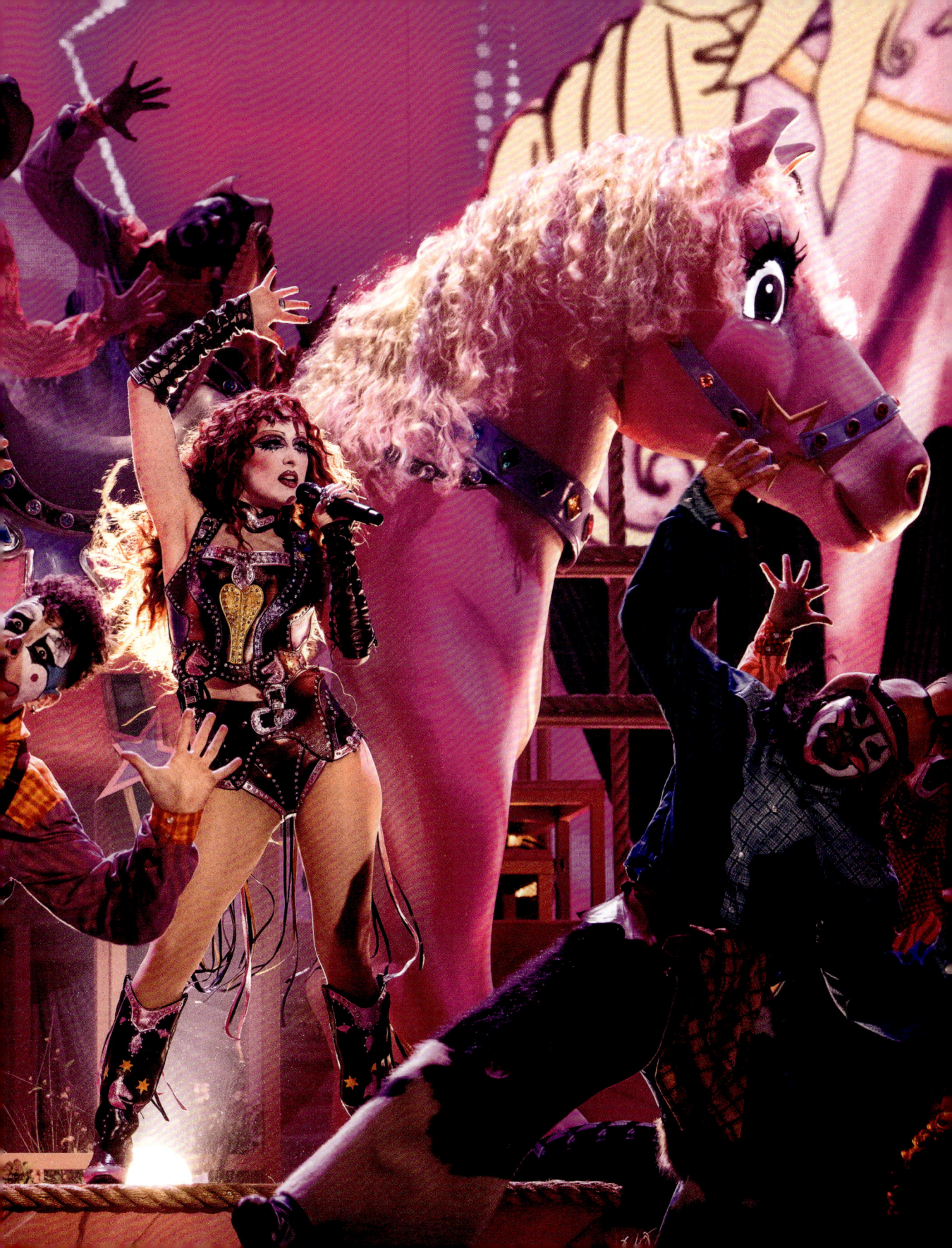

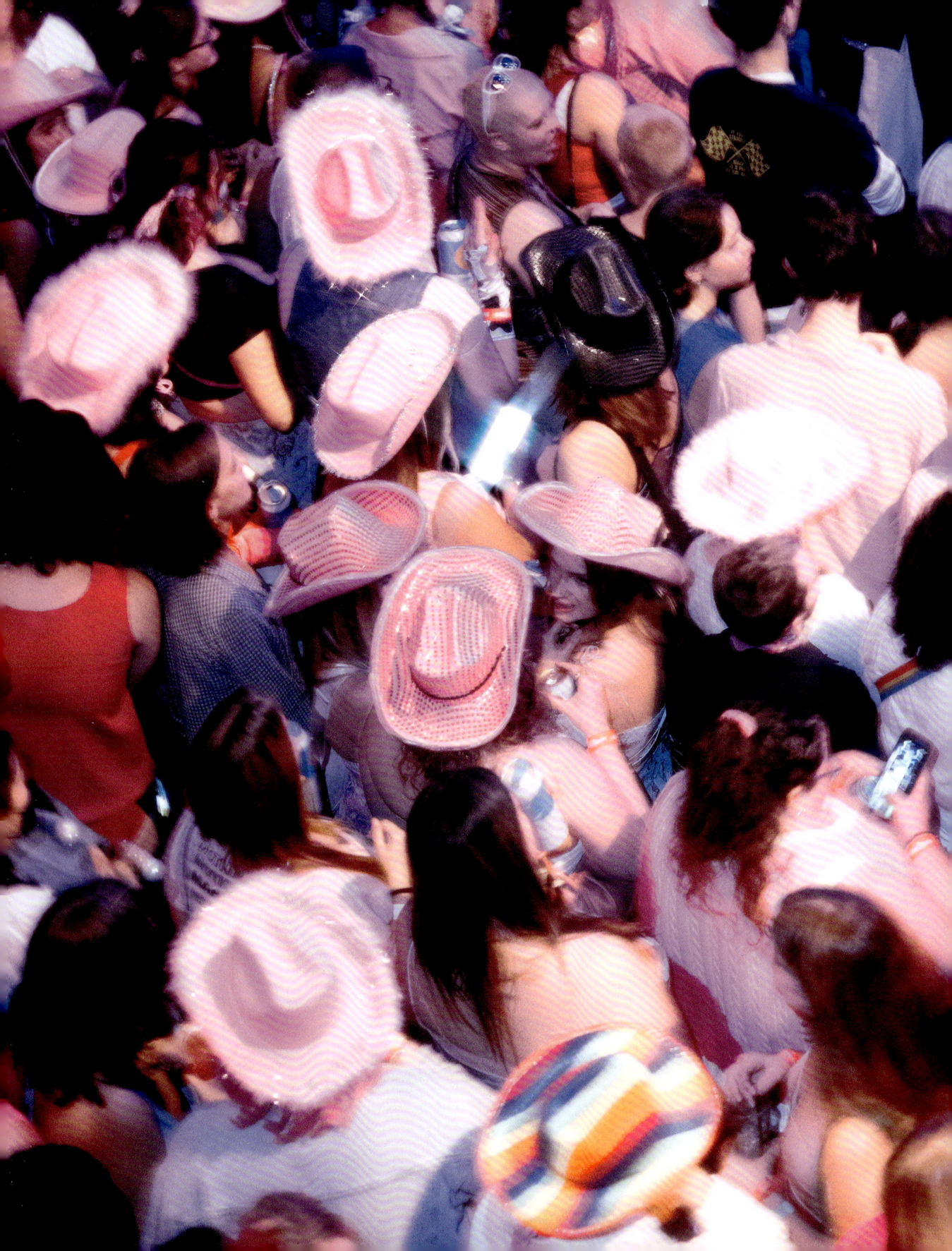

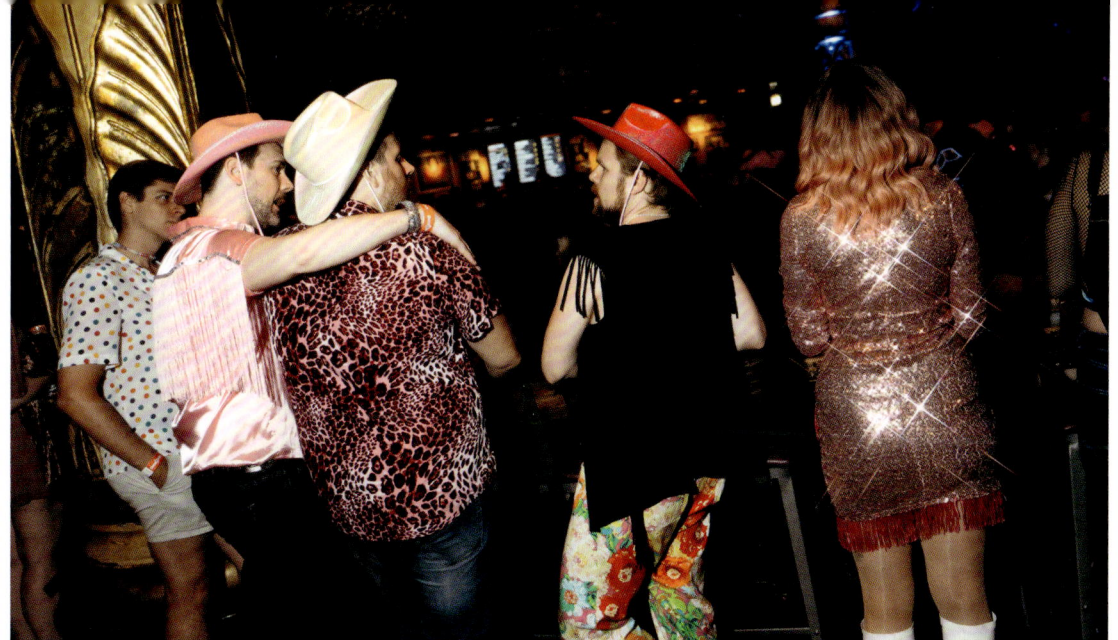

about what our parents think about us.') Yet the girl remains unapologetic. This is a song about triumph.

'Pink Pony Club' wasn't the first song Roan and Nigro wrote during the Atlantic Records sessions, but it was the first song where they knew they had something special. 'I've got this feeling a couple of times in my career of when you write a song that's so bold, your body starts to give you these weird mixed signals because you start to like it so much,' Nigro told NPR. 'And then you actually feel like it's special, but then you're afraid. You feel like, *oh, are people going to understand this?*' The artists in the room certainly did. Fellow *Midwest Princess* songwriter Justin Tranter told *Hits* that after hearing it, he pronounced it 'possibly the best song ever written [...] like an American Songbook standard.'

But Nigro's apprehension did turn out to be warranted. When Atlantic's reps heard 'Pink Pony Club', they seemed put off not only by the concept of the song but by its execution, too. A key element of the single is the crucial, gloriously indulgent guitar solo that comes in after the bridge and closes the song. Nigro's original demo had a synth solo there, but Roan insisted it should be a guitar – albeit one with 80s keytar energy. LA session musician Sam Stewart, the son of Eurythmics' Dave Stewart, brought that vision to life. But Atlantic wanted Roan and Nigro to axe the guitar solo; a suggestion that, armed with the hindsight of watching it become a sleeper hit as well as the gut-level insight of hearing the song even once, reads as almost *objectively* wrong.

'Pink Pony Club' got *some* promo when it was released in 2020 – Spotify added it to its Indie Pop playlist. Roan released an acoustic version, with an accompanying boudoir-themed video. At the time, the song was left adrift, a victim of Atlantic's dismissal. Over four years after its official release, 'Pink Pony Club' found its vindication. The single, riding the momentum of Chappell's other chart hits, peaked at number 13 on the UK Singles Chart and 26 on Billboard's Hot 100. The song is surely now opening minds and silencing haters – but that's not Chappell's main concern. She's just gonna keep on dancing.

Song Twelve

NAKED IN MANHATTAN

RELEASE DATE	18 February 2022						
WRITTEN BY	Kayleigh Rose Amstutz, Daniel Nigro, Skyler Stonestreet						
US BILLBOARD CHART POSITION	16						
UK CHART POSITION	N/A						
PRODUCTION CREDITS	Produced by Daniel Nigro	Engineered by Daniel Nigro	Mixed by Mitch McCarthy	Synths, Bass, Drum Programming, BGVS by Daniel Nigro	Drum Programming by Ryan Linvill	Lead and BGVS by Kayleigh Amstutz	Mastered by Randy Merrill at Sterling Sound

fter Atlantic dropped her, Chappell Roan put out a small TikTok with a big announcement. While applying some flashy green eyeshadow, she dropped a preview of 'Naked in Manhattan': the first single of her post-Atlantic career as an independent artist and a salvo thrown at everyone who doubted her independent hit-making skills. And also thrown, as the video clip's emphasis of the long hiatus implies, at everyone who barred her from releasing music for over a year. (Chappell would later re-release it, in December 2024, as a B-side to the re-release of 'Pink Pony Club'.)

The song is a first for Roan and is also about firsts. 'Naked in Manhattan' dramatizes Roan's first hookup with a woman and the joy she felt when realizing that that possibility wasn't just there all along, but that it would remain there for decade after exhilarating decade. When she first started writing her *Midwest Princess* repertoire, that hadn't yet become more than a possibility. Roan had been dating a man for a couple of years at that point and had never dated a woman. 'I wrote a lot of queer songs while I was dating him, even though I had never kissed a girl,' she told the *Q with Tom Power* podcast. 'A lot of it came from daydreams and fantasizing.' And then, one day, it no longer had to.

'Naked in Manhattan' is a collaboration with prolific pop songwriter Skyler Stonestreet, whose other collaborators include Dua Lipa ('IDGAF') and Reneé Rapp (much of *Snow Angel*). The song is a paean to crushing, bonding hard and somehow managing to get in your happy feelings to Lana Del Rey – specifically 'Ride' and 'Mariners Apartment Complex', Roan said

in a Reddit AMA. After announcing the single on TikTok, Roan described its target audience, 'closeted hyper femmes on the softball team'. And the song is as wild, and as playfully suggestive, as its title. Its arrangement is a sugar bomb of synths, reminiscent of Robyn's *Body Talk*, as well as flirty call-and-response wolf-whistling between Chappell and her backing vocalists. Roan shows off the full versatility of her voice: polished, processed hooks, pure fluted high notes, exuberant spoken parts and even some near yodelling.

Chappell went through four different choruses during the writing process, and the one she eventually chose takes a cue from one of the all-time queer classics. She proclaims her lust with no metaphors, simply begging, 'Touch me, touch me, touch me...' The line is almost definitely a wink at 'Touch-A, Touch-A, Touch Me' from the iconic *Rocky Horror Picture Show*; if Roan didn't watch the actual film, or attend one of the many midnight screenings that made it a beloved cult classic, she might have seen high-school girlfriends Brittany and Santana flirt over the song on an episode of *Glee*.

The cover art to 'Naked in Manhattan' is yet another first: it's the first time we see the former Kayleigh Rose embrace her Chappell Roan alter ego as part of her official musical image. Chappell has a softly painted face and is wearing a risqué outfit as she waits on a subway platform. Although 'Naked in Manhattan' references New York in its title, it's textually a song about being a smalltown transplant. New York is a metaphor; Chappell realized that the wanderlust that visiting the city stirred in the former Midwesterner was similar to new-relationship energy – specifically, a new relationship with a girl.

Chappell calls her new love 'Constant like cicadas in the summertime' – the background-sound of the insects that seasonally visit the Midwest and South but never venture north of Illinois. The word 'constant' is key: Roan is in this for the long haul; and she marvels not only at how the girl she has a crush on is hot, but also at her socially simpatico background. Their path to embrace their sexuality ran through the same suburban culture: peaches and girly hair clips, crushes on *Mean Girls*' Regina George and, of course, Lana. Roan has huge expectations for their hookup, 'Let's make it cinematic / Like that one sex scene that's in *Mulholland Drive*!' That's a very early-20s thing to say, getting past one's romantic anxieties by dressing them up in secondhand cinematic thrill. The dress-up is the point – a slumber-party game, but even more fun.

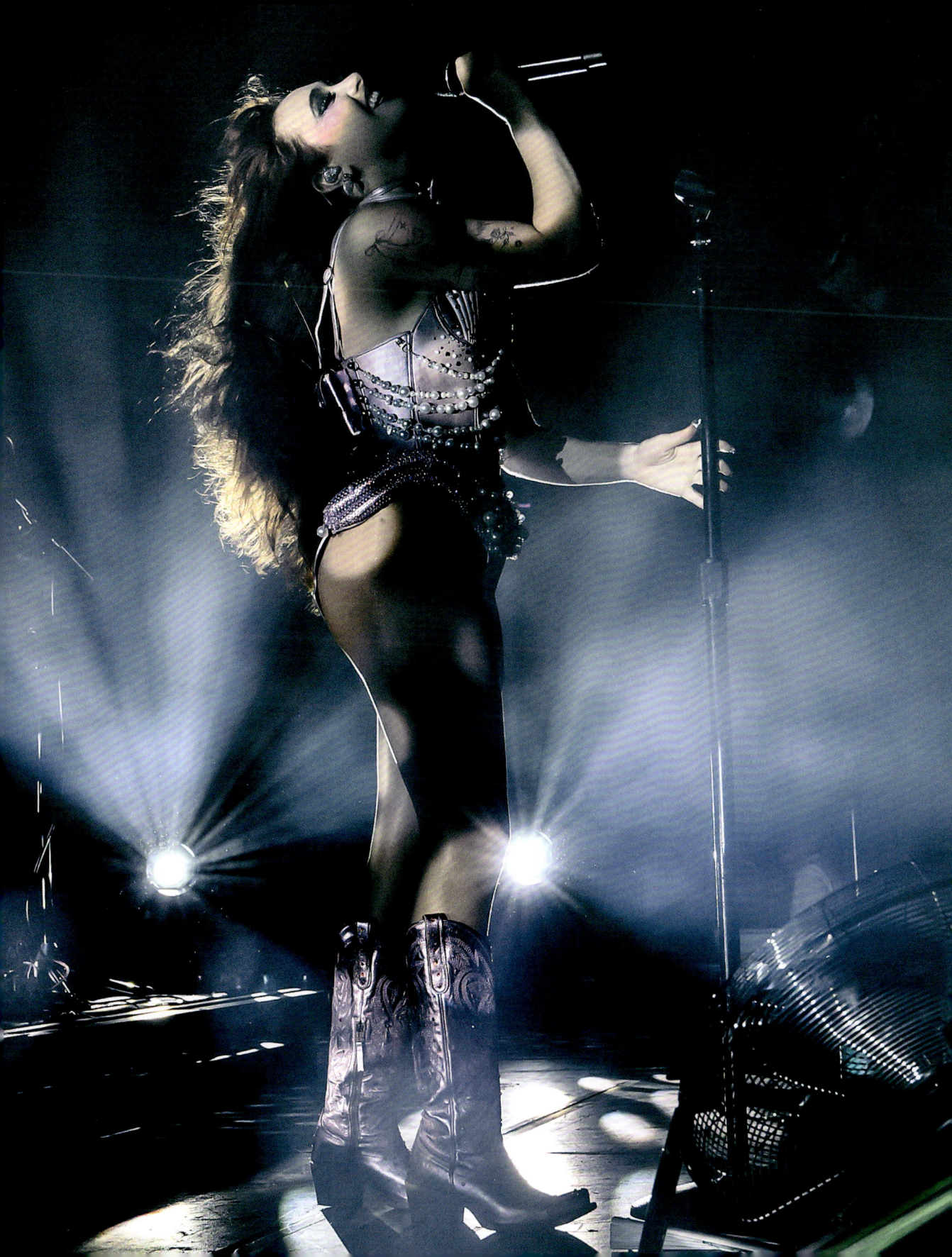

TRACK by TRACK

Song Thirteen
CALIFORNIA

RELEASE DATE	Album only							
WRITTEN BY	Daniel Nigro, Kayleigh Rose Amstutz							
US BILLBOARD CHART POSITION	N/A							
UK CHART POSITION	N/A							
PRODUCTION CREDITS	Produced by Daniel Nigro	Mixed by Mitch McCarthy	Mastered by Randy Merrill at Sterling Sound	Piano, Guitars, Bass, Drum Programming and Synths by Daniel Nigro	Brass Arrangement by Ryan Linvill	Guitars by Erick Serna	Drums by Sterling Lawes	Lead vocals by Kayleigh Amstutz

The Rise and Fall of a Midwest Princess is almost all rise; 'California' alone represents the fall. Roan hadn't yet been dropped by Atlantic when she wrote the song – although one of the A&R people did ghost their meeting to showcase the lyrics. Roan was dwelling on what-ifs and pre-emptive doubts, and 'California' became an accidental prophecy, as the real-life events of 2020 began to mirror the story of the song, right down to moving back to Missouri. These events just drew out further what was already written in the song, about uprooting yourself for a city where you don't know anyone, and being thrown at a young age into a cutthroat industry; then, as Roan told *Making the Album*, 'feeling like [your dreams] didn't come true and you just want to go home 'cause you let yourself down and everyone else down.'

The first verse is like a lost refrain from Woody Guthrie's 'This Land Is Your Land'. Roan romanticizes the 'amber clay roads' of her hometown and the leaves turning brown in the fall – a callback to the nature she waxed nostalgic about during her 2017 interview in Atlantic's generic high-rise building. But that line is also a direct reference to the Mamas and the Papas' 'California Dreamin'', where the brown leaves and grey skies represent the dreams you're trying to escape. In Roan's telling, California is still the land of dreams, while her home is just a 'dying town'; one of many in the modern Midwest, a plight dramatized in unending stories and think pieces. When she asks for someone to 'Come get me out of California', she sounds as though she's regressing, like a kid calling her parents to take her away from a bad day at

THE MAMAS AND THE PAPAS

school. The overall mood of the song isn't a nostalgic homecoming, but more like asking for a mercy kill.

The music video, which Roan made with ad-man Ethan Seneker, brings out that despair even in its low-key lyrics-video form. It's a similar concept to the 2018 film *Her Smell*, where Elisabeth Moss's former rock star crashes out of the industry and ends up at home, alone, with nothing to do but remember. Chappell, too, is alone in her house and all she can do is kill time without enjoyment, sitting out on the deck staring at nothing, doodling in school notebooks then collapsing on top of the page, revisiting old childhood photos and diaries until she gets to the page that reads 'SUCCESS!', swinging around on a swivel chair just to feel something. The video was recorded during the COVID-19 lockdown, and these images evoke the loneliness of quarantine just as much as the loneliness of failure. One scene, though, is unmistakably about fame. Halfway through the video, we see Chappell singing in front of a curtain of copper streamers, shooting the camera a smouldering, Old Hollywood, look. Afterwards, the camera sharply zooms out, revealing that she is not on a big stage, just on a makeshift set constructed in her empty, darkened living room. The California glitz exists only in an unreachable dream.

Like 'Pink Pony Club', 'California' has hints of musical theatre. That stage scene, a glamorous performance that cuts away to dingy reality, hits the same beats as a last-act scene with fallen starlet Roxie Hart in Rob Marshall's *Chicago* adaptation. And the hook of the chorus slips down the scale, following the same melodic path of 'Will I?' from Rent. 'California' is also one of the more country-adjacent tracks on the record. When you're a short drive away from rural Missouri, even if you're not a diehard country-music fan, you're

SUNRISE

probably still going to hear snippets of country music on the radio, or over the loudspeakers at the diner, or blasting out of speakers at a homecoming tailgate. Roan did, and the influence is subtle but apparent. Because with different production trappings, 'California' could absolutely be a country song. It's a deep country-music tradition to juxtapose a thriving but cruel big city that offers compromised fame with a beloved hometown that's fallen on hard times. And as down-home country stardom and Hollywood pop stardom continue to merge into the same thing, more and more of those songs get written. Some of the many recent songs that position Los Angeles against the sticks – whether moving to LA or moving back, loving your small hometown or feeling stuck in it – include Thomas Rhett's 'Country Again', pop-turned-country star Dasha's breakout hit 'Austin' and singer-songwriter Kassi Ashton's eerily similar 'California, Missouri'.

Roan ends 'California' in an unresolved place: 'I almost had it going / But I let you down…' She sounds totally defeated; after a percussion-driven crescendo on the bridge, the outro is almost a cappella, as if the very instrumentation of the song is slinking away in shame. However, the events of 2022 and beyond – Chappell's return to LA, and her rise from her career ashes – add a subtext to 'California' that wasn't there when she wrote it. In 2020, 'California' felt like a prophecy that came true. In 2025 and beyond, it feels like Chappell's ritual of closure: allowing herself to feel all the pain and doubt of her past, then exorcizing it for good.

Song Fourteen

GUILTY PLEASURE

RELEASE DATE	Album only								
WRITTEN BY	Kayleigh Rose Amstutz, Nate Campany, Marcus Anderson, Daniel Nigro								
US BILLBOARD CHART POSITION	N/A								
UK CHART POSITION	N/A								
PRODUCTION CREDITS	Produced by Daniel Nigro	Engineered by Daniel Nigro	Assistant Engineer, Austin Healey	Lead and BGVs by Kayleigh Amstutz	Violin and Viola by Paul Cartwright	Acoustic Guitar, Bass, Drum Programming, Percussion, Drums, BGVs, Moog, Juno 60, and Synths by Daniel Nigro	Mixed by Geoff Swan	Mastered by Randy Merrill	Recorded at Amusement Studios

oan has called this one of her favourite songs off *Midwest Princess*, because of its sheer weirdness. Like 'Femininomenon', the sound mirrors the subject matter as a ballad that yearns to be more, to unleash its freak. And then does.

'Guilty Pleasure' is 'a representation of the whole [album] arc', Roan told *The Line of Best Fit*. Its genre, simply put, is 'yes'. The song begins as a ballad, but this far into *Midwest Princess* it won't come as a surprise that it doesn't stay one. Roan's verses are swarmed by multitracked backing vocals: a high-pitched, witchy vocalization that swoops periodically out in front of her actual words.

At the 50-second mark, where the drop of 'Femininomenon' went (and where the drop usually goes, in general), Roan thrusts the song into a higher key as she escalates the lyrical stakes, 'So shame on me and shame on you.' The actual drop comes a minute in: a new-wave sequencer line that 'pogoes' between notes, clashes and un-clashes with the key and just generally does its own thing, as if it exists in a whole other world beyond Roan's chorus.

Roan's lyrics are as frank and lustful as ever. 'Feels like pornography watching you try on jeans,' she sings, as if proposing to move a shopping date into the closest lockable room. While the song still has that hesitant push-pull between what 'good girls' do and don't do – perhaps because it was one of Roan's earlier compositions – Roan's vocal has no such shame. She sings about the 'guilty *pleasure*' her crush gives her in a twirling high note: a coo of delight that suggests that, deep down, she's really *not* feeling *that* guilty. Then, on the bridge, Roan's voice does its own pogo-ing: an extended Cranberries-esque yodel.

The final seconds of 'Guilty Pleasure', are the kind of tremendous high note Roan would later perfect with 'Good Luck, Babe!'. The bridge to 'Good Luck, Babe!' is raw but technically immaculate – an enormous belted, 'I told you so' that summons the power of all the divas before her to smite an ex. The climax (and it is truly a *climax*) of 'Guilty Pleasure' is not polished at all; Roan lets her voice spin out up the scale, tension-free. The mood is *abandon* abandon. All her inhibitions are gone, all her years of internalized shame, all the smalltown hellfire telling her being queer was a sin and all her own fears that she wasn't worthy of the thing that felt so deeply right.

And so, after Roan throws her queer fanbase a slumber-party dance-off, the final words on *The Rise and Fall of a Midwest Princess* are the only ones they could be: 'Pleasure, pleasure, pleasure!'

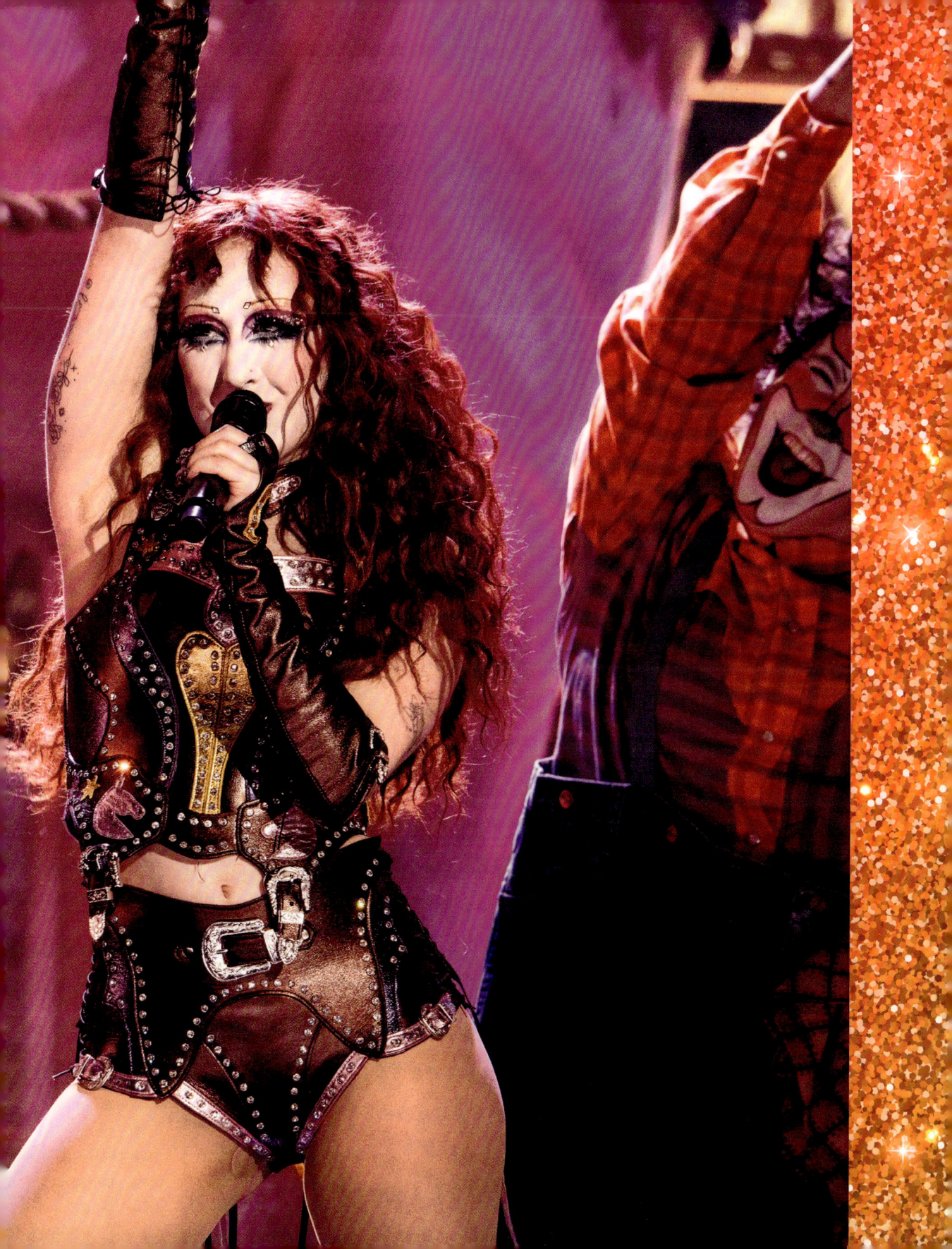

FLETCHER & RODRIGO

Chappell Roan's contract with Atlantic Records ended badly. But towards the end of Roan's time with them, the label gave her a gift that became worth more than they knew: the chance to tour with artists who truly got her.

Chappell Roan's first tourmate of her 2020s reincarnation was more closely aligned with her new persona than Declan McKenna had been, let alone Vance Joy. Cari Fletcher – who would later be known as the queer singer-songwriter Fletcher – had tried out for *The X Factor* in 2011 as a teen, hoping to compete solo. The show's producers, however, had other plans; as they often did, they tossed her into a manufactured group with three other aspiring artists – in this case, country girl group Lakoda Rayne. It gained little traction.

During the COVID-19 lockdown, Fletcher released a project that was much more herself: *The S(ex) Tapes*. The project was messy, and it was gay. Fletcher had one awkward quarantine sitch: stuck in an apartment with her ex, YouTuber Shannon Beveridge. They didn't avoid each other – not that one could easily do that, in most New York apartments – but leaned into the situation, filming the videos for records together. These weren't *literal* sex tapes, but they were, as Fletcher told *Ladygunn*, chronicles of the two

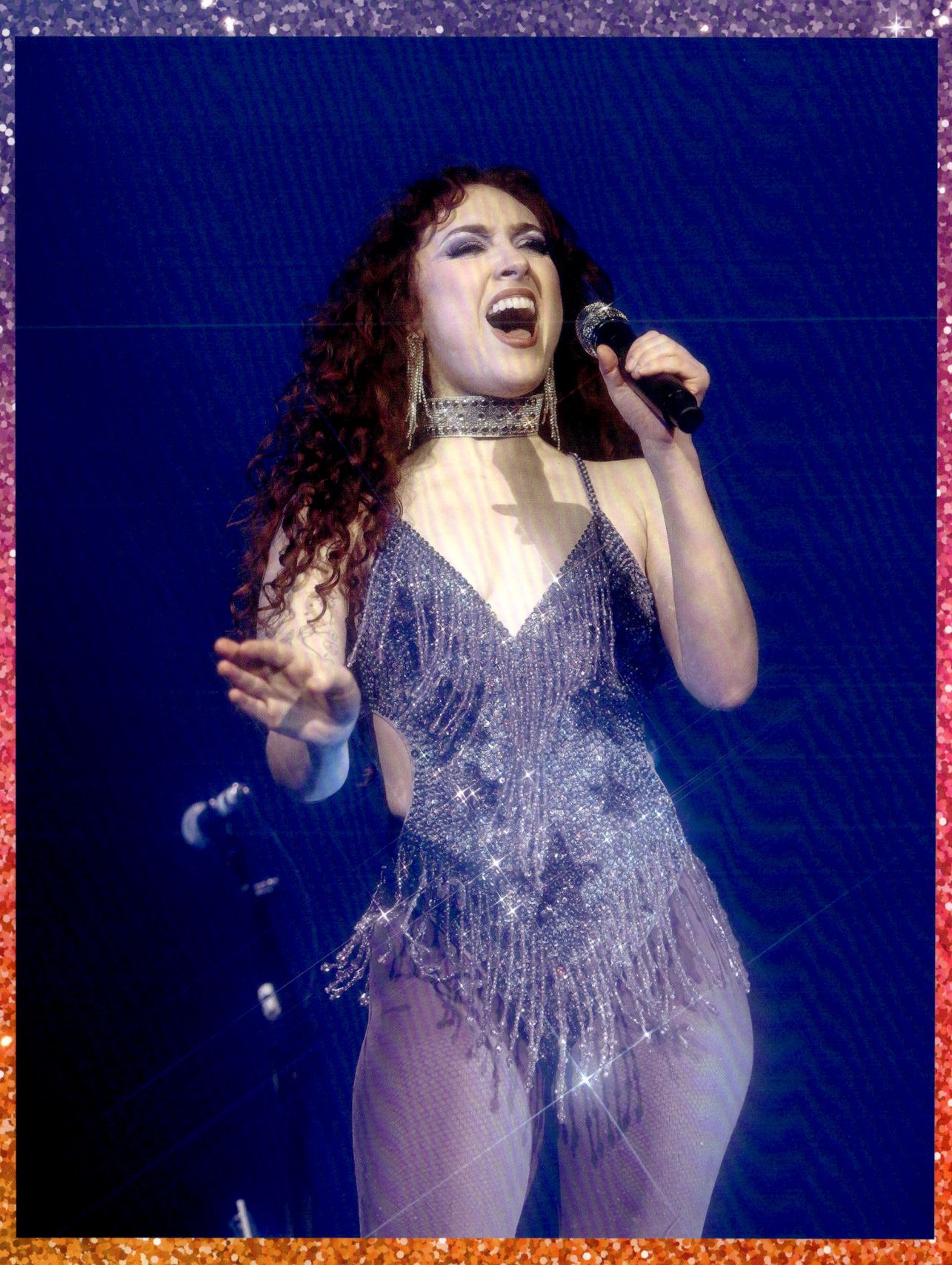

women 'being caught in their most vulnerable form'. Her follow-up singles were just as chaotic and as unbothered. On 'Becky's So Hot', Fletcher brags about lusting after the Instagram thirst traps of her ex's new girlfriend because – well, see the title.

Roan opened for Fletcher on ten shows in the back half of her 2022 tour for her album *Girl of My Dreams*. (In a full-circle moment, several songs on that album, including the title track, were produced by Roan's old *School Nights* producer Jennifer Decilveo.) By now, she'd truly started to become Chappell; her iconic outfits all came out, including the 'Femininomenon' motorsports getup, and she'd honed her various live covers to perfection. As she told *Billboard*, the tour was even more confirmation that 'the live show is where the heartbeat of the project is.'

The Fletcher tour was also a space where Chappell could let loose and present a less industry-showcase-polished version of herself – albeit unintentionally at times. As she told Nardwuar, she got alcohol poisoning one night during the tour and threw up so hard that she lost her voice for days. Being unable to sing for five nights of the tour, she decided to make the most of lip-synching, 'I'm going to be a drag queen to my own music.' And, as always, she documented the whole process on TikTok, from the initial throat scratchiness to 'sound check and [steaming] throat af' to the audience that embraced her even at her vocally shakiest.

As all of this was happening, Dan Nigro's A&R instincts came through again. Nigro had started working with Olivia Rodrigo, a former Disney Channel actor who'd starred in the mockumentary *High School Musical: The Musical: The Series.* Rodrigo had recently signed to Geffen Records to break out of the Mouse House into a mainstream musical career, and her first single was the

confessional ballad 'drivers license'. Children's television channels such as Disney and Nickelodeon had great talent scouts, not just for acting but also for musical potential, and Rodrigo was one of many teenage stars who'd tried to transition from siloed Radio Disney to mass worldwide fame. Some succeeded, from Britney Spears and Christina Aguilera after *The Mickey Mouse Club* to Miley Cyrus and Ariana Grande after *Hannah Montana* and *Victorious* respectively. Others, despite being talented, faded into obscurity. But while Rodrigo had poise and precocious, fully formed songwriting chops, so that her becoming one of the success stories surprised no one, few people predicted just how *fast* 'drivers license' would become a hit.

All this was in part thanks to Chappell Roan. The reason Rodrigo asked Nigro to produce her debut was that she'd heard 'Pink Pony Club' and loved it. Roan and Rodrigo became friends; Rodrigo was at Chappell's birthday party in February 2022. Rodrigo even used to hang out with Chappell at the doughnut shop when she still worked there.

Chappell and Olivia were not only friends, though, they were also creative collaborators. Major-label artists often work in the same buildings and pop in on one another's sessions, which is how Roan ended up singing (uncredited) background vocals on a couple of Rodrigo's *GUTS* tracks. She's on 'Obsessed' and 'Lacy' – maybe, coincidentally, the two songs on the record whose lyrics fixate on other women in ways that many fans interpret as anywhere from crush-adjacent to full-on wanting. She's possibly on bratty shout-along 'Bad Idea Right?' too – while Roan is pretty sure the producers didn't end up using her take, she still swears she heard her voice in the mix.

Rodrigo's debut album, *SOUR*, was an instant favourite with critics, who likened her defiant songwriting style to that of Fiona Apple and Alanis Morissette, and with fans who saw their lives in her relatable, bedroom-pop lyrics.

In early December 2021, Rodrigo announced the dates of her SOUR Tour. Although she probably could have filled arenas, she chose smaller venues instead and several cities sold out nearly immediately. She had four openers and they fell into two categories. First, lower-key singer-songwriters Gracie Abrams and Holly Humberstone. Second, pop-loving, DIY-styled artists with self-aware personas and huge LGBTQ+ fan followings such as *Heartstopper* soundtrack artist Baby Queen – and, for one night, Chappell Roan.

Roan's opening set was on 27 May 2022, at the Bill Graham Civic Auditorium in San Francisco. How did she feel about it? As she posted online, 'OMG I'M OPENING FOR @oliviarodrigo MAY 27 SAN FRANCISCO. I love u SO MUCH Olivia & I can't wait !!!! LETS GOOO'.

She performed the songs that had earned her all the online buzz – 'Naked in Manhattan', 'California', 'Femininomenon', 'Casual', 'My Kink Is Karma' and 'Pink Pony Club' – as well as the older tracks 'Love Me Anyway' and (her old favourite) 'Bitter'. But May 2022 was still well before *Midwest Princess* came out and also before the splashy Bowery Ballroom show that got her signed. A video of her 'California' performance shows that she was still in an intermediate phase of the glow-up. She still has her natural light-brown hair and her outfit is a lower-key version of her wild 'Chappell Roan' looks: a modified pink tube dress with sparkly embellishment on the bust and a cutout at the thighs, long gloves and spangly silver Chelsea boots.

Going in, Roan knew the stakes were higher than ever. The night before the Olivia Rodrigo show, she'd done a show at downtown LA bar and beer garden Resident. This was a headlining show with a full band, but only a couple of hundred people in attendance – most of them, she told *The New Nine*, 'drunk as f*ck'. Now she had an audience of thousands and an endorsement from one of the pop world's biggest 'it girls'. She was understandably intimidated, but those nerves could not withstand the sound of an admiring crowd. 'I got off stage, went back to my hotel, and thought, "I guess this is what it feels like to perform for an arena,"' she told *Visit Springfield* in 2023. 'And it really doesn't feel that different.'

The GUTS Tour did feel different, to put it mildly. The SOUR Tour and album had become such massive hits that an Olivia Rodrigo tour was no longer routine album promo: it was an *event*. And so, when Rodrigo released her follow-up to SOUR, 2023's GUTS, she was riding the high of being nearly universally beloved in the pop world.

By 2025, Rodrigo's GUTS Tour had spanned five continents and made over $186 million. Once again, the artists that opened for her reflected her eclectic influences: pop belter Remi Wolf, chill alt-R&B singer PinkPantheress and legendary 90s alt-rock band The Breeders. And then there was Chappell Roan, not for one show, but for twenty.

Nowhere was the energy higher than in Los Angeles on 20 August – the night of a performance immortalized in *Netflix's Olivia Rodrigo: GUTS World Tour* movie. This tour date, a surprise appearance, wasn't part of Roan's announced schedule. The cheering is already loud when Rodrigo hints that her next guest opened for her on the SOUR Tour, and it further escalates as Rodrigo gushes that her guest is 'one of the most singular, inspiring, powerful artists I've ever had the pleasure of meeting.' And when Chappell Roan makes her appearance, well – 'I've heard lots of really loud screaming in my life... but I truly don't think I've ever heard a scream as energetic as the scream when I announced that Chappell was coming onstage,' Rodrigo later told *Billboard*.

Roan walks out in a cloud of charisma: in a pink corseted minidress, embellished with flowers, and looking overjoyed to reunite with her former tourmate, who dons a black bra and shorts with a fishnet overlay and whose loose dark hair contrasts with Chappell's wild mounted mane of red. Both are sparkling, and wearing matching black leather boots. They hug, taking in the audience's adoration. As Rodrigo's backing band vamps through a rock arrangement of the chorus of 'HOT TO GO!', the pair teach the audience the choreography – although, judging by the energy of the crowd, few people in attendance needed the introduction. Their performance is athletic and aerobic, the two artists projecting a relaxed confidence as they race down the stage.

The GUTS Tour brought Chappell's music to a new audience, but the most important thing she took away from it was more intangible. After the 'HOT TO GO!' duet, she posted an Instagram snapshot of the performance with the caption, 'You make me feel like a rockstar, Olivia.' That's the kind of feeling that can power a whole career.

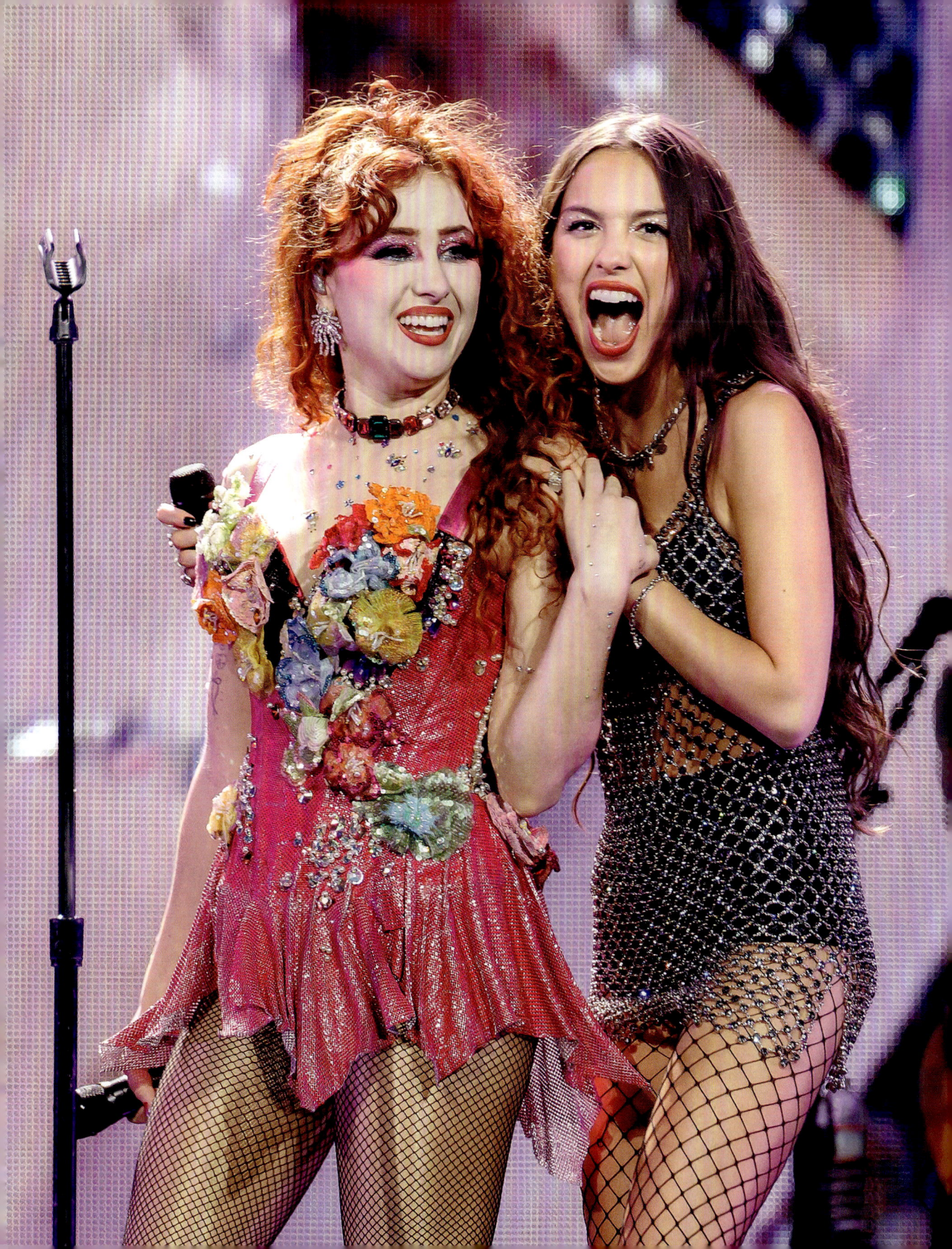

GOOD LUCK, *Babe!*

As most major-label songwriters do, Chappell Roan and Dan Nigro recorded dozens of tracks during the *Midwest Princess* sessions. Many of them got cut – not necessarily because they weren't good, but because they didn't fit the album's concept or aesthetic.

Roan didn't want her new career to devolve – again – into record-label cynicism and trendy cash grabs. In particular, 2024 saw the escalation of one of the worst trends in pop: artists releasing extreme-scare-quotes 'deluxe' albums just days after the original, under increasingly flimsy pretences, in order to juice their sales by making fans repeatedly buy a basically unchanged record. Sabrina Carpenter's *Short n' Sweet* got a flash-sale-style 'deluxe' release, with the artificial exclusivity of being available for only 24 hours. Taylor Swift released a whole 34 versions of *The Tortured Poets Department*.

Ariana Grande flat-out admitted that her *Eternal Sunshine* re-release was only 'slightly deluxe'. Roan was pressured to embrace the trend for 'Good Luck, Babe!' (co-written by Roan, Nigro and Justin Tranter) but she refused. According to Island's Justin Eshak, she wanted to keep doing it the way that she'd been doing it.

In the single art for 'Good Luck, Babe!', Chappell Roan wears a satin gown, a crimson escoffion – a flowing medieval headdress – and a broad pig nose over her real one. She sits in three-quarter profile as if posing for a laborious oil painting, but her portrait is captured by something a whole lot quicker: an everyday digital camera, maybe one built into a phone. Her pupils spark red under its flash, matching the colour of her satin gown. The image and all its contrasts – a serious gaze and a silly nose, an extravagant outfit photographed cheaply against a plain beige wall – made the perfect

introduction to the song itself. The song, produced by Roan alongside Justin Tranter and Dan Nigro, is superficially similar to 'Casual'; it's about wanting someone who keeps you at arms' length when all you want to do is fall at their feet. But unlike 'Casual', 'Good Luck, Babe!' is explicitly written to a woman – Roan's original title was 'Good Luck, Jane'. She sings to a woman who's all in on the sexual side of their relationship but still can't quite admit that she has deep feelings for another girl. Maybe this woman doesn't want to grapple with what it would mean about her and her identity, her place in the world. Maybe she doesn't want to have to tell anyone she's queer. Maybe she's still holding out for a politically uncomplicated life, with a husband and a tidy house and a couple of kids – a life that doesn't ask her to have any hard conversations about who she is and what she wants. She might just be scared to take the plunge into real love. Whatever the reasons, Chappell knows they're just ways to hold herself back – and she wants better for both of them.

The arrangement of 'Good Luck, Babe!' sets chintzy Wham! synths against sweeping cinematic strings, as Roan addresses a would-be ex-girlfriend with a complicated, but deeply real, mix of yearning, disgust and magnanimity. The song features Roan's most acrobatic vocal in years, culminating in a belted, hyper-passionate high note on the bridge; she recorded the song in four different keys to get it right. 'You can kiss a hundred boys in bars / Shoot another shot, try to stop the feeling,' Chappell sings in the chorus in a fluttering heady voice as the strings froth up into a crescendo. When she wishes her soon-to-be ex good luck with all that, floating at the very top of her vocal range, you can hear the thorns poking through the gossamer. At the bridge, she comes crashing down into the full melodrama the situation deserves. 'When you wake up next to him in the middle of the night / With your head in your hands, you're nothing more than his wife,' she sings, as if about to break into a scream. 'And when you think about me all of those years ago / You're standing face to face with "I told you so"...' The bassline throbs and the drums roll as she seethes back into the chorus.

Amid heartbreak, Chappell finds solace by projecting revenge years down the line. Someday, her ex will be haunted by the thought that she threw away the fiercest love she ever knew just because she couldn't bring herself to quit being straight. The feeling they shared will sear through the remainder of her days – she'll never get to forget about Chappell; the world will stop spinning before those embers grow cold. As Chappell finishes singing the final chorus, the song itself starts to slow down, like someone has just pulled the plug on the turntable. Chappell's voice gets low and slow before she stops singing entirely.

'Good Luck, Babe!' certainly doesn't cannon-blast you with glitter like Roan's poppier hits. But all becomes clear once you listen to Roan's incandescent bridge, then ride out the emotion with her. There goes the feeling -- and there goes the whole world with it.

Coachella

Throughout 2024, Chappell was busy proving that she doesn't take festivals lightly. Her enormous, exuberant music is no more perfectly at home than when it's at a huge outdoor bash in the summertime, where the preoccupations and trivialities of everyday life tend to melt away. It's been clear that she's treated each festival performance as not just another stop on tour, but instead its own special revue. During the first weekend of Coachella 2024, she wore a latex tank top with 'EAT ME' printed in block letters on the front. For weekend two, she was a sparkling butterfly in massive, lace-trimmed, scarlet wings. She took the stage at New York's Governors Ball by climbing out of a literal big apple, dressed, of course, as the Statue of Liberty, her skin painted the muted green of oxidized copper, holding a blunt in one hand and a torch in the other.

Along with Governors Ball and Lollapalooza, Coachella was among the most coveted of the festivals Chappell Roan played in 2024. Taking place at the Empire Polo Club in Indio across two weekends in April, Coachella draws both enormous stars – that year's headliners were Lana Del Rey, Doja Cat and Tyler, the Creator – but also indie bands starting to generate buzz and early-career pop stars just about to reach their apex. This was Roan's first time playing the festival, and she performed one small ritual to psych herself up before hitting the Gobi Stage, 'I do knock on wood,' she told *Vogue*. 'I don't even care if it's actually wood!'

The poster for every Coachella announcement shares a design aesthetic – artists' names superimposed onto pastel Southwestern sunsets – that's so immediately recognizable it's become a meme. There's a strict hierarchy to the artists' names, which are arranged like an eye chart: pop royalty on top in a big, easy-to-read font, and everyone else in text that's increasingly hard to read as you get closer to the bottom. This placing implicitly reflects how big of a deal the festivals' organizers think the artists are – and sometimes, they get it very wrong. Music blog *Stereogum*, known for telling things like they are, said that the 2024 poster's sidelining of well-known rising pop stars such as Sabrina Carpenter, Renée Rapp and Chappell Roan felt like 'actual intentional insults'.

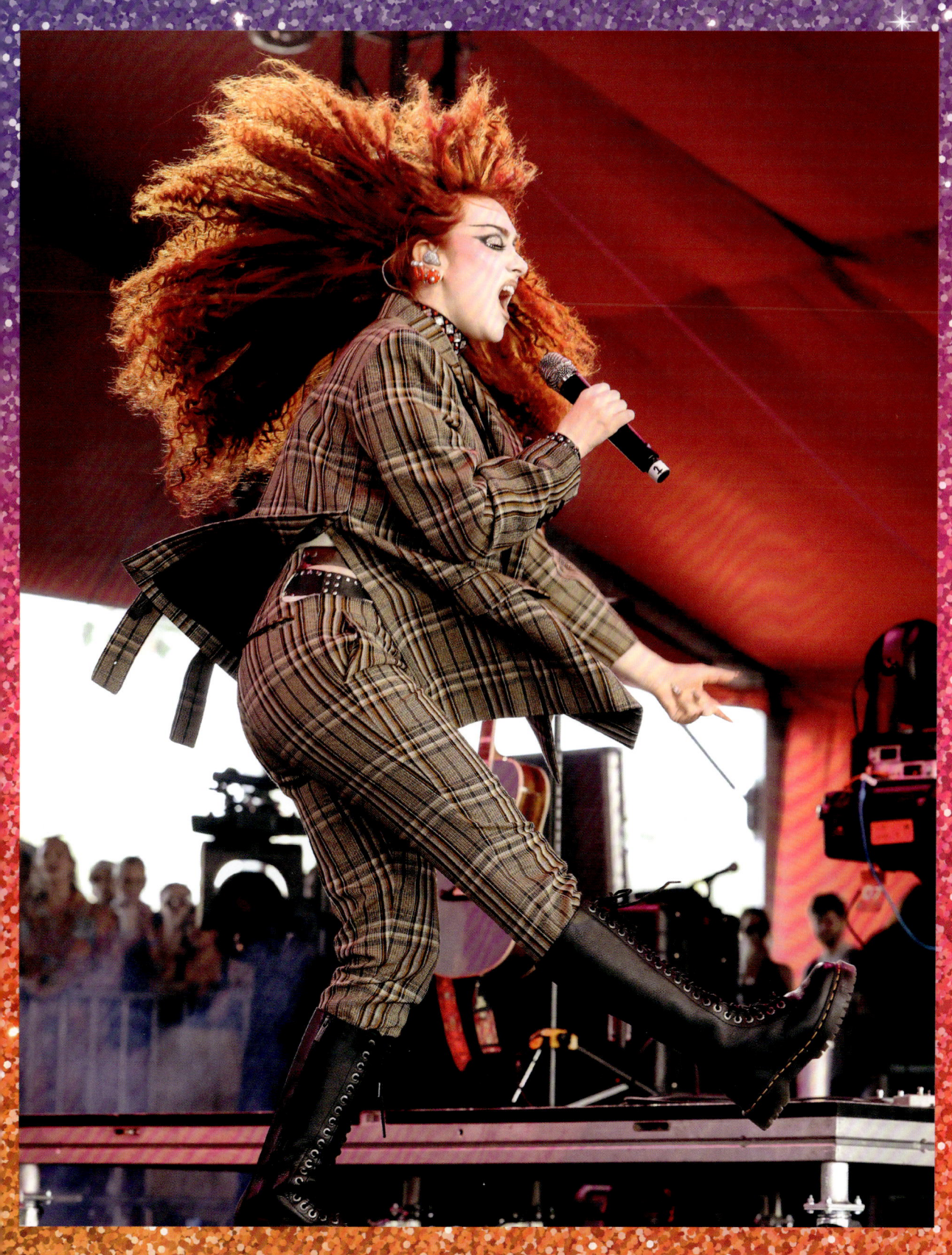

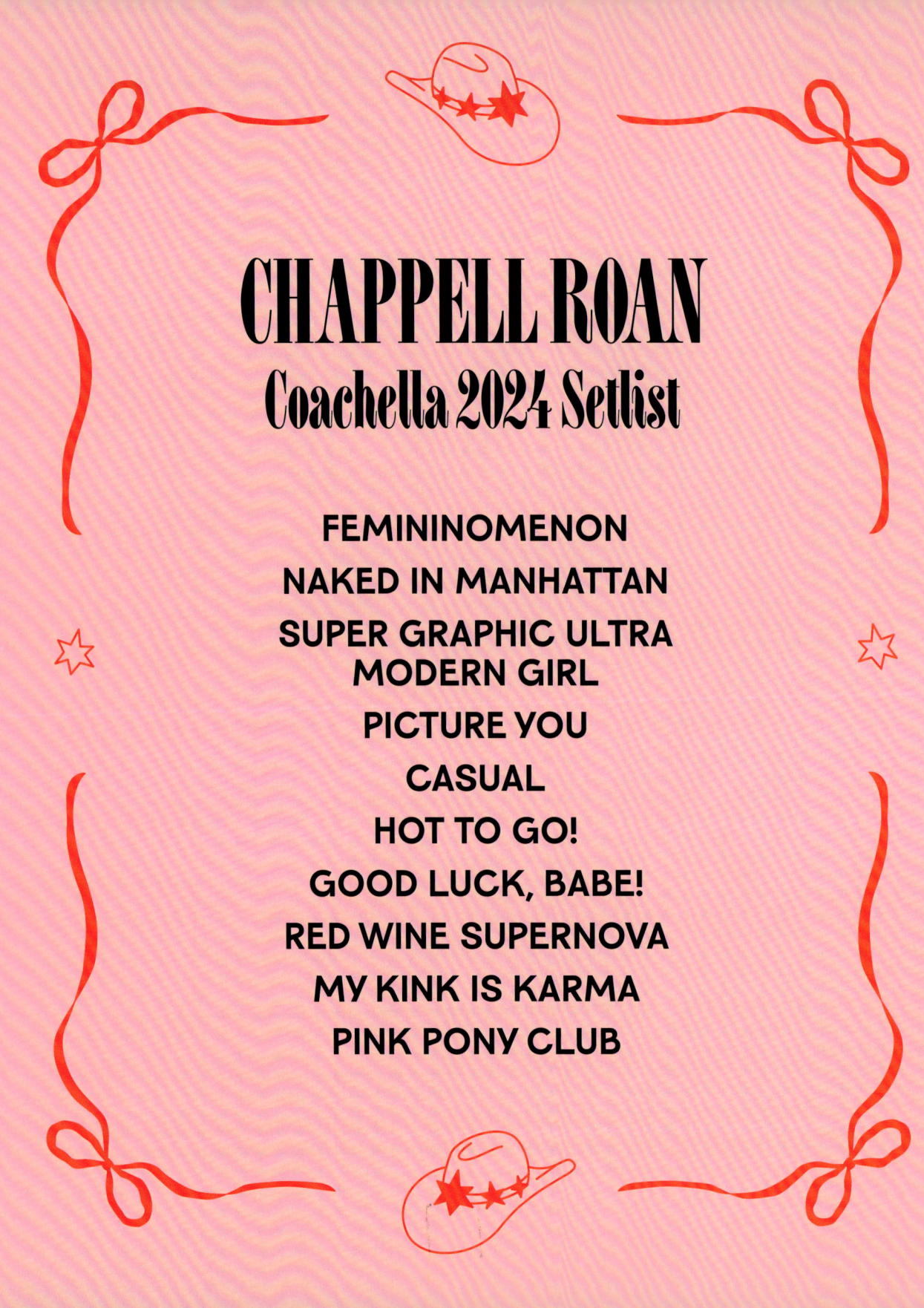

Clearly few people – besides Chappell fans, who already knew what she brought to the stage – expected her set to be as monumental and career-accelerating as it turned out to be. Roan's booking agent Jackie Nalpant summed it up in *The New York Times*, 'It's a zeitgeist moment. You can't manufacture it.'

Footage of Chappell's opening speech for the first weekend shows her gleefully welcoming the crowd. 'Welcome to Coachella 2024! I'm so grateful to be here,' she says. 'I've never been at Coachella. My name is Chappell Roan […] This set goes out to y'all, my other [Midwest] Princesses.' Here, Roan deploys her now signature look from *The Rise and Fall of a Midwest Princess* album cover. Her makeup recreates the white and pink rosy cheeks and her hair is worn down. She wears leopard-print leggings with her 'EAT ME' top. There's also a nod to leather kink in the LGBTQ+ community: a leather chastity belt with studs. She completes the look with black Dr. Martens. Her band members wear tops similar to Roan's, with the slogan 'EAT THE RICH' reinforcing her vehemently anti-capitalist politics. As her lyrics flash on a screen behind her, the crowd takes thousands of photos and videos, each a tiny piece of the show's immortality.

A few songs in, Chappell scurries off stage before bringing on a blonde wig. After placing it on the mic stand, she tells the fans how she's brought her wig with her and then sings 'Picture You'. Bubbles float across the stage, and while her set is minimalist – simply a wind machine and lighting – she engrosses her onlookers as they sing alongside their 'favourite artist's favourite artist'.

Chappell's sets were met with exuberant acclaim for her 'standout performances […] with her ability to turn the Gobi tent into one big huddle of euphoria and joy,' according to *NME*. This review went on to suggest that this was just the beginning for Roan, 'The rapturous response, coupled with Chappell Roan's infectious, theatrical stage presence, conjured images of a steady climb through the festival's ranks for Roan to come.' *New York* magazine concurred, writing that her 'witty sapphic glitter-pop' was finally getting the recognition it deserved.

For Coachella, Chappell Roan was styled by Euphoria makeup artist Donni Davy – yet another fan of hers – who DMed her after seeing her name on the Coachella lineup to ask if she could do her makeup for free. Chappell also debuted one of her most talked-about fits: a butterfly suit with a six-foot pink and glittery wingspan. On Instagram, Roan shared the costume's inspiration: Deee-Lite frontwoman and social activist Lady Miss Kier, who had worn a similar butterfly costume for her 1992 Infinity Within Tour. Miss Kier's suit was high fashion – its designer, corset-maker Mr Pearl, famously worked with Thierry Mugler, Alexander McQueen and John Galliano. Chappell's version had more alternative roots, though. Her suit was designed by Samanfah Wilson, also known as Jackalope Land: a former children's party performer and 'professional mythical creature for hire' who turned an Etsy side business making glittery, fantastical costumes into a flourishing career. Davy added antenna-styled eye makeup, highlighted with jewels. Once again, Chappell had blended fashion, drag and performance art into a striking personal expression and a revelatory live show. As she wrote in her Instagram post, the experience was 'an absolute dream come true. To play @coachella AND be a butterfly…gagged.'

GOVERNERS *Ball*

After Coachella became Chappellchella, every 2024 festival lucky enough to have Chappell booked knew they had to step it up, since the person they'd pigeonholed into a midlist-artist tier had proved to be a certified phenomenon. Huston Powell, a booker for Governors Ball in New York, had to rethink the whole event because, as he told *The New York Times*, 'It felt like Chappell Roan mania […] like everyone wanted to see her.'

Roan arrived at Governors Ball in a red apple, with smoke coming from within. Heads turned as she was revealed to the crowd dressed as the Statue of Liberty but with a signature twist – she was smoking a joint. The outfit was a striking visual statement, her makeup encapsulating every inch of America's most famous symbol of 'freedom and justice'. But as Roan stood mimicking Lady Liberty's iconic silhouette and *contrapposto* stance (which have led some to call the statue 'the biggest drag queen of all'), her dress was making a further statement – with the cut of its tasselled skirt showing her bare butt cheeks.

In an interview with *Harper's Bazaar*, Roan's stylist Genesis Webb revealed how she and Roan collaborated on the outfit. 'I sent Chappell a reference of a Playboy Bunny coming out of a cake,' she said, 'and she was like, "Let's do an apple. We should have it be a bong, a smoking apple."' From there, the Statue of Liberty apparently came naturally, 'It's so camp and obviously so New York.' Genesis had been saving the dress – a Monique Fei piece – for a while and said Chappell was 'so game' for it. 'I even made attachments for the belt, because I thought she might not want her butt out. And she was like, "Can we take these off?"'

Roan's Statue of Liberty outfit combined the biggest symbol of American freedom

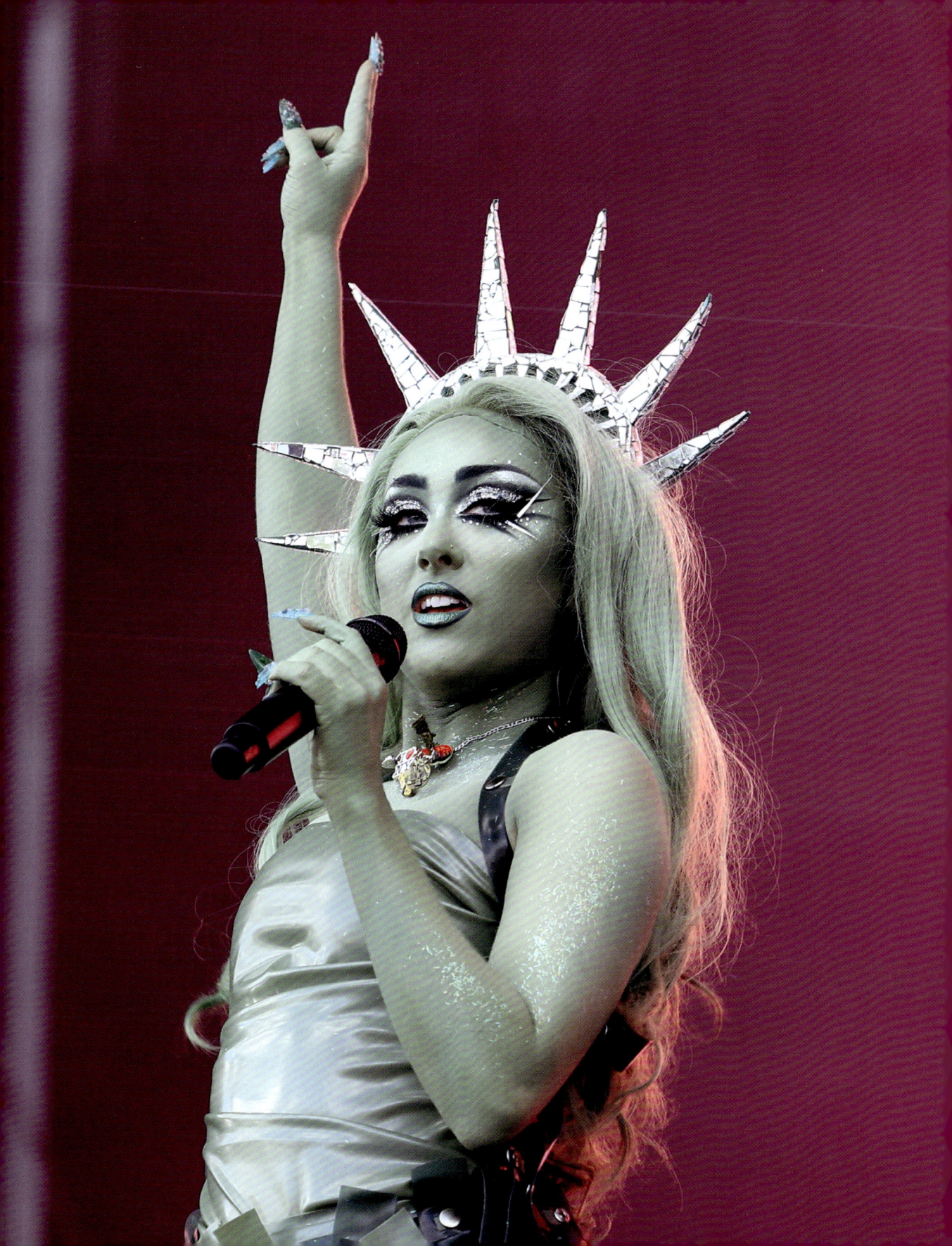

with an act of rebellion that reflects her stance on the issues she cares about most. By reimagining the Statue of Liberty – traditionally a symbol of hope and liberty – in her performance as a powerful symbol of resistance, she was giving her own nod to the fight for freedom in all its forms.

Roan had recently declined an invitation to perform at the White House's Pride celebrations. In a powerful moment that was widely shared on social media, she addressed both the crowd and the Biden administration. 'As a response to the White House, who asked me to perform for Pride, we want liberty, justice, and freedom for all. When you do that, that's when I'll come.' Roan was alluding to the inscription on the Statue of Liberty – 'give me your tired, your poor, your huddled masses yearning to breathe free' – and the ideals where the US continues to fall short. Expanding on her message, she stated, 'That means freedom in trans rights, that means freedom in women's rights [...] and it especially means freedom for all oppressed people in occupied territories.' She then dedicated 'My Kink Is Karma' to the administration: a confident taunt towards the people in power and call for meaningful action.

Through this moment, Roan's performance on the Governors Ball stage transcended the ordinary concert, becoming a statement of solidarity and a rallying cry for justice. Her speech was an invitation to listeners everywhere – not just in the audience – to advocate alongside her for a world where everyone can be themselves and express themselves freely without oppression. The moment was fitting for New York, a cultural epicentre of change and activists. Roan took her place among them: an artist with her eyes wide open, awake to the struggles of those who have been historically marginalized.

For another Governors Ball outfit, Chappell fashioned a second New York icon: this time, the yellow taxi – right down to earrings made of Arbre Magique Little Tree Car Air Fresheners. These dress-ups reinforced her relatability to her fans, who make outfits and whom she encourages to dress up for her concerts. She debuted a new song at Governors Ball, too. 'The Subway' is a folky, Lilith Fair-ready, midtempo track that combines Laurel Canyon cool with the attitude and sapphic sensibility of Melissa Etheridge. In it, to escape a lingering breakup, Roan vows to do the cross-country journey of 'California' in reverse. Actually, it's a journey across countries, plural. In a searing line, Chappell roars, 'F*ck this city, I'm movin' to Saskatchewan!' And despite this being an unreleased track, Roan's super-graphic ultra-modern fans soon sang the words back at her.

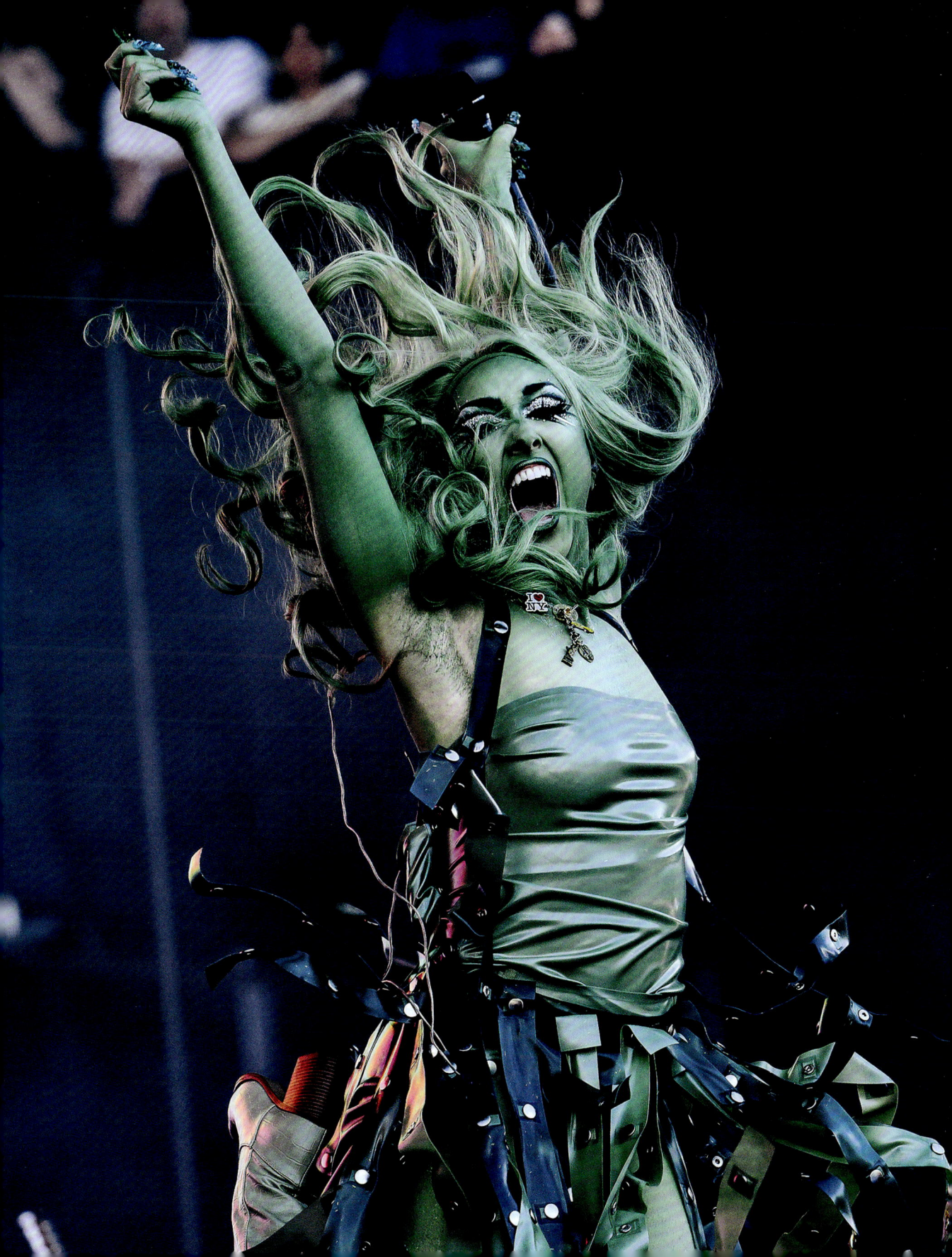

CHAPPELL *Lollapalooza*

Before she even steps onstage, Chicago's Grant Park is packed and ready to blow. Chappell Roan isn't headlining Lollapalooza. She's playing at 5pm on Thursday, the opening date of the annual four-day festival, when, on a typical year, the festivities would only just now be starting to heat up. The Midwestern sun, still high, beats down heavy on the crowd. The crowd is massive.

Crowds like this don't usually gather for daytime sets, but they have today. Here's everyone: 80,000 devotees in bedazzled pink cowgirl hats, baby tees and glitter makeup. Across the whole day, a total of 110,000 people will attend the festival – and 8 out of 11 of them are here to see Chappell Roan. Festival organizers had to move her set from the modest IHG Hotels & Resorts stage to the bigger T-Mobile stage at the southern edge of the park when they realized, in the months leading up to it, just how big this party would be. They'd say, after the fest, that her set was the best-attended daytime set that Lolla had ever seen in its 33-year history. They even had to switch her spot with Kesha's, her fanbase was so big. (Kesha, another of Roan's many musician fans, was happy to swap.)

The festival was a notable moment not just for Roan's artistry, but for her personally as well. It coincided with the seventh anniversary of her grandfather's passing, and also the release date of *The Rise and Fall of a Midwest Princess*. In an Instagram post, she remarked, 'I was crying as I walked on stage at @lollapalooza because of the overwhelm of

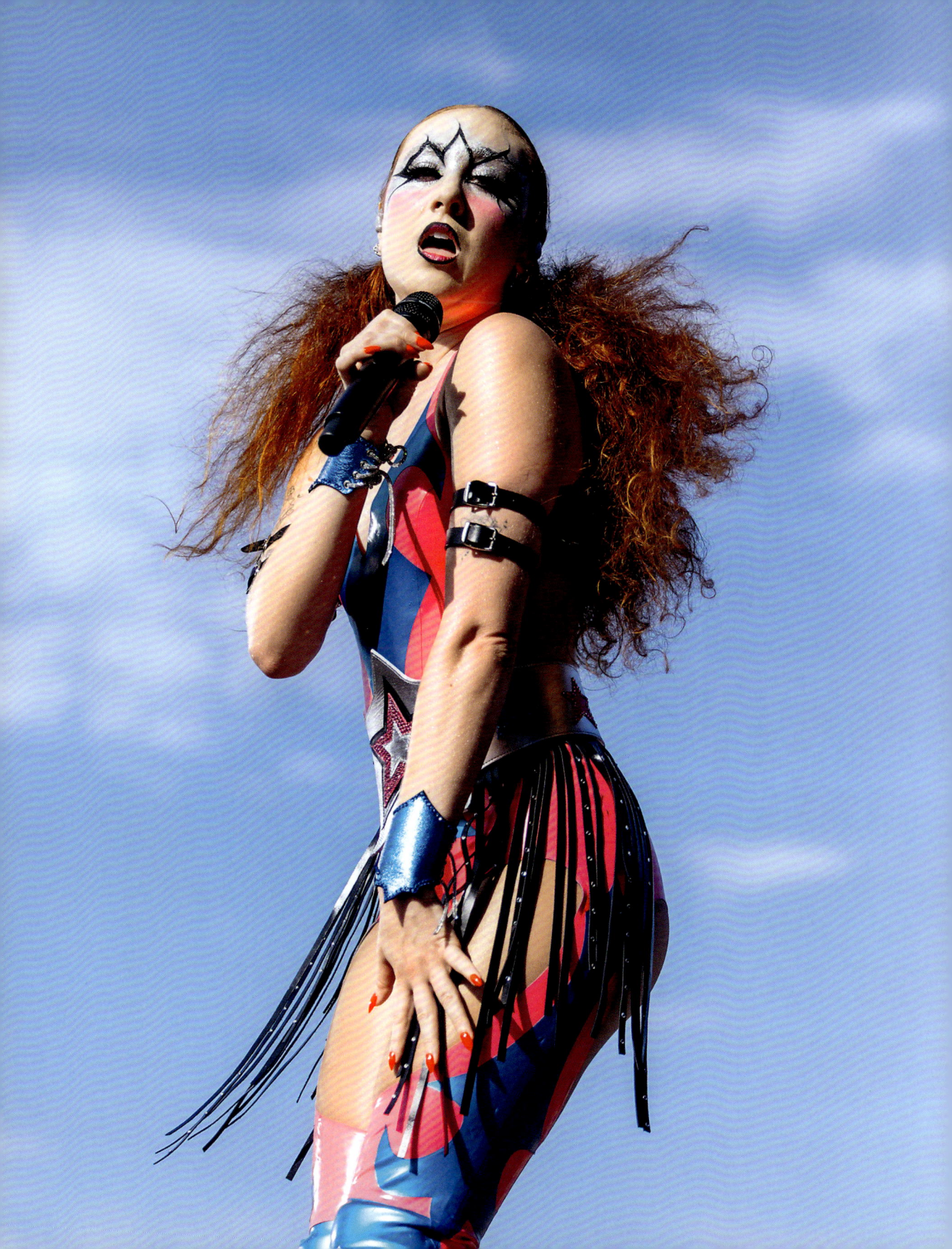

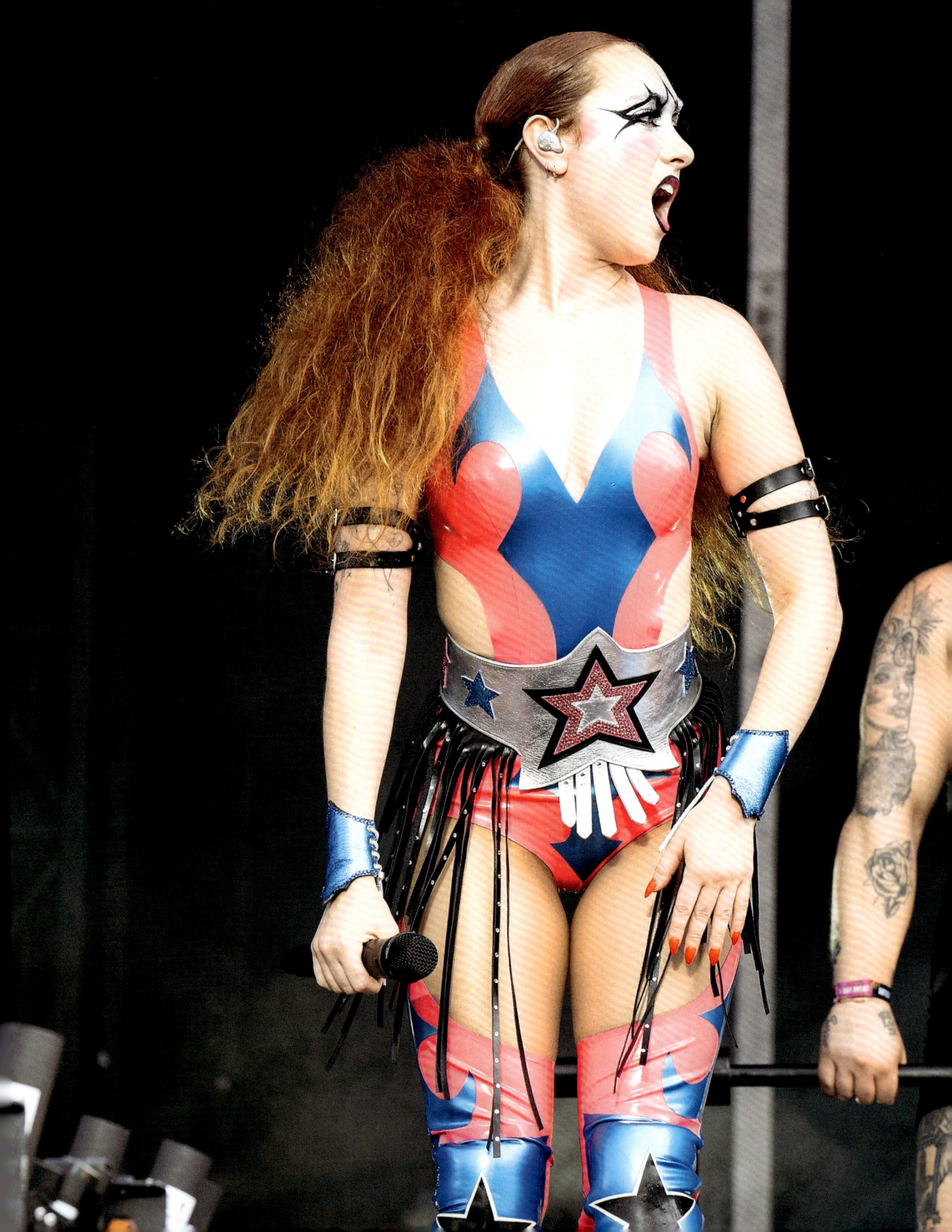

support. Thank you thank you thank you 😍😍 I will remember this forever…Good job team.'

Roan's Lollapalooza set was a spectacle of theatricality and energy, pushing boundaries with a unique stage setup. She had the stage transformed into a hybrid gym and wrestling ring that would bring a playful yet powerful physicality to her performance. Then the stage came to life. Chappell's band walked on. So did about half a dozen athletes in black singlets and red bikinis. Against a fuchsia screen, the words 'CHAPPELL WRESTLING' ballooned in size, glittering, a spoof on the logo for Everlast boxing equipment. The drummer climbed into a boxing ring to get to her kit. The athletes showed off their muscles as they stretched and warmed up. The band played some guitar fanfare, the dazzlingly strong people onstage started lifting weights. It's standard practice for pop stars to invite dancers on the stage for a festival set. But powerlifters? That might have been a first.

When she finally appeared, Roan embodied the ultimate wrestling-inspired aesthetic. Clad in a pink, blue and silver latex leotard paired with a matching leather luchador mask and leather bicep bands crafted by the 'post-fetish' leather brand Zana Bayne, she exuded both power and camp. As she approached the microphone, she put her fists up, ready to spar. Her ensemble included a championship belt shaped like a star, a playful nod to her self-proclaimed status as the 'Pop Music World Champion'. The mask, a centrepiece of her look, drew comparisons to the elaborate costumes of professional wrestlers, incorporating hues of pink, blue and

white based on Monica Helms's 1999 Transgender flag. This reaffirmed her commitment to standing with marginalized people through her signature theatricality.

Among the bodybuilders Chappell had recruited from gyms around Chicago was Inez Carrasquillo, the strongest woman in North America and the fourth-strongest woman in the world. While Chappell started an impassioned rendition of 'Femininomenon', Inez did barbell curls. A boxer did push-ups while her coach cheered her on. Directly behind Chappell, three women bodybuilders in red lipstick laughed while they spotted each other's bench presses.

Roan's fascination with professional wrestling and its overlap with drag was evident throughout the performance. Wrestling, like drag, is an art form full of pageantry, physicality and larger-than-life personas, making it a fitting inspiration for Roan's bold aesthetic. Wrestling events such

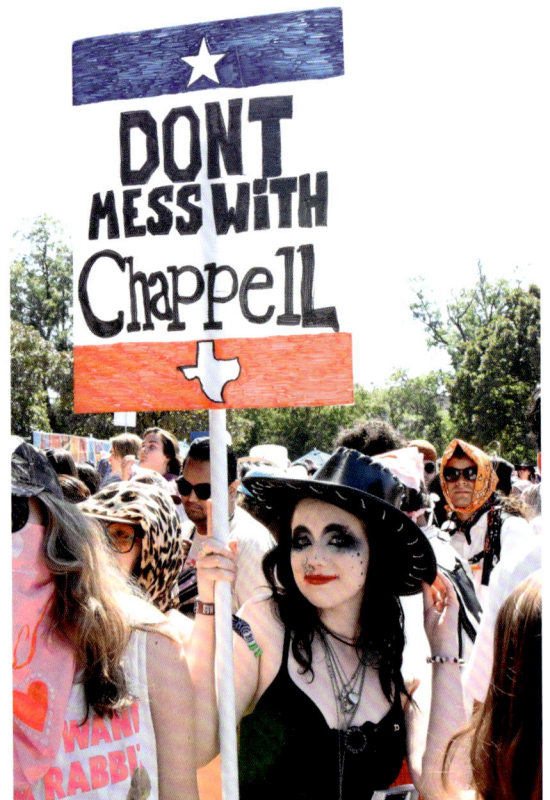

as Paris Is Bumping and CHOKE HOLE, which merge queer culture with the world of wrestling, were clear influences on her creative vision.

In true luchador fashion, Roan began her set with her face concealed by the mask, building anticipation and mystery. Midway through the performance, she removed the mask to reveal her full makeup – inspired by the band KISS, with a signature white canvas-like face with erratic black lines painted on for emphasis – her fiery red hair tied back. While unmasking in professional wrestling often signifies the end of a career or persona, for Roan it symbolized the start of a new chapter. This act, combined with her heartfelt Instagram post about feeling 'overwhelmed' by the support, highlights the vulnerability and authenticity she brings to her artistry.

Roan danced and gyrated across the stage, often sprinting up the runway to interact with the audience. Mid-set, before singing 'Casual', she added to the atmosphere

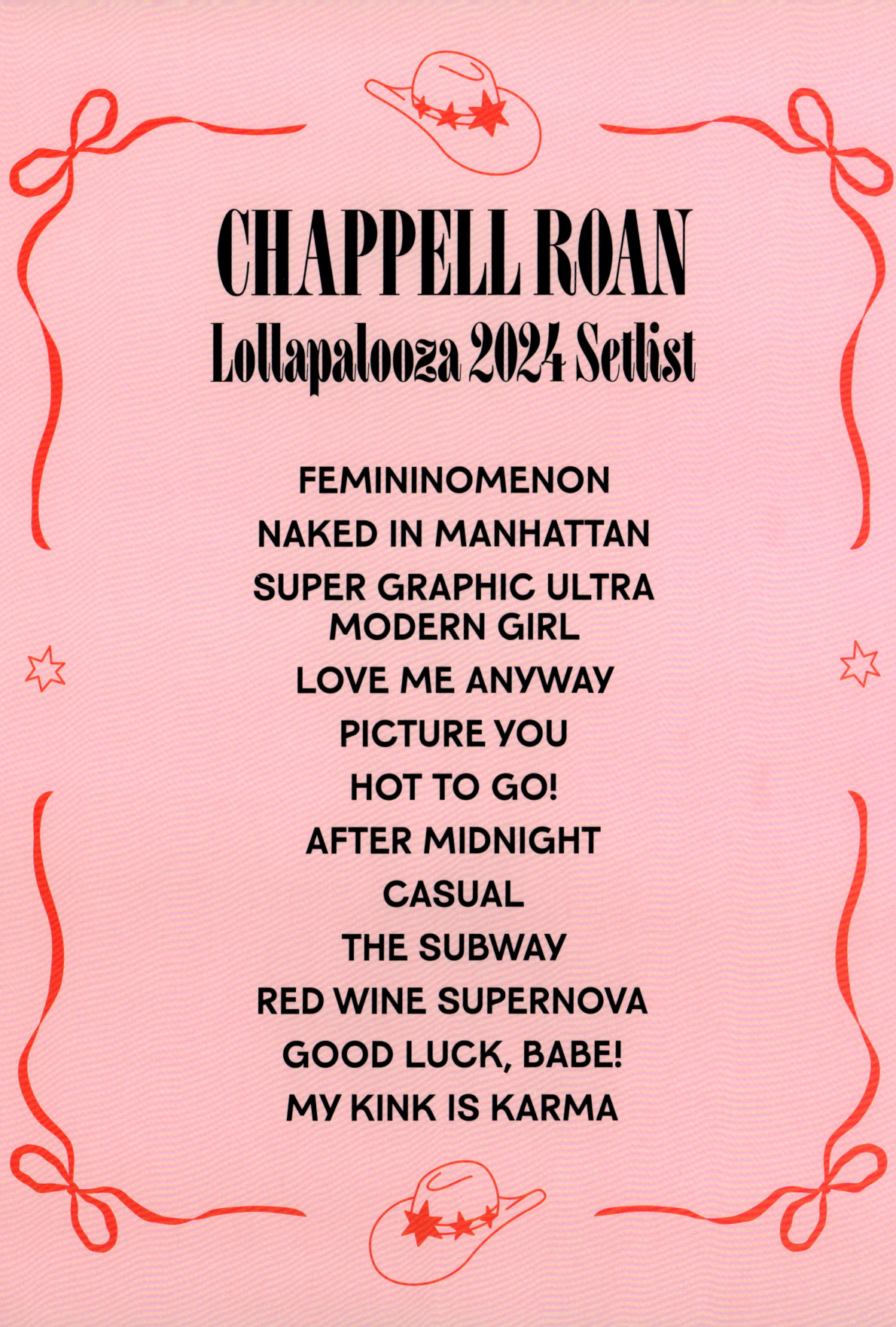

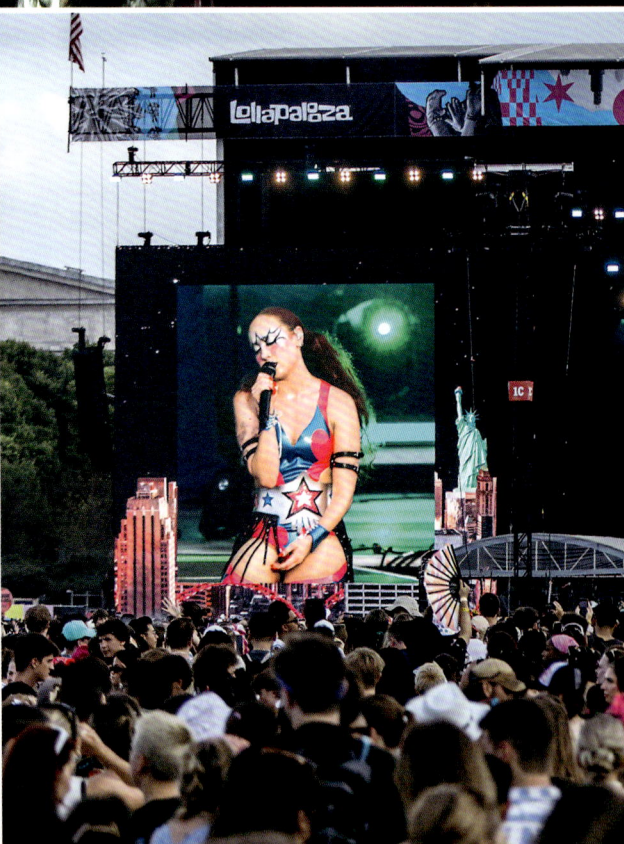

by enthusiastically inviting the crowd to greet her all-female band's current lineup – 'We have Lucy on the drums, Devon on guitar and Allee on the bass!' That's Lucy Ritter, who had previously played in the touring production of Alanis Morisette's *Jagged Little Pill* musical; Devon Eisenberger, who played Katy Perry's Las Vegas residency; and Allee Fütterer, a former hardcore musician who has played for indie artist Weyes Blood and pop star Conan Gray.

The performance reached its zenith during 'HOT TO GO!', where the crowd's energy seemed to mirror Roan's. Fireworks and synchronized lighting turned the stage into a real-life music video as Chappell pounded around the stage – every moment meticulously crafted yet bursting with life.

Afterwards, Lollapalooza posted a clip on Instagram of masses in the crowd co-ordinating themselves to 'HOT TO GO!', all singing the lyrics in unison. The caption read, 'It's Chappell's world and we're just living in it.' Watching this footage, it's clear that the extent of Chappell's popularity can't be underestimated.

The show received wild press acclaim. Local Chicagoan press outlets such as *The Daily Illini* said admiringly that Roan 'overwhelmed' the stage. *The Chicago Sun-Times* noted that 'her star wattage has grown in real time, to the point where Lolla organizers pivoted as much as they could to move [Roan] to a bigger stage in the final hour.' News outlets ABC7 and CNN also led with the story of Roan's set being 'the biggest Lollapalooza set of all time'. And renowned music magazine *Rolling Stone* summed it up best, 'It's irrefutable: Chappell Roan is a bona fide pop star who's cemented her place in the canon.'

Roan credited her team for this success, but the undeniable magic of the moment lay in her ability to transform a festival set into an unforgettable experience. From the wrestling-ring stage design to her seamless blend of activism, artistry and camp, Roan had proved herself as a true force to be reckoned with in the music industry.

REDEFINING *Fame*

Chappell Roan has taken it upon herself to showcase – in frank terms – the unfortunate realities for pop stars in the limelight. She's done this by being blazingly vocal about the mistreatment she has faced at such an early point of her career: at the hands of people within the music industry, on her own social media and from overzealous fans who have overstepped the boundary between what is and isn't acceptable for someone who performs for a living.

Through TikTok and then live on tour, Roan has built up a fanbase that's fiercely, uncommonly devoted. She appreciates how endearing those fans are and she's said that the fact that fans reach out to say her music has changed their lives means more than any award or accolade she's received. She's also said that she wants her fans to feel like they are part of a 'safe community' when they attend a Chappell Roan show – and every night she performs, thousands of people do.

By 2024, though, that devotion was curdling into something else. The conversations that Roan had started, along with her hints and musings about her life and future projects, created a relationship with her fans as consumers of her art. But some fans had begun to develop a more intense parasocial relationship, imagining that this connection with her music extended to a real, close connection with her in person. The puzzles Roan created for fans while promoting the *Midwest Princess* singles on TikTok created a sort of game for fans, to try to piece together her next moves as an artist. A few of her more entitled fans saw them as something else: an invitation to also piece together clues to her private life.

As her fame grew, Roan became increasingly uncomfortable with this

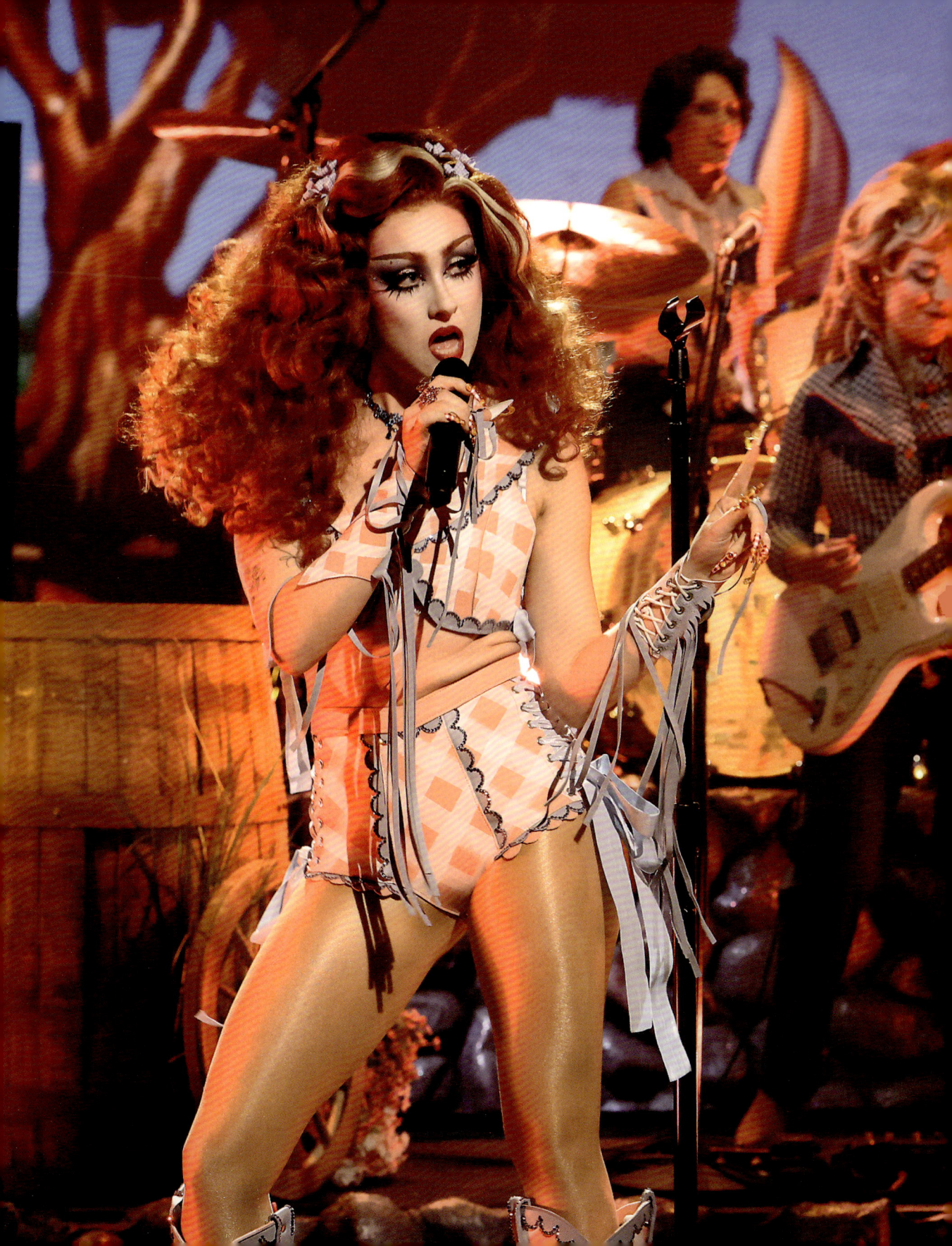

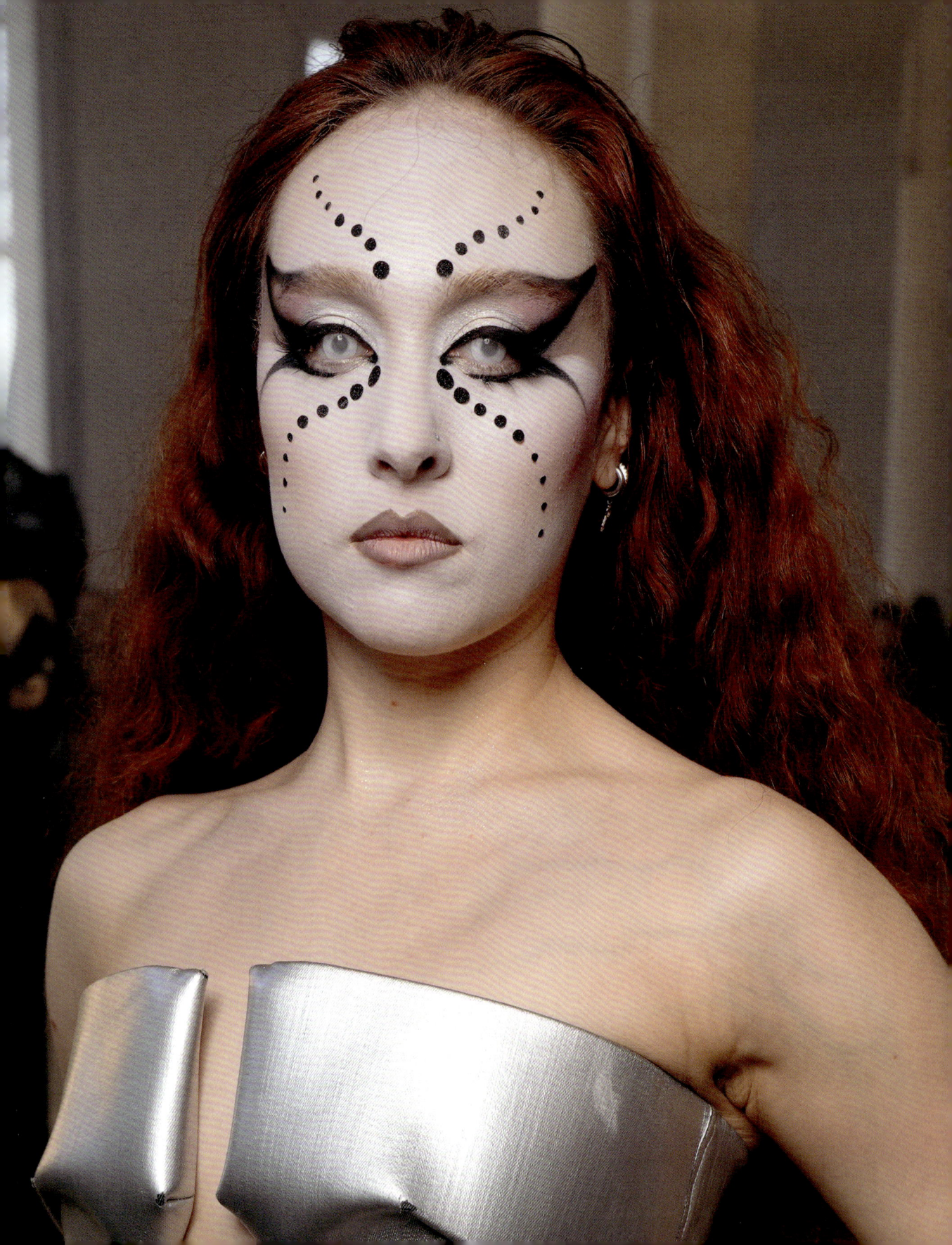

behaviour and with feeling as though she was personal property when she wasn't on stage performing for the masses. In a 2024 *Rolling Stone* cover story, she revealed just how far some fans' sense of entitlement went. She detailed how a fan 'grabbed and kissed her without permission', seemingly viewing her as not just a performer, but also as property to be ravaged.

Chappell told *Rolling Stone* that one fan had showed up at her hotel room. In an interview with *The Face*, she said that others had bought plane tickets just so they could get past airport security and track her down when she was travelling. In one incident, two men cornered her before a flight with posters they wanted her to sign. When Roan told them she couldn't sign things at an airport – as anyone who's ever had to rush from terminal to terminal in a chaotic airport can understand – those 'fans' harangued her until security intervened. She recalled one of the men's out-of-pocket words exactly, 'You should really humble yourself. Do you know where you are right now? Don't forget where you came from.' It wasn't just Chappell herself who was targeted, either; she also said that some fans were disseminating personal details about the lives of her family in Missouri and that people were outright stalking them – apparently with no recognition of the hurt being caused.

Things got so bad that Chappell Roan finally said out loud what many of her peers were merely thinking and called this kind of behaviour by its name: abuse. 'I don't care that abuse and harassment, stalking, whatever, is a normal thing to do to people who are famous or a little famous,' Roan said in one TikTok. This statement – a simple plea to be treated with dignity – would cause ripples across the internet and among her fans.

That TikTok was the first of two videos Roan posted in the second half of 2024, along with a lengthy Instagram post, discussing how her increasing fame has led to a change in some fans' behaviour outside of her place of work – 'work' being when she is 'on stage [...] performing [...] in drag' and doing press and events. In the Instagram post, she firmly set out her intention to 'draw lines and set boundaries' with her fans, making clear that overstepping these thresholds is neither warranted nor welcome.

Roan wrote about her decade-long effort to 'build [her] project' and expressed her gratitude for her success and the love and community that has come with it. But she

REDEFINING FAME

also addressed the normalization of 'predatory' behaviour and her urgent need to 'feel safe'. The main gist of her argument reinforced the fact that she, as a woman, does not need extra harassment. Quite simply, she noted, 'women don't owe [anybody] sh*t'; any harassment is unwarranted and won't be tolerated on her watch. She said her own experiences echo that of women who are told they're 'asking for it' because they've chosen to dress the way they want to. She also emphasized her right to personal freedom and privacy despite her fame. 'I chose this career path because I love music and art and honoring my inner child,' she said, but 'I do not accept harassment of any kind because I chose this path, nor do I deserve it.' Roan turned comments off on this post and confirmed that she wasn't seeking anyone's response or reaction. If people saw her as a b*tch or ungrateful because of it, well, 'baby, that's you'; she was just expressing her fears and boundaries and asking fans to reflect and respect them.

Here, Chappell Roan started a dialogue about the stigma faced by women in the entertainment industry by discussing her own experiences of real-life harassment at the hands of so-called fans who get overly friendly and don't allow her personal space. She has spelled out that behaviours such as catcalling and other 'nonconsensual physical and social interactions' are causing distress in her public life. And she has drawn attention to the double standards that celebrities often have to deal with. As she told *Rolling Stone,* 'You can't yell at a random b*tch who's on the sidewalk that you don't know. It's considered catcalling or harassment.'

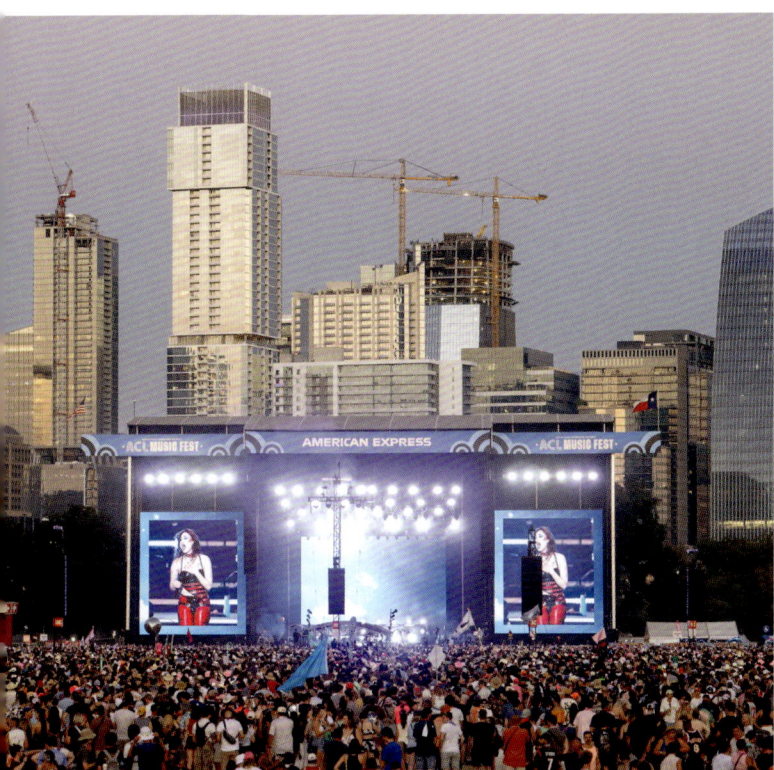

In one video posted on TikTok, Chappell is shown speaking to an audience about some of the bullying and abuse she's faced on social media. In this clip, she emphasizes how she's unable to scroll on her social media without feeling 'bad about [herself]'. She proceeds to share that she's lost some of the joy that doing livestreams on apps such as TikTok used to bring – she says she can't 'even post a caption anymore as she doesn't want to deal with [the stress].' She then goes on to state that she has received comments that encourage her to hate herself, and that there's a barrage of hate that she feels is 'bully[ing] the f*ck out of [her]'. This encounter gives unique insight into Roan's reflections on the state of social media as a seemingly endless pit of abuse, and makes a wider point about how giving millions of users easy direct contact online can be detrimental to a pop star's sanity and confidence. It deserves and necessitates an important conversation about the responsibilities of global tech companies to protect the celebrities who help support their interests, but in doing so can be – as Roan puts it – reduced to 'a shell, a turtle shell'.

There is clear evidence here that Roan is struggling with the internal realities of being in the limelight – but also that this struggle 'motivates [her] and gives [her] energy' to always prioritize her own mental and physical health. This is one of the frankest responses Roan has given on the subject of her supernova rise and the unsavoury experiences it has led to on social media.

For Roan, the poor behaviour of some in the online community seems to target women in the pop industry in particular. On *The Comment Section with Drew Afualo*, she

REDEFINING FAME

WITH ELTON JOHN

WITH SABRINA CARPENTER AND BILLIE EILISH (RIGHT)

expressed her disdain for this creepiness, saying that, 'People have started to be freaks, like, [they] follow me and know where my parents live, and where my sister works.' She went on to say that she'd told herself years ago that if her fame got to the point of her 'family being in danger' she'd quit altogether. Not only that, but people's intrusive behaviours have also made her reconsider doing anything to 'make [herself] more known'.

When Roan spoke out about this on her own social media, she had the support of virtually every young female artist navigating the pop scene today – all of whom know well the challenge of maintaining your safety and wellbeing as a pop star in the digital era. To name just a few, Charli XCX, Sabrina Carpenter and Billie Eilish all reached out. Miley Cyrus invited her out then defended her in an interview with *Harper's Bazaar*, stating she wishes 'people would not give [Chappell] a hard time [...] [It's] really hard coming into this business with phones and Instagram.'

The support kept pouring in. According to *Rolling Stone*, Lorde gave her tips on going incognito at the airport. Songwriters Phoebe Bridgers, Lucy Dacus and Julien Baker of the sapphic supergroup Boygenius invited her to hang out away from the stress, and singer-songwriter Mitski – who has also publicly struggled with the more overbearing people in her fanbase – sent an email commiserating, 'I just wanted to humbly welcome you to the sh*ttiest exclusive club in the world, the club where strangers think you belong to them and they find and harass your family members.' (Fewer young male artists reached out than female artists, Roan told *Rolling Stone* – but among the guys who did was her early bigtime fan, Troye Sivan.)

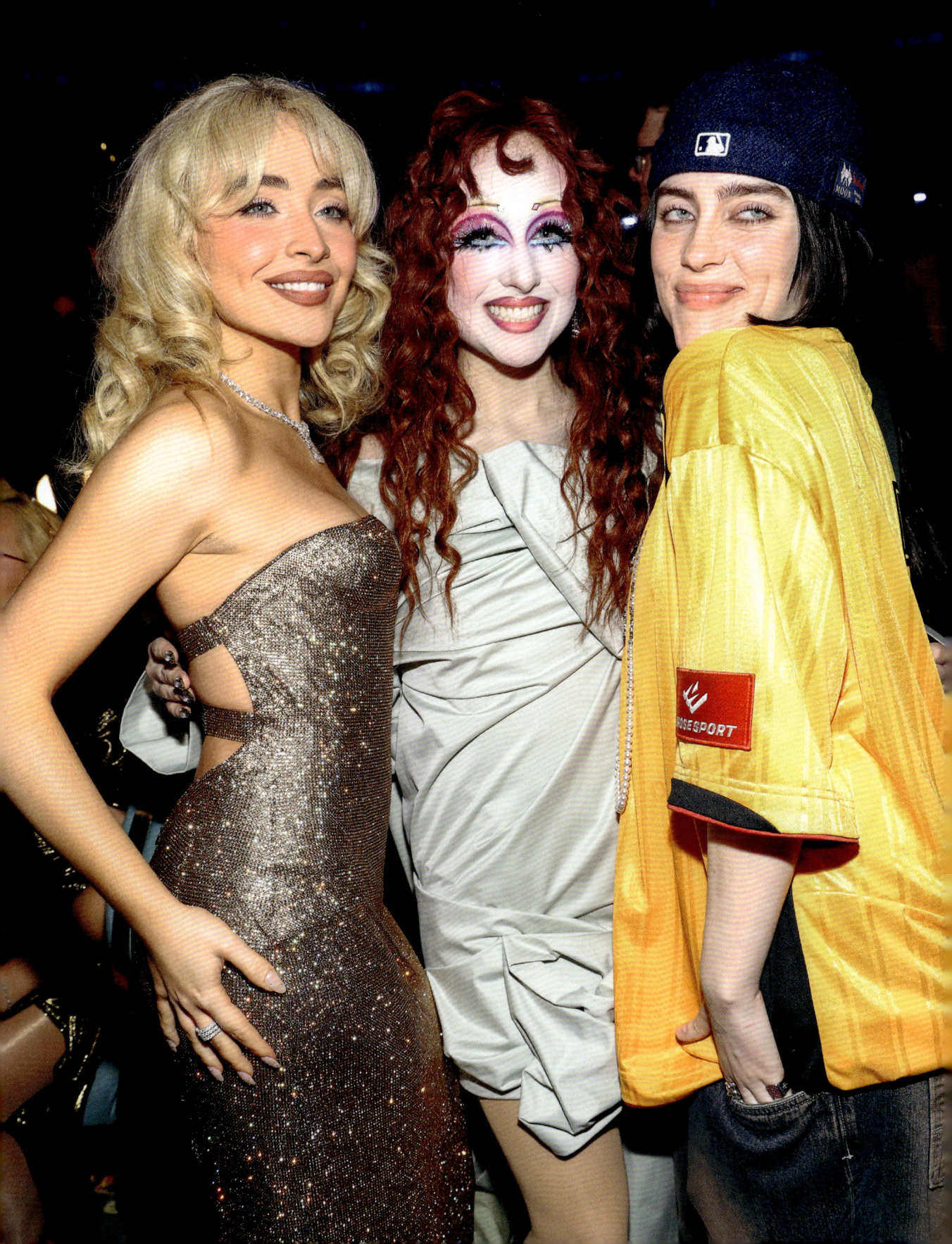

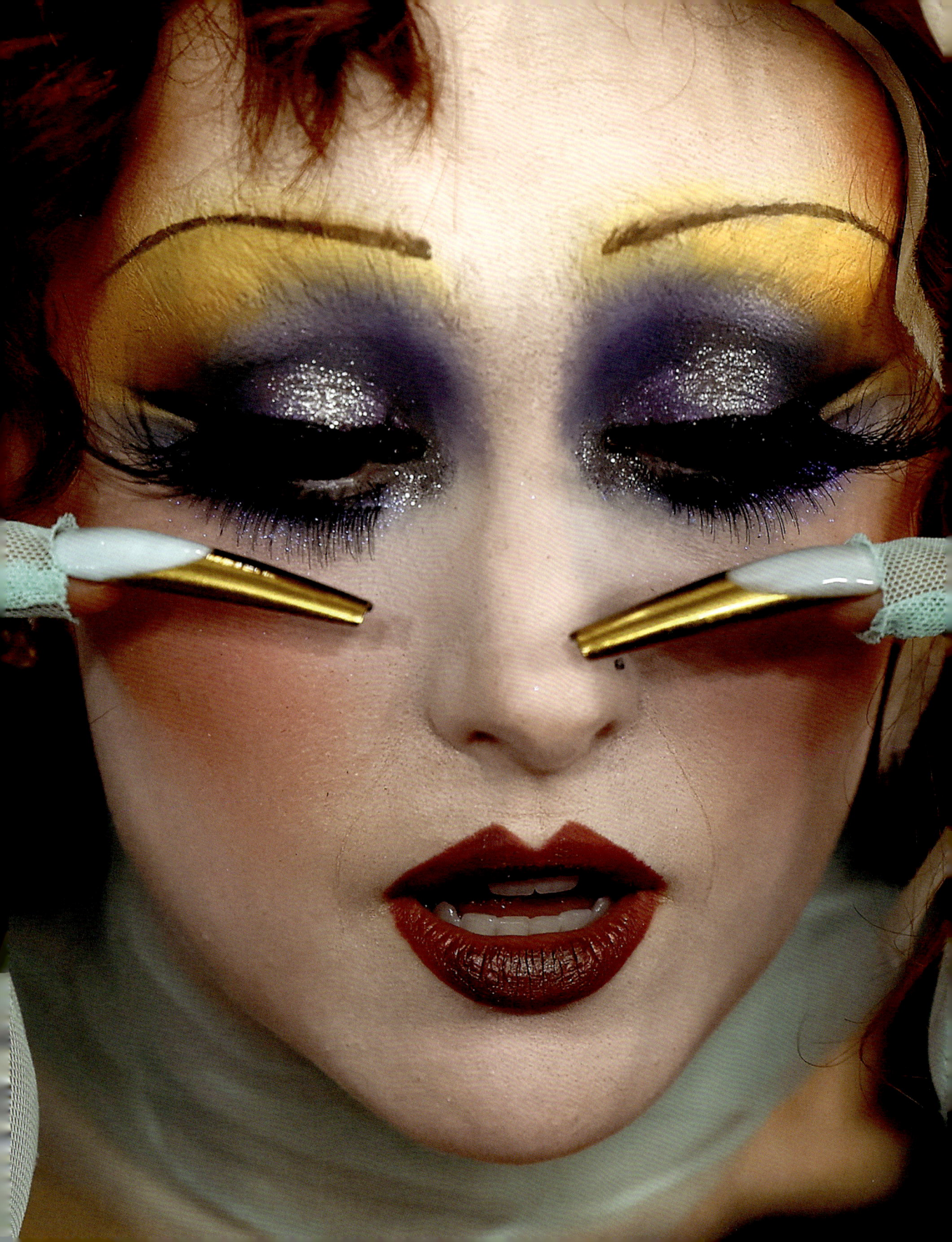

The older generations have also come to her defence, believing that the conversation about how we treat pop icons is long overdue. Lady Gaga gave Roan her number. Stevie Nicks commented in an interview with *Rolling Stone* that Chappell's schedule is 'as bad as any schedule [Fleetwood Mac] ever did, and she's new, and she's young.' She then went on to praise Roan's clear refusal to simply 'drop dead' – and noted that it's vital for women in the industry to be aware of their personal capacity so they don't completely burn out. And Elton John – who at one point checked in on Roan 11 times in 5 days – told her, 'If you need to stop, say *stop*.' His husband, David Furnish, told *Variety* in 2025 that Elton still 'keeps an eye on her.'

It's clear that there is a lot of support for Roan from within the pop community. Many pop stars have had to walk the same tightrope with social media, but Chappell Roan has been both resilient and pioneering in her willingness to vocalize this issue, despite the risk of being siloed. A notable demonstration of this was on the MTV VMA red carpet, when Chappell called out at a paparazzo who had shouted, 'Shut the f*ck up!' to her. 'You shut the f*ck up!' she said, before pointing her finger and adding, 'Don't. Not me, b*tch.' She then gathered herself and moved on and into the award show. Roan later discussed the overwhelming and scary nature of the red carpet in an interview with *Entertainment Tonight*. 'I think for someone who gets a lot of anxiety around people yelling at you, the carpet is horrifying,' she said. 'And I yelled back. I yelled baaaack – you don't get to yell at me like that.'

Similarly, while attending the premier for Olivia Rodrigo's *GUTS World Tour* movie, Chappell spotted a photographer from a previous red carpet and walked up to confront them. 'You were so disrespectful to me at the Grammys. You yelled at me at the Grammy party,' she said. 'I deserve an apology for that.' It's unclear if she ever received that apology, though, as she was quickly pulled back onto the carpet to pose for the cameras.

The supportive responses Chappell received after she called out this predatory behaviour also made her feel heard. As she told *Entertainment Tonight*, 'I do think people really listen. I feel heard, and it feels good.' She went on to explain that artists can find it hard to speak up, because they're worried about their fans hating them, but, as she said, 'We're not actually talking about fans, we're talking about people who are harassing – and if you happen to be a fan, we are talking to you.'

She reflected more on her stance during an interview with BBC Radio 1, when she was being presented with their Sound of 2025 award. Here she spoke about her mental health and said she hadn't expected the 'abuse of the machine and the internet, and people in real life.' She went on to reveal that she'd been attending therapy since the summer of 2024 to deal with the consequences of the negative fan interactions, and that she's been 'trying to grip onto' the therapeutic process, as the loss of faith she's experienced has been overwhelming. She showed a clear understanding of the overzealous nature of her fans – despite her 'not even [being] that famous', by her own estimation – and of why people approach her and other celebrities in public. But she also set a precedent by stating that it is a matter of safety. 'I know they don't know how unsafe it makes me feel,' she explained, and urged her legions of fans to step back and consider her as a human being first and foremost.

In answer to the question of whether it should fall upon Roan to make her overzealous fans understand the discomfort she feels, she replied, 'No, but they shouldn't be surprised if I say no to a photo [with them] or they shouldn't be surprised if I'm going to stand up for myself [...] Don't be surprised if I protect myself.' Referring to an industry where many people climb the ranks by kowtowing to senior executives and their unruly demands, Roan suggested she 'would be more successful if [she] wore a muzzle.' She also said that her response to disrespectful behaviour has been the same her whole life; it's just that 'now there are cameras' on her and what she's doing is not what's expected of her as a pop star. In other words, she's being true to herself – and nothing about her has changed despite her astronomic rise.

As if to perfectly illustrate this, when she was asked towards the end of the interview about scolding VIPs at Outside Lands in 2021, she retorted, 'Well, I'm on stage and I have the mic, so I can do whatever I want!' She had got ready, done her makeup and hair, got dressed up and flown there to perform for people, she said unapologetically. 'I may not be the girl you came to see, but just try...'

THE MIDWEST *Princess* TOUR

In 2023, Chappell Roan kicked off her second headlining tour, this time to support the launch of her debut album: *The Rise and Fall of a Midwest Princess*. The tour comprised 94 scheduled dates (of which 89 were performed) across 6 legs, starting in Springfield, Missouri (playing to a small crowd of 1,300) and ending in Austin, Texas in October 2024 (where approximately 75,000 people attended the show).

The tour hadn't been planned to be massive at the outset. Everyone had expected it to be the kind of starter tour undertaken by an artist who *might* become a pop star, sometime in the future. Then Coachella happened. The crowds got bigger and bigger – and Roan's promoters had to move several of the later shows to larger venues, since the original ones were beyond capacity. The festival bookers, who generally schedule musicians in a strict hierarchy, with the most popular artists on bigger stages later in the night, had to shuffle their whole lineups around. Outside Lands put her in the same timeslot – and, by implication, the same echelon – as Billie Eilish.

It's hard to overstate how busy she was at the time – when Stevie Nicks pointed out how brutal Chappell's schedule was, she wasn't exaggerating. The March 2024 leg of the Midwest Princess Tour coincided with Roan's opening spots on Olivia Rodrigo's GUTS Tour, and so she ricocheted between the two events with very little turnaround. For instance, on 9 March, she was with Rodrigo in Nashville's Bridgestone Arena. The next day, she was in Cincinnati for her own tour.

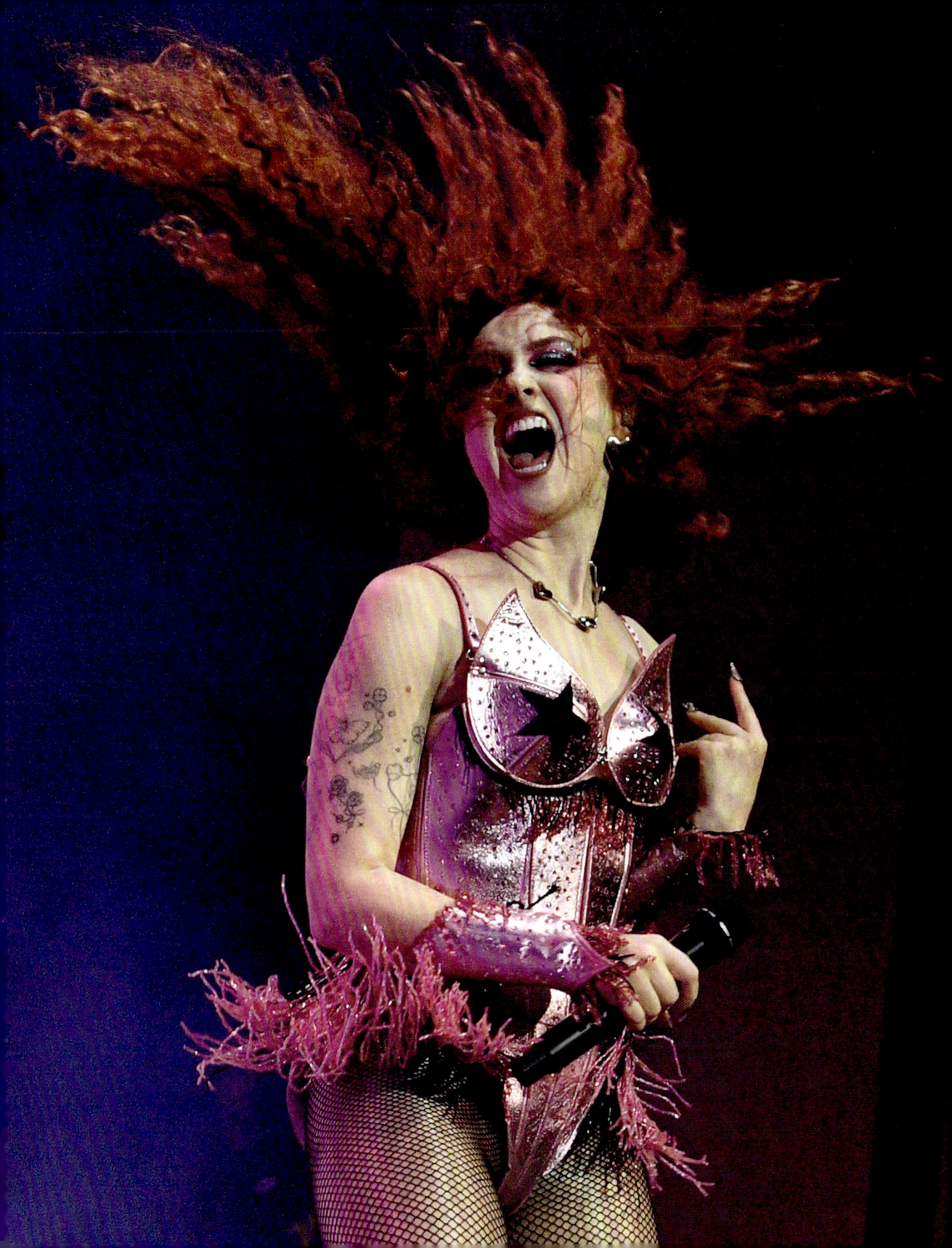

USA
20 SEPTEMBER: Gillioz Theatre, Springfield
25 SEPTEMBER: Goldfield Trading Post, Roseville
27 SEPTEMBER: The Depot, Salt Lake City
29 SEPTEMBER: Ogden Theatre, Denver
1 OCTOBER: First Avenue, Minneapolis
3 OCTOBER: The Rave, Milwaukee
4 OCTOBER: House of Blues, Chicago
5 OCTOBER: House of Blues, Chicago
7 OCTOBER: Brooklyn Bowl, Nashville
8 OCTOBER: Old National Centre, Indianapolis
10 OCTOBER: Saint Andrew's Hall, Detroit

CANADA
11 OCTOBER: The Opera House, Toronto
12 OCTOBER: Théâtre Fairmount, Montreal

USA
14 OCTOBER: The Fillmore, Philadelphia
15 OCTOBER: House of Blues, Boston
17 OCTOBER: Brooklyn Steel, NYC
18 OCTOBER: Brooklyn Steel, NYC
20 OCTOBER: 9:30 Club, Washington, DC
21 OCTOBER: 9:30 Club, Washington, DC
22 OCTOBER: The Underground, Charlotte
24 OCTOBER: Buckhead Theatre, Atlanta
25 OCTOBER: Beacham Theatre, Orlando
26 OCTOBER: Revolution Live, Fort Lauderdale
28 OCTOBER: Joy Theater, New Orleans
29 OCTOBER: House of Blues, Houston
31 OCTOBER: House of Blues, Dallas
1 NOVEMBER: Scoot Inn, Austin
3 NOVEMBER: Van Buren, Phoenix
5 NOVEMBER: 24 Oxford, Las Vegas
7 NOVEMBER: UC Theatre, Berkeley
9 NOVEMBER: Wonder Ballroom, Portland

CANADA
10 NOVEMBER: Hollywood Theatre, Vancouver

USA
11 NOVEMBER: Showbox, Seattle
14 NOVEMBER: Wiltern, Los Angeles

AUSTRALIA
24 NOVEMBER: Liberty Hall, Sydney
25 NOVEMBER: Brisbane Powerhouse, Brisbane
26 NOVEMBER: 170 Russell, Melbourne
27 NOVEMBER: 170 Russell, Melbourne

GERMANY
3 DECEMBER: Frannz Club, Berlin

THE NETHERLANDS
5 DECEMBER: Melkweg, Amsterdam

FRANCE
6 DECEMBER: Les Étoiles, Paris

UK
7 DECEMBER: Heaven, London
8 DECEMBER: Heaven, London

THE MIDWEST PRINCESS TOUR

USA
22 FEBRUARY: SOMA, San Diego
24 FEBRUARY: Jones Assembly, Oklahoma City
3 MARCH: Iron City, Birmingham
10 MARCH: Andrew J Brady Music Center, Cincinnati
17 MARCH: Val Air Ballroom, West Des Moines
25 MARCH: Higher Ground Ballroom, South Burlington
3 APRIL: College Street Music Hall, New Haven
5 APRIL: Stage AE, Pittsburgh
6 APRIL: Intersection, Grand Rapids
8 APRIL: Midland Theatre, Kansas City
9 APRIL: Boulder Theatre, Boulder
12 APRIL: Empire Polo Club, Indio
19 APRIL: Empire Polo Club, Indio
17 MAY: The Hangout, Gulf Shores
19 MAY: Jannus Live, St Petersburg
20 MAY: Firefly Distillery, North Charleston
22 MAY: Rabbit Rabbit, Asheville
23 MAY: Brown's Island, Richmond
24 MAY: Terminal B at the Outer Harbor, Buffalo
26 MAY: Harvard Athletic Complex, Boston
28 MAY: Jacobs Pavilion, Cleveland
29 MAY: The Sylvee, Madison
30 MAY: Saint Louis Music Park, Maryland Heights
1 JUNE: State Theatre, Kalamazoo
4 JUNE: Little Rock Hall, Little Rock
5 JUNE: Cain's Ballroom, Tulsa
7 JUNE: KEMBA Live!, Columbus
9 JUNE: Flushing Meadows Corona Park, NYC
11 JUNE: The NorVa, Norfolk
12 JUNE: Red Hat Amphitheater, Raleigh
13 JUNE: Columbia Township auditorium, Columbia
15 JUNE: Big Four Lawn, Louisville
16 JUNE: Great Stage Park, Manchester
19 JULY: Capitol Hill, Seattle
31 JULY: Vic Theatre, Chicago
1 AUGUST: Grant Park, Chicago

CANADA
2 AUGUST: Parc Jean-Drapeau, Montreal

USA
4 AUGUST: Avenue of the Saints Amphitheater, St Charles
11 AUGUST: Golden Gate Park, San Francisco

UK
13 SEPTEMBER: Manchester Academy, Manchester
15 SEPTEMBER: O2 Academy Glasgow, Glasgow

IRELAND
17 SEPTEMBER: 3Olympia Theatre, Dublin

UK
19–21 SEPTEMBER: O2 Academy Brixton, London

GERMANY
23 SEPTEMBER: Velodrom, Berlin

USA
1 OCTOBER: FirstBank Amphitheater, Franklin
2 OCTOBER: Walmart AMP, Rogers
3 OCTOBER: Westfair Amphitheater, Council Bluffs
6 OCTOBER: Zilker Park, Austin
13 OCTOBER: Zilker Park, Austin

THE MIDWEST PRINCESS TOUR

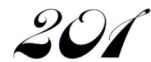

Roan's tour to promote *The Rise and Fall of a Midwest Princess* began at the Gillioz Theatre in her native Springfield, Missouri, with a capacity of just over a thousand. Footage taken by the audience shows her easily connecting with her fans from the outset, asking them, 'Aren't the queens amazing?' referring to her opening drag acts. As she tries to connect her equipment on stage, she laments, 'This outfit is really hard to breathe in!' – to which the crowd responds with a roar, unanimously cheering her on.

Dressing up is something that Roan asks of her fans – not to dress up as Roan per se, but *with* her: to be who they are. Before the Midwest Princess Tour had even begun, her Instagram was strewn with enthusiastic encouragement for people to dress up, 'Go full out, I wanna see makeup beat, outfits serving cvnt, wigs snatched. 👑 turn OUT. I promise you won't be the only one!! Be who you arrrreeee 😊😊' Fans took heed. In a video of her performance of 'Pink Pony Club' at the Gillioz Theatre, the crowd is full of costumery, proudly shaking glam cowboy hats at the stage, arms clad in fingerless gloves, flowing gossamer fabric and, in the case of one fan, full-length leather opera gloves.

For fans who wanted a little more structure to their outfit planning, Chappell announced a variety of themes for her shows – each of them styled around one of her songs or aesthetics. Every three months, she rounded up on Instagram which themes she envisioned for which tour dates. 'Swipe to find your city!!' she said on 1 September 2023. 'Every show I have a theme that is inspired by a song off the album!'

She brought these themes to life with collages of style inspirations fans could consult, and created channels in her fan Discord server devoted to each theme for people to share ideas. For example, the New York shows had a 'Slumber Party' theme – referencing 'the rush of slumber-party kissing' she immortalized in

'Naked in Manhattan.' Chappell illustrated this with a collage of girls in pyjamas hugging giant teddy bears; girls lounging in robes with green mud masks; and the cover of Britney Spears' notorious 1999 *Rolling Stone* profile in which she posed in her childhood bedroom. Other cities, like San Diego, had a black-and-red 'My Kink Is Karma' theme. Chappell's suggested inspirations included pinup-style heart-print crop tops and miniskirts; dramatic wide-brimmed black hats; and fuzzy red boas – or, for the more literal, 'kink attire if you're feeling bold. No kink shaming here ladies.' London and Glasgow, among other cities, got a 'Midwest Princess' theme of post-Y2K country fashion: Von Dutch caps; utility cargo pants with a midriff-revealing low rise; and lots of the colourful-camo trend that was all over mall shops like Rue 21 or Wet Seal in the mid-2000s.

By doing this, as Alex Jhamb Burns wrote in *Vogue*, Roan honed 'a new mode, where the outfit you wear [to a concert] is as significant a part of the experience as the music you will hear.' For fans, this extended prelude to the show – from consulting Chappell's mood boards and tracking down costume items, to hyping up one another's ideas and finished outfits online and then finally attending the show and seeing a crowd just as resplendently attired as them – makes every single Chappell Roan tour date an interactive, participatory event that can last for months.

Of course, fans could also go directly to the source and shop Chappell Roan's own wares. Like her themes, her merch is designed with purpose: a homage to her Missouri upbringing, given a hyper-femme makeover. On a light-pink T-shirt, the name of 'The Midwest Princess Tour' is emblazoned. Alongside it are hearts, cats, ponies and butterflies – symbolism that,

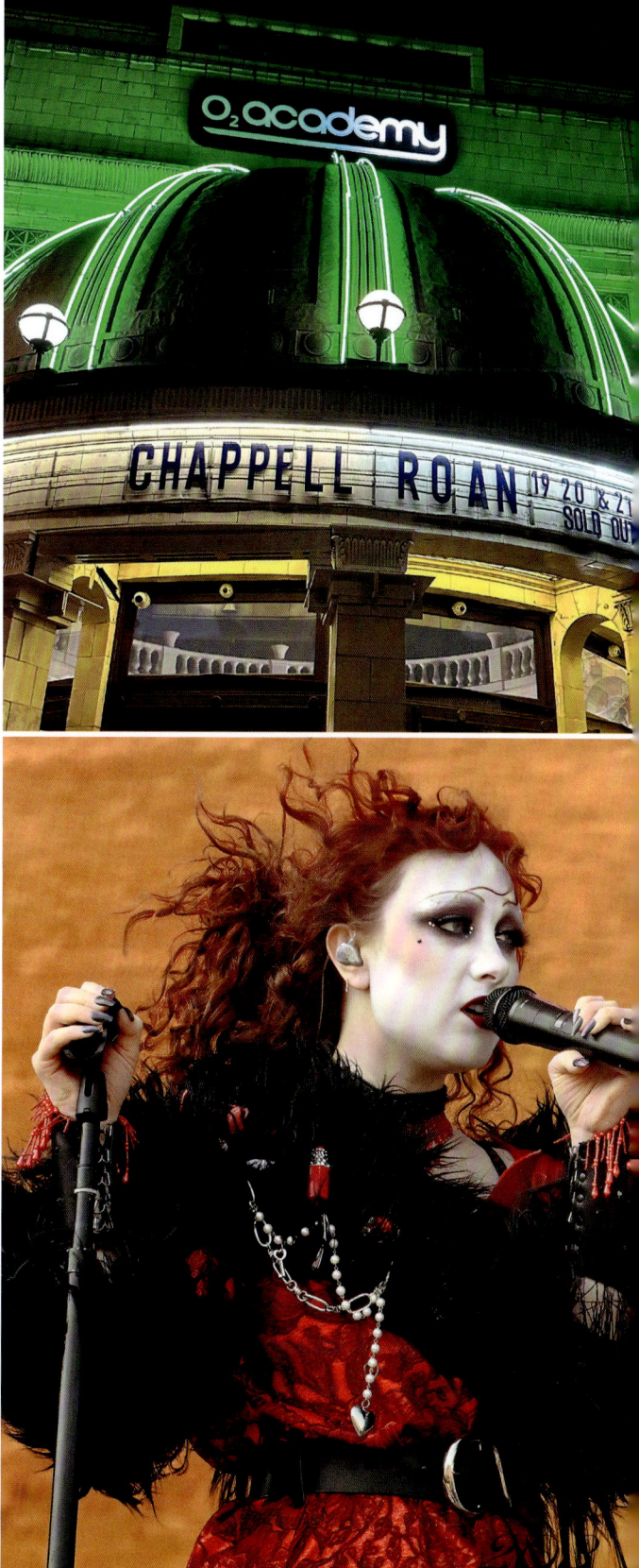

THE MIDWEST PRINCESS TOUR

with soft ribbons and pink palettes, suggests a sense of vulnerability. Another T-shirt features Roan at its centre adorned with a rainbow and butterfly wings – calling back to her iconic Coachella costume. The camo cap with the name of her album is eye-catching and once again shows Roan taking pride in her roots.

There are also stickers among her merch – specifically, tweaks of the kind of brash, political bumper stickers that can be found on certain American cars. On one, Roan parodies the popular 'HONK if you love Jesus!' sticker beloved of religious truckers, with 'HONK if you're a Midwest Princess!' – complete with a smiley-face emoji. Another sticker aims at a much more specific target: the Christian outreach billboards set alongside highways around the US by the evangelical organization Gospel Billboards. In 2017, one of these signs was posted by Highway 65 in Chappell's native Missouri. Loosely paraphrasing John 3:36, the billboard asked passing drivers, 'Where are you going: Heaven or Hell?' – the destinations illustrated with cumulus clouds and hellfire respectively, like a sermon in clipart. Chappell turns the design into a playful, self-referential and very pink ad, 'Where are you going: THE PINK PONY CLUB or HELL?' She replaces the Gospel Billboards phone number with '620-HOT-TO-GO' and turns the Bible citation into verse 3:16 of the fictional Book of Chappell.

This technically qualifies as blasphemy, at least to more orthodox religious communities – but then, Roan is no stranger to upsetting members of her own community, especially if the jokes are good and the style is flawless.

Of all the thousands of fans who flock to Roan's shows, her focus has always been on her queer fanbase and providing them a safe, celebratory atmosphere to be themselves; to those 'in the Midwest who don't have a queer space to go to, maybe my show can be that and they can dress up and feel safe.' Her confidence in creating a haven for queer kids is a huge marker of her relatability. In a 2024 interview with *IQ*, her management Adele Slater and Anna Bewers stated that inclusivity has been Roan's goal from the start, 'including gender-neutral bathrooms and accessibility for all [...] to ensure all fans feel safe and respected at every show.' She has, they noted, created 'a platform for local drag queens to open, and every show is themed to create an all-embracing and devoted community into Chappell's world, where everyone is welcome.'

Yet Chappell and her queer fans know very well how much that kind of safe environment is under attack. Slater and Bewers continue by referencing 'the drag situation right now': the ongoing situation where much of the conservative United States, including a Missouri House committee, debated GOP-

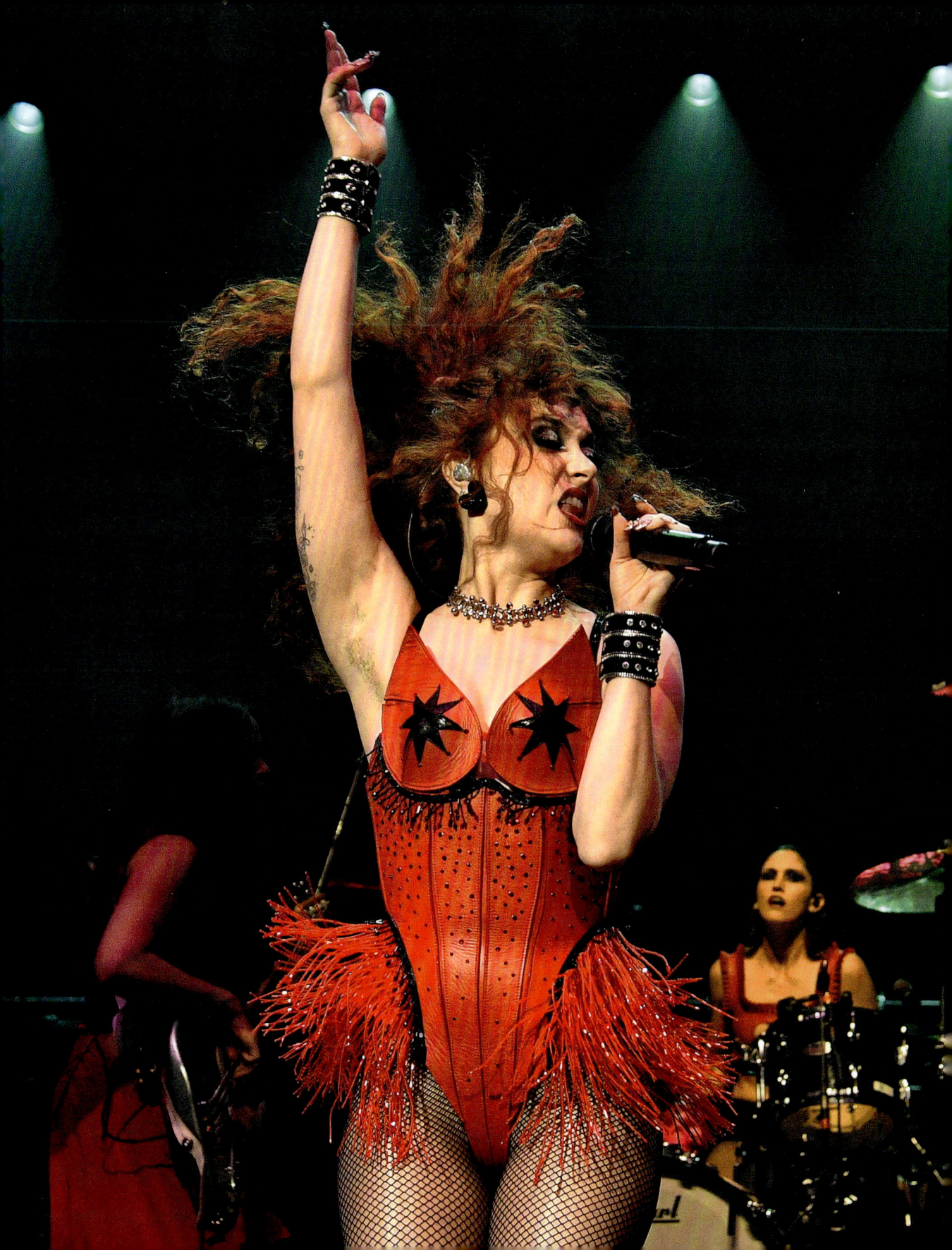

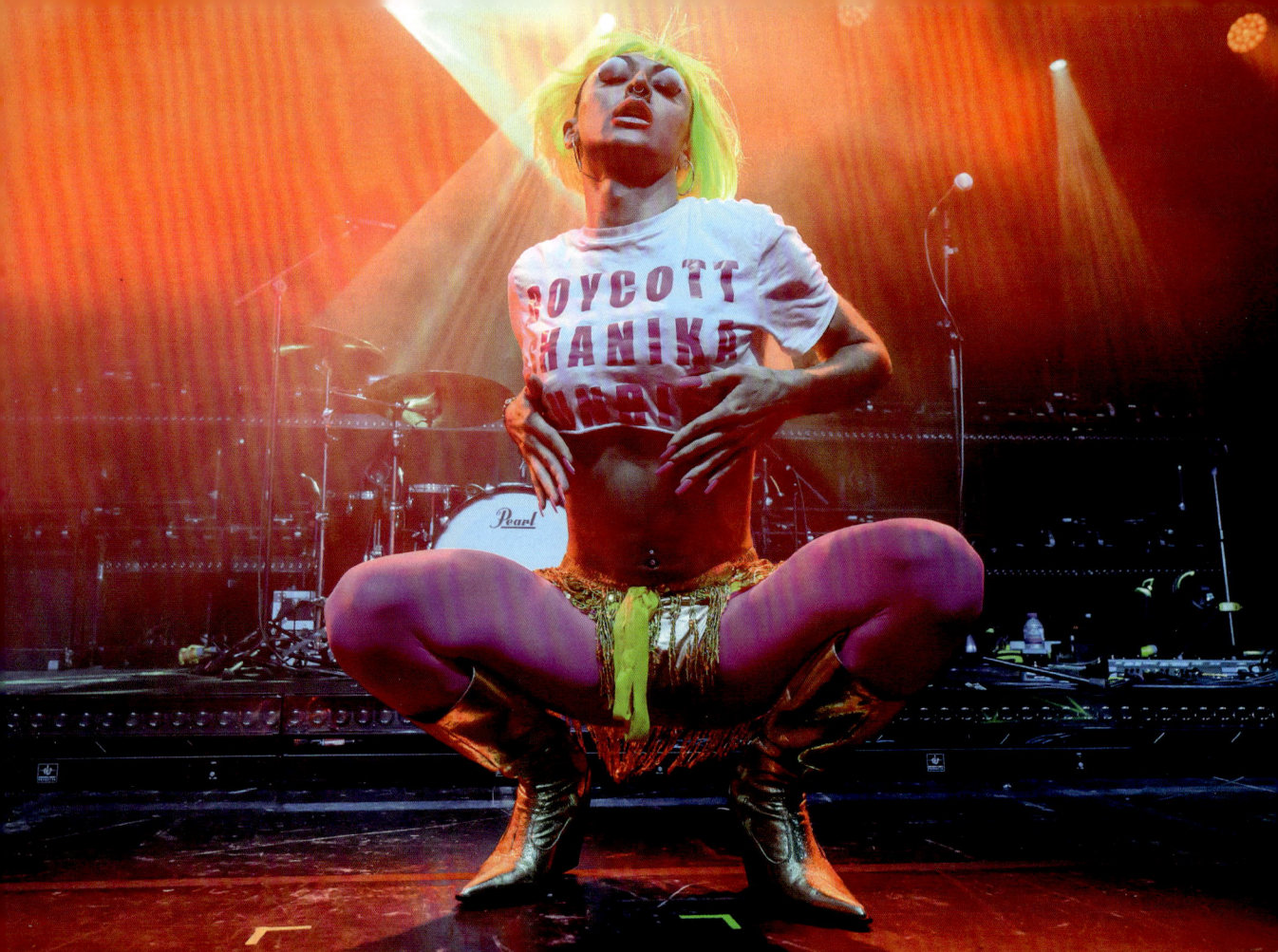

backed legislation that would restrict drag performances by claiming they're 'sexually oriented businesses', an assault on gay and trans rights that has only intensified in the months since this interview.

In the first UK leg of the tour, Roan performed at the iconic Heaven nightclub. True to form, she connected with her British fans by giving the prized opening slot to local drag queens: Bones and Inga Rock. In a pinned post on Instagram, Inga Rock said: 'Thank you @chappellroan for giving us local queens over the world a stage to shine and meet your amazing fans.' The connection to the extended LGBTQ+ community is something Roan achieves by simply taking control of her shows, and the decision to include lesser-known artists is noted on a global scale.

Roan received unanimous praise for her artistry during the tour, as reviewers marvelled at how she drew tremendous love from superfans while welcoming in thousands of newcomers, too. *Stereogum*'s headline got straight to the point, 'Chappell Roan is a Star'. Beneath it, Tom Breihan noted how Roan's all-women touring band was a bare-bones guitar/bass/drums operation, with the femininomenal synths left as backing tracks. This is the kind of setup you'd expect from an artist who hadn't thought she'd sell a couple of

thousand tickets, let alone enough to sell out the 16,000-capacity Brown's Theatre in Richmond. 'She's in that magical space where people are excited to see her, to take part, and to be excited,' he said. 'She's the right person at the right time.' The Observer's Kitty Empire meanwhile wrote about the Dublin show, 'The slow-burn breakout US star [...] delivers a set packed with witty queer energy, pulsating pop.' She, too, saw how Roan's star power was already so huge that it practically burst through the walls to escape containment of the Olympia Theatre – a smaller capacity of 1,240 – and observed, 'It's like watching lightning escape from a bottle.'

Among the tour's other notable mentions in the UK press, The Independent's Annabel Nugent remarked how Roan 'serenaded a blonde wig on a mic stand with [...] the scrappy energy of a much smaller act, totally endearing because it [was] so incongruous to her level of fame.' The Mail Online's Adrian Thrills wrote that fans seeing Roan perform live were 'witnessing the coronation of pop's next major star.'

Roan's connection to her fans in the UK was palpable, with people desperate to get tickets to the small venues as Roan's star rose. It was during her time in the UK that Roan started to be heavily critical of the constant harassment she was experiencing in her life beyond her stage persona, donning a natural look on social media and addressing the need to maintain acceptable boundaries with her fans, likening herself to a 'random lady'. Though it was by this time hard to imagine Roan being a mere 'random' person on the street, she was making an important point about her privacy and the need to be Kayleigh off stage. The feeling that she had to perform constantly already seemed to be taking its toll.

In July 2024, Roan posted on X that she 'had to jump out of the lineups for Superbloom in Munich and Lollapalooza Berlin'. In late August 2024, she announced the cancellation of further shows in France, Netherlands and Germany at the start of September (when she was now scheduled to attend rehearsals for the MTV VMAs). She vowed to 'be back' stating her 'heartbreak' about being unable to start the European leg as anticipated. She later cancelled two more September dates, this time in New York City and Columbia, Maryland, citing mental-health reasons.

Roan attracted some criticism for the cancellations, with the Mail Online writing about her fans being left disappointed and out of pocket. But the words of her late grandfather helped Roan make the choice that was best for her. 'There's something [he] said that I think about in every move I make with my career,' she told Radio 1. 'There are always options. So, when someone says, "Do this concert because you'll never get offered that much money ever again," it's like, who cares?' She continued, 'If I don't feel like doing this right now, there are always options. There is not a scarcity of opportunity. I think about that all the time.'

Throughout the cancellations, Roan continued to have strong support from her close family, with her mother Kara sharing how proud she was of her daughter. On *A Carpool Karaoke Christmas* in December 2024, after listening to 'Pink Pony Club', Kara said, 'It's kind of emotional, actually. I teared up listening to it [...] We love her so much and we're so proud of what she does and who she is, and what she stands for.'

Awards SEASON

11 September 2024

MTV VIDEO MUSIC AWARDS

- **BEST NEW ARTIST**
 Chappell Roan – **WON**

- **SONG OF SUMMER**
 Good luck, Babe! – **NOMINATED**

- **BEST PUSH PERFORMANCE OF THE YEAR**
 Red Wine Supernova – **NOMINATED**

- **BEST TRENDING VIDEO**
 HOT TO GO! – **NOMINATED**

Roan performed 'Good Luck, Babe!' at the VMAs in a medieval-themed stage set: a modern Joan of Arc wearing plate armour, flanked by voguing knights and standing in front of an imposing castle. If anyone in the VMA audience had any doubts about Chappell's Best New Artist nomination, her performance silenced them as dramatically as the flaming arrow with which she lit that castle ablaze. In one of her most vocally dynamic performances ever, she extended the high note on the bridge to theatre-diva lengths then repeated it over the final chorus with triumphant virtuosity.

STARBURST

1 November 2024

NRJ MUSIC AWARDS

- INTERNATIONAL BREAKTHROUGH OF THE YEAR – Chappell Roan – **NOMINATED**

French radio station NRJ nominated Chappell alongside Benson Boone, Dasha, Myles Smith and Teddy Swims for the title, playing host to the best of French and international music icons. Chappell did not attend the event herself, and Benson Boone won the category.

10 November 2024

MTV EUROPE MUSIC AWARDS

- BEST SONG – 'Good luck, Babe!' – **NOMINATED**
- BEST NEW ACT – Chappell Roan – **NOMINATED**
- BEST PUSH – Chappell Roan – **NOMINATED**
- BIGGEST FANS – Chappell Roan – **NOMINATED**

12 November 2024

VEVO DSCVR

- DSCVR ARTIST OF THE YEAR Chappell Roan – **WON**

Roan performed 'Red Wine Supernova' and 'Casual'. For her rendition of 'Red Wine Supernova', she wore a pink bodice with jewels and matching boots. For 'Casual', she opted for black fishnet tights with what appeared to be a latex leather bra and pants, her forearms covered in the same material. Her guitar player wore a tartan dress and leather BDSM accessories.

18 November 2024

BREAKTUDO AWARDS

- INTERNATIONAL NEW ARTIST OF THE YEAR
 Chappell Roan – **NOMINATED**

20 November 2024

ARIA MUSIC AWARDS

- MOST POPULAR INTERNATIONAL ARTIST
 Chappell Roan – **NOMINATED**

28 November 2024

DANISH MUSIC AWARDS

- INTERNATIONAL ALBUM OF THE YEAR
 The Rise and Fall of a Midwest Princess
 NOMINATED
- INTERNATIONAL HIT OF THE YEAR
 'Good luck, Babe!' – **NOMINATED**

WON

12 December 2024

BILLBOARD MUSIC AWARDS

- TOP NEW ARTIST – Chappell Roan – **WON**
- TOP FEMALE ARTIST – Chappell Roan – **NOMINATED**

STARBURST

10 January 2025

BBC RADIO 1 SOUND OF 2025

- BBC RADIO 1 SOUND OF 2025 CHAPPELL ROAN – **WON**

Roan accepted the award in a thirty-minute interview with Jack Saunders, wearing a vintage 70s YSL tartan blazer and a Vivienne Westwood W Violin shirt.

WON

25 January 2025

TRIPLE J HOTTEST 100

WON

- SONG OF THE YEAR – 'Good luck, Babe!' – **WON**

Roan accepted the award from the Australian broadcaster Triple J in a video interview, barefaced and wearing a black tank top and a grey hoodie for a relaxed and cosy look.

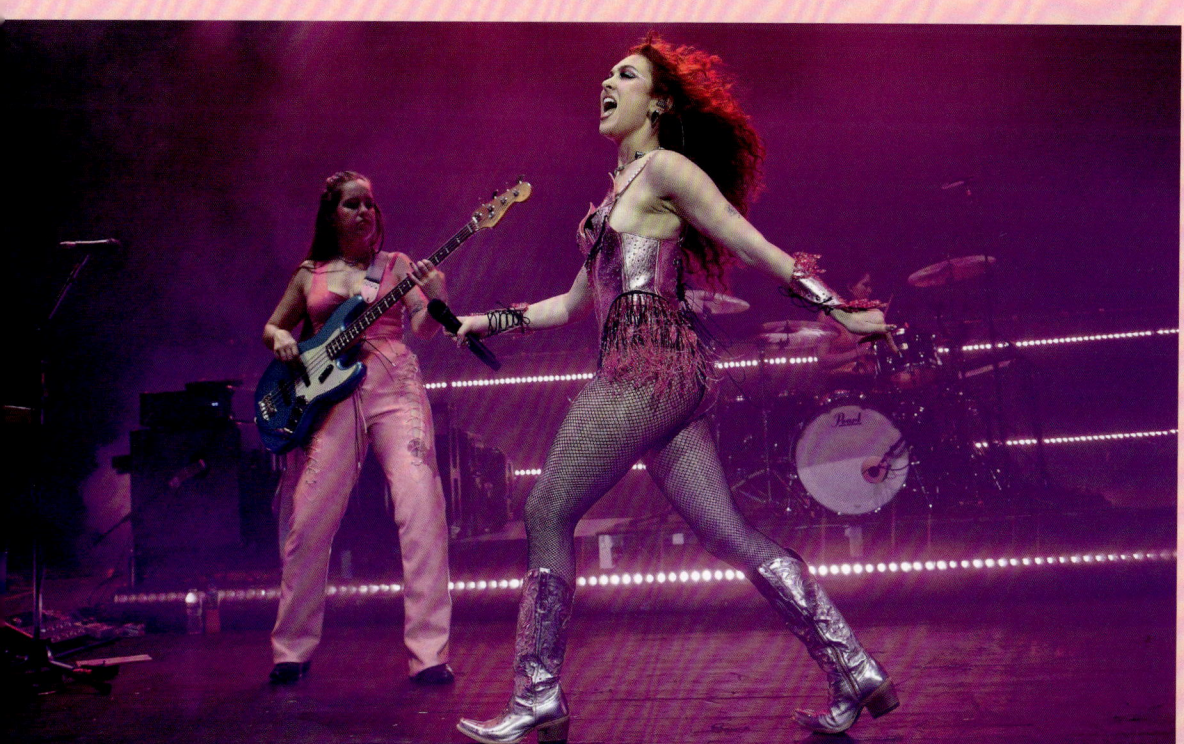

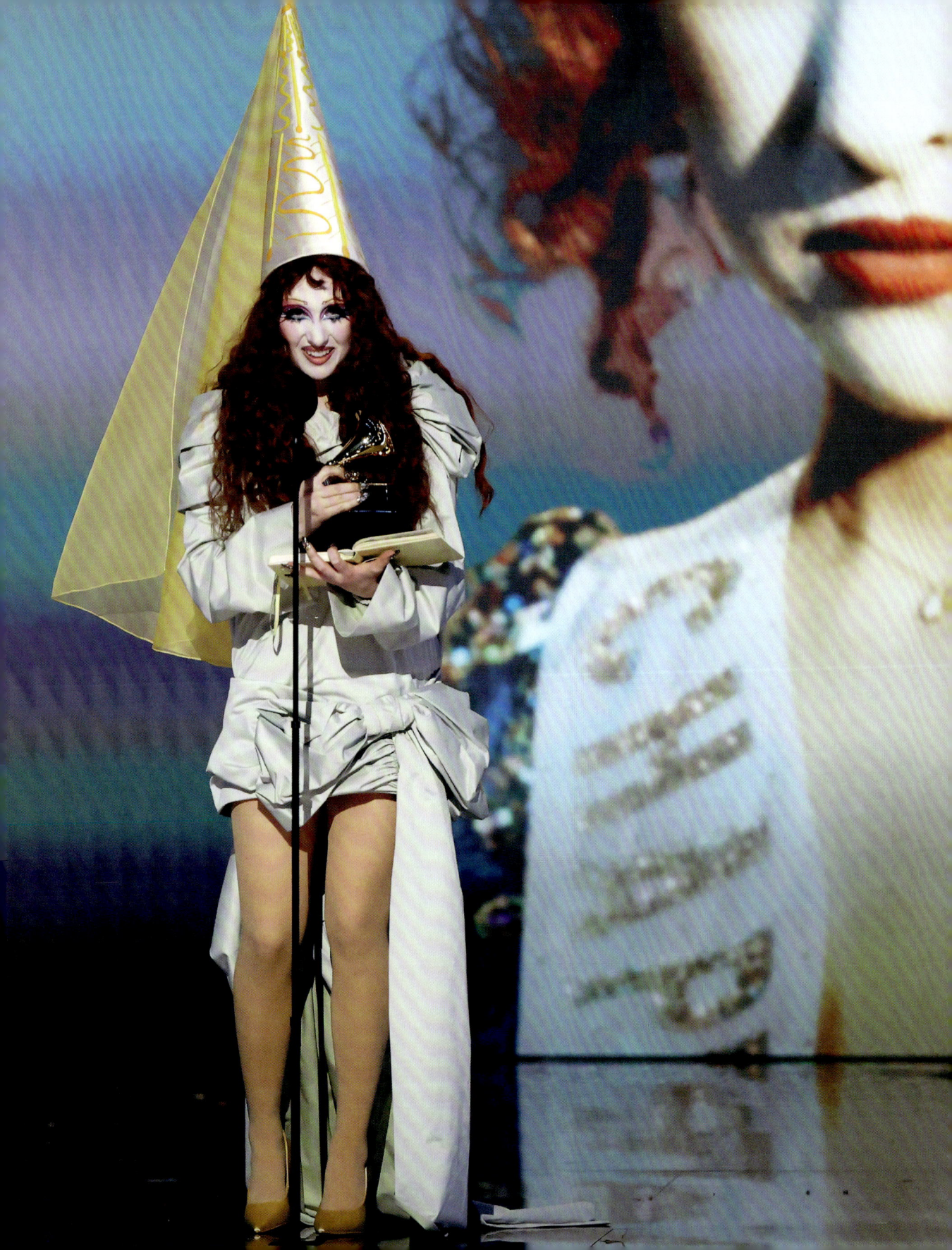

2 February 2025

WON

67TH GRAMMY AWARDS

- BEST NEW ARTIST – Chappell Roan – **WON**
- RECORD OF THE YEAR – *Good luck, Babe!* **NOMINATED**
- SONG OF THE YEAR – *Good luck, Babe!* **NOMINATED**
- BEST POP SOLO PERFORMANCE – *Good luck, Babe!*– **NOMINATED**
- ALBUM OF THE YEAR – *The Rise and Fall of a Midwest Princess* – **NOMINATED**
- BEST POP VOCAL ALBUM – *The Rise and Fall of a Midwest Princess* – **NOMINATED**

Love them or hate them, the Grammys loom over every pop star's career, especially when they're breaking out. When she was 14, Roan had announced on the modest Springfield's Got Talent stage, 'I want to win a Grammy [...] and I'm gonna do whatever it takes to get it.' When she was 17, Atlantic Records lured her with a promise of a Grammy campaign that never happened. Years later, on a new label with a new album, it finally did: six Grammy nominations, plus an invitation to perform at the ceremony.

Roan wasn't just nominated for some Grammys. She was nominated for *all* the major Grammys: the 'Big Four' of Best New Artist, Album of the Year, Record of the Year and Song of the Year. That's rare: according to *Billboard*, only sixteen artists have ever been nominated for all four in the same year. That group includes legends such as Cyndi Lauper, Mariah Carey, Tracy Chapman and Amy Winehouse – and, more recently, Roan's peers Olivia Rodrigo and Sabrina Carpenter. The number of newer musicians on the list – and the absence of the last few generations of pop megastars (with the exception of Carey) – reflects how the pop industry has evolved to trust young women with more creative control over their music, even when they're just starting out. It also indicates the breadth of Roan's talent. Record of the Year is an award for performers, while Song of the Year is specifically for songwriters. Roan is both.

AWARDS SEASON

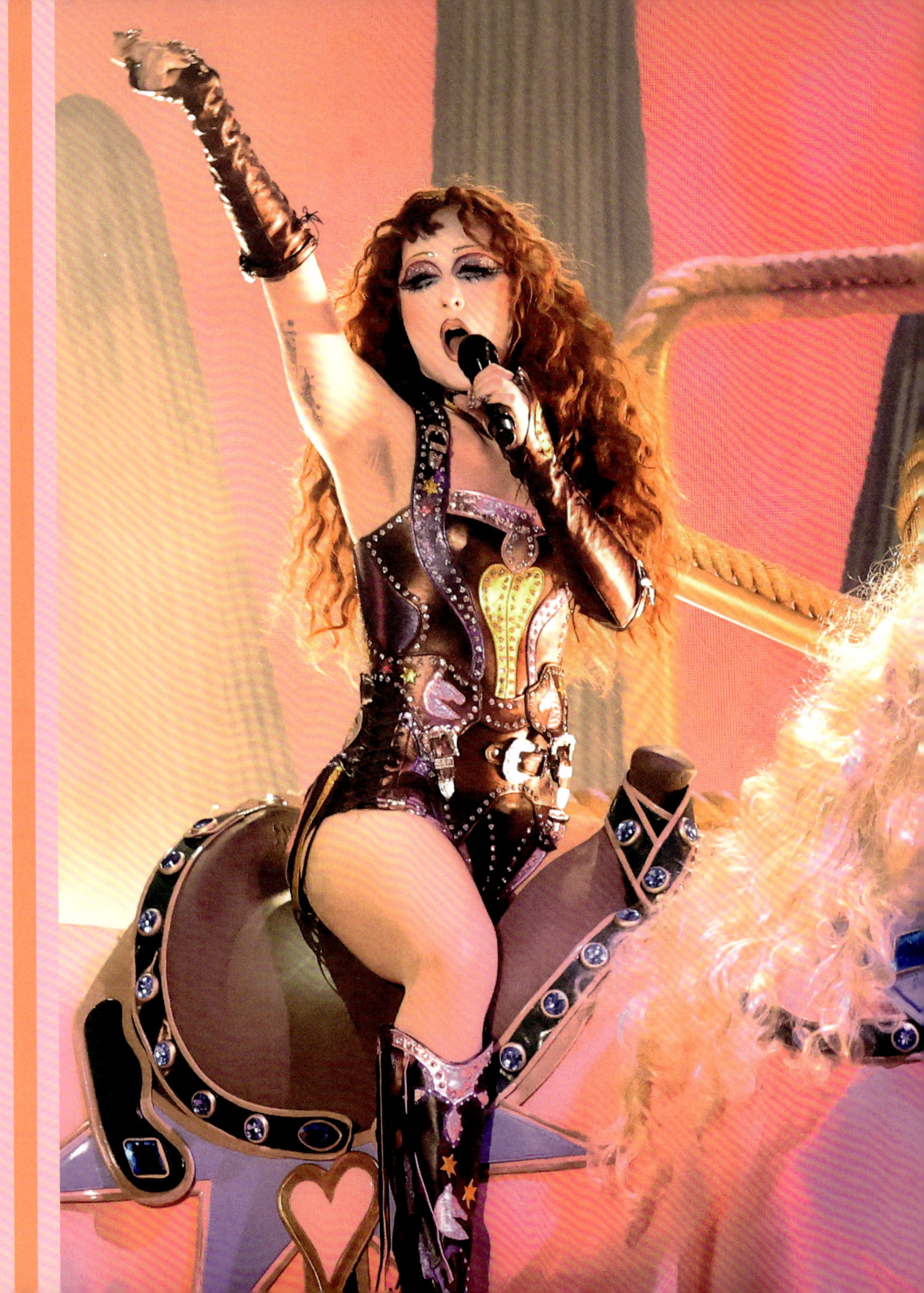

Despite the historical accomplishment, Roan approached everything with her unfiltered, goofy humour and the down-to-earth perspective of a smalltown girl. Other artists might have their PR rep assemble a bland 'honoured to accept this nomination' post, the kind of thing that AI could write (and, these days, perhaps does). Yet here was Chappell Roan responding on Facebook, 'I'm hungies – 6 Grammy nom nom nom nom nom noms!' A month later, in December 2024's *A Carpool Karaoke Christmas* with Zane Lowe, Roan visited her local Andy's Frozen Custard and proclaimed: 'I would literally have an Andy's Frozen Custard custom rather than a Grammy. I'm not kidding, I'm actually serious.'

And Chappell wasn't so starstruck as to drop her own principles. She assessed the Grammys, as an institution, with the same not-to-be-fooled rigour that she used to vet labels. In the same *Carpool Karaoke*, she told Lowe that she knew that the awards ceremony was 'a talent show for the popular kids' – but she also acknowledged the generational shift in who got to be those popular kids. 'Oh my God, how amazing is it that a gay artist wrote a gay song that went Number 1,' she said to Lowe. 'With a gay writer who did not grow up in the industry, did not have an in, has been busting her ass for like a decade? That's honourable to me.'

As always, she remained outspoken and willing to defy institutions. She also told Lowe that if she won a Grammy and got to make a speech, she planned to say 'something controversial'. Here are echoes of Fiona Apple's iconic 1997 MTV VMA speech, where she savaged the music industry, 'This world is bullsh*t.' Apple faced massive criticism for this at the time – the same old disingenuous stuff those men shouted at Roan at the airport – but Apple has since been vindicated as absolutely right. Time will tell

whether the world's truly learned that lesson, but Chappell was secure in her resilience, no matter how people might react, '[My] fearlessness comes from in my heart knowing I'm always going to be okay.'

Critics and viewers agreed: the 2025 Grammy Awards were the best that the ceremony had been in years, full of highlights with surprisingly little filler. And first among those highlights, they also agreed, was Chappell Roan – both as a performer and as a firebrand speaker for musicians' rights.

Chappell made her first impression in style during the pre-show red-carpet festivities. Her stylist, Genesis Webb, dressed her in a Jean Paul Gaultier dress from the designer's Spring/Summer 2003 show. (Webb had apparently kept her eye on that dress for ten years, telling E! that she'd 'slept with it in her room because it's that precious.') The gown is a floor-length cloud of pink and aqua pastels, with a print inspired by French painter Edgar Degas's depictions of ballerinas – an effect that is enhanced by several skirt-like tufts of tulle at the hem.

Pink and aqua are also the colours of the transgender pride flag. This was no coincidence, as Roan used her pre-show platform to speak in support of the trans community. As the rarefied ceremony got underway, an onslaught of targeted policies by the incoming Republican administration was actively endangering trans people in the United States. Along with Lady Gaga, Roan was one of only a couple of people to address this during the event. 'I would not be here without trans girls,' she told the red-carpet interviewer. 'Trans people have always existed, and they will forever exist. And they will never, no matter what happens, take trans joy away, and that has to be protected more than anything.'

Later, for her performance of 'Pink Pony Club', Chappell took West Hollywood to the Wild West. At the back of the stage set was a saloon, with glitzy stars mounted on the wall like sheriff badges, next to a punny billboard reading 'My Drink Is Karma'. Pink lightning and Barbie-esque blonde ponies zoomed by on a projected screen and through a 'Pink Pony Portal' at centre stage. Welcoming the audience to this Western world was a posse of yee-haw harlequins, in plaid work shirts and fringed leathers, pirouetting through choreography by Ryan Heffington.

And finally, wearing a studded black leather outfit and a clown-badged cowboy hat with a large pink plume, was Chappell herself, atop – what else? – a Trojan Horse-sized pink pony. The horse had been Chappell's idea and her art director, Maris Jones, had brought it to stage-storming life. 'There's nothing more iconic than combining girly fun, a hint of gold and marble elegance and Hot Wheels, baby!' Jones said of the prop.

Even on the biggest stage of her life thus far, Chappell was in strong, confident vocal form, from the low verses to the sugary pop choruses to her earnest, magnanimous bridge. Handling guitar, amid a starburst of sparks, was Andrea Ferrero, playing a custom Gibson Les Paul Tribute decked out in shiny disco-ball silver. Ferrero took the spotlight again during the finale, too, as Chappell crawled towards her with Bowie-esque stage flair. What better vindication for the 'Pink Pony Club' guitar solo than to give it pride of place on the rock institution's biggest stage?

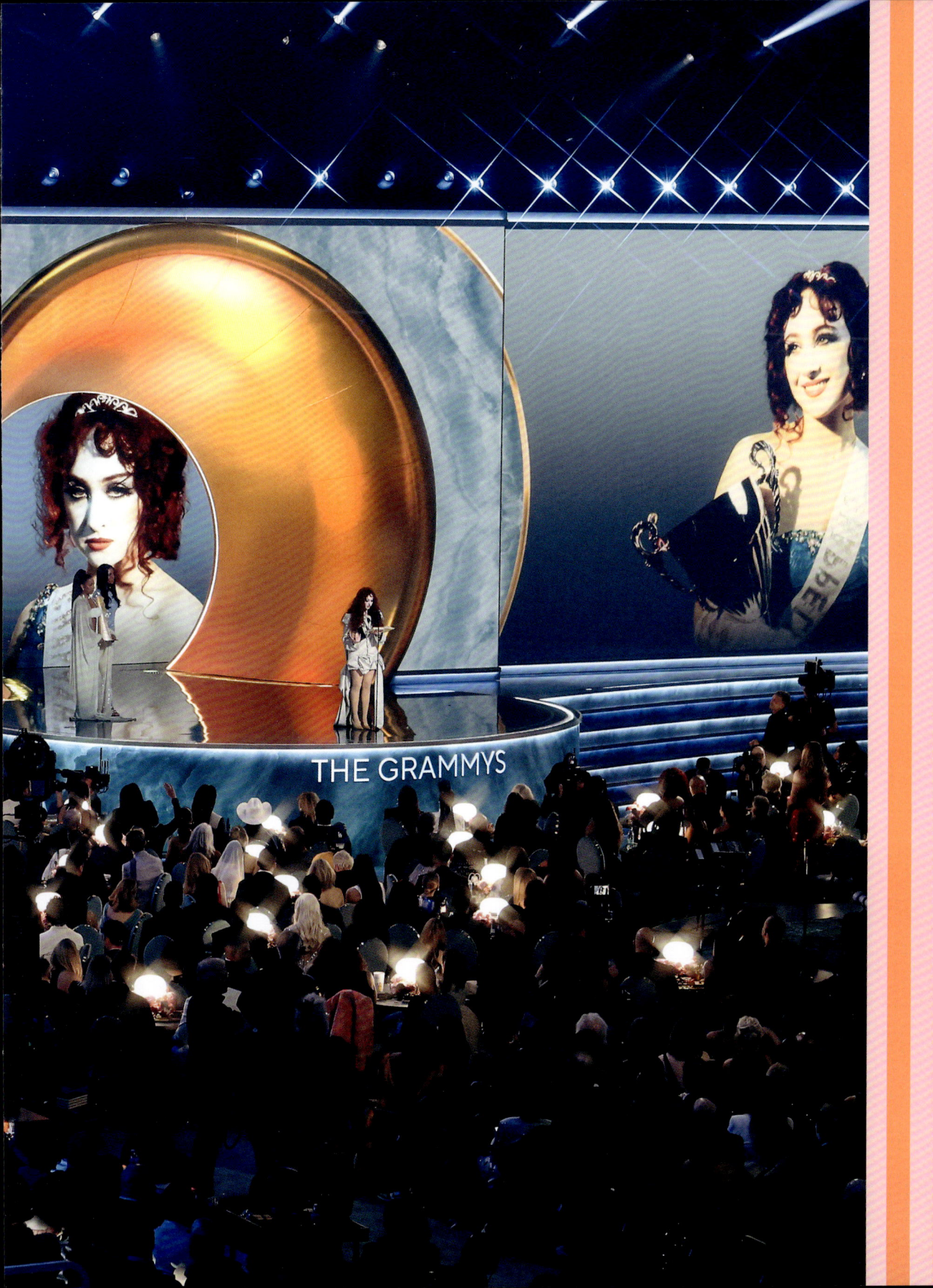

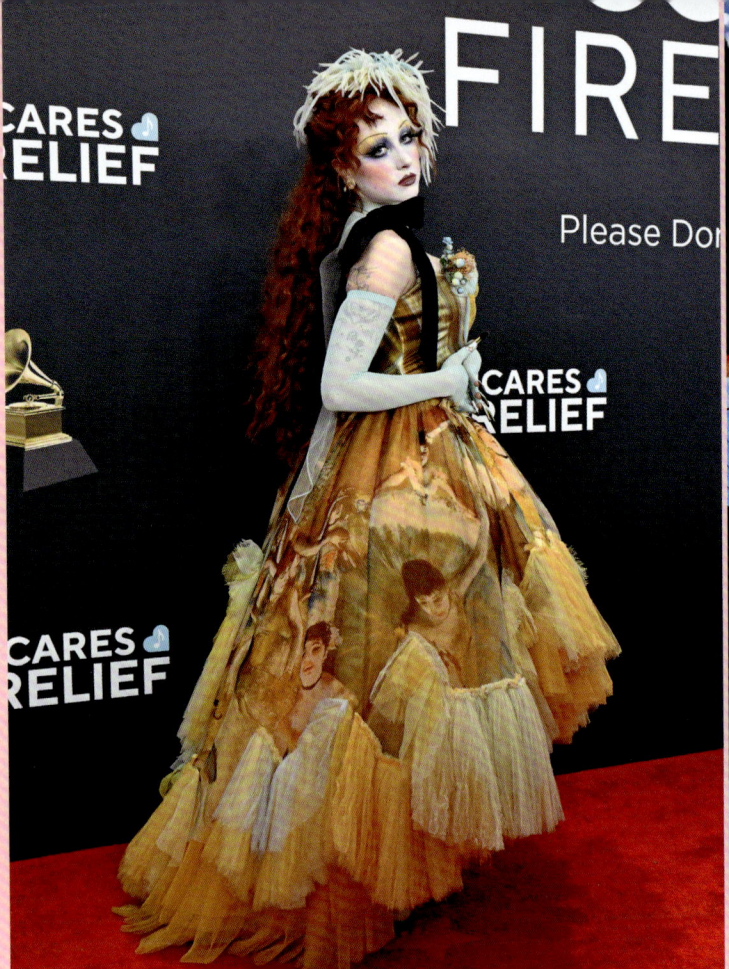

But Roan had the final word. She strutted back to centre stage to close the song in front of the majestic pink steed, now flanked by starry flags in – again – the blue, white and pink colours of trans pride.

For all its spectacle, 'Pink Pony Club' wasn't even Roan's biggest headline of the night, nor her biggest accomplishment. As a teen, she had said she'd do 'whatever it takes' to get a Grammy; that night, she achieved her teenage goal and won Best New Artist. And as an adult, she'd promised that if she did win that Grammy, she'd say 'something controversial'. Now she would achieve that goal, too.

Chappell took the stage after her third costume change: an Oscars-meets-Ren Faire gown with a large bow at the train and an equally large headdress – a gauzy white version of the 'Good Luck, Babe!' escoffion. (When the hat fell off near the start of her speech, Chappell just laughed – a true student of the showbiz school of 'the show must go on'.) Roan clutched a notebook and read out thanks and shoutouts: to her family, to Dan Nigro, to Charli XCX ('Brat was the best night of my life this year'), to her grandfather and namesake.

There was a nervous tremble in Chappell's voice as her eyes locked onto her

tiny book. The big moment was upon her, with all the gravity she'd anticipated; would she meet it? She began reading a statement she'd planned for some time, punctuating each word with a shake of the gramophone-topped award, 'I told myself, if I ever won a Grammy and I got to stand up here in front of the most powerful people in music, I would demand that labels and the industry profiting millions of dollars off of artists would offer a liveable wage and healthcare, especially to developing artists.'

She went on, 'Because I got signed so young, I got signed as a minor, and when I got dropped I had zero job experience under my belt; and, like most people, I had a difficult time finding a job in the pandemic and could not afford health insurance. It was so devastating to feel so committed to my art and feel so betrayed by the system and so dehumanized to not have healthcare.'

She turned the page, stammered; the Grammy fell from her hand. She was clearly nervous, still emotional over these events. Yet she continued. 'And if my label would have prioritized artists' health, I could have been provided care by a company I was giving everything to. So, record labels need to treat their artists as valuable employees with a liveable wage and health insurance and

protection.' And then all her nerves disappeared, and her parting shot assured her a raucous ovation and a spot in the post-Grammy highlights reels, 'Labels, we got you, but do you got us?'

Almost all the headlines called Chappell's speech and stagecraft among the best parts of the ceremony. *Rolling Stone* called her 'Pink Pony Club' set 'a spectacular highlight of the night.' Billboard wrote that 'it was crystal-clear that she was born to be a star.' And Lindsay Zoladz of *The New York Times* agreed, 'A star certainly was born Sunday night – one with guts and conviction.' Fans did indeed compare Roan's acceptance moment to Fiona's famous – and now vindicated – speech.

The charts rewarded Chappell, too. *The Rise and Fall of a Midwest Princess* re-entered the US album charts, surging to number 3 on Billboard's Top Album Sales chart as of 15 February and also cracking the top 10 of the Top Streaming Albums and Billboard 200 charts. 'Pink Pony Club' re-entered the UK's Official Single Sales chart at number 9 and later the Billboard 100 at number 5. 'Good Luck, Babe!', 'HOT TO GO!' and 'Casual' also saw streaming boosts. The Grammys had dubbed Chappell Roan the Best New Artist; now everyone seemed to be in agreement.

Everyone, that is, but one writer. Jeff Rabhan, a former music-industry exec, wrote an article for *The Hollywood Reporter* criticizing Chappell's speech. The article was typical dinosaur fare, full of infantilizing references to 'puppy dogs and ice cream', mansplanations of the contractual machinations of the music industry, which Roan had cited openly in dozens of interviews for years, and disingenuous suggestions that she wasn't doing enough – all with the smugness of the thought-terminating guy from the 'You want to improve society...yet you participate in society!' meme.

This patronizing piece was criticized by most – including *The Hollywood Reporter* itself, which ran a follow-up by 90s rock icon and Songwriters of North America co-founder Kay Hanley, 'Major labels, it's time to change your ways. The shot heard 'round the world has just been fired by a 26-year-old icon. Good luck.' Nor did it escape Chappell's notice. In an Instagram story, she called the writer's bluff, 'Wanna match me $25K to donate to struggling dropped artists? I love how in the article you said "put your money where your mouth is." Genius !!! Let's link and build together and see if you can do the same.'

Chappell had been linking and building together with others already. That month, she'd partnered with Backline, a mental-health nonprofit geared toward people in the music industry and their families, to create a mental-health fund called the 'We Got You!' campaign. Her $25,000 donation was matched by fellow Grammy pop nominees Sabrina Carpenter and Charli XCX, as well as musicians Noah Kahan and Lauv and labels and executives all the way up to the corporate juggernauts AEG Global Touring and Live Nation.

Whether those industry titans will follow through with that support remains to be seen; though $25,000 is a much smaller fee to a megacorporation than to a new artist, even a Best New Artist. For Chappell, their contributions were nevertheless a victory. For years, she'd found the music industry unwilling to truly listen to her. Now, in front of the world, she'd made it listen – and then, even for a moment, maybe reluctantly, take action.

'Labels

WE GOT YOU, BUT DO YOU GOT US?'

1 MARCH 2025

BRIT AWARDS

- **BEST INTERNATIONAL SONG**
 'Good luck, Babe!' – **WON**

- **BEST INTERNATIONAL ARTIST**
 Chappell Roan – **WON**

WON

Awards season continued to fete Chappell Roan throughout 2025. In March, she won two BRIT Awards, for Best International Song and Best International Artist. Chappell didn't attend the ceremony in person but gave her acceptance speeches on video – and she had a lot to say to those in attendance. Accepting her award for Best International Song, she once again declared her creative independence and called for a less unforgiving industry. 'Artists deserve the freedom to write bad songs and to explore horrible concepts and to flop, and rise, and not be pressured into making music based off what's trending.' And in her Best International Artist speech, she explicitly acknowledged both her marginalized fans and her activist precursors, dedicating the award to 'trans artists, to drag queens, to fashion students, sex workers, and [the late] Sinéad O'Connor.'

STARBURST

17 MARCH 2025

IHEARTRADIO MUSIC AWARDS

- POP ARTIST OF THE YEAR – Chappell Roan – **NOMINATED**
- BEST NEW POP ARTIST – Chappell Roan – **NOMINATED**
- FAVOURITE SURPRISE GUEST – Olivia Rodrigo Bringing Out Chappell Roan – **NOMINATED**
- FAVOURITE TOUR TRADITION – 'HOT TO GO!' – **NOMINATED**
- BEST LYRICS – 'Good Luck, Babe!' – **NOMINATED**
- FAVOURITE TOUR STYLE – The Midwest Princess Tour – **NOMINATED**

16 APRIL 2025

POLLSTAR AWARDS

- SUPPORT/SPECIAL GUEST OF THE YEAR – Chappell Roan – **WON**
- NEW HEADLINER OF THE YEAR – Chappell Roan – **WON**

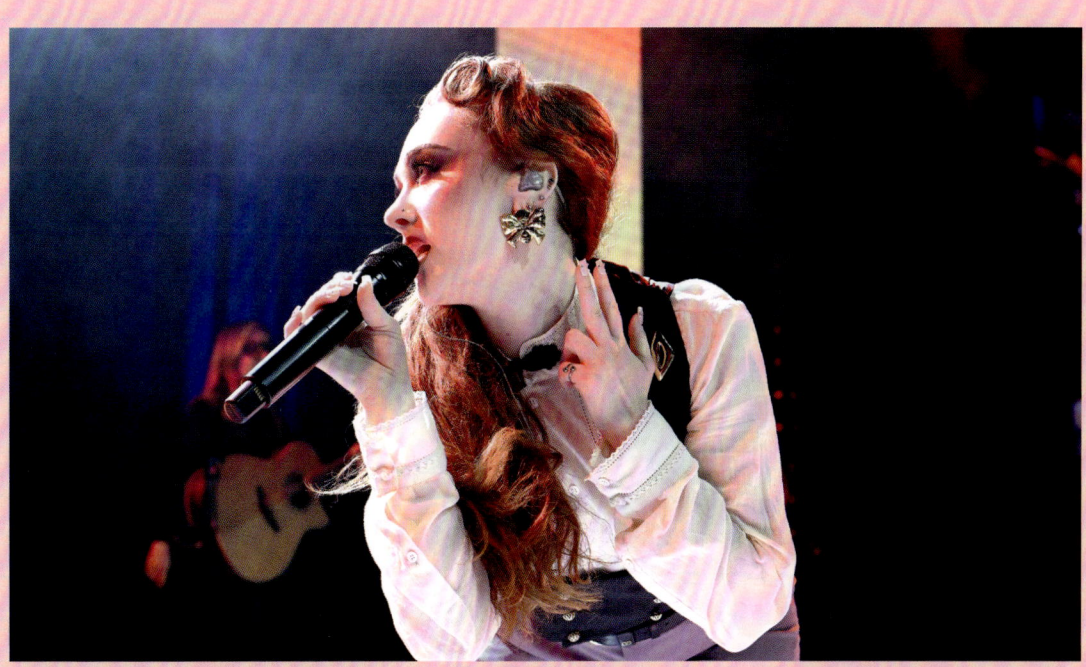

AWARDS SEASON

TV APPEARANCES

Chappell Roan was invited to be a guest on *The Tonight Show Starring Jimmy Fallon* in June 2024. The look was designed by Kentucky native Gunnar Deatherage, who reached out to her style team after witnessing her meteoric rise. After assessing Gunnar's online portfolio on social media, Chappell's style team decided to trust him with the project.

Her ensemble featured a white feathered dress and matching crown, embodying the timeless elegance of *Swan Lake*'s Odette. In conversation with *Queer Kentucky*, Gunnar explained he'd approached the theme from an abstract perspective that was 'a little more aggressive in details. The softness of the white swan with the wickedness of the black swan.' The skirt was the main inspiration, 'I had this idea of making the dress appear as though Chappell were wrapped in large swan wings. I think the end result felt very high fashion!'

For the show, Roan donned a voluminous blonde wig styled into ringlets, complemented by bleached eyebrows and monochrome makeup – marking a departure from her signature red curls and dramatic face paint. This ethereal look was completed with stiletto nails, adding to the overall 'white swan' aesthetic.

Roan ended 2024 with seemingly endless goodwill, having gained an audience willing to follow her career and her music anywhere through whatever reinvention she could dream up. On her next album, she's said, she has no desire to limit her sound. According to Rolling Stone, she and Nigro have written acoustic tracks, 80s synthpop tracks and 70s folk throwbacks. And for even more inspiration, lately she's been getting into outsider artists such as troubadour Daniel Johnston and amateur sister-act-turned-cult-phenom The Shaggs. As Chappell told *Making the Album*, for the next album, 'The songs will tell us what the vibe is.'

In November 2024, on *Saturday Night Live*, Roan debuted a new song she'd teased on Instagram a month before: a 'lesbian country anthem' co-written with Dan Nigro and called 'The Giver'. The song's a twangy take on 'Femininomenon' and 'Super Graphic Ultra Modern Girl'. Over a frolicking fiddle, Roan

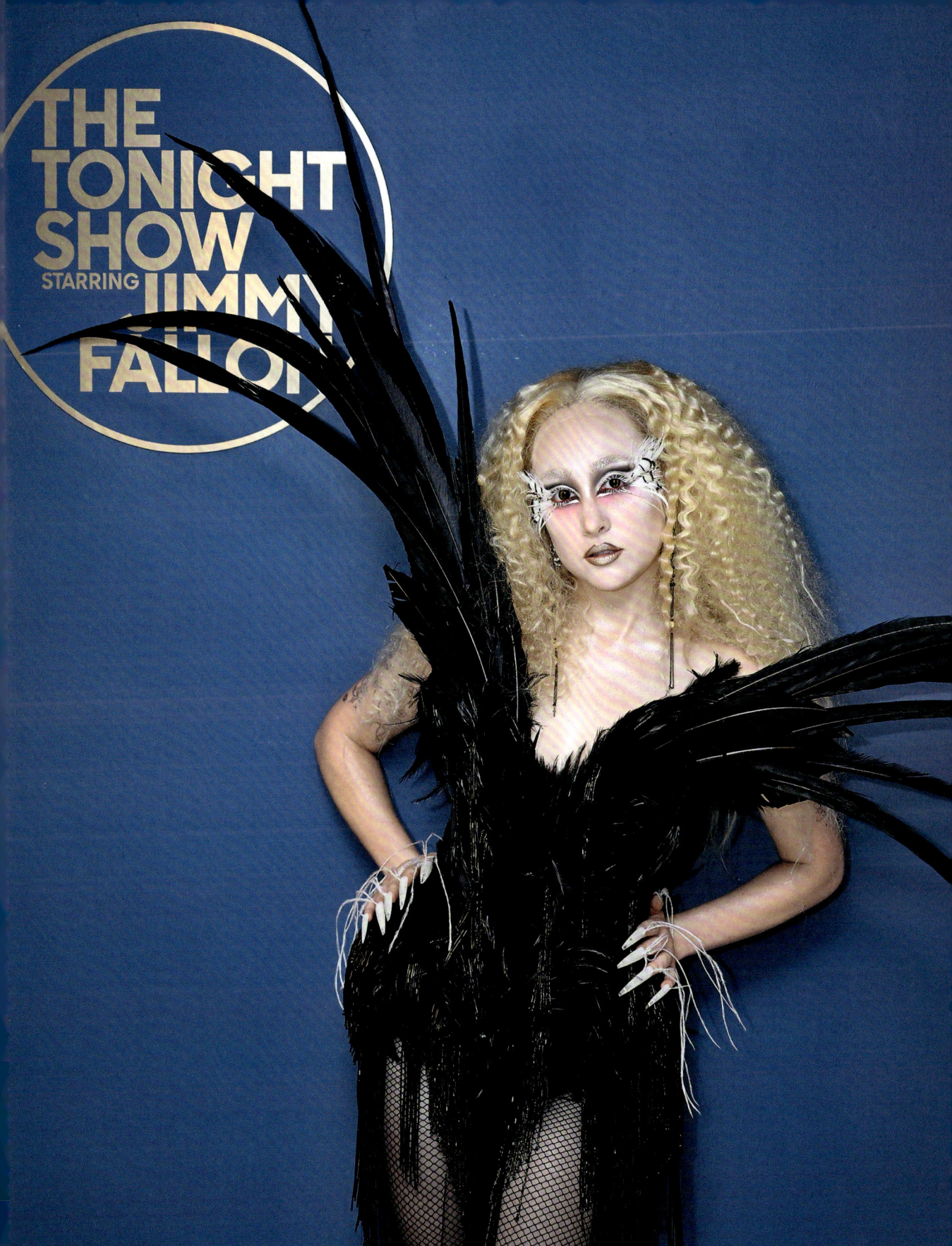

sings, 'Good luck finding a man who has the means / To rhinestone cowgirl all night long!' One awestruck YouTube commenter called back to Roan's on-stage banter, 'Isn't there supposed to be an "O" in "country"? Nope!'

Roan has a lot of country company. You might call 2019 the year of the yee-haw agenda, when Lil Nas X rocketed from Twitter fame to *fame*-fame with 'Old Town Road' – a single with huge influence, not just in stomping on the barrier between pop and country stardom, but also in freeing the next generation of artists to cross to country in a fun and perhaps gay way. The previous few decades' pop-country crossovers were much safer: adult-contemporary such as Faith Hill's 'Breathe' or Lady A's 'Need You Now' and the lite hip-hop stylings of Sam Hunt or Florida Georgia Line. When artists full-on crossed over, the music tended toward middle-of-the-road versions of the new genre. On the pop side: Lady Gaga's very un-Gaga *Joanne*; Miley Cyrus's post-*Bangerz* regression 'Malibu'; and the spate of bland country hits by alumni of shows such as *The Voice*. On the country side: Maren Morris's vocal on EDM producer Zedd's 'The Middle' or Taylor Swift's whole career since *1989*.

Fast-forward to 2024: you've got Shaboozey's smash hit 'A Bar Song', which samples J-Kwon's 2004 club-rap hit 'Tipsy', and an ascendent Orville

Peck, an openly gay man reinventing country music's rugged blue-jeans masculinity as a bedazzled form of camp. Beyoncé released the full-on genre exercise *Cowboy Carter*, and Lana Del Rey and Ed Sheeran have announced their own country pivots.

Roan isn't just jumping on the bandwagon here, though. 'Red Wine Supernova' is yee-hawed up; 'California' is an off-duty cowboy tune. Roan's vocal versatility has extended to Adele-esque crooning, quirky indie-pop voice, huge pop belting and earnest, studied yodelling. Every so often, hints of twang come out in her pop vocals – for instance, in the last couple of notes of 'Super Graphic Ultra Modern Girl'. And the influence flows in the other direction, too. Country starlet Kacey Musgraves – herself no stranger to glam pop-country, with her ebullient single 'High Horse' – covered 'Pink Pony Club' on her Deeper Well Tour in 2024. It matters that 'The Giver' is a specifically *lesbian* country song. Country music is a product of the red states, and both its fans and labels can be viciously reactionary. In 2003, the country industry destroyed the career of one of its most reliably bankable artists, girl group The Chicks (formerly the Dixie Chicks), after frontwoman Natalie Maines criticized then US president George W. Bush's authorization of the Iraq War.

By 2015, red-state bigotry had only gotten worse, and thus little had changed. Country band Little Big Town (songwriters: Lori McKenna, Hillary Lindsey and Liz Rose) released a single called 'Girl Crush' that year. The song was an update of Dolly Parton's 'Jolene' that tiptoed further into its sapphic subtext, but in a safe, deniable way. Lyrics such as 'I want to taste her lips / 'Cause they taste like you' came with a winking implication that that woman was the girlfriend of her guy crush (though the person's gender is notably never actually specified). But even this mild subtext – which some mainstream outlets argued was queerbaiting – got the song pulled from several country radio stations, pressured by irate listeners calling in about the 'gay agenda'. The song did have the support of one of country radio's biggest names, Bobby Bones, who used his show to give frontwoman Karen Fairchild a platform to denounce the prejudice, and went on record himself to say that 'it shouldn't even matter if it's a lesbian song.'

This was a brave, admirably firm stance from a man working in an extremely conservative genre. But it's also a very straight-guy thing to say. It does matter that it's a 'lesbian song'. Queer representation has been present in country music all along, both behind the scenes and on the stage. One of Orville Peck's spring 2024 singles was a cover of what some outlets called the first mainstream queer country song: Ned Sublette's then obscure 1981 single 'Cowboys are Frequently Secretly Fond of Each Other', which the far better known legend Willie Nelson frequently played on tour then recorded in 2006. Others include the band Lavender Country, as well as folk crossovers such as k.d. lang and Tracy Chapman. Even the bro-iest of bro-country tracks and trad-wifest of feminine hits are frequently the work of gay or lesbian songwriters such as Shane McAnally – the Max Martin of country music, given the sheer number of his hits – Brandy Clark and Brandi Carlile.

Carlile's interview with Roan at the Grammy Museum in November 2024 marked a passing of the torch. When Carlile likened Roan's vocal swoops to those of Patsy Cline, the message was clear: cowgirls are frequently fond of each other, too – and this time, not secretly.

A SPARKLING *Future*

There's so much to be said for Chappell Roan's ability to create her own kind of star: one who not only captivates the world, but also maintains her own personal boundaries, despite her level of fame. There seems to be nothing she can't redefine. She survived the label gauntlet, built a following of devoted queer fans, including YouTubers Troye Sivan and Connor Franta, then repaid the favour by endorsing local drag acts in her shows.

In 2024, Roan sent an email to all the fans who had subscribed to her mailing list, wrapping up her impossibly eventful year. It read:

I only released one song this year, and 'Good Luck, Babe!' did quite well for herself, if I do say so myself. It's all thanks to the lovely people who lifted this project up – with tears in their eyes, wiping sweat from their lashes after waiting in concert lines for hours upon hours, with burnt fingers from hot-gluing gems to their pink cowgirl hats, and documenting the chaos on TikTok so others could revel in the 'drag circus' of this year.

In redefining her fame by pointing at her successes as well as her stumblings, Roan is relatable not only to her fans, but also to anyone who has had to conquer internal or external doubts. She embodies the outsider who managed to make it to the biggest tables in the music business, up to and including the Grammys. In 2024's *A Carpool Karaoke Christmas*, she is aware of the fact she is no longer an outsider per se but also acknowledges that it is a 'double-edged sword' to be nominated for the music industry's most lauded televised award ceremony.

Chappell Roan is destined for a sparkling future. She embodies the authenticity and freedom that are central values of the countries where her music is most popular. As an artist, she never compromises on her vision of healthy artistry – and she won't accept the unwelcome and even dangerous behaviour of obsessive fans and intrusive strangers. A few detractors accused her of newfound entitlement for talking about her lived experience, but the overwhelming

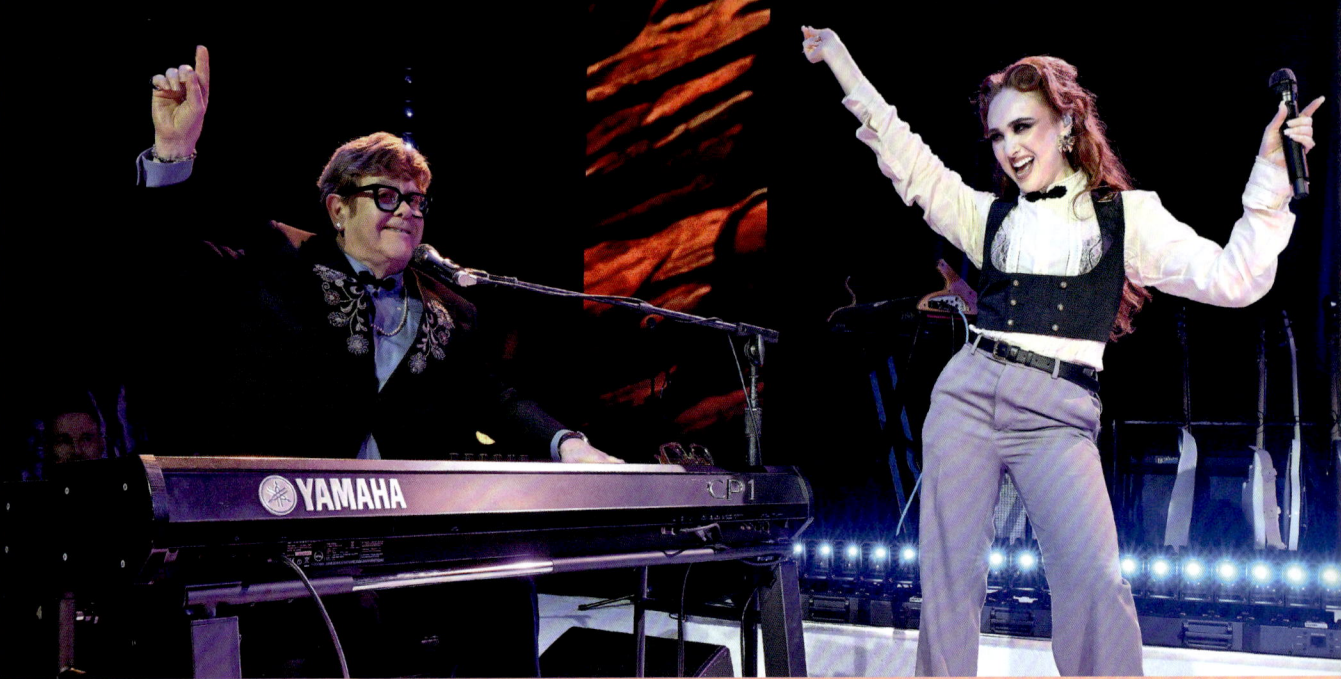

consensus has been that Roan asserting her boundaries was good and necessary: a sign that she has taken control of her fame in ways that were unavailable to young pop stars before her.

This resistance to being controlled or undermined is a theme that runs consistently through all her interviews and public-facing messaging. Speaking to *Grammy* in April 2024 about her signing to Island Records, she reiterated that she wasn't going to allow her creativity to be compromised. 'I ended up signing [in 2023] because this project honestly got too big to be independent anymore. [But] I just wasn't willing to give up anything, any creative control or for any amount of money.' She repeated that stance in her September 2024 Rolling Stone cover story, stating that she would turn down lucrative brand collaborations without hesitation if they didn't fit her musical persona, or if she didn't agree with what that brand represented. The saying that 'every man has his price' does not apply to a femininomenon: 'No amount of money is going to [make me] consider working with [someone],' she said. 'It has to be 100 per cent right.'

Another way in which Chappell Roan has redefined her fame is by not only learning hard lessons from her early career struggles and mistakes, but also being willing to risk her reputation to make sure the next generation wouldn't have to repeat them. She's shared with upcoming talent what not to do when starting out – particularly when many newly signed artists are still minors in the eyes of the law. The bravery it takes to acknowledge not only her mistreatment but also her missteps is just a further sign that Roan has a long future ahead of her, taking her fans on the journey to a healthier, mutually respectful form of fandom.

Over the 2024 holiday season, she basked in her success while scoring a few more accomplishments for the year to boot. She collaborated with Sabrina Carpenter on the 'Espresso' singer's Netflix special

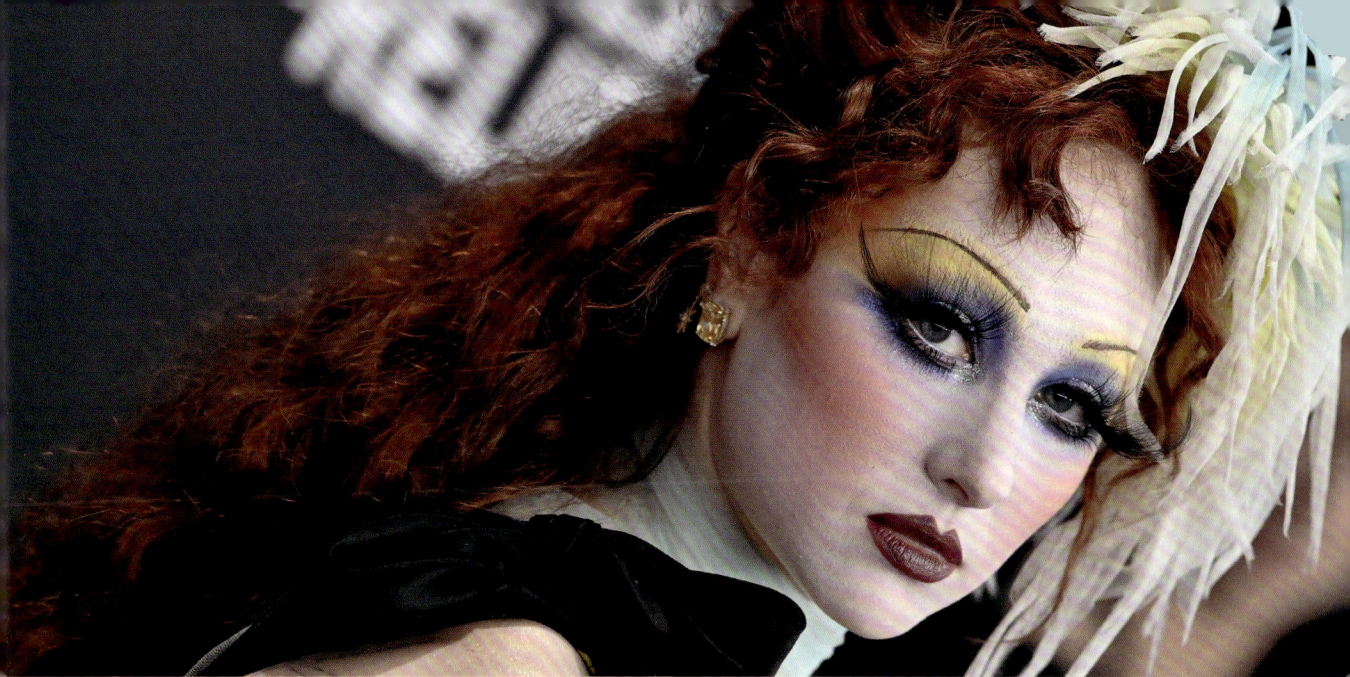

A Nonsense Christmas, singing Wham!'s festive, beloved tale of holiday heartbreak, 'Last Christmas'. There was *A Carpool Karaoke Christmas* with Zane Lowe and her parents. And she did a holiday livestream with her friend Ramisha – not the awkward, stage-managed label promotions of her past, but an authentic hangout among friends to which she invited the world. And the whole industry took note of her bounty of Grammy nominations for *The Rise and Fall of a Midwest Princess*.

Chappell has sufficiently proved herself since the success of *The Rise and Fall of a Midwest Princess* that she could now likely collaborate with almost anyone in pop music – from Carpenter and the new generation of rising popstars, to icons who are also her fans, such as Stevie Nicks and Cyndi Lauper. Her debut of 'The Giver' on *Saturday Night Live* already seems like the first of many new hits. She is determined to control her future and to give her fans what they want while asserting her own authority – as a popstar, and as a human being who needs a break from time to time.

Her star just continues to rise and rise, and she knows how to keep it aloft. On a 2024 episode of *What Happens Live with Andy Cohen*, Paris Hilton divulged the advice she'd give to Chappell Roan – 'everyone should always be nice to everyone' – and then added that Roan didn't need to heed any advice after all. Fellow guest Cyndi Lauper nodded in agreement. For her part, Lauper noted that Chappel Roan 'is visual, and you know, I love those visual things.'

Speaking of Chappell's fame, Lauper elevated her career beyond music, 'I think she's great. It's performance art.'

Not only does Roan have bags of talent and more to share with the world, but her visual performances are also gaining praise from stars with decades of experience and hits. Chappell will be studied in the history books as one of pop music's newcomers during the 2020s, but one whose supernova rise was a decade in the making. There's no doubt we'll be hearing a lot more about Chappell Roan and her art in 2026 and beyond.

SOURCES

INTRODUCTION

Joan Summers and Trixie Mattel, 'Chappell Roan is Taking It', *Paper*, 4 June 2024

Brittany Spanos, 'Chappell Roan is a Pop Supernova. Nothing About it Has Been Easy', *Rolling Stone*, 10 September 2024

Thania Garcia, 'Billboard Music Awards 2024', *Variety*, 12 December 2024

Maya Georgi and Larisha Paul, 'Chappell Roan Dedicates Best New Artist VMAs Win to the "Queer and Trans People Who Fuel Pop"', *Rolling Stone*, 11 September 2024

'Chappell Roan', *Chartmetric*, 2025 <https://app.chartmetric.com/artist/717312> [accessed 6 February 2025].

PART 1: GLIMMERINGS
FROM THE MIDWEST TO THE GLOBAL STAGE

'Willard city, Missouri', United States Census Bureau, [n.d.] <https://data.census.gov/profile/Willard_city,_Missouri?g=160XX00US2979882> [accessed 3 March 2025]

'Kayleigh Rose on Radar Radio', *Radar Radio with Megan R*, Apple, 17 June 2015

James Ray Gold, 'Traces of Gold: An Early American History of Michael Gold and His Descendants', Stone Mogen, 2002 <https://stone.mogenweb.org/authors/section1.html> [accessed 4 February 2025]

NardwuarServiette (@nardwuar), 'Nardwuar vs. Chappell Roan', *Nardwuar's Video Vault*, YouTube, 16 December 2024 <https://www.youtube.com/watch?v=CD9K5_vAGPc> [accessed 4 February 2025]

Claudia Cox, 'Part-Time Jobs and Clubbing: Inside Chappell Roan's Life Before Her Fame', *The Tab*, 21 August 2024

Bringin' it Backwards (@BringinitBackwards), 'Interview with Chappell Roan (Chappell Returns!)', *Bringin' it Backwards*, YouTube, 14 September 2022 <https://www.youtube.com/watch?v=TykZd16Cfms> [accessed 4 February 2025]

Ellise Shafer, 'Confessions of a "Midwest Princess": How Chappell Roan's Debut Album Arose from the "Deep Pits of Hell" to Become a "Dream Come True"', *Variety*, 22 September 2023

Lauren O'Neill, 'Chappell Roan on Audience Participation, Playing a Character and Being Horny', *Polyester*, 19 September 2023

Capital Buzz (@capitalbuzz), 'Chappell Roan Breaks Down Every Song On "The Rise and Fall of a Midwest Princess"', *Making the Album*, YouTube, 16 January 2024 <https://www.youtube.com/watch?v=PF96UOuIHw0> [accessed 5 February 2025]

Martha McHardy, 'Chappell Roan's Uncle is Missouri GOP Rep., Sponsored Anti-Abortion Bill', *Newsweek*, 26 September 2024

Claudette Riley, 'Incumbent Darin Chappell Faces Challenger Bryce Lockwood for Missouri House 137', *Springfield News-Leader*, 26 September 2024

Avery Stone, 'A Night Out with Chappell Roan', *Nylon*, 11 July 2023

MUSICAL ROOTS & EARLY INSPIRATIONS

'Kayleigh Rose on Radar Radio', *Radar Radio*

Anderson-Burris, 'Mary Maxine (Tomlin) Lansdown', *Oklahoma Cemeteries*, 1 February 2022 <https://www.okcemeteries.net/garfield/memorialpark/l/LansdownMary.htm> [accessed 4 February 2025].

Bringin' it Backwards (@BringinitBackwards), 'Interview with Chappell Roan', *Bringin' it Backwards*, YouTube, 29 May 2020 <https://www.youtube.com/watch?v=OUELORAMn2c> [accessed 4 February 2025]

Kate Atkinson, 'Interview with Chappell Roan', *I Dream of Vinyl*, 7 May 2020

Chappell Roan (@chappellroan), 'Episode 1: Homecoming', TikTok, 23 August 2023 <https://www.tiktok.com/@chappellroan/video/7270333826914635050?lang=en> [accessed 4 February 2025]

Kathryn Lindsay, 'The Drop: Exclusive Music Video Premiere For Chappell Roan's "Die Young"', *Refinery 29*, 3 January 2018

Josh Osman, 'Chappell Roan is a Rising Queer Pop Princess', *Gay Times*, 31 August 2023

Chappell Roan (@Chappell Roan), 'Hey! I'm going live', Facebook, 22 September 2017 <https://www.facebook.com/ChappellRoan/videos/1687947594571938/> [accessed 4 February 2025]

Claudette Riley, 'Willard Community Named One of Nation's Best for Music Education – Again', *Springfield News-Leader*, 28 March 2016

'Exclusive Interview with "Chappell Roan"', *Illustrate*, 19 June 2022

Maria Sherman, 'A Conversation with Chappell Roan, the Yodelling, Queer Pop Icon of Tomorrow', *The Seattle Times*, 3 October 2023

Chappell Roan (@chappellroan), 'OK this song obviously did not age well', TikTok, 1 February 2022 <https://www.tiktok.com/@chappellroan/video/7059562957663161646?lang=en> [accessed 4 February 2025]

Chappell Roan (@chappellroan), 'Ella Marija Lani Yelich-O'Connor please please lemme into heaven', TikTok, 2 February 2022 <https://www.tiktok.com/@chappellroan/video/7060215257024908591?lang=en> [accessed 4 February 2025]

BREAKING OUT: MUSICAL INFLUENCES & LOCAL FAME

Canton Post, 'From School Days to "School Nights": Former Willard Student Hits All the Right Notes', *Willard High School*, 2018 <https://web.archive.org/web/20240410174828/https://www.willardschools.net/site/default.aspx?PageType=3&DomainID=8&ModuleInstanceID=2379&ViewID=6446EE88-D30C-497E-9316-3F8874B3E108&RenderLoc=0&FlexDataID=4351&PageID=9> [accessed 4 February 2025]

Shaad D'Souza, 'Chappell Roan, Pop's Next Big Thing: "I Grew Up Thinking Being Gay Was a Sin"', *The Guardian*, 29 December 2023

Oasis Hotel & Convention Ctr (@springfieldoasis), 'After winning Springfield's Got Talent at the Oasis, Chappell Roan said she had goals to win a Grammy', Instagram, 20 June 2024 <https://www.instagram.com/springfieldoasis/reel/C8cwyxYPjq1/> [accessed 4 February 2025]

Bringin' it Backwards, 'Interview with Chappell Roan (Chappell Returns!)'

Gregory J Holman, 'Chappell Roan is a Singer from Willard. She Just Made the Big Time.', *Springfield News-Leader*

Chappell Roan (@chappellroan), 'My summer camp friends surprised me & i literally cried', TikTok, 22 August 2023 <https://www.tiktok.com/@chappellroan/ideo/7269924811096 3094827?lang=en> [accessed 4 February 2025]

The Mystery Hour (@The Mystery Hour), Facebook, [n.d.] <https://www.facebook.com/login/?next=https%3A%2F%2Fwww.facebook.com%2Fthemysteryhour%2F> [accessed 11 March 2025]

Matthew Kent, 'On the Rise: Chappell Roan', *The Line of Best Fit*, 22 June 2023

John Serba, 'All These Famous People Attended the Same Small Northern Michigan Arts Camp', *Michigan Live*, 6 August 2017

Bowen Yang, 'Chappell Roan and Bowen Yang on Queers, Fears, and Surviving Superstardom', *Interview*, 19 August 2024

Craig Manning, 'How an Interlochen Alumnus Became the Most Talked-About Pop Star of the Summer', *The Ticker*, 11 August 2024

Creative Knightmare (@CreativeKnightmare), 'Chappell Roan Before Fame Documentary (2014)', YouTube, 24 August 2015 <https://www.youtube.com/watch?v=Cxr9KZkhgFw> [accessed 3 March 2025]

THAT GOOD HURT: SCHOOL NIGHTS

Jai Garret, email to author, 2024

'Kayleigh Rose on Radar Radio', *Radar Radio*

'Kayleigh Rose', *CD Baby*, 2015 <https://web.archive.org/web/20150414044516/http://www.cdbaby.com/Artist/KayleighRose> [accessed 4 February 2025]

Sabrina Shahryar, 'Chappell Roan to Release Debut Album "The Rise and Fall of a Midwest Princess" on September 22', *Crucial Rhythm*,

12 September 2023

James Factora, 'Troye Sivan Saw Chappell Roan's Success Coming a Decade Ago', *Them*, 22 April 2024

Isabella I, 'Did Connor Franta Just Spill the Tea on His Past with Troye Sivan?', *Instinct*, 14 August 2024

Holman, 'Chappell Roan is a Singer from Willard', *Springfield News-Leader*

Spanos, 'Chappell Roan Is a Pop Supernova', *Rolling Stone*

Chappell Roan Hub (@chappellroanhub), 'Chappell Roan signing her contract with Atlantic Records in 2015', Instagram, 27 February 2025 <https://www.instagram.com/chappellroanhub/reel/DGlC4U3M-cC/> [accessed 11 March 2025]

Bringin' it Backwards, 'Interview with Chappell Roan'

NardwuarServiette, 'Nardwuar vs. Chappell Roan'

Shelby Styron, 'Have Yourself a Merry Little Christmas – Chappell Roan', *Ozarks First*, 21 December 2018 <https://www.ozarksfirst.com/yesterday/have-yourself-a-merry-little-christmas-chappell-roan-12-21-18/> [accessed 4 February 2025]

Prozac Dealer Indie Archive (@Prozacdealer), 'Chappell Roan live interview 2017', YouTube, 25 October 2024 <https://www.youtube.com/watch?v=n8QADTL2CRY> [accessed 11 March 2025]

Kat Visti and Cami Liberty, 'Chappell Roan: Interview', *Unclear*, 10 December 2017

Chappell Roan (@chappellroan), 'I wrote this about a boy who was literally so mean to me in high school lol', TikTok, 23 March 2022 <https://www.tiktok.com/@chappellroan/video/7078108366291127595> [accessed 4 February 2025]

Chappell Roan (@ChappellRoan), 'Bad for You (Acoustic)', YouTube, 28 September 2017 <https://www.youtube.com/watch?v=ielgkjfVJt0> [accessed 4 February 2025]

Summers and Mattel, 'Chappell Roan is Taking It', *Paper*

Angela Peterson, 'Chappell Roan Moves Majestic Crowd with Impeccable Musical Connection', *The Badger Herald*, 14 March 2018

'School Nights Performed by Chappell Roan', *Setlist FM*, [n.d.] <https://www.setlist.fm/stats/songs/chappell-roan-6bcad6ce.html?songid=3f409db> [accessed 4 February 2025]

Mitch Mosk, 'Premiere: Chappell Roan's Haunting "Bitter" Dwells in Darkness', *Atwood Magazine*, 1 February 2018

'Holding onto anger is like drinking poison and expecting the other person to die', *Fake Buddha Quotes*, 26 June 2012

Crystal Llamas, 'Chappell Roan's Journey with Bipolar Disorder', *BP Hope*, 3 February 2025

Ms. Dacity, 'Chappell Roan: The "Kaleidoscope" interview', *Daily Trojan*, 30 March 2023

Visti and Liberty, 'Chappell Roan: Interview', *Unclear*

Lola Jacob, 'Chappell Roan Releases Her Debut Album "The Rise and Fall of a Midwest Princess"', *Coup de Main*, 22 September 2023

THE NAME 'CHAPPELL ROAN' & THE ORIGINS OF AN ICON

Sonya Ribner, 'Slumber Party Pop: A New Authenticity with Chappell Roan', *Cherwell*, 12 August 2022

Visti and Liberty, 'Chappell Roan: Interview', *Unclear*

Ribner, 'Slumber Party Pop', *Cherwell*

Justin Enriquez, 'Chappell Roan Goes Uncharacteristically Barefaced and Barefoot in New York City as Rising Star Shares New Instagram Snaps', *Mail Online*, 4 July 2024

Nicole Fell, 'Chappell Roan Opens Up About Her Mental Health, Love and Onstage Persona: "Chappell Is a Character"', *The Hollywood Reporter*, 8 November 2024

Abby Monteil, 'From Joan of Arc to Lady Liberty, 7 Chappell Roan Looks Perfect for Halloween', *Them*, 16 October 2024

NardwuarServiette, 'Nardwuar vs. Chappell Roan'.

Q with Tom Power (@QwithTomPower), 'Chappell Roan on the Rise and Fall of a Midwest Princess, Perseverance and the Freedom of Drag', *Q with Tom Power*, YouTube, 19 October 2023 <https://www.youtube.com/watch?v=f5UBV_Gpihg> [accessed 5 February 2025]

Crayola aka Gigi Zahir (@crayolathequeen), Instagram, 3 October 2024 <https://www.instagram.com/p/DAqFrgQqM2r/?hl=en> [accessed 3 March 2025]

Nuray Bulbul, 'Chappell Roan's Google "Easter Egg": "Your Favourite Artist's Favourite Artist" Takes Over Search Engine', *The Standard*, 21 June 2024

Jonathan Graffam-O'Meara, 'Can a Woman be a Drag Queen? Chappell Roan Shows Anyone of Any Gender Can Perform in Drag', *The Conversation*, 9 July 2024

NPR Music (@nprmusic), 'Chappell Roan: Tiny Desk Concert', YouTube, 21 March 2024 <https://youtu.be/w4WiXKGCJhg?si=aA0ch SJTTNqGr4lu&t=240> [accessed 5 February 2025]

foxiegaspie, 'Midwest Princess Tour/Festival Show FAQ', Reddit, 30 March 2024 <https://www.reddit.com/r/chappellroan/comments/1br3z4o/midwest_princess_tourfestival_show_faq/?rdt=48049> [accessed 5 February 2025]

Bianca Betancourt, 'A Behind-the-Scenes Look at Chappell Roan's Legendary *Saturday Night Live* Debut', *Harper's Bazaar*, 8 November 2024

Brittany Spanos, 'Chappell Roan is the Independent "Thrift Store Pop Star" Ready to Take Over the World', *Rolling Stone*, 27 October 2022

Chappell Roan Hub (@chappellroanhub), 'Chappell Roan at the Grammy Museum in Los Angeles – November 7th, 2024', Instagram, 28 November 2024 <https://www.instagram.com/reel/DC7YEf3xLyd/?igsh=b29jZnl1dng5eW43> [accessed 5 February 2025]

THE MAKING OF AN ALBUM

Spanos, 'Chappell Roan Is a Pop Supernova', *Rolling Stone*

Craig Marks, 'Daniel Nigro Fronted an Emo Band. Now He Makes Pop Smashes', *The New York Times*, 21 October 2024

'Exclusive Interview with "Chappell Roan"', *Illustrate*

Bringin' it Backwards, 'Interview with Chappell Roan'

Bringin' it Backwards, 'Interview with Chappell Roan (Chappell Returns!)'

Ross Semple, 'Singer Declan McKenna on Ditching Labels: "I'm Here to be Experimented With"', *Attitude*, 3 July 2107

OPENING FOR VANCE JOY & DECLAN MCKENNA

Tyler Jenke, 'Every One of Triple J's Hottest 100 Winners, Ranked', *Rolling Stone*, 22 January 2022

'Vance Joy, "Riptide" Wiki', *Last FM*, [n.d.] <https://www.last.fm/music/Vance+Joy/_/Riptide/+wiki> [accessed 5 February 2025]

'Vance Joy – Average Setlist for Year: 2017', *Setlist FM*, [n.d.] <https://www.setlist.fm/stats/average-setlist/vance-joy-bdd8596.html?year=2017> [accessed 5 February 2025]

'Lay It On Me Tour', *Wikipedia*, [n.d.] <https://en.wikipedia.org/wiki/Lay_It_On_Me_Tour> [accessed 5 February 2025]

'Chappell Roan – October 12 2017 Setlist', *Setlist FM*, [n.d.] <https://www.setlist.fm/setlist/chappell-roan/2017/first-avenue-minneapolis-mn-bac7d9e.html> [accessed 5 February 2025]

chappell roans unreleased & demos (@chappellroansongs), 'Lavish – Chappell Roan (unreleased)', YouTube, 30 July 2024 <https://www.youtube.com/watch?v=Jg6wY7sUqwU> [accessed 5 February 2025]

'Amy Shark – October 12 2017 Setlist', *Setlist FM*, [n.d.] <https://www.setlist.fm/setlist/amy-shark/2017/first-avenue-minneapolis-mn-3ac7d9b.html> [accessed 5 February 2025]

Visti and Liberty, 'Chappell Roan: Interview', *Unclear*

Arianna O'Dell, 'Get to Know Declan McKenna, the British Rocker Shaking Up the Indie Scene', *GRAMMY*, 11 November 2024

Sophie Williams, 'Glastonbury Festival Shares Details of 2025's Emerging Talent Competition', *Billboard*, 21 January 2025

Chris Willman, 'A Master Class with Chappell Roan and Dan Nigro, Conducted by Brandi Carlile, Reveals Secrets of a Brilliant Debut at the Grammy Museum', *Variety*, 9 November 2024

WELCOME TO THE PINK PONY CLUB

Kira Wakeam, Ailsa Chang and Christopher Intagliata, 'How Chappell Roan's Producer Dan Nigro Crafts Pop Hits for a New Generation', *NPR*, 23 December 2024

Mary Kate Carr, 'Chappell Roan Says it Took Years to Convince Anyone to Release Her Grammy-Nominated Album', *AV Club*, 8 November 2024

Q with Tom Power, 'Chappell Roan on the Rise and Fall of a Midwest Princess'

Bringin' it Backwards, 'Interview with Chappell Roan (Chappell Returns!)'

PART 2: SUNRISE
FALLING & RISING

Emily Treadgold, 'Chappell Roan: Trust That It Will Somehow Work Out', *The New Nine*, 2 August 2022

'Pink Pony Club', *Wikipedia*, [n.d.] <https://en.wikipedia.org/wiki/Pink_Pony_Club#:~:text=In%20the%20aftermath%20of%20Roan,Princess%2C%20released%20via%20Island%20Records.> [accessed 5 February 2025]

Spanos, 'Chappell Roan Is a Pop Supernova', *Rolling Stone*

Delia Cai, 'The Femininomenonal Ascent of Chappell Roan', *The Face*, 16 September 2024

No Labels Necessary (@nolabelsnecessary), 'Chappell Roan keeps it real in her VMA interview about dealing with "fame"', Instagram, 19 December 2024 <https://www.instagram.com/nolabelsnecessary/reel/DDxjZvct_Lj/?locale=es> [accessed 5 February 2025]

Lyndsey Havens, 'Inside Daniel Nigro's New Imprint Amusement Records', *Billboard*, 9 June 2023

Cai, 'The Femininomenonal Ascent of Chappell Roan' 'Florence + The Machine Round-Up!', *Oh No They Didn't!*, 11 April 2022

Stephen Daw, 'Chappell Roan's Big Year: How the DIY Indie-Pop Star "Casual"-ly Thrived in Her Post-Label Era', *Billboard*, 20 December 2022

Chappell Roan (@chappellroan), 'iamchappellroan.com', TikTok, 18 November 2022 <https://www.tiktok.com/@chappellroan/video/7167197462589869358?lang=en> [accessed 5 February 2025]

Chappell Roan Hub (@chappellroanhub), 'Chappell Roan on July 1st, 2022', Instagram, 29 October 2024 <https://www.instagram.com/reel/DBuFCjzywo6/?igsh=cGdmOWp4ZGlnMXdz> [accessed 5 February 2025]

Chappell Roan (@chappellroan), 'I'm freaking out', TikTok, 16 December 2021 <https://www.tiktok.com/@chappellroan/video/7042421153666813189> [accessed 5 February 2025]

'Chappell Roan – Bowery Ballroom', *Oh My Rockness*, 19 August 2022

Craig Marks, 'The Rise of Chappell Roan: Behind the Scenes, *Hits*, 13 September 2024

Dan Rys, 'Island's Time: How Sabrina Carpenter, Chappell Roan & More Are Fueling the Label's Best Run In Years', *Billboard*, 18 July 2024

Daniel Nigro (@dan_nigro), 'I'm extremely excited to introduce Amusement Records', Instagram, 13 March 2023 <https://www.instagram.com/dan_nigro/p/CpvK3Ghrzke> [accessed 5 February 2025]

THE NAKED IN NORTH AMERICA TOUR

Chappell Roan (@ChappellRoan), 'Chappell Roan – Naked in North America 2023 Tour Video', YouTube, 12 June 2023 <https://www.youtube.com/watch?v=_iNc79-gPlw> [accessed 12 March 2025]

Chappell Roan (@chappellroan), 'just by purchasing a ticket to my spring tour, you were helping the queer community', TikTok, 27 June 2023 <https://www.tiktok.com/@chappellroan/video/7249167469615516974?lang=en> [accessed 12 March 2025]

Amy (@sparkupbuzzcut), 'Chappell Roan singing the climb by Miley Cyrus is literally everything', TikTok, 3 March 2023 <https://www.tiktok.com/@sparkupbuzzcut/video/7206462822451072302> [accessed 12 March 2025]

pinkponyarchive (@pinkponyarchive), 'two years ago today, chappell roan covering lana del rey's "brooklyn baby" during soundcheck in philadelphia, PA!', Instagram, 25 February 2025 <https://www.instagram.com/pinkponyarchive/reel/DGgTzjGxJmf/> [accessed 12 March 2025]

Maggie Didier, 'Show Review: Chappell Roan on the Naked in North America Tour', *Backward Noise*, 28 February 2023

Ms. Dacity, 'Chappell Roan Brings "Pink Pony Club" to L.A. with "Naked in North America" Tour', *Daily Trojan*, 21 March 2023

THE STORY BEHIND THE SONGS

Chris Willman, 'A Master Class', *Variety*

Doug Klinger and Luke Orlando, 'Jackie! Zhou talks about Chappell Roan "Hot to Go!" and "Super Graphic Ultra Modern Girl"', *Music Videos Never Die*, 12 June 2024

Treadgold, 'Chappell Roan...', *The New Nine*

SONG ONE: FEMININOMENON

Jude Cramer, 'Chappell Roan's Nearly Been Married Twice, An Old TikTok Reveals', *Into*, 28 June 2024

Bringin' it Backwards, 'Interview with Chappell Roan (Chappell Returns!)'

'Toriphoria', *YesSaid*, [n.d.] <https://www.yessaid.com/int/1998-07_AP.html> [accessed 3 March 2025]

Amazon Music (@amazonmusic), 'The Walk In with Mo Heart: Chappell Roan is Bringing TACKY to the Masses (And Why She Loves It)', YouTube, 6 November 2023 <https://www.youtube.com/watch?v=tt-U6vM5bNY&t=18s&ab_channel=AmazonMusic> [accessed 5 February 2025]

Chappell Roan (@chappellroan), 'Replying to @shutthehellup147', TikTok, 3 August 2022 <https://www.tiktok.com/@chappellroan/video/7127445856436997419> [accessed 5 February 2025]

Chris Willman, 'A Master Class', *Variety*

SONG TWO: RED WINE SUPERNOVA

Daniel Nigro (@dan_nigro), 'Red Wine Supernova is Out!!!', Instagram, 19 May 2023 <https://www.instagram.com/dan_nigro/p/Csb0wTivL4d/?hl=en> [accessed 5 February 2025]

Lizzie Logan, 'From the Donut Shop to a World Tour: Chappell Roan is Doing Pop Her Way', *Glamour*, 18 May 2023

statdaddygayalien, 'The Original Demo Version of Red Wine Supernova', Reddit, 4 July 2024 <https://www.reddit.com/r/chappellroan/comments/1dvc8b0/the_orginal_demo_version_of_red_wine_supernova/> [accessed 5 February 2025]

Havens, 'Inside Daniel Nigro's New Imprint', *Billboard*

Willman, 'A Master Class', *Variety*

Chappell Roan (@chappellroan), 'Pre-save Red Wine Supernova', TikTok, 5 May 2023 <https://www.tiktok.com/@chappellroan/video/7229477247940398378?lang=en> [accessed 5 February 2025]

'Life & Work with Magical Katrina Kroetch of Downtown', *Voyage Phoenix*, 12 July 2023

SONG THREE: AFTER MIDNIGHT

alex (@AlexanderSemtex), 'Nothing Good Happens After 2am', YouTube, 31 July 2019 <https://www.youtube.com/watch?v=EKQT7WjPUIk> [accessed 5 February 2025]

Anderson-Burris, 'Mary Maxine (Tomlin) Lansdown', *Oklahoma Cemetries*

Capital Buzz, 'Chappell Roan Breaks Down Every Song'

Bringin' it Backwards, 'Interview with Chappell Roan (Chappell Returns!)'

Nick Venable, 'Miley Cyrus Recalls Foam Finger VMAs Performance Criticism In New Thong-Centric Post', *Cinema Blend*, 8 June 2021

Sam Prance, 'Chappell Roan Breaks Down Every Song on The Rise And Fall of a Midwest Princess – Making the Album', *Capital FM*, 16 January 2024

SONG FOUR: COFFEE

'Maya Kurchner', *Position Music*, [n.d.] <https://www.positionmusic.com/artist/MTM4MjQOO.S0wNjlhNTk> [accessed 5 February 2025]

Prance, 'Chappell Roan Breaks Down Every Song', *Capital FM*

Tomás Mier, 'How Chappell Roan Found "Complete Freedom and Euphoria" Making Her Debut Album', *Rolling Stone*, 21 September 2023

SONG FIVE: CASUAL
Sarah Fournell, 'A "Casual" Conversation with Chappell Roan', *WECB*, 27 October 2022

Daw, 'Chappell Roan's Big Year', *Billboard*

Damian J Ference, '"R-Rated Taylor Swift": Why This Priest Is Paying Attention (and Listening) to Chappell Roan', *America: The Jesuit Review*, 26 July 2024

Willman, 'A Master Class', *Variety*

Amelia Engstrom, 'Q & A Director of Chappell Roan's "Casual" Music Video Discusses Symbolism', *The Daily Texan*, 10 March 2024

SONG SIX: SUPER GRAPHIC ULTRA MODERN GIRL
'Supergraphic Ultramodern (1970s)' ([n.d.], *CARI* <https://cari.institute/aesthetics/supergraphic-ultramodern> [accessed 5 February 2025]

Capital Buzz, 'Chappell Roan Breaks Down Every Song', *Making the Album*

Eric Baldwin, 'Building Identity: 10 Bold Supergraphics That Make a Statement', *Architizer*, 19 June 2017

'Supergraphic Ultramodern (1970s)', *CARI*

Kent, 'On the Rise: Chappell Roan', *The Line of Best Fit*

Chris Azzopardi, 'On the Tour Bus with Chappell Roan: Everything the Superstar Told Us About Drag, Making Straight Boys Dance and Being Part of Pop Music's "Alliance of Queer Girlies"', *Pride Source*, 16 August 2024

Lady Gaga Now (@ladygaganownet), '@chappellroan talks to PopBuzz about how she got inspired by Lady Gaga's "Alejandro" for her song "Super Graphic Ultra Modern Girl"', Instagram, 27 June 2024 <https://www.instagram.com/reel/C8uY1bso3Pu/?igsh=MzRlODBiNWFIZA%3D%3D> [accessed 5 February 2025]

Jkayjnr (@jkayjnr), 'Cyndi Lauper communicates with Aliens – Live & Kicking 1995 1/4', YouTube, 14 January 2009 <https://www.youtube.com/watch?v=1lj0-X2aups> [accessed 5 February 2025]

Kathryn Milewski, 'Top 10 Chappell Roan Songs', *Live 365*, 23 July 2024

Hugh McIntyre, 'Inside the Making of the "Barbie" Soundtrack', *Forbes*, 20 July 2023

SONG SEVEN: HOT TO GO!
Chappell Roan (@chappellroan), 'I finally had the courage to write this song', TikTok, 19 July 2023 <https://www.tiktok.com/@chappellroan/video/7257314830040714539?lang=en> [accessed 6 February 2025]

Rebecca Alter, 'Chappell Roan Just Wants to be Hanna Montana', *New York Vulture*, 2 August 2023

Capital Buzz, 'Chappell Roan Breaks Down Every Song'

Hannah Dailey, 'Watch Chappell Roan Scold VIP Section for Being "Too Cool" to Do Her "Hot to Go!" Dance', *Billboard*, 12 August 2024

Spanos, 'Chappell Roan is a Pop Supernova', *Rolling Stone*

SONG EIGHT: MY KINK IS KARMA
Mosk, 'Premiere: Chappell Roan's Haunting "Bitter" Dwells in Darkness', *Atwood Magazine*

Capital Buzz, 'Chappell Roan Breaks Down Every Song', *Making the Album*

Aimée Lutkin, 'Chappell Roan's Complete Dating History', *Elle*, 28 March 2025

Festiverse (@festiverse), 'Chappell Roan talking to her ex boyfriend in Karma', TikTok, 2 August 2024 <https://www.tiktok.com/@festiverse/video/7398352532059327775> [accessed 6 February 2025]

Jude Cramer, 'Chappell Roan's Kink Is Karma, And Our Kink Is Chappell Roan', *Into*, 8 July 2022

SONG NINE: PICTURE YOU
Mier, 'How Chappell Roan Found "Complete Freedom and Euphoria"', *Rolling Stone*

SONG TEN: KALEIDOSCOPE
Capital Buzz, 'Chappell Roan Breaks Down Every Song', *Making the Album*

E! News (@enews), '#ChappellRoan opens up about falling in love with her best friend during a discussion with #BrandiCarlile at the @grammymuseum', TikTok, 8 November 2024 <https://www.tiktok.com/@enews/video/7435039399026478378> [accessed 6 February 2025]

Stone, 'A Night Out with Chappell Roan', *Nylon*

Mier, 'How Chappell Roan Found "Complete Freedom and Euphoria"', *Rolling Stone*

Willman, 'A Master Class', *Variety*

Carol Ann Duffy, 'Name', *Collected Poems* (Pan Macmillan, 2015), p.371

Caroline, 'Carol Ann Duffy: *Rapture* (2005) Poems', *Beauty Is a Sleeping Cat*, 14 February 2013

SONG ELEVEN: PINK PONY CLUB
Greta Cross, 'Which Springfield Club Inspired Chappell Roan's "Pink Pony Club"? Here's What We Know', *Springfield News-Leader*, 5 October 2024

Madison Yohn, 'We Sat Down with Chappell Roan, a Springfield Native Turned Pop Artist', *Visit Springfield Missouri*, 17 February 2023

Elina Shatkin, 'The Abbey: The Story of an L.A. Icon', *Discover Los Angeles*, 15 March 2022

P. Claire Dodson, 'Chappell Roan Talks "Casual" Music Video, Trans Rights, and Creating the Pink Pony Club of Her Dreams', *Teen Vogue*, 9 March 2023

Hillel Aron, 'The Unlikely Story of David Cooley and the World's Most Famous Gay Bar', *WeHoOnline*, 4 January 2013

Alice Gustafson, 'Chappell Roan: How an Unforgettable Night at a Gay Club Led to Pink Pony Club', *Headliner*, [n.d.] <https://headlinerhub.com/chappell-roan-california-here-we-come.html> [accessed 6 February 2025]

Bringin' it Backwards, 'Interview with Chappell Roan (Chappell Returns!)'

Wakeam, Chang and Intagliata, 'How Chappell Roan's Producer Dan Nigro Crafts Pop Hits', *NPR*

Marks, 'The Rise of Chappell Roan', *Hits*

Marks, 'Daniel Nigro Fronted an Emo Band', *The New York Times*

Tim Tucker, 'Lo Moon's Sam Stewart: "I Do Session Work in LA for Producers and Artists, and They Always Want Me to Bring My Gretsch"', *Guitar World*, 23 May 2022

Chappell Roan (@ChappellRoan), 'Thank you @Spotify for adding "Pink Pony Club" to your Indie Pop playlist', X, 10 April 2020 <https://x.com/ChappellRoan/status/1248663046194704384> [accessed 6 February 2025]

Chappell Roan (@ChappellRoan), 'Pink Pony Club (Acoustic)', YouTube, 27 April 2020 <https://www.youtube.com/watch?v=1U9Ph_Qeh-E> [accessed 6 February 2025]

'Chappell Roan', *Billboard*, [n.d.] <https://www.billboard.com/artist/chappell-roan/> [accessed 6 February 2025]

Lydia Spencer-Elliott, 'Chappell Roan's Dad Breaks Down in Tears As He Reveals What the Singer Taught Him About Life', *The Independent*, 17 December 2024

SONG TWELVE: NAKED IN MANHATTAN
Chappell Roan (@chappellroan), 'Presave link in bio ;)', TikTok, 2 February 2022 <https://www.tiktok.com/@chappellroan/video/7059934403279129903> [accessed 6 February 2025]

Madeline Kinnaird, '#NowPlaying – Chappell Roan, "Naked in Manhattan"' *NPR*, 15 March 2022

Q with Tom Power, 'Chappell Roan on the Rise and Fall of a Midwest Princess'

Chappell Roan (@ChappellRoan), 'I'm Chappell Roan and I'm so excited to answer all your questions!', Reddit, 26 October 2022 <https://www.reddit.com/r/popheads/comments/ye5ku7/im_chappell_roan_and_im_so_excited_to_answer_all/> [accessed 6 February 2025]

Daniel Nigro (@dan_nigro), 'It's been two years, and 4 different chorus ideas later but this song is finally out in the world', Instagram, 18 February 2022 <https://www.instagram.com/dan_nigro/p/CaIB6EZpnqj/> [accessed 6 February 2025]

Janet Loehrke and Doyle Rice, '"Trillions" of Cicadas? See How and Where Dual Cicada Broods Will Emerge in 2024', *USA Today*, 2 February 2024

SONG THIRTEEN: CALIFORNIA
Capital Buzz, 'Chappell Roan Breaks Down Every Song', *Making the Album*

yaz (@chappellpherom0an), 'chappell roan on not feeling like she fit in california and being homesick', TikTok, 9 July 2024 <https://www.tiktok.com/@chappellpherom0an/video/7389653242818465054> [accessed 6 February 2025]

'Hey! I'm going live', Facebook, 22 September 2017

Katy Rossing, 'Smothered: American Nostalgia and the Small Wisconsin Town', *Hypocrite Reader*, January 2012 <https://www.hypocritereader.com/12/smothered-american-nostalgia> [accessed 6 February 2025]

SONG FOURTEEN: GUILTY PLEASURE
Jude Cramer, 'Here's Why Chappell Roan Almost Never Performs Her Favorite Song From Her Album', *Into*, 12 August 2024

Kent, 'On the Rise: Chappell Roan', *The Line of Best Fit*

PART 3: STARBURST
FLETCHER & RODRIGO

Mey Rude, 'Fletcher Opened Up About Her Sexuality in Heartfelt Instagram Post', *Out*, 20 December 2021

Steffanee Wang, 'The Making of Fletcher's Perfectly Messy Pop', *Nylon*, 15 September 2020

Weslee Kate, 'Fletcher and "The S(ex) Tapes" Are Here – Are You Ready?', *Ladygunn*, 4 November 2020

Daw, 'Chappell Roan's Big Year', *Billboard*

NardwuarServiette, 'Nardwuar vs. Chappell Roan'

Chappell Roan (@chappellroan), 'Becky's So Hot - FLETCHER', TikTok, 6 November 2022 <https://www.tiktok.com/@chappellroan/video/7162694606725844266?lang=en> [accessed 12 March 2025]

'Olivia Rodrigo', *Rolling Stone* [n.d.] <https://www.rollingstone.com/t/olivia-rodrigo/> [accessed 6 February 2025]

Capital Buzz, 'Chappell Roan Breaks Down Every Song', *Making the Album*

SOUR

Callie Ahlgrim, 'Baby Queen Says She Wants Her Songwriting to Be "Uncomfortably Honest". So Far, So Good', *Business Insider*, 14 April 2021

Chappell Roan (@chappellroan), 'OMG I'M OPENING FOR @oliviarodrigo', Instagram, 29 January 2022 <https://www.instagram.com/chappellroan/p/CZUruJfvMqg/?hl=en> [accessed 3 March 2025]

Treadgold, 'Chappell Roan...', *The New Nine*.

Yohn, 'We Sat Down with Chappell Roan', *Visit Springfield, Missouri*

GUTS

Jason Lipshutz, 'Inside Olivia Rodrigo's Concert Film: Chappell Roan, The L.A. Joke She Had to Include & Uplifting Young Women One Week Before the Election', *Billboard*, 29 October 2024

Chappell Roan Fashion & Style (@chappellroanstyle), 'August 20th 2024/Guts Tour Hot To Go Special Appearance', Instagram, 25 August 2024 <https://www.instagram.com/chappellroanstyle/p/C_EzDmAutEv/?img_index=1> [accessed 6 February 2025]

Jaden Thompson, 'Olivia Rodrigo and Chappell Roan Rock Out at LA Show in Bold Leather Boots', *Footwear News*, 21 August 2024

GOOD LUCK, BABE!

Marks, 'The Rise of Chappell Roan', *Hits*

Teen Vogue (@teenvogue), '"Good Luck Babe" or "Good Luck Jane"?', Instagram, 25 December 2024 <https://www.instagram.com/teenvogue/reel/DEAoI3iIB7e/> [accessed 6 February 2025]

COACHELLA

Chappell Roan (@chappellroan), '@coachella what an insane experience', Instagram, 19 April 2024 <https://www.instagram.com/chappellroan/p/C59P681y2up/?hl=en&img_index=9> [accessed 6 February 2025]

Margaux Anbouba, 'Chappell Roan on Her First-Ever Coachella and the Magic of Makeup', *Vogue*, 14 April 2024

Tom Breihan, '19 Thoughts on the Coachella 2024 Poster', *Stereogum*, 17 January 2024

Tricia Romano and Chona Kasinger, 'Chappell Roan Booked a Tour. Then She Blew Up', *The New York Times*, 24 July 2024

Rhian Daly, 'Coachella 2024: Surprises, Technical Difficulties and a Distinct Lack of Vibes', *NME*, 16 April 2024

Emma Madden, Alex Suskind and Rebecca Alter, 'The Highs, Lows, and Woahs of Coachella 2024', *New York Vulture*, 15 April 2024

Chappell Roan (@chappellroan), 'inspired by the incredible @theladymisskier – this was an absolute dream come true', Instagram, 24 April 2024 <https://www.instagram.com/chappellroan/p/C6H8QOHvizR/?hl=en-gb&img_index=5> [accessed 6 February 2025]

Sam Neibart, 'How Chappell Roan Transformed Into a Human Butterfly For Coachella Weekend Two – Exclusive', *Nylon*, 22 April 2024

'PEARL', *Lady Keir*, 20 January 2011

'Meet Samanfah Wilson: Fantasy Costume Designer', *Shoutout LA*, 26 February 2025

'Romano & Kasinger, 'Chappell Roan Booked a Tour', *The New York Times*

GOVERNORS BALL

US Weekly (@UsWeekly), '#ChappellRoan Channels Lady Liberty at Gov Ball NYC!', YouTube, 10 June 2024 <https://www.youtube.com/shorts/wRQK9frDo-U> [accessed 6 February 2025]

Izzy Grinspan, 'Chappell Roan's Tour Wardrobe Is a Case Study in How to Build a Pop Star', *Harper's Bazaar*, 9 July 2024

Chappell Roan Fashion & Style (@chappellroanstyle), 'June 9th, 2024/Gov Ball Taxi Outfit', Instagram, 17 July 2024 <https://www.instagram.com/chappellroanstyle/p/C9ioSCeOhqu/?hl=en-gb&img_index=1> [accessed 6 February 2025]

Gabriella Medina, 'Chappell Roan Says She Declined to Perform at the White House for Pride', *Los Angeles Magazine*, 10 June 2024

CHAPPELL LOLLAPALOOZA

Cai, 'The Femininomenonal Ascent of Chappell Roan'

Chappell Roan (@chappellroan), 'I was crying as I walked on stage at @lollapalooza', Instagram, 3 August 2024 <https://www.instagram.com/chappellroan/p/C-NnmIzMyR8/?hl=en-gb&img_index=1> [accessed 6 February 2025]

Austin Weatherhead, 'Lucy Ritter Shines as Drummer for Rising Pop Star Chappell Roan', *Drummer World*, 2024 <https://www.drummerworld.com/articles/news/lucy-ritter-chappell-roan-drummer/> [accessed 12 March 2025]

Jenna Scaramanga, 'Devon Eisenbarger Plays with the World's Biggest Popstars – But Still Jams Covers In Amusement Parks', *Guitar World*, 26 November 2024

'All Made Up (Allee Fütterer)', *La Bella*, [n.d.]

Lollapalooza (@lollapalooza), 'It's Chappell's world and we're just living in it', Instagram, 2 August 2024, <https://www.instagram.com/lollapalooza/reel/C-JsR-fxzru/?hl=en-gb> [accessed 6 February 2025]

Ella Narag, 'Chappell Roan Overwhelms T-Mobile Stage in Packed Set', *The Daily Illini*, 2 August 2024

Selena Fragassi, 'Chappell Roan Is Our Favorite Artist's Favorite Artist — and Chicago's: Lollapalooza Review', *Chicago Sun-Times*, 2 August 2024

Elizabeth Wagmeister, 'Chappell Roan May Have Had the Biggest Lollapalooza Set of All Time', *CNN*, 5 August 2024

Althea Legaspi, Nina Corcoran and Kalia Richardson, 'Chappell Roan Gives Headline-Worthy Set; Megan Thee Stallion, Hozier Talk Cease-Fire on Lolla Day One', *Rolling Stone Québec*, 2 August 2024

REDEFINING FAME

Andrea Dresdale and Carson Blackwelder, 'Chappell Roan on "Abusive" Side of Fame: "If This Ever Gets Dangerous, I Might Quit"', *ABC News*, 17 September 2024

'Chappell Roan: Quit Touching Me, Shouting My Real Name!!!', *TMZ*, 24 August 2024

Jon Blistein, 'Chappell Roan Says a Fan Once Kissed Her Without Permission', *Rolling Stone*, 10 September 2024

Cai, 'The Femininomenonal Ascent of Chappell Roan', *The Face*

Lauryn Overhultz, 'Pop Star Chappell Roan Accuses Fans of Stalking, Harassment in Scathing Videos', *Fox News*, 20 August 2024

Tess Patton, 'Chappell Roan Sets a "Superfan" Boundary After "Too Many Nonconsensual" Interactions', *The Wrap*, 23 August 2024

Gabriella Angelina, 'Chappell Roan's Privacy Plea Is an Overdue Cultural Reset', *Out*, 26 August 2024

jessica (@lucille_ballz), 'actually heartbreaking to hear in person', TikTok, 23 September 2024 <https://www.tiktok.com/@lucille_ballz/video/7417891348952452385?q=lucille_ballz%20chappell&t=1740582232923> [accessed 3 March 2025]

'I Miss Frolicking Ft. Chappell Roan', *The Comment Section with Drew Afualo*, Spotify, 17 July 2024 <https://open.spotify.com/episode/7w5XYqFMFe1fBemwaFwtm6> [accessed 6 February 2025]

Chelsey Sanchez, 'Miley Cyrus Defends Chappell Roan: "I Wish People Would Not Give Her a Hard Time"', *Harper's Bazaar*, 20 November 2024

Justin Curto, 'Chappell Roan's Stalker Made Her Hire Security, Which Is "So Lame"', *New York Vulture*, 10 September 2024

Poppy Burton, 'Mitski Welcomed Chappell Roan to "the Shittiest Exclusive Club in the World" and Warned of Fandom', *NME*, 10 September 2024

- Brittany Spanos, 'Chappell Roan: The Pain and Pleasure of a Pop Supernova', *Rolling Stone UK*, 19 September 2024

- Angie Martoccio, 'Stevie Nicks: "I Believe in the Church of Stevie"', *Rolling Stone*, 24 October 2024

- Julyssa Lopez, 'From Lady Gaga to Mitski, Here Are All the Artists Supporting Chappell Roan', *Rolling Stone*, 11 September 2024

- Marc Malkin, 'Chappell Roan Was Booked for Elton John's Oscars Party After They Became "Dear" Friends, David Furnish Says: "He Keeps an Eye on Her"', *Variety*, 18 February 2025

- Daniel Kreps, 'Chappell Roan on VMAs Red Carpet Incident: "You Don't Get to Yell at Me Like That"', *Rolling Stone*, 12 September 2024

- Lauren Huff, 'Chappell Roan Claps Back at VMAs Photographer Who Yelled "Shut the F— Up": "Not Me, Bitch"', *Yahoo! News*, 12 September 2024

- E! News (@enews), 'Chappell Roan CONFRONTS "Disrespectful" Photographer on Red Carpet', YouTube, 26 October 2024 <https://www.youtube.com/watch?v=zOATY-MQRF4> [accessed 6 February 2025]

- Daniel Welsh, '"You Shut The F*** Up": Chappell Roan Fires Back At Photographer On VMAs Red Carpet', *HuffPost*, 12 September 2024

- BBC Radio 1 (@bbcradio1), 'Chappell Roan – BBC Sound of 2025 Exclusive Interview', YouTube, 20 January 2025 <https://www.youtube.com/watch?v=ZEhSOz0VoqQ&ab_channel=BBCRadio1> [accessed 6 February 2025]

- Mark Savage, 'Chappell Roan: "I'd Be More Successful If I Wore a Muzzle"', *BBC News*, 20 January 2025

- Ilana Kaplan, 'Chappell Roan Says If Fame "Gets Dangerous" She "Might Quit": "That Part Is Not What I Signed Up For"', *People*, 16 September 2024

THE MIDWEST PRINCESS TOUR

- Josh Kurp, 'Chappell Roan's Final Tour Date of 2024 Featured Another Massive Crowd, a Possible "SNL" Hint, and a Daring Outfit', *Uproxx*, 14 October 2024

- 'The Midwest Princess Tour', *Wikipedia*, [n.d.] <https://en.wikipedia.org/wiki/The_Midwest_Princess_Tour> [accessed 6 February 2025]

- FoxieGaspie (@foxiegaspie), 'Chappell's Monologue [Gillioz Theatre Midwest Princess Experience 09.20.23]', YouTube, 23 September 2023 < https://www.youtube.com/watch?v=Ib65a6N9Q_0&list=PLQcTWz_V2K-Wr87RZUQxzey7QppO-ArNi&index=12> [accessed 6 February 2025]

- Chappell Roan (@chappellroan), 'TOUR THEMES PART 2', Instagram, 1 September 2023 <https://www.instagram.com/chappellroan/p/CwqchjlSY-n/?img_index=1> [accessed 12 February 2025]

- Chappell Roan (@chappellroan), 'FALL TOUR THEMES PART 1', Instagram, 1 September 2023 <https://www.instagram.com/p/CwqbKg2SGDT/?img_index=1> [accessed 12 February 2025]

- FoxieGaspie (@foxiegaspie), 'Chappell Roan – Pink Pony Club [Live at Gillioz Theatre Midwest Princess Experience 09.20.23]', YouTube, 23 September 2023 <https://www.youtube.com/watch?v=8PpSxOQZrQ0> [accessed 12 March 2025]

- Steven Daly, 'Britney Spears, Teen Queen: Inside the Heart and Mind (and Bedroom) of Britney', *Rolling Stone*, 15 April 1999

- Chappell Roan (@chappellroan), 'Swipe to find ur city', Instagram, 23 January 2024 <https://www.instagram.com/p/C2bpYD1u3i-/?img_index=7> [accessed 12 March 2025]

- Chappell Roan (@chappellroan), 'us themes', Instagram, 20 September 2024 <https://www.instagram.com/p/DAJrHKzS6pR/?img_index=3> [accessed 12 March 2025]

- Alex Jhamb Burns, 'Chappell Roan and the Rise of Concert Costume Parties', *Vogue*, 20 October 2023

- *Chappell Roan UK* <https://chappell-roan-uk.backstreetmerch.com/> [accessed 6 February 2025]

- Andrew Sullender, 'Springfield-native Chappell Roan brings 'queer celebration' to homecoming concert', *Springfield News-Leader*, 29 January 2023

- Lisa Henderson, 'Chappell Roan's Live Team on Her "Exhilarating" Rise', *IQ*, 9 October 2024

- Annelise Hanshaw, 'Restrictions on Drag Performances Debated by Missouri House Committee', *Missouri Independent*, 7 March 2024

- Inga Rock (@theingarock), 'Thank you @chappellroan', Instagram, 9 December 2024 <https://www.instagram.com/p/DDXZ122sLKA/?hl=en&img_index=1> [accessed 3 March 2025]

- Tom Breihan, 'Chappell Roan is a Star', *Stereogum*, 24 May 2024

- Kitty Empire, 'Chappell Roan Review – a Super Graphic Ultra Modern Showbiz Star', *The Guardian*, 21 September 2024

- Annabel Nugent, 'Chappell Roan Review, Manchester: The Last Time We'll See This Maximalist Splendour in Such Small Surroundings', *The Independent*, 14 September 2024

- Adrian Thrills, 'Chappell Roan Review: The Midwest Princess Who's Pop's Next Big Star', *Mail Online*, 20 September 2024

- Anagricel Duran, 'Watch Chappell Roan's Parents Talk About "Pink Pony Club" and Sing Along on "Carpool Karaoke" Special', *NME*, 16 December 2024

- Pete Allison and Riyah Collins, 'Singer Chappell Roan Calls Out Fans' "Creepy Behaviour"', *BBC News*, 20 August 2024

- Chappell Roan (@ChappellRoan), 'Due to some scheduling shifts, I've had to jump out of the lineups for Superbloom and Lollapalooza Berlin', X, 26 July 2024 <https://x.com/ChappellRoan/status/1816745694440673474> [accessed 6 February 2025]

- Chappell Roan (@ChappellRoan), 'Due to scheduling conflicts, I have had to make the extremely hard decision to cancel my Paris and Amsterdam shows', X, 29 August 2024 <https://x.com/ChappellRoan/status/1829066599292453294> [accessed 6 February 2025]

- Rebecca Lawrence, 'Chappell Roan Leaves Fans Thousands of Pounds Out of Pocket as She Cancels European Tour Dates Last-Minute Because of "Scheduling Conflicts"', *Mail Online*, 29 August 2024

- Savage, 'Chappell Roan: "I'd Be More Successful If I Wore a Muzzle"', *BBC News*

AWARDS SEASON

- 'Chappell Roan', *Wikipedia*, [n.d.] <https://en.wikipedia.org/wiki/Chappell_Roan#Awards_and_nominations> [accessed 6 February 2025]

- Caroline de Sortiraparis, 'NRJ Music Awards 2024: The Full List of Nominees', *Sortiraparis.Com*, 1 November 2024

- Max Pilley, 'Here Are All the Winners from the 2024 MTV EMAs', *NME*, 10 November 2024

- Chappell Roan (@ChappellRoan), 'Chappell Roan – Red Wine Supernova (Live) – Vevo DSCVR Artists to Watch 2024', YouTube, 8 November 2023 <https://www.youtube.com/watch?v=uMshgHF9Gso> [accessed 6 February 2025]

- Chappell Roan (@ChappellRoan), 'Chappell Roan – Casual (Live) – Vevo DSCVR Artists to Watch 2024', YouTube, 8 November 2023 <https://www.youtube.com/watch?v=JCJKq2-I0Z0&t=116s> [accessed 6 February 2025]

- 'Winners & Nominees', *ARIA Awards 2024*, [n.d.] <https://www.aria.com.au/awards/nominees> [accessed 6 February 2025]

- Chappell Roan Fashion & Style (@chappellroanstyle), 'Chappell Roan for BBC Radio One award acceptance/January 2025', Instagram, 10 January 2025 <https://www.instagram.com/chappellroanstyle/p/DEqcqrLxQMi/?img_index=1> [accessed 6 February 2025]

- triple j (@triplej), 'Chappell Roan "Good Luck, Babe!" wins triple j's Hottest 100 2024', YouTube, 25 January 2025 <https://www.youtube.com/watch?v=ignLZ1JKI_k> [accessed 6 February 2025]

- Nina Frazier, '2025 GRAMMYs: See the Full Winners & Nominees List', *GRAMMY*, 3 February 2025

- Jeff Kessinger, 'Say hello to fall – and pet a mini horse – at the 25th Cider Days', *Springfield Daily Citizen*, 15 September 2023

- Oasis Hotel, 'After winning Springfield's Got Talent', Instagram

- Paul Grein, 'Grammy Awards: All the Artists Who've Been Nominated in the Big 4 Categories in the Same Year', *Billboard*, 28 January 2024

- Chappell Roan (@Chappell Roan), 'I'm hungies', Facebook, 22 November 2024 [accessed 10 February 2025]

- Hannah Dailey, 'Chappell Roan on Potential 2025 Grammy Speech: "You Know Me, I'm Gonna Say Something Controversial"', *Billboard*, 16 December 2024

- 'GLAAD Returns to the Red Carpet at the 67th

Annual Grammy Awards with Co-Hosts Chrishell Stause & Anthony Allen Ramos for Special Coverage Bringing LGBTQ Music Artists Into Focus', *GLAAD*, 29 January 2025

Joan Summers, 'How Maris Jones Brought Chappell Roan's 'Pink Pony Club' to the Grammys', *Paper*, 3 February 2025

Laura Molloy, 'Chappell Roan Dedicates Her BRIT Award to "Trans Artists, Drag Queens, Fashion Students, Sex Workers, and Sinead O'Connor"', *NME*, 2 March 2025

Taylor Fields, '2025 iHeartRadio Music Awards: See The Full List of Nominees', *iHeartRadio Music Awards*, 22 January 2025

TV APPEARANCES

Spencer Jenkins, 'Chappell Roan Gives "Swan Lake" in Dress Designed by Kentuckiana Native Gunnar Deatherage', *Queer Kentucky*, 21 June 2024

Capital Buzz, 'Chappell Roan Breaks Down Every Song', *Making the Album*

Chappell Roan (@chappellroan), 'This is a clue', Instagram, 25 October 2024 <https://www.instagram.com/p/DBjmfZbSfFt/?img_index=2&igsh=MTZhemY1dzU5dTR0bQ> [accessed 11 February 2025]

Chappell Roan (@ChappellRoan), 'The Giver (She Gets the Job Done) – Chappell Roan (unreleased)' YouTube, 14 March 2025 < https://www.youtube.com/watch?v=mhsnDeMTmuY> [accessed 24 March 2025]

Cavan Sieczkowski, 'Radio Stations Pull Little Big Town's "Girl Crush" Over Complaints Of Song's "Gay Agenda"', *Huffpost*, 2 February 2016

Willman, 'A Master Class', *Variety*

A SPARKLING FUTURE

Chappell Roan, 'Last email of 2024', Chappell Roan, 2024 <https://www.iamchappellroan.com/subscribe/> [accessed 6 February 2025]

Kelly Nguyen, 'Chappell Roan's Big Year: The "Midwest Princess" Examines How She Became a Pop "Femininomenon"', *GRAMMY*, 19 April 2024

(@wwhl), 'Paris Hilton Shares Her Opinions', *Watch What Happens Live with Andy Cohen*, YouTube, 16 September 2024 < https://www.youtube.com/watch?v=GIEJxns2P-s > [accessed 6 February 2025]

PICTURE CREDITS

ALAMY STOCK PHOTO: Al Powers / Powers Imagery / Invision / AP 26; Chris Pizzello/AP Photo 70-71; Alive Coverage/Sipa USA 124-125;

CATIE LAFFOON: 33, 36;

JAMIE SCHULTZ: 17, 40, 65;

DAVID LA MASON: 43;

GETTY IMAGES: Christopher Polk/Billboard 7; Scott Kowalchyk/CBS 8-9; Francesco Prandoni/Archivio Francesco Prandoni/Mondadori 18 al; Max Morse 18 ar; Kevin Mazur/WireImage 19 al; Jamie McCarthy 19 ar; Tim Graham 20 al; Rick Diamond 20 bl; Hulton Archive 21; Maury Phillips/WireImage 26-27; John Medland/Disney Channel 27; Kevin Mazur 38; Michel Linssen/Redferns 39; Mary Mathis for The Washington Post 47; Mary Mathis for The Washington Post 48-49; Mike Prior 50 ar; Kevin Mazur/Getty Images for Live Nation 50 al; Kevin Mazur/Getty Images for Live Nation 51 al; Michael Ochs Archives 51 ar; Noam Galai/Getty Images for Audible 52; Matt Winkelmeyer 53; Stephen J. Cohen 54; Kevin Mazur/Getty Images for The Recording Academy 56; Matthew J. Lee/The Boston Globe 58; Astrida Valigorsky/WireImage 60 al; Robin Little/Redferns 60 ar; Jamie McCarthy/Getty Images for Live Nation 61 ar; Pete Still/Redferns 61 al; Jim Bennet 63; Kevin Winter/Getty Images for Coachella 66; Steve Jennings/WireImage 67; Jim Bennet 67; Andrew Lipovsky/NBCU Photo Bank/NBCUniversal 67; Maya Dehlin Spach/FilmMagic 69; Mary Mathis for The Washington Post 72-73; Mary Mathis for The Washington Post 75; Rebecca Sapp/Getty Images for The Recording Academy 78; Kevin Mazur/Getty Images for The Recording Academy 79; Mary Mathis for The Washington Post 80-81; Mary Mathis for The Washington Post 85 ar;Mary Mathis for The Washington Post 87; Michael Putland 88 al;Michael Montfort/Michael Ochs Archives 88 ar; Duncan Raban/Popperfoto 89 ar; Scott Gries 89 al; Mary Mathis for The Washington Post 90; Rick Kern 94-95; Erika Goldring/WireImage 96-97; Jeffrey Mayer 100 al; Thierry Orban/Sygma 100 bl; Axelle/Bauer-Griffin/FilmMagic 103; Jason Kempin 109; Katja Ogrin/Redferns 113; Rodin Eckenroth 116; Erika Goldring 128-129; Kevin Mazur/Getty Images for The Recording Academy 131; John Shearer/Getty Images for The Recording Academy 140-141; Mary Mathis for The Washington Post 142; Mary Mathis for The Washington Post 143; Katja Ogrin/Redferns 147; Michael Ochs Archives 150; John Shearer/Getty Images for The Recording Academy 154-155; Christopher Polk/Billboard 157; Christopher Polk/Billboard 158; Kevin Mazur/Getty Images for Live Nation 158-159; Christopher Polk/Billboard 159; Frazer Harrison 161; Christopher Polk/Billboard 163; Steven Simione/FilmMagic 165; Alberto E. Rodriguez/WireImage 166; Dania Maxwell/Los Angeles Times 169; Marleen Moise 173; Marleen Moise 174; Nina Westervelt/Billboard 175; Natasha Moustache 177; Erika Goldring/WireImage 178-179; Medios y Media 182 t;Natasha Moustache 182 br;Will Heath/NBC 185; WWD/Swan Gallet 186; Natasha Moustache 188 al; Rick Kern 188-189 ac; Marleen Moise 189 ar; Michael Kovac/Getty Images for Elton John AIDS Foundation 190; Kevin Mazur/Getty Images for The Recording Academy 191; Allen J. Schaben/Los Angeles Times 192; Jim Dyson 197; Marleen Moise 202; Astrida Valigorsky 203 br; Jim Dyson 203 ar; Katja Ogrin/Redferns 206; Jim Dyson 211; Kevin Winter/Getty Images for The Recording Academy 212; Amy Sussman 214-215; Christopher Polk/Billboard via 217; Axelle/Bauer-Griffin/FilmMagic 218 al; John Shearer/Getty Images for The Recording Academy 218-219 ac; Kevin Winter/Getty Images for The Recording Academy 219 ar; JMEnternational 222; Michael Kovac/Getty Images for Elton John AIDS Foundation) 223; Todd Owyoung/NBC 225; Todd Owyoung/NBC 226; Vittorio Zunino Celotto/Getty Images for Valentino 229; Michael Kovac/Getty Images for Elton John AIDS Foundation 230; Axelle/Bauer-Griffin/FilmMagic 231;

IMAGN IMAGES: ©Andrew Jansen – USA TODAY NETWORK 23;

ISTOCK: Ashley Porter 11; Nastya Prokopchuk 14; DenPotise 25; DenPotise 71; vector_ann 102; komunitestock 109; Alhontess 111; bankrx 150; Daisha 167;

SHUTTERSTOCK: ResinReleasem 14-15; Chones 31; Ganna Pavlyukevych 34; Christian Bertrand 38-39; Anastasiia Khikhlovskaia 127; Liane Carbone Photography 151; Steve Galli 180; ZUMA Press Wire / Daniel DeSlover 182; Used throughout: BIRD_Tanakorn; Glitter_Klo; HenadziPechan; Lenka_X; MRPrize; Nika Mooni; Stephanie Zieber; Strawberry_Queen; surachet khamsuk; Unleashed Design; VolodymyrSanych

ABOUT THE AUTHORS

KATHERINE ST. ASAPH is a music journalist and cultural critic living in New York City. Katherine's work blends sharp analytical depth with a distinct voice, offering readers fresh perspectives on both emerging and established artists. She has been a contributor to *Pitchfork* since 2012 and a pop music columnist for *Stereogum* since 2023. Her writing has also appeared in *Spin*, MTV Hive and T*he Village Voice*, where she covers everything from the evolution of pop trends to underground music movements.

HAMZA JAHANZEB is a queer writer, producer and leading voice in cultural criticism. He reviews West End and Broadway theatre industries, television, film, art galleries and contemporary music. His work has been quoted in *The New York Times*, *BBC* and *The Guardian*. Hamza also produces events, most recently for the British Library and Jaipur Literature Festival, where leading musical theatre performers from *Hamilton* and *Les Misérables* performed inside the iconic British landmark in a first for the festival. A dedicated advocate for inclusivity and #BookJobTransparency, Hamza is a force for good within the publishing industry spotlighting and evoking thoughtful discussions around authenticity (née sensitivity) reads which he carries out during his spare time, providing clients with access to his rolodex of hundreds of cultural consultants across the globe built over a decade of networking. Keep up to date with Hamza at hamzajahanzeb.co.uk

ACKNOWLEDGEMENTS

KATHERINE:

- To Anna, Chris, Jayson, Jeremy, Jessica, Jill, Mark, Maura, Sam, Scott and Will, for support along the way.
- To Aaron, Annie, Cat, Eugene, Ian, Kat, Kate, Klay, Meb, Naeem, Nelson, Nolan, Phil and Wish, for moral support.
- To the *Jukebox* writers, for being your favourite pop writer's favourite pop writers for 17 years.

HAMZA:

My sincere thanks to the following beautiful humans in my life:

- To my family for your love, particularly cousin Noreen for always being there.
- To Mireille Cassandra Harper: I am so proud to call you a dear friend and am truly appreciative of your patience, kindness and extreme generosity.
- To Marcus and Johnny: for being the kindest souls, best travel buddies and taking me under your wing when I first moved t'London!
- To Katie Roden, James Spackman, Shobna Gulati, Asma Khan, Emily Noto, Katie Packer, Louie Stowell, Louise Doughty, Tricia Sinclair, Irvine Iqbal, Norma Linney, Sandeep Mahal, Samar Habib, Bee Rowlatt, Val and Clare Pearson, Mira Sethi, Sunny Singh, Monisha Rajesh, Dotti Irving, Kasia, Colin, Zoe, Tim, Gina, Shahnaz, Kevin, Virginie, Shelley and the MNG/Eurospan gang.
- My deepest gratitude to D.S. and J.T. – truly guiding lights for me – who always believed that *every night's another reason why I left it all*. Your unwavering faith in me has been appreciated as has your wisdom, guidance and support over the years.
- To my co-writer Katherine St. Asaph, Steph, Pauline, Ros Webber and the Rights team at Cassell (Hachette UK); to all the folks at Running Press, Carrie Bloxson and Sara Munjack at HBG.
- Finally, to Kayleigh Amstutz Rose i.e. Chappell Roan and Daniel Nigro for ensuring that: *I'm gonna' keep on dancing!*